An Essential Introduction to Maya Character Rigging

CHERYL CABRERA

An Essential Introduction to Maya Character Rigging

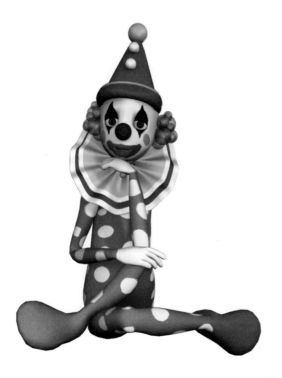

ELSEVIER

AMSTERDAM • BOSTON • HEIDELBERG • LONDON • NEW YORK • OXFORD
PARIS • SAN DIEGO • SAN FRANCISCO • SINGAPORE • SYDNEY • TOKYO

Focal Press is an imprint of Elsevier

Focal Press is an imprint of Elsevier
Linacre House, Jordan Hill, Oxford OX2 8DP, UK
30 Corporate Drive, Suite 400, Burlington, MA 01803, USA

First edition 2008

Notice
No responsibility is assumed by the publisher for any injury and/or damage to persons
or property as a matter of products liability, negligence or otherwise, or from any use
or operation of any methods, products, instructions or ideas contained in the material
herein.

British Library Cataloguing in Publication Data
A catalogue record for this book is available from the British Library

Library of Congress Catalog Number: 2007941700

ISBN: 978-0-240-52082-7

For information on all Focal Press publications
visit our website at www.focalpress.com

Printed and bound in Canada

08 09 10 11 11 10 9 8 7 6 5 4 3 2 1

Working together to grow
libraries in developing countries

www.elsevier.com | www.bookaid.org | www.sabre.org

ELSEVIER BOOK AID
International Sabre Foundation

DEDICATION

To my students

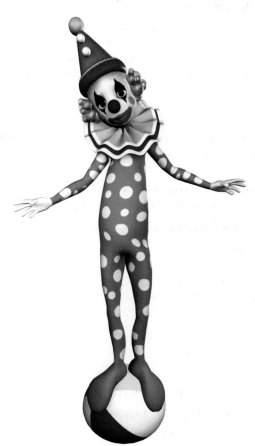

Contents

Foreword

It's 3 a.m. A hard rain pounds against my office window. I sip my coffee. Hot. Bitter.

Hmm. Too bitter. I sprinkle some sugar and give it a swirl.

Perfect.

I finish downloading the latest version of Bones for 3DStudio DOS 4 and launch the application. My XT brings it up in a matter of minutes. Fast. The way I like it.

My anticipation mounts as I open the demo data. Reaching forward with the mouse, I select the character's hand and prepare to pull.

I take another sip of coffee.

It's good. Real good.

I begin pulling my character's hand and the right arm extends. The elbow bends, the geometry deforms, and a slow grin spreads across my unshaven face.

This is going to be awesome.

Then, as the arm stretches further, I notice a slight tremble in the left leg. With concern, I realize that further I pull the arm, the more the leg shakes until suddenly the entire character lurches forward, His left leg shoots toward the sky as the hips twist and the head lists to the right. I shove the arm back toward the body and the hips pivot. Suddenly the left arm spasms, his legs buckle and the head continues to twist and jerk. Frantic now I pull the arm back out and the body spins 180 degrees. The right leg flips up and I swear his knees are breaking in at least three different directions. I begin to whimper, thrashing the arm back and forth, the poor character dancing like a possessed demon in its final throws of death, and with final pull I yank the mouse out of the computer, throw myself back in my chair and scream "NOOOO!!!!"

Thankfully, things have changed a lot since 1994. Software has gotten cheaper, tools have gotten better, and great instructional material like this book you hold in your hands have become available.

A well made character rig works like an extension of the animator. It does what the animator expects, when they expect it. It helps them make the right decisions, but gets out of the way when they want to power through something. It enables, instead of distracts. Easier said than done, right? How does one know what to put into an animation rig? What tools are best? What features are must-haves?

There are only two ways to really know what features are necessary in an animation rig: experience, and communication.

Communication is relatively easy. You simply ask the animator what they want. You may find the answers difficult to interpret at first, as most often the answer is "yes, but

only sometimes". This can cause more work for you, but think of it this way: let's say it takes an animator one minute to manually match an IK arm to the position of an FK arm. You can create a button to do this task instantly, but it will take you a week to implement it. Is it worth it? If the animator would use this tool 10 times per day, that's a 10 minute savings per day, right there. Nearly an hour per week. Expand that to 50 weeks for the year and you've saved a single animator about 41 hours of work. An entire week of matching FK and IK arms. Nice! If you work at a film studio and there are 45 animators, you've just saved the department 45 weeks of work. With an average salary of 64,000 per year, you've saved the studio about 55,000 dollars. That's with only one feature that took you one week to implement! (average salary based on info from *The Animation Guild*: http://www.animationguild.org/)

The other method of learning what to put into a rig is through experience, and that's where Cheryl's book really comes in handy. The best way to get experience is to actually try and create a short film yourself. Cheryl does a fantastic job of walking you through the process from modeling, to texturing and rigging using examples from real short films by students, many of whom are now working in the feature film industry.

It's this method of learning that I recommend the most. I've created a few short films in my time, and although most are so horrible that that they will never see the light of day, the amount that I learned from each was priceless.

So take Cheryl's book. Follow the instructions. Absorb. Then pick up a few other books, maybe a DVD or two, learn as much as humanly possible, and then learn some more. Our industry is an exciting and creative one, where anything is possible as long as we can conceive of some way to do it. My challenge to you? Be one of those that makes these things not only possible, but fun.

Jason Schleifer
Supervising Animator
DreamWorks Animation

Preface

When I began teaching 3D character animation six years ago, there were few resources available to help students learn and understand the fundamentals of the character rigging process. Understanding these tools and procedures are a key component to animation in the 3D environment. The technical vocabulary of rigging characters is necessary for animators to communicate their needs to character technical artists, but this knowledge is also invaluable to anyone who may find themselves in a position where rigging becomes part of their own job description. In the past six years, there have been several books released that cover intermediate and advanced concepts which build on a foundation that doesn't seem to exist in other materials. Because of this, I've decided to put my classroom materials together and present them to the reader, hopefully answering most of the questions that come with introductory learning of character rigging.

The assignments in this book have been tested by students in my classroom. Over several years they have evolved from basic course notes into thoroughly detailed step-by-step instructions. During this progression, some of the same problems kept arising for students. These issues are clearly indicated in boxes throughout the book. However, because new issues come up with every student and version of the software, I have created a website to support this book for FAQs and other postings. Please make sure to visit and check things out: www.mayacharacterrigging.com

Instead of covering only basic rigging, I included the first four chapters to provide an overview of a simple character design and creation process. In these four chapters you will find a simplified approach to design, modeling, and texturing a character. The last four chapters cover joint placement, control rig creation, clean-up, and the skinning process. Each chapter begins with explanations of the tools used during the assignments. The assignments of each chapter, when put all together, will result in a character ready for animation. The glossary words are highlighted in red throughout each chapter, and a summary is provided to recap the main points. This book is intended to be worked through from beginning to end. However, the workflow overview below provides a flowchart toward completion, as some of the chapter assignments can be done simultaneously with other chapters when using File Referencing (explained in Chapter 5).

The enclosed DVD provides example files to work along with the assignments using the clown character, Bobo, which I have created exclusively for this book. In addition, there are finished student animated shorts that can be used to capture your imagination and provide inspiration for creating your own characters. The shorts shown on the DVD are unique because these shorts were all made by students, and for most of them, were their very first completed animations. Many of them have been accepted to festivals, and some have even won awards.

An instructor manual is available for this book by contacting the publisher. If more information is necessary or if you have any further questions, please contact me via this email: info@mayacharacterrigging.com

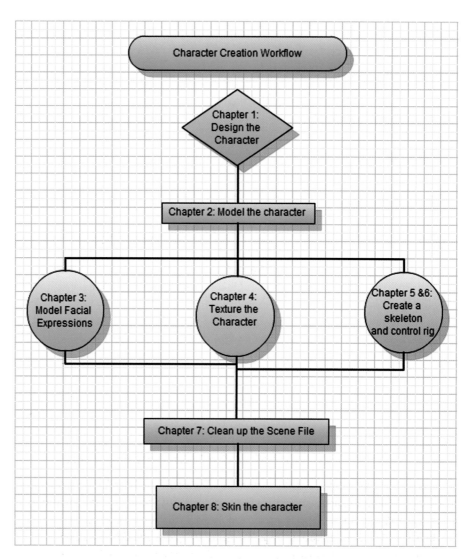

Workflow overview.

Acknowledgments

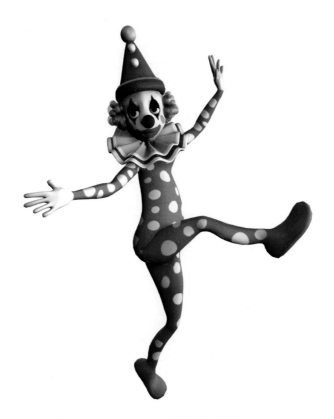

Merci *Gracias* Mahalo *Danke schön* Grazie *Yokoke* Thank You ...

Special thanks to the following people for their help during this entire process:

First and foremost, I want to thank my students. This book is written for them. To the following students in particular, for contributing their artwork and words of wisdom: Chris Beaver, David Bokser, Josh Burton, Sean Danyi, Arturo de la Guardia, John Doublestein, Nick Dubois, Nathan Englehardt, Katie Folsom, Jeff Gill, Chris Grim, Fay Helfer, Neil Helm, David Leonard, Adam Levine, Mark McDonald, Rob T. Miller, Luke Nalker, Dan Nichols, Zach Parrish, Tonya Payne, Sara Pitz, Brett Rapp, Tim Robertson, Colin Senner, Eric Urban, Ben Willis, and Ryan Yokley.

Second, I want to acknowledge all of the Maya authors and artists I've encountered along my journey to learn and teach this subject – specifically Jason Schleifer, Chris Maraffi, and the many others who've taught the Maya Masterclasses that I have attended at SIGGRAPH between 2002 and 2007.

I need to thank Lucilla Hoshor, for introducing me to the people at Focal Press at SIGGRAPH 2003. Apparently, Lucilla knew before I did that I was going to write a book.

A special thanks to Georgia Kennedy, my supportive and phenomenal contact at Focal Press. Georgia's encouragement and confidence saw me through the entire uphill climb, especially her insistence that I get some sleep during the process!

Thanks to Kevin Nield*, my technical editor, former student, teaching assistant, and all round nice guy. Without him, much of what I wrote wouldn't make any sense!

My sincere thanks go to Jenn West**, my editor and friend who knew absolutely nothing about Maya. She was able to tell me when I needed to re-word and clarify things to help her understand what on earth I was talking about.

Thanks again to not only the students, but also the faculty of the School of Film and Digital Media at the Savannah College of Art and Design, for their constant support and questions of "How's the book going?"

A special thanks to all of my family and friends who have encouraged me throughout the years to pursue my dreams, including special recognition of my teachers and mentors who have also instilled in me the curiosity of learning and fostered my ability to problem solve. An extra special thanks to Randy Asprodites, Penny Clarke Johnson, Sue Dee Lazzerini, Darlene Marr, Tom Mavor, Elemore Morgan, Jr., Dana & Bob Niedergall, Pat Perrone, Heidi Poche`, Chyrl Savoy, David Thibodaux, Dickie Wagner, and Paul Werner.

And finally, a super-duper special thanks to my children, Joshua and Nathanael, and my loving husband, Michael Cabrera. His encouragement and willingness to spend five weeks away with our two-year-old son so that I could finish this book was down right amazing!

Characters by Kevin Nield, served up on a tray with his head and fruit (2007).

* Kevin Nield graduated from Savannah College *of* Art and Design in the Fall of 2007 with an MFA in Animation. In the approximately 2% of his time not tweaking models, props, lighting, rigs, etc. on the computer, he tries to devise ways of testing whether or not he has woken up in the same universe on this particular day. You can check up on his work or tell him about your universe at: www.kevinnield.com

** Jennifer West developed her love of English grammar through avid reading and conversations with her English-teaching father. She received her Bachelors of Arts in English Literature from Armstrong Atlantic State University in 2006. She has gone on to pursue a Masters in Library and Information Science from the University of South Carolina, anticipating a May 2008 graduation. To contact her about her editing and research services, please email her at: jenncwest@gmail.com

Introduction

There is something to be said for learning from your mistakes. Throughout my years as a professor of 3D character animation, I have seen many students make the same mistakes over and over again. I must say that much of what I have learned about Maya, I have learned because of the mistakes that I or my students have made. Hopefully, our loss will be your gain, and you will be able to avoid the same mistakes that we have previously made. I am going to show you a streamlined way of creating a character in Maya. The method that I am going to show you is an evolved and simplified process, and it is one that works for me and my students. It is one that has developed as an amalgamation of a variety of approaches that I have learned from different people and my own added techniques. It is not the only way to accomplish the end result. As with anything in Maya, there is more than one way to do the same task. There is no "right way" of achieving your goal. As an artist and a student, you should explore different approaches and assimilate what works best for you into your own approach.

The workflow, or production pipeline, is extremely important. There are some things that must occur before others, and some things that can be done simultaneously throughout the production. Throughout each chapter, I will be listing the tasks that will be accomplished and specifying an order. You should pay close attention to the workflow, because it will save your valuable time in the long run.

An Overview of the Interface

There are many aspects to the Maya User Interface, and it can be pretty overwhelming for a new user. This book does not cover everything that Maya has to offer. If you want more information, make sure to utilize the Maya help files, which can be easily accessed by hitting **(F1)** on your keyboard. This book does assume that you have an understanding of 3D space and the XYZ coordinate system of establishing points in that space. This section explains some of the interface areas that we will be using frequently.

This book has been written using the PC keyboard for the assignments. However, Maya is consistent across all platforms. If you are using a Macintosh and a tool calls for using the **Ctrl key**, then you should use the **Command key**. If the tool calls for using the **Insert key**, then you should use the **Home key**. Be aware that Maya is case sensitive. This is particularly important when using **Hotkeys**. Throughout this book, Hotkeys, or Keyboard shortcuts will appear in parenthesis ().

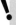 If your keyboard shortcuts are not working, the first place to check is your **CAPS LOCK** to see if it is on.

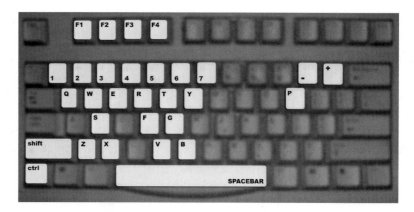

Keyboard with highlighted Hotkeys.

Common Hotkeys used in Maya

F1	Maya Help
F2	Animation menu
F3	Modeling menu
F4	Surfaces menu
1	Rough NURBS smooth/Actual polygonal preview
2	Medium NURBS smooth/Polygonal smooth + actual cage preview
3	Fine NURBS smooth/Polygonal smooth preview
4	Wireframe mode
5	Shaded mode
6	Hardware texturing
7	Show light simulation
q	Select tool
w	Move tool
e	Rotate tool
r	Scale tool
t	Show manipulators
y	Last tool selected
s	Sets a keyframe
f	Frame selection in current view
g	Repeat last command
ctrl+ g	Groups selection
p	Parents first selection (or more) to last selected
P (shift + p)	Unparents first selection (or more) to last selected
v	Snap to point
b	Resizes artisan brush
x	Snap to grid
z (ctrl+ z)	Undo
Z (shift + z)	Redo
+ /=	Increase manipulator size
−	Decrease manipulator size
Spacebar (hold)	Show hotbox

Spacebar (tap) When done over a viewport, maximizes/minimizes current window
Insert Key Pivot point edit mode

To navigate in Maya you need a three-button mouse. Holding down the **Alt key** and pressing the left mouse button **(LMB)** in the perspective view panel will tumble your view. Holding down the **Alt key** and pressing the middle mouse button **(MMB)** in the view panel will track your view. Holding down the **Alt key** and pressing the right mouse button **(RMB)** in the view panel will dolly your view. The track and dolly moves also work in most Maya windows, such as the **Hypergraph**, not just in the view panels.

Maya's perspective view panel and hypergraph.

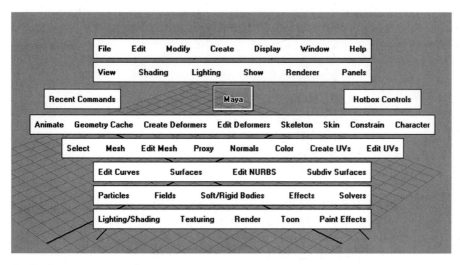

The Hotbox.

The **Hotbox** is a quick method for accessing menu items and tools wherever your cursor is located. Simply press and hold down the **Space bar** on the keyboard for it to appear. You can customize the Hotbox by pressing and holding the **Space bar, LMB**

and hold on the **Hotbox Controls menu** on the right. While still holding the **LMB** down (a marking menu will appear), drag your mouse to the option you want to enable or disable, such as **SHOW ALL**, then release the **LMB**. Show All will allow all menu systems to appear. The hotbox saves time and frees up valuable screen space if you hide the menu bar by customizing your settings/preferences, which will be done later in this section.

The **Marking Menu** is a quick method for accessing a subset of menu choices of the most commonly used tools for a particular object. Simply place your cursor over an object, **RMB** and hold for the **Marking Menu** to appear. To select an option from a Marking Menu, while still holding the **RMB** down, drag your mouse to the option you want, and then release the **RMB**.

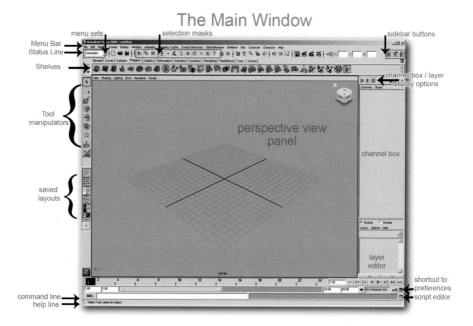

The Main Window.

The **Menu bar** displays six common drop-down menu items (**File**, **Edit**, **Modify**, **Create**, **Display**, and **Window**) and the remaining menu items change based on the current menu set. The current menu set can be changed using the Hotkeys (we will be using **F2** – Animation, **F3** – Polygons, and **F4** – Surfaces) and or by selecting the menu set from the **Status Line, or toolbar**. Some tools in the drop-down menus have little boxes next to their name. These are called **option boxes**.

Clicking on the box next to the name of a menu item will open an options window where settings can be changed for that tool. As I refer to menu items, they will appear in brackets as follows: **[Menu > Submenu > Submenu – option box]**.

The Status Line, or toolbar, contains shortcuts to many of the commonly used tools in Maya. We will be using the menu sets, **selection masks,** and sidebar buttons.

Menu items with option boxes to the left.

The **Shelves** hold commonly used actions and tools, allowing them to be accessed by clicking an **icon**. If you double click on an icon, the options window will open. These can help save time if you are using the menu bar, but the Hotbox is usually faster.

The **Channel box** is usually the first tool for editing object attributes. The information displayed in the channel box changes, depending on what kind of object or component you have selected. If nothing is selected then the channel box is blank.

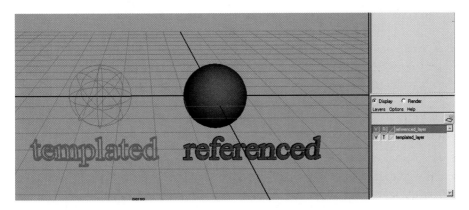

The Layer Editor showing spheres applied to two layers with one set to template and one to reference.

The **Layer Editor** is useful for organizing your Maya scene file. We will be using display layers. Objects can be assigned to a layer which can then be labeled and set for display options. Referencing the layer allows an object to be viewed normally, but not selectable. Templating the layer allows the objects to be viewed as a wireframe, but not selectable. You can also turn the visibility of a layer on and off.

Setting User Preferences

Preferences in Maya are, well, preferences. Everyone prefers to do things in a different way. The reason why Maya is such a powerful program is because it is fully customizable. You can configure the interface to your particular likes and dislikes. My suggestions are what work for me. I will be writing this book with these suggestions in place.

To change your settings/preferences:

1. With Maya open, go to **[Window > Settings/Preferences > Preferences]**.

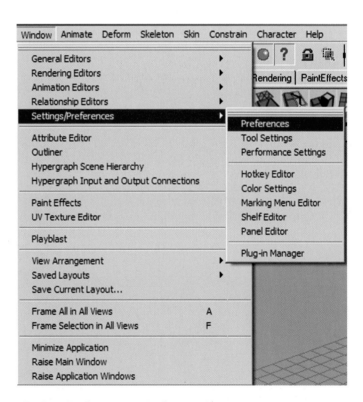

[**Window** > **Settings/Preferences** > **Preferences**].

2. Click on **interface** and set the following:
 a. Show menu bar: uncheck "**In main window**" (this forces you to use your Hotbox to choose menu items).

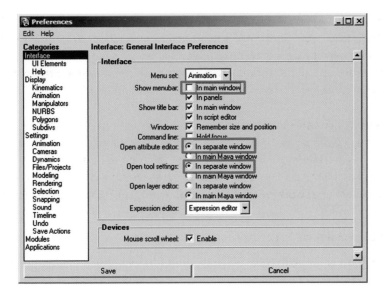

The preferences interface category.

 b. Open attribute editor: choose "**In separate window**".

 c. Open tool settings: choose "**In separate window**".

3. Click on **animation** and set the following:

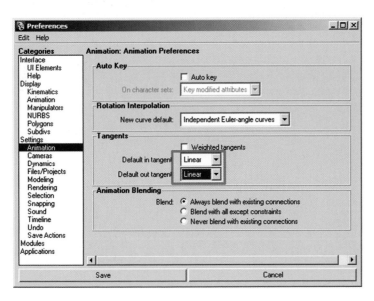

The preferences animation category.

 a. Default in tangent: choose "**linear**".

 b. Default out tangent: choose "**linear**"

4. Click on **selection** and set the following:

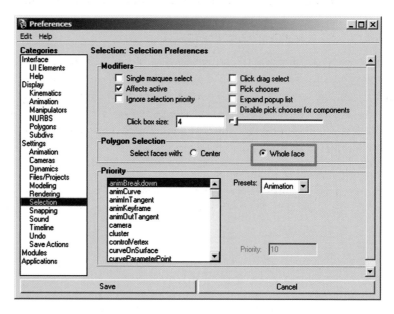

The preferences selection category.

 a. Polygon selection: choose "**whole face**" (this makes selecting MUCH easier because it allows you to click anywhere on the polygonal face instead of having to click exactly on the little dot in the center).

5. Click on **Undo** and set the following:

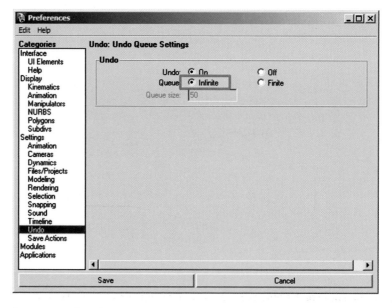

The preferences undo category.

a. Queue: choose "**Infinite**" (a must, unless you have a slow computer).
b. If you have a slow computer: choose "**Finite**" with a queue size of 100.

Setting Up Your Project Folder and Scene Files

Before you begin working, it is best to develop a file system for storage and organization. Maya has a built-in folder system for storing different aspects of your project. If you are organized, you will save valuable time during the entire production process. This folder system must be the first thing you create when you begin a project. By placing all of your files and related resources into this folder and subfolders, you can be assured that Maya will be able to find your project assets.

To create a new project folder, do the following:

1. From your computer's desktop, go to [**Start** > **Programs**] and select Maya.
2. Once Maya is open go to [**File** > **Project** > **New ...**] the New Project window opens.

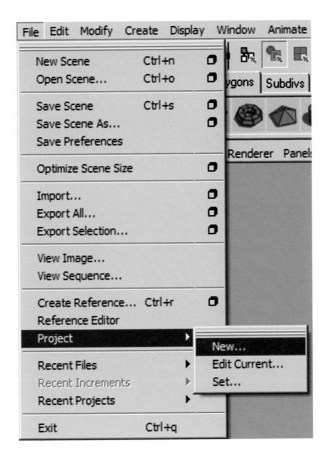

[**File** > **Project** > **New ...**]

3. Enter the name of the new project in the Name text box [a]. For example, *MayaCharacterRigging*

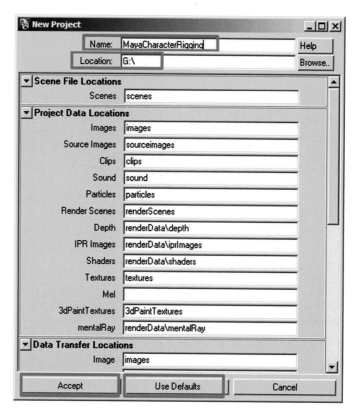

The New Project window.

4. In the Location text box, enter or browse to the directory that will contain the new project (e.g. G:\)
5. Click **Use Defaults** to let Maya assign the default folder names for your project.
6. Click **Accept**.

Designing Your First Biped Character

1

- ➢ **Former Student Spotlight: Zach Parrish**
- ➢ **Workflow**
- ➢ **Introduction**
- ➢ **Character Design**
- ➢ **Creating Character Sheets**
- ➢ **Summary**
- ➢ **Assignments: Designing a Character**

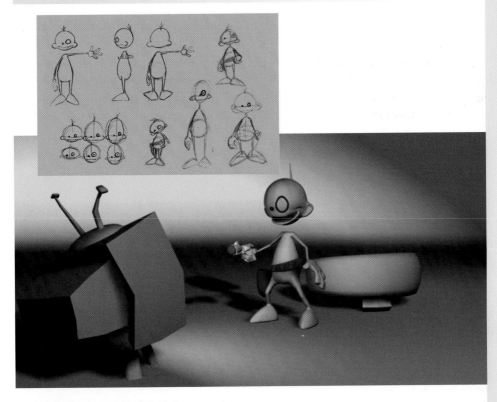

Little Billy by Sean Danyi (2004).

Former Student Spotlight: Zach Parrish

Rigging is the big step in creating a short film that most beginners completely underestimate. Many blossoming students or beginners are anxious to start making things move and do not give as much thought and foresight to the end result. The final outcome really begins with the first time the character is sketched out. The concept for a character dictates its personality, which dictates how it moves, which dictates how it can be modeled and rigged. Give some thought to the whole picture as you work through your film and it will enhance the end result that much more.

The few problems I had on my short film were a direct result of not thinking ahead. I was too anxious to make things move that I didn't fully plan each step. My models feet were big, almost as long as his leg; consequently, I had to sort of swing his feet out to the side to make him walk semi-naturally. The problem was, that I didn't think about this when I was modeling or rigging. So the rig was not as flexible as it could have been, which slowed and limited the animation process. The creation of that short film taught me more than I had anticipated. I think it's a big stepping stone in the maturation of a student film maker to do the whole process, even if it isn't for a whole film. It can be used to simply do a basic animation exercise. That way, you learn the pitfalls, the easier areas, and also the areas you prefer to focus on. And finding your area of interest is the most important part.

Zach graduated with his Bachelor of Fine Arts degree in 3D animation from the Savannah College of Art and Design (SCAD). During his final quarter at SCAD, he began online courses through Animation Mentor. He was hired directly out of SCAD by Rhythm & Hues Studios in Marina Del Rey, CA. He is currently working at Rhythm & Hues, continuing his education with Animation Mentor and looking forward to his future endeavors in the world of Character Animation. You can see more of his work and what he is up to at his website: www.zapmyshorts.com

Bananas by Zach Parrish (2006).

Workflow

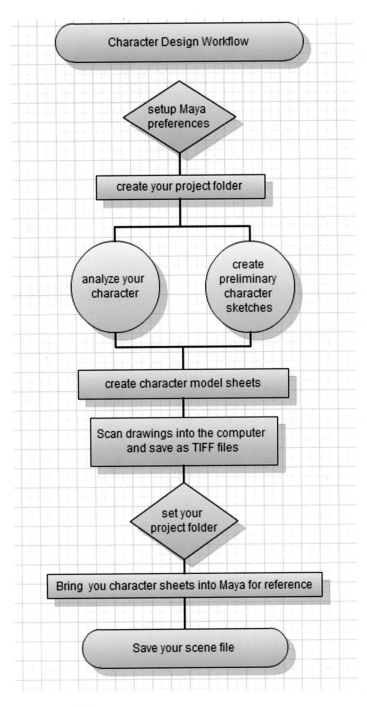

Character Design Workflow.

Introduction

Bananas by Zach Parrish (2006).

Creating a character can be an enormous task. Production studios invest months (and sometimes even years) to simply get the design of a character just right. Sometimes, there is an entire team of artists with varied backgrounds (such as painters, sculptors, and concept artists) who work together to develop a single character.

When designing your first character to model, rig, and animate, it is important to remember the most important rule of all: KEEP IT SIMPLE. Complexity will come later. A **biped** is a great character for beginners to start with because of the varied problems that will be addressed during the process. It is also one of the easiest of which to gather research since you, in fact, are bipedal. When you have a question about how something moves, you simply have to study your own mechanics. Many of the rigging solutions that are used for a biped can be reused with other types of creatures and props. However, it is important to stick to simple and stylized design ideas. The more realistic and detailed the character becomes, the more difficult it is to set up for animation.

Character Design

Analyzing Your Character

The first character you design should be simple. Remember this general rule: the easier and the simpler you make the design, the easier and the simpler the entire process will

be. This rule really applies to anything in life. You will encounter obstacles, so why complicate the situation – unless, of course, you thrive on challenges and have no problem tackling these obstacles on your own.

In addition to thinking about what your character looks like, you should consider other aspects that will help define their design. For a well-rounded character, you should base your design on a realistic character or story. Even though you may not be pursuing an animated story with the character for your first animation, in order to get a plausible character, there needs to be some type of background developed for personality, motivation, and purpose. If you do not have a concrete story idea, you can still answer questions that help create this background. This process is called **character analysis** and has been used by writers and actors for many years.

You should ask not only questions like color, gender, and height, but also questions that answer background information, such as whether the character has brothers, sisters, or is an only child. How old is the character? Is he a child? Is she a teenager? Is he a parent? Are they androgynous? Schizophrenic? All of these answers have a huge impact on how the character behaves and will actually help you come up with ideas for how they look. It is really not important that your audience knows the answer to these questions. As an animator, however, the more you understand your character, the more believable your character will become. As you answer these questions (Assignment 1.1), try to visualize your character. Keep a sketchbook handy and begin preliminary sketches. As you sketch, think about design considerations discussed in this chapter.

Design Considerations

For your first character design, there should be requirements as well as limitations. The first requirement is to make sure that your character is bipedal. You can design animal characters as long as they move like a human. You can design tails, large ears, or antennae for added character. Stay away from birds unless their wings will function like human arms, but realize that bird legs operate more like human arms than legs. Characters that use their arms to walk, such as monkeys, can be completed with this process, but I highly recommend that you feel comfortable with creating and animating bipedal characters before you attempt a character that walks on all fours. The reason for this is because it takes more time for research and development of creatures to which you do not have instant access. With a humanistic biped, you can refer to your own skeleton, muscle structure, and motion.

Others may tell you that designing and modeling your characters in a relaxed posed will bring you better deformations, especially in the shoulders, elbows, and knees. While this may be true, this type of pose is definitely more difficult to rig for the first time. Your character should be designed, modeled, and rigged in the T-pose for a predictable and reliable process.

Preliminary sketches in sketchbook.

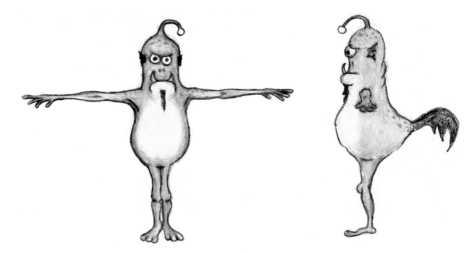

Character from "Trigger" by Ryan Yokley (2002). Adding big teeth, a tail, and antennae are great ways to give your character extra personality! This character's legs are drawn too close together. Make sure to leave some space between them.

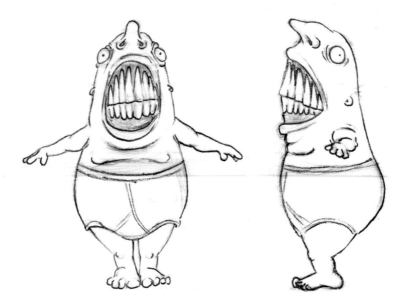

Character from "Sniff" by Dan Nichols (2004). This character's arms are not drawn parallel to the ground, and feet are too close together. This can be more difficult to rig for the first time. Make sure your arms are straight, not sloped.

Quite frankly, robots and aliens are overdone. In order for your design to stand out among the others, your design must be different. If you insist on designing a robot, make sure that all bendable areas (knees, ankles, toes, shoulders, elbows, wrists, fingers, neck, hips, and the torso) are designed for flexibility, such as rubber hoses.

Characters from "Botones" by Arturo deLaGuardia (2002). Robots and aliens can make great characters if your story and design are unique!

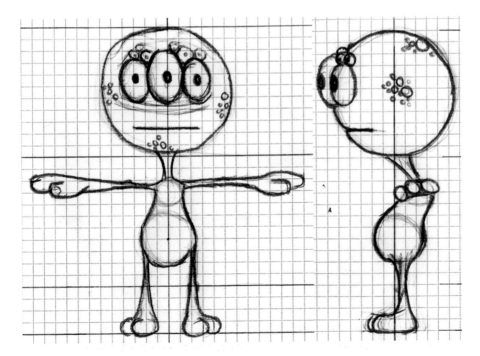

Character by Neil Helm (2006). The man of many eyes!

Characters can also be made of primitive objects. Cylinders can be used for the limbs and a sphere for the head, etc. The only real concern is to make sure the objects have enough divisions for deformations later. We will talk in more detail about this when we discuss modeling techniques in Chapter 2.

Characters, Storyboard and Frame from "Sticky" by Katie Folsom (2004). These characters are made from modified primitive objects. A simplified design can still convey emotion and tell great stories.

Proportions

Character by Eric Urban (2006). Larger, exaggerated head and arms on this character create a focal point and require more work when animating. Extra arms means extra work Fly wings are great, just stay away from bird wings as a beginner.

When you begin to draw out a character design, you must consider proportions. The height proportion of a perfect human body is equal to eight heads high. The arm span from the shoulder to the finger tips is about three and a half heads long, and the opened hand is the same size as the face. This is, however, animation. Anything goes! We have the freedom to exaggerate anything which will make the character more interesting. For a simple approach and to ensure your first experience rigging goes smoothly, I highly recommend a slender character with normal proportions, or perhaps one or two things exaggerated, such as longer arms, or a larger head.

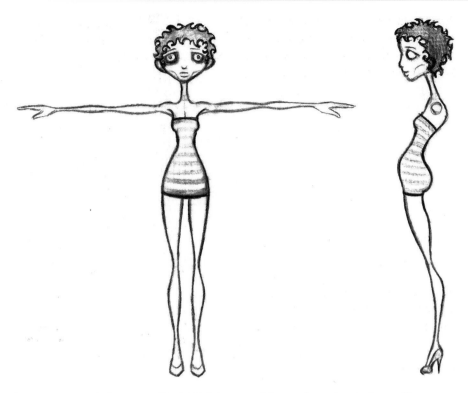

"Libby" Character by Fay Helfer (2004). Longer, thinner character designs will ensure your first experience in 3D character creation goes smoothly.

> **!** Anything that is exaggerated, especially larger, draws focus.

Because it draws focus, it takes greater effort to create plausible animation with an exaggerated body part, since the audience is paying more attention to that area. Larger heads are top heavy, particularly if the body is smaller in proportions. Attention is brought to the head because of its size, and all movement is heightened. Because the head doesn't deform outside of facial features, it appears to be a floating boulder. Large feet are generally not a problem if the character has long legs. However, if the character has short or fat legs, the ankle movement is limited when flexing and pointing the foot. Large hands can be a huge problem and quickly die if the animator leaves them in a single position for too many frames. Much attention is drawn to the hands because they serve a needed purpose, and we use them for so much of what we do, including expressing what we say. Therefore, an animator must keep them alive when animating.

Begin by figuring out how many heads high your character will be. The length of the arms, legs, and torso will need to be considered because different challenges occur with different sizes. Short, fat characters are harder to set up and animate than tall and thin ones. Problems are encountered with shorter characters because of a limited

range of motion, caused by their shorter limbs. If the character is plump or overweight, that decreases the range of motion as well. A shorter character will waddle in lieu of walking or striding. For them to walk, they must take shorter, quicker steps. The arms have limited range of motion as well. If the character has to reach the top of his head, he probably won't be able to reach. This could introduce some funny animation. Imagine a character trying to scratch his head with short arms. If he can't reach his head, he may have to rub it on a wall or utilize a prop to satisfy this need. Another solution would be to design longer arms beyond normal proportions, or add some stretching ability in the controls for the arm, so that the character has the ability to extend his reach.

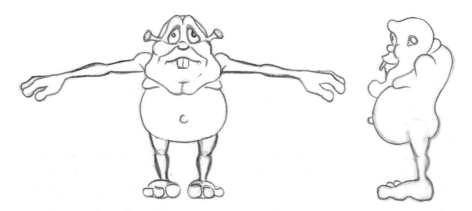

"Bernie" Character by Fay Helfer (2004). Shorter, fatter character designs are more difficult. Longer arms can help with range of motion, but then become an exaggerated feature.

Clothing Considerations

If you design your character with clothing, make sure to stay away from rigid ornamentation and details in flexible areas of the body, particularly in the torso area. The torso is one of the most flexible areas of your body, so any rigid object will constantly intersect the deforming geometry of the clothing. Examples include buttons, belt buckles, and armor. There are more advanced ways of controlling these items (such as using hair follicles to rivet the button in place), but these techniques are outside the realm of this book. If the geometry of these items is treated as a flexible, rubbery object, be aware that the item will stretch and distort. Design your clothes with the idea that they are made of some kind of stretchable fabric or material, such as knit, lycra, or rubber. If your detail objects are modeled separately and overlap other geometry, such as a necktie over a shirt, there are interpenetration issues that can be alleviated by setting up a control rig (which will be discussed in Chapter 6) or by adding dynamics (which will not be covered in this book).

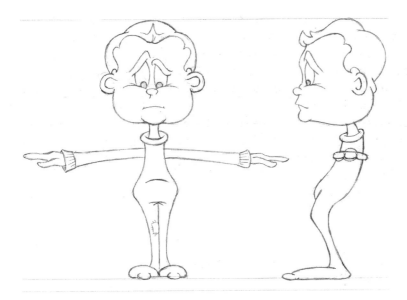

Character by Nathan Englehardt (2005). Design your character's clothing to be simple and of stretchable fabric. Posture is fine to alter, but be careful not to distort the center of gravity too far.

Rigid objects can be placed in non-flexible areas, such as eyeglasses on the face, a helmet on the head, a watch on the forearm, earrings on the ears or rings on the fingers. Think about where the object will be positioned, and if the area has little or no need for bending, then the object should not cause a problem. Model these objects separately so that if they do become an issue, you can reevaluate their necessity and hide or delete them if necessary.

3D Render and Concept drawing for "Bernie" by David Leonard (2006).

It is not necessary that your character be modeled as one seamless piece of geometry. Even if the character is designed without clothing, you can strategically place the seams so that they do not become a focal point.

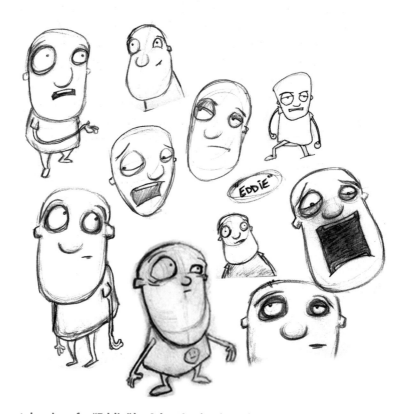

Concept drawings for "Eddie" by Adam Levine (2004).

Creating Character Sheets

Begin by creating some rough drawings of your character using lines, spheres, and cylinders. I prefer drawing the side views first, because I can think about the character's posture, draw a line to represent their spine, and then draw spheres or ovals where the shoulders and hips belong. Think about the shape of the head and torso. Some typical shapes include round, oval, pear, apple, and hourglass.

Once you have created preliminary sketches based on your character analysis and design considerations, you are ready to finalize the design into a **character sheet**. In 2D animation, character model or turnaround sheets are typically used by the animation staff to ensure artistic consistency by all animators during a production. In 3D animation, these drawings are used as reference during the modeling process.

For the most predictable motion achieved during setup later, the character's front pose should be drawn in the "T" stance: arms parallel to the ground with the palms facing down (not forward) with fingers open. The thumbs can be in any position. The feet

should be facing straight ahead and flat on the ground. The legs can be bent slightly and should be hip distance apart with some space between them and the feet. Be careful not to make an inverted "V" shape with the legs. Having the legs spread too far will cause undesirable rotations. The head should also be facing forward. It is not necessary to draw the arms in the side view. You also want to draw a top view of the arms with the hands and a separate top view of the feet. Additional drawings of the back and $\frac{3}{4}$ views are not absolutely necessary, but can prove useful.

You should begin by drawing either the front or side view first. Once the first drawing is complete, you can draw horizontal guidelines to indicate the positions of the top of the head, the eyes, the chin, the top of the shoulder, the top of the pelvis, the top of the thighs, knees, and the feet to ensure that they line up in the other views.

Nick

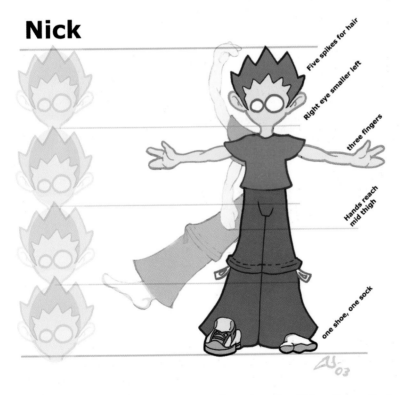

Five spikes for hair

Right eye smaller left

three fingers

Hands reach mid thigh

one shoe, one sock

Character Sheet by Nick DuBois (2003). The palms should face down, the legs should have some space between them.

When the drawings of the front, side, hand, and foot are complete, it is a good idea to photocopy the originals and ink the photocopies to clean up the lines. The inked images will make a cleaner scan than a pencil drawing. Ink your character outlines in black and the horizontal guidelines in blue. Scan the drawings and prepare them for use as a reference in Maya. You will then save these images into the source image folder in your project files, and bring these drawings into a Maya scene file to use as a reference when modeling (Assignment 1.2).

Summary

1.1 When creating your character, KEEP IT SIMPLE.

1.2 The easier and the simpler you make the design, the easier and the simpler the entire process will be.

1.3 The more you understand your character, the more believable your character will become.

1.4 Creating a character analysis will help you achieve greater understanding of your character's background.

1.5 Characteristics you should include on a bipedal character for optimal learning:

Two legs.

Two arms.

Two hands and two fingers, which include a minimum of a thumb and middle finger or mitt.

1.6 Characteristics you should include for a more predictable outcome:

T-pose.

Feet should be planted on the ground, hip distance apart.

Toes should be facing forward.

Geometry should be present in the crotch area.

Palms should face down.

Shoulders should be defined on top, arcs in the armpit.

1.7 Characteristics you should avoid until further experience:

Buttons and rigid objects.

Wings.

Four legs.

Poses other than a T-pose.

1.8 Characteristics you can include to add personality:

Ears.

Tails.

Antennae.

Teeth.

1.9 Design concerns:

Overweight characters decrease the range of motion a character has because geometry will collide, causing interpenetration.

Short legs equal a limited range of motion.

Large feet are awkward, especially with short legs.

Exaggerated proportions create a focal point.

Overlapping geometry creates interpenetrations when designing clothing.

1.10 Creating a character sheet finalizes the design and aids in the modeling process.

Assignments: Designing a Character

Assignment 1.1: Analyze Your Character

On a sheet of paper, answer the following questions about your character. Keep your sketchbook handy and draw any ideas that come to mind.

1. Where is your character from? Did your character grow up somewhere else or did they always live in the same place? Did they grow up in the city or in a log cabin on a mountain? Are they from this planet or another? Are they from a wealthy family or a poor one? Were they educated as a child? Are they an only child? Do they have siblings?

2. Where does your character live? What country, city, or planet does this character call home? Do they live in a city or the country? Alone or with a roommate? Still with their parents? Are they married? Do they have any children?

3. What is your character name and how old is your character? Is he a child? A teenager? An adult?

4. What does your character look like? What is your character's height? Are they small, or tall? Is your character thin or fat? Do they have an apple shaped torso? Is it round? Is it square? What shape is their face? Do they have big ears? How about a tail? Are they male or female? Do they have any physical abnormalities? (large nose, big feet, etc.).

5. How does your character earn a living? What is their trade or career? Are they a student? Are they a criminal?

Assignment 1.2: Create Character Model Sheets

Materials Needed:
pencil
8 ½" × 11" paper or smaller, but no smaller than 5" × 7"
black and blue markers or pen and ink
access to a photocopier
access to a scanner
Adobe Photoshop or other image editing software.

1. Draw front or side of character.
 a. First determine proportions. Draw a circle for the size of the head. Then stack 5 to 8 of these circles to establish your character's height. Draw horizontal guidelines across the page at the top and bottom of each sphere. Begin the drawing for your character to the right of this stack of circles. Proceed to EITHER b or c.

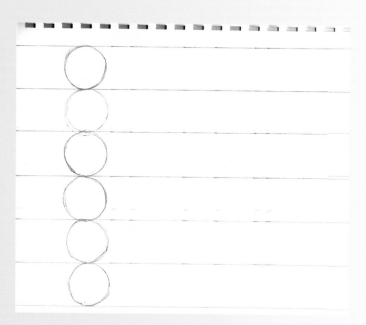

Proportional circles six heads high with horizontal guidelines.

b. Beginning with the **FRONT** view: Draw a circle for your head. Don't worry about shape at this point – you can change that later. Think about how long the neck will be and then draw a smaller circle for the shoulder area and one for the hip area. Draw ovals to represent the feet.

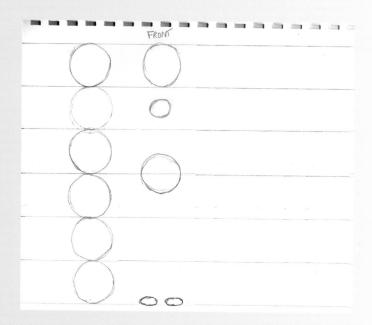

Head, shoulder, torso, and feet roughed in for the front view.

Draw lines for the neck, connecting the head to the shoulders. Draw lines for the torso, then lines for the legs. The arms and hands are 3 ½ heads long. The hand alone should be ¾ of a head long, about the size of the face. Make sure the character is drawn in the T stance, arms parallel to ground, palms facing down, feet should be facing forward and hip distance apart, space between legs and feet, head forward. Redefine the shape of the face if necessary.

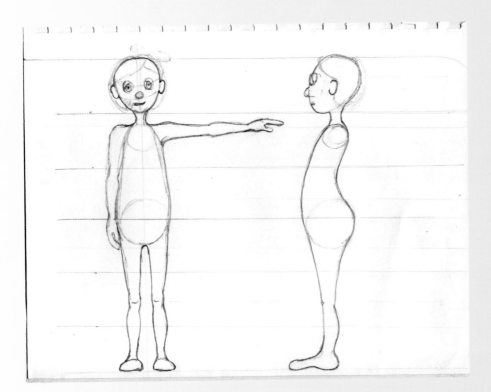

Sketched character front and side drawings.

c. Beginning with the **SIDE** view: The side view should be drawn so that your character is facing to the left of your computer screen. Again, begin by drawing a circle for your head. Draw a curve that represents the spine and posture of your character. Draw a smaller circle for the shoulder area and one for the hip area. Draw an oval to represent the foot.

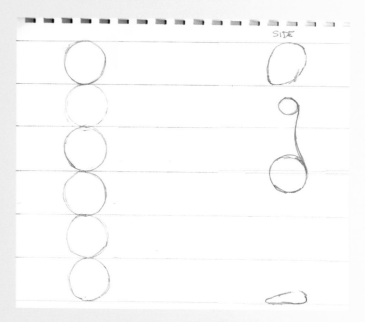

Head, shoulder, torso, and feet roughed in for the side view.

Draw lines for the neck, connecting the head to the shoulders. Draw lines for the torso, then lines for the legs, consider if you want the legs to be bent or straight. Redefine the shape of the face if necessary.

2. Redraw horizontal guidelines.

Once the front or side drawing is complete, redefine the horizontal guidelines to indicate the positions of the top of the head, the eyes, the chin, the top of the shoulder, the top of the pelvis, the top of the thighs, knees, and the feet to ensure that they line up in the other views. These lines are helpful to ensure that your proportions are consistent from one view to the next.

3. Draw the additional images, front or side, top of arm and hand, top of foot, and back (optional).

 a. Follow the same guidelines discussed already to complete the side or front drawing.

 b. On a separate sheet of paper, draw the arm and hand from the top view. Do not forget to use your proportion guidelines. The arms and hands are 3½ heads long. The hand alone should be ¾ of a head long, about the size of the face.

 c. On a separate sheet of paper, draw the foot from the top view.

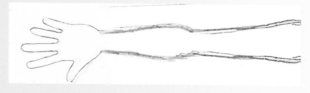

Arm and hand drawing, top view.

4. Photocopy the original drawings.

5. Ink the photocopy.

 Using a black marker or ink, trace the photocopy outline of your character. Using a blue marker or ink, trace the horizontal guidelines in blue.

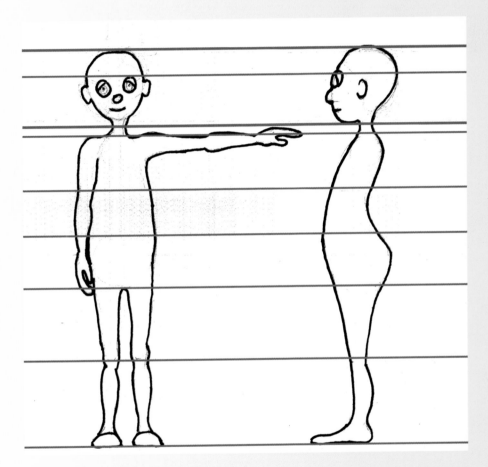

Inked photocopy with blue guidelines.

Assignment 1.3: Scan and Prepare

Materials Needed:
 access to a scanner
 Adobe Photoshop or other image editing software.

1. Open Adobe Photoshop or your scanning software.

2. Scan your drawings with a resolution no lower than 200 (dpi, ppi, etc.).

 a. In Photoshop, go to [**File > Import**] and choose your scanner.

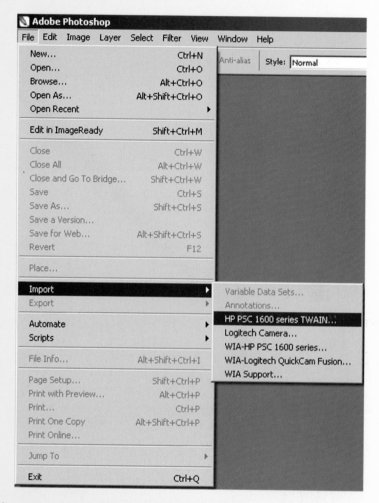

File > Import.

b. In the scanner settings, choose the appropriate resolution.

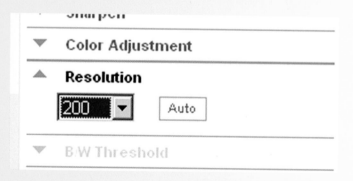

Adjust your scanner resolution to a minimum of 200 dpi.

3. Once scanned, you will need to clean up your image by doing the following:

a. In Photoshop, go to [**Layer > Duplicate Layer ...**] and click **OK** to create a copy of the background image. This is necessary in order to rotate in the next step.

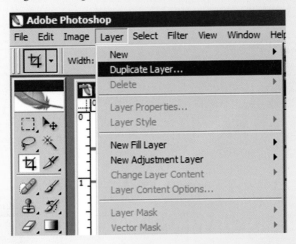

Layer > Duplicate Layer ...

b. Go to [**Edit > Free Transform**] or press (**ctrl + t**) on the keyboard and rotate the image so that the guidelines are perfectly horizontal across the image. If your image was placed straight on the scanner, and your drawing was not crooked, this will not be necessary.

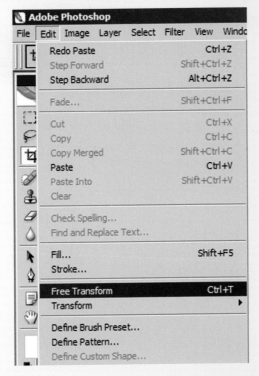

Edit > Free Transform.

c. Go to [**Image > Adjustments > Levels**] or press (**ctrl + l**) on the keyboard slide by click dragging the white triangle shape to the left to set the highlights of the image and remove any dark areas.

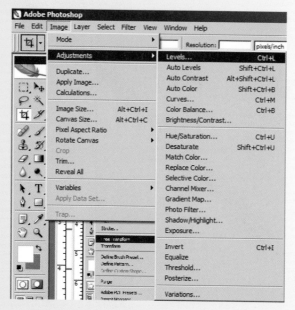

Image > Adjustments
> Levels.

d. Choose the paintbrush tool by pressing (**b**) on the keyboard. Erase any stray marks if necessary.

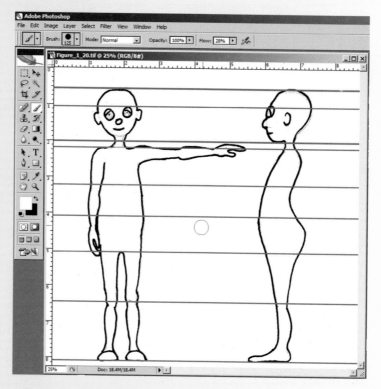

Clean up your image using a white paintbrush.

e. Choose the crop tool by pressing (**c**) on the keyboard. Drag select around the front and side drawings to remove any unnecessary areas. Hit **enter** on your keyboard to execute the crop.

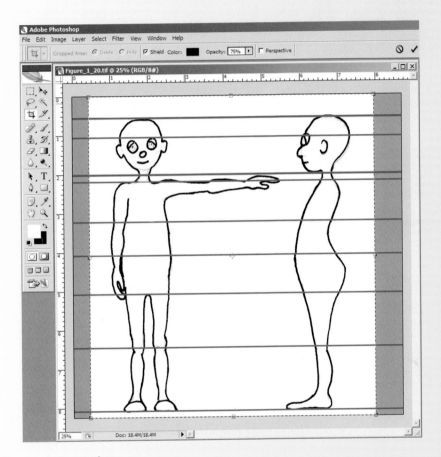

Crop any unwanted area.

f. Go to [**Layer > Flatten Image**]. This will remove the additional layer and prepare the file for saving.

g. Go to [**File > Save As**] and save the file in TIFF format. Type in the name of the file, something like the name of your character: *name_characterSheet.tif*. Save these files in your sourceimages folder in your Maya project file.

h. Repeat steps a–g for the arm and hand from the top view, the foot from the top view, and any additional drawings you may have.

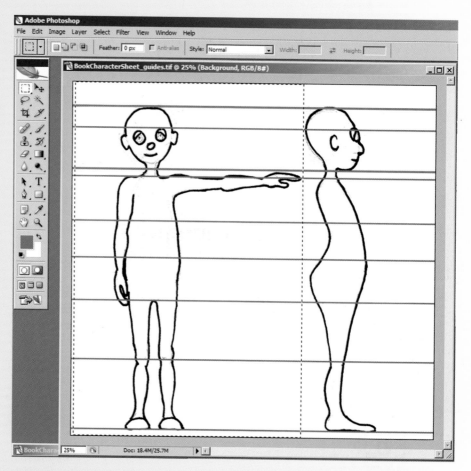

Marquee select the front view of your character.

4. Divide the front and side images into separate files.

 a. In Photoshop, choose the rectangular marquee tool – by pressing (m). Click drag around the front view to create a selection.

 b. Go to [Edit > Copy] or press (ctrl + c) on the keyboard to make a copy.

 c. Go to [Edit > New] or press (ctrl + n) to make a new file. Photoshop automatically creates the new file with image dimensions based on what was copied into the clipboard. Hit Enter.

 d. Go to [Edit > Paste] or press (ctrl + v) on the keyboard.

 e. Go to [Layer > Flatten Image].

 f. Before closing the file, make a note of the image dimensions. Go to [Image > Image Size …] Under Pixel Dimensions, make a note of the width and height of the image. You can include these numbers in the file name for accessible notation.

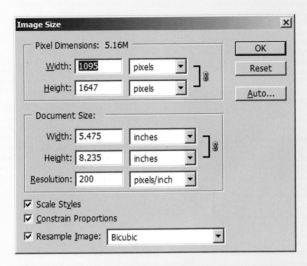

Record the width and height of the image's pixel dimensions for use in Maya.

g. Go to [**File > Save As**] and save the file in TIFF format. Type in the name of the file: *name_front_widthXheight.tif*. Save these files in your sourceimages folder in your Maya project file.

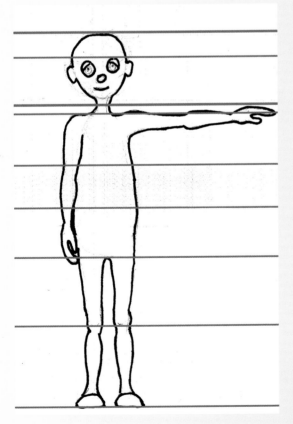

Front view saved as
name_front_widthXheight.tif.

h. Repeat steps a–g for the side view, naming the saved file: *name_side_widthXheight.tif*.

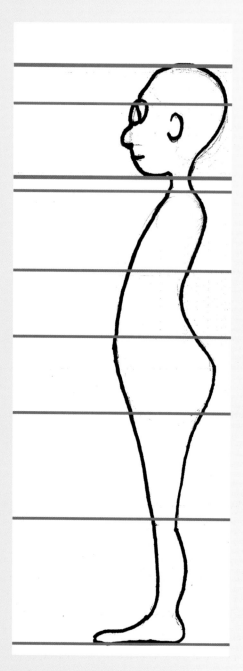

Side view saved as *name_side_widthXheight.tif*

i. Repeat steps a–g for the arm and hand from the top view, the foot from the top view, and any additional drawings you may have. Since I drew half a T-pose, I created a T-pose in Photoshop by duplicating and flipping the drawing horizontally.

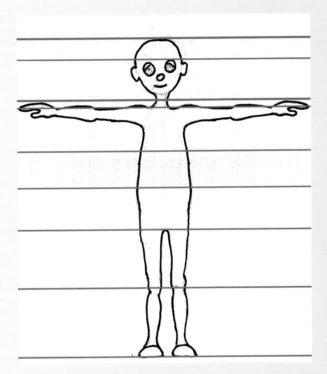

T-pose created in Photoshop.

Assignment 1.4: Bring Your Drawings into Maya

When bringing an image into Maya, I recommend the use of a NURBS plane and a file texture that is mapped onto that plane. I do not recommend the use of Maya's image plane, which is an option for the camera. The reason for this is that it is difficult to reposition camera image planes, which may be necessary during the modeling process.

1. If you haven't created a project folder already, make sure to do so now:

 a. From your computer's desktop, go to **START** > **PROGRAMS** and select Maya.

 b. Once Maya is open go to [**File** > **Project** > **New** …] the New Project window opens.

 c. Enter the name of the new project in the Name text box [a]. For example, *MayaCharacterRigging.*

 d. In the Location text box, enter or browse to the directory that will contain the new project [b] (e.g. G:\).

 e. Click **Use Defaults** to let Maya assign the default folder names for your project.

 f. Click **Accept**.

2. Set your project.

 a. Go to [**File > Project > Set ...**] browse to your project folder and click **OK**.

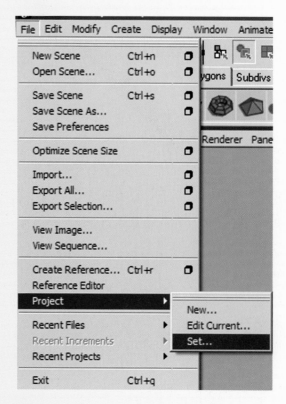

File > Project > Set ...

> The proper way to start Maya is to set your project before you begin working for the day. You should never double-click directly on a scene file in order to open Maya, as this will change the relative paths to absolute paths when saving your files. This will cause problems, especially with larger scene files and in larger productions.

3. Create a plane for the front view and assign a shader to it. Go to [**Create > NURBS Primitives > and uncheck interactive creation**].

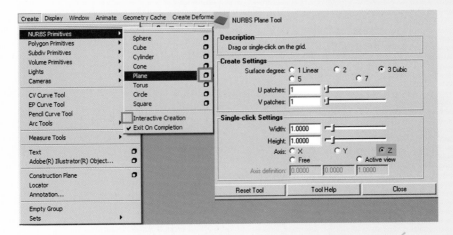

Create a NURBS plane on the Z axis.

a. In the perspective window, go to [**Create > NURBS Primitives > Plane –
 option box**]. Name the plane: *front_reference_plane*.

> **!** The Maya scene uses centimeters as the default proportions. You can change this in
> the preferences.

b. In the channels box, rescale the plane according to your image dimensions from
 Photoshop but at a 1/100 of its original value. For example, my image is
 1095 pixels × 1647 pixels. My width would be 10.95, the ScaleX value. The
 height would be 16.47, the ScaleY value. Otherwise, your image will be
 incredibly large for your scene.

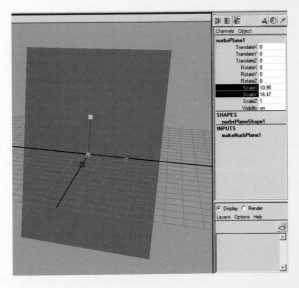

Change the Scale of the plane to match 1/100th of the pixel dimensions of the file.

 c. Go to [**Window** > **Rendering Editors** > **Hypershade**].

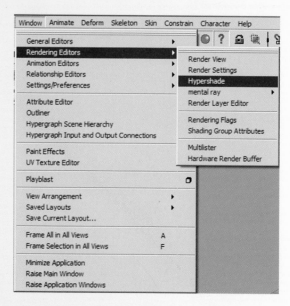

Window > **Rendering Editors** > **Hypershade.**

 d. In the hypershade, go to [**Create** > **Materials** > **Lambert**] (or click on the lambert material on the left hand side of the hypershade window).

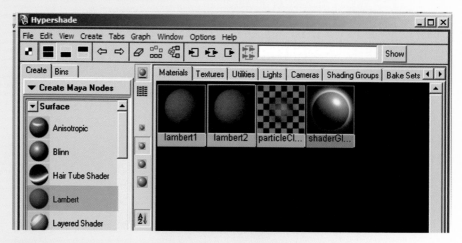

Click on the lambert material on the left in the hypershade window.

! Materials will be discussed further in Chapter 4. Lambert material isn't shiny, so it's easy to see while you are working. You don't want to use the default Lambert1 material because everything created in Maya has the Lambert1 material as a default. If you change that material, everything you create in Maya will have the changes as well.

e. MMB (middle mouse button) click and drag the newly created lambert material onto your NURBS plane, *front_reference_plane.*

f. Double-click on the newly created lambert material. This will open the attribute editor. Rename the material *front_reference_lambert.* It is important to take time and label everything in Maya to keep an organized scene file.

g. Click on the checkered box to the right of Color. This will open the Create Render Node window.

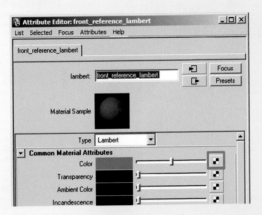

Click on the checkered box to the right of the Color attribute in the Attribute Editor.

h. Under the 2D Textures section, make sure that "normal" is selected. Then click on **File.** This will connect a File node to the color inputs of the shader.

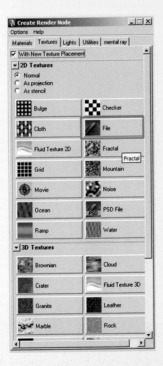

Click on File under 2D Textures in the Create Render Node window.

i. Click on the **Folder icon** to the right of "Image Name". This should open the sourceimages folder (assuming you set the project as in step 1). Choose *name_front_widthXheight.tif* which tells Maya where to find the file we would like to display on our plane, then click **"open"**.

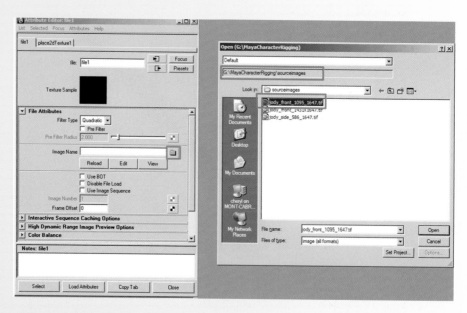

Click on the folder icon in the Attribute Editor for file1.

This file does NOT exist inside the Maya scene file. We have simply created a **path** to the file.

j. You should now see the image appear in your Maya view panel if you move your cursor over a view panel and press (6) on your keyboard, which turns Hardware Texturing on.

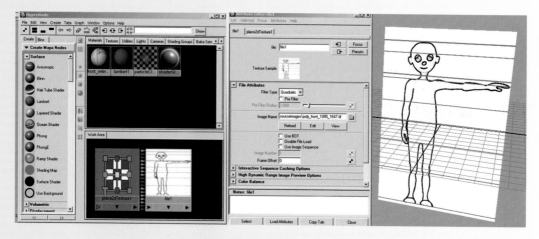

Your image appears on the NURBS plane if you press (6) on the keyboard while your cursor is over a view panel.

4. Create a plane for the side view and assign a shader to it. These steps are similar to those for the front view, but changes have been made to the plane axis and the scale axis.

 a. In the perspective window, go to [**Create > NURBS Primitives > Plane – option box**]. Change the axis to the X axis, then hold down the x key on the keyboard and click on the center of the grid. Name the plane: *side_reference_plane*.

 b. In the channels box, rescale the plane according to your image dimensions from Photoshop. My image is 586 pixels × 1647 pixels. My Width would be 5.86, the ScaleZ value. The Height would be 16.47, the ScaleY value.

 c. Go to [**Window > Rendering Editors > Hypershade**]. In the hypershade, go to [**Create > Materials > Lambert**]. MMB click and drag the newly created lambert material onto your NURBS plane, *front_reference_plane*.

 d. Double-click on the newly created lambert material. Rename the material *side_reference_lambert*.

 e. Click on the **checkered box** to the right of Color, and then click on **File** listed under 2D Textures.

 f. Click on the **Folder icon** to the right of Image Name.

 g. Choose *name_side_widthXheight.tif*.

5. Repeat steps a–i for your top arm and hand view, top foot view, and any other views you may have. Remember, you will have to change the axis that the plane is created on and scaling axis will be different for each view. Experiment to see which one should work.

6. Reposition the images and make them non-selectable.

 a. Your side image should be facing toward the left of your screen. If not, you can rotate it simply by clicking on the *side_reference_plane* and in the channel box, type 180 for rotateY.

Make sure your side image faces toward the left side of your screen.

b. Click on your side image and using the Move tool – by pressing (**w**), click only on **X** (**red arrow**) and **Z** (**blue arrow**) to align the *side_reference_plane* with the left edge of the *front_reference_plane*.

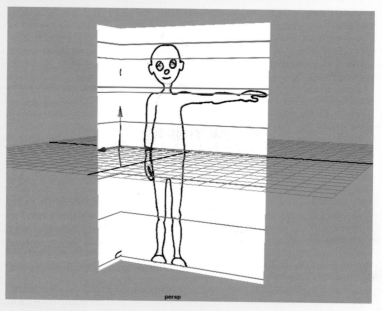

Reposition the side plane to line up with the left edge of your front plane.

Shift select both planes, then using the grid as a guide and your move tool, make sure the *front_reference_plane* is centered in the front view and the *side_reference_plane* is centered in the side view.

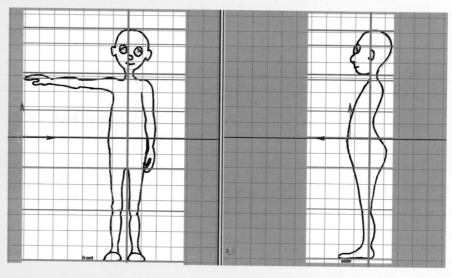

Reposition your front and side planes to be centered on the grid.

c. The height of the planes should automatically line up. If not, use the move tool or press (**w**) and click only on the **Y** (**green arrow**) to adjust their positions. It is okay if your drawings do not line up exactly. These images are going to be used as a starting point when modeling, not the "be all and end all" of your design.

d. Reposition any other images as necessary.

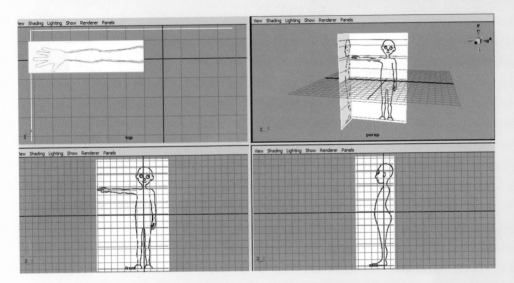

Reposition other planes, such as the top arm view.

e. In the Layer Editor of the Channel Box, click the "create a new layer" box. Double-click on the new layer (layer1) and rename this layer *reference_layer*, then click **save**. Shift select all of the planes you have made, **RMB** click and hold on top of the *reference_layer* and choose Add Selected Objects. To make the objects non-selectable, click two times in the **empty box** between the V (visibility) and the layer name. An R (reference) should appear. This keeps any objects assigned to a layer visible but not selectable.

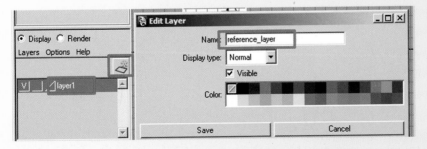

Click on the create a new layer button in the Layer Editor and rename it
reference_layer.

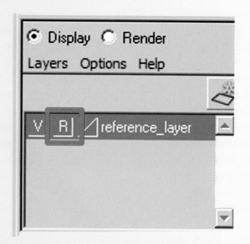

Assign all of your planes to the layer and make it a referenced layer R.

7. Save your scene file.

 a. Go to [**File > Save As**]. This should open the scenes folder of your project (assuming you set the project as in step 1).

 b. Name your scene *01_referenceImages.ma*.

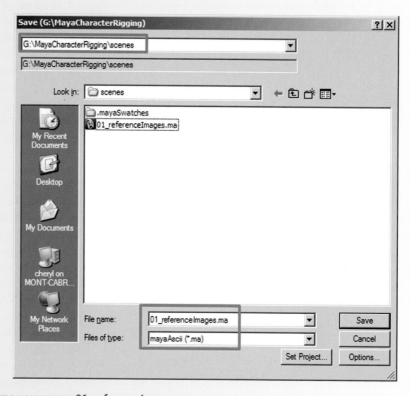

Name your scene *01_referenceImages.ma*.

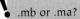

.mb or .ma?

Maya binary files (.mb) are stored using the binary code and are smaller in file size. Maya ascii files (.ma) are stored using text and can be opened for editing. It really does not matter which type you use, however, if you need to open a newer file in an older version of Maya, you can edit the ascii file in Wordpad, or another text editing program, to state the earlier version.

Creating Your First Biped Character: Modeling Basics

2

- ➢ **Former Student Spotlight: Jeff Gill**
- ➢ **Workflow**
- ➢ **Introduction**
- ➢ **Modeling Tools in Maya**
- ➢ **Former Student Spotlight: Chris Grim**
- ➢ **Summary**
- ➢ **Assignments: Modeling a Character**

Characters, from left to right, by Katie Folsom, Ben Willis, Cheryl Cabrera, David Bokser, and Ryan Yokley.

Former Student Spotlight: Jeff Gill

Once upon a time, I submitted a demo reel to a respectable animation studio, and was lucky enough to sit with them as they critiqued my work face to face. In one segment, I had animated a free rig from the internet of a guy walking into a movie theater, eating popcorn, and reacting to what he saw on the screen. But rather than point out the flaws in my character's animation, the two recruiters focused purely on the character's design and the confusion it spawned over why anyone would enter a movie theater wearing nothing but a pair of underwear and some goggles. At the time I thought no one would look that deeply into the matter ... after all, animations live in a world where anvils can fall from the sky without the slightest hint of reason.

However, when designing characters for animation, I've learned that it's truly important to consider your audience. The simpler you design your characters, the less your audience will be distracted from the storytelling of your animation, which will then result in a greater finished product. Simpler designs are not only easier to rig/animate/model/you-name-it, but actually help to show line of action, which is key to any successful character driven piece.

So if it seems like a fun idea to model someone with an arrow jutting out the side of their head just because it looks cool, then go for it. But try keep in mind how your character will be animated and in what context they'll be shown. After all, the last thing you'd want to do is spend several weeks of your life toiling over a beautiful animation, only to leave your audience wondering "how on earth would that guy put on a shirt without stretching out the neck hole?"

Jeff Gill is a graduate from the Savannah College of Art and Design with a BFA in Animation. His work has been screened throughout the world, including the Black Mariah Film Festival as well as the San Francisco International Film Festival, and has received numerous awards for online competitions, such as mtvU's Best Animation on Campus and Firefox Flicks. For more information on Jeff or his work, visit: www.jeffgill.net

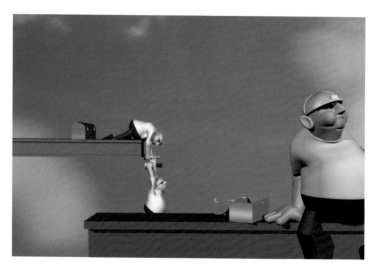

Snack attack by Jeff Gill (2006).

Workflow

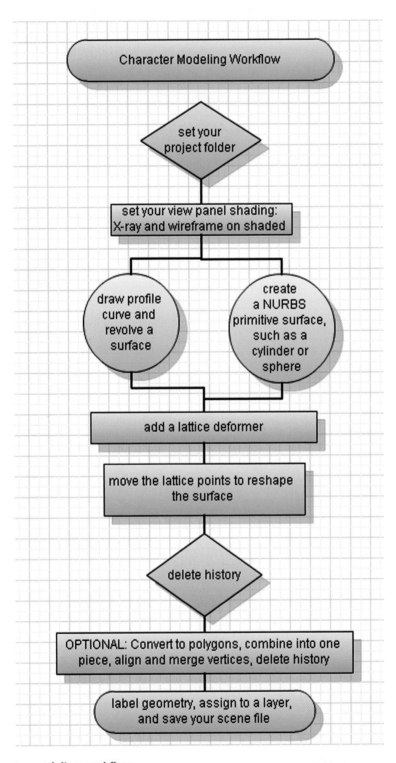

Character modeling workflow.

Introduction

Modeling a character is an extensive process that can take many hours to complete. The modeling process will be easier and quicker to complete if you begin with a simple character design. When the design is more complicated, it will take longer to add the details. As with anything, the more you do something, the easier it becomes and the better you get at it. Practice makes perfect, right? So, don't expect your first character model to become the one you animate. Take this time to explore the tools and begin learning how to problem solve your approach in order to achieve the desired shapes. Problem solving, after all, is the true heart of working successfully in 3D. Understand that your first try at modeling a character should be for practice and that you shouldn't be afraid to scrap your experimentation and start again. You may discover that a second attempt will lead to a more satisfying result.

Be aware that the method of modeling a character that is explained in this chapter is only one approach, and that as a student, you should be exploring and figuring out what works best for you. There is never "the best way" or "the only way" but rather technique. Just as a fine artist develops his own style, you will find your own method. This approach analyzes the character's body and breaks it down into simpler shapes that make up the whole. Just as a stone or wood sculptor roughs out their proportions first and refines the details later, we will begin with basic shapes before we add the details.

Work in X-ray Mode with Wireframe on Shaded

Because we are using NURBS planes to display our reference drawings, changing your display to wireframe mode by pressing (**4**) on the keyboard would cause the drawing to disappear. So, to resolve this, you can change your shaded mode by pressing (**5**) on the keyboard in your view panel under the SHADING menu and set the display to X-ray (which allows you to see through your model) with wireframe on shaded (which allows you to see the lines on the geometry). This is important so that you can see what you are doing when modeling and still see your reference drawings.

Object Mode and Component Mode

All geometry in Maya can be manipulated on several levels. In Object mode, you can select the entire piece of geometry and translate (move), rotate, and scale the whole thing. If you right click on top of the geometry, you will reveal a Marking menu of component levels, which allows you to manipulate finer details, much like a sculptor would manipulate clay. You can also turn on the component level in the Status Line or by pressing (**F8**).

NURBS, Polygons, or Subdivision Surfaces?

Which type of geometry should I use for my character? Many students ask me this question, and my advice is to work in either **NURBS** or **Polygons** or a combination of both, because **subdivision surfaces** can introduce other problems that lead to unpredictable results when bending and flexing during animation.

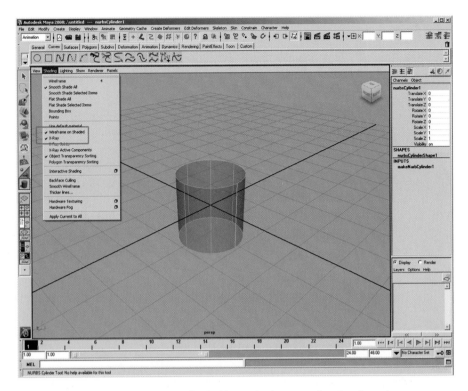

Turning X-ray mode on with wireframe on shaded in each view panel makes it easier to see what you are doing when you are modeling in Maya.

object mode ——— ——— component mode

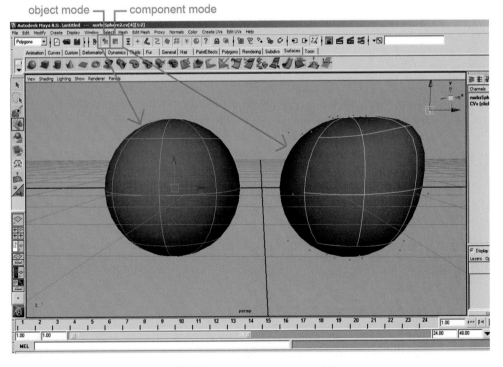

Object mode allows you to affect the ENTIRE piece of geometry, while component mode affects only a certain area.

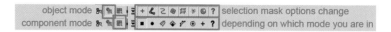

The Status Line mode options.

In the approach that I am going to show you, the character will be modeled first using NURBS. The geometry can remain as NURBS. I have also included optional assignments to show you how to convert the NURBS surfaces to Polygons if you want to create a single seamless piece of geometry. It is important to note that your geometry does NOT need to be a single piece. It is perfectly fine to have separate pieces of geometry for each part of the body. It is also perfectly fine to have some pieces as polygons and others as NURBS surfaces. Once the skeleton and **rig** is complete, they will move together in unison when you are animating them.

Modeling Tools in Maya

There are endless ways to approach modeling, and Maya has many tools that can be used during this process. This chapter only covers the tools that I feel give you the easiest finished product and will be covered in the order that we will be using them. It is a good idea to read through this section first then refer back to the tool descriptions as you are working through the assignments.

Tools can be found in menu sets and shelves and will be indicated when each tool is discussed. Remember that the hotbox is a quick way of accessing your menu sets. To display the hotbox, simply place your cursor anywhere in Maya and hold down the spacebar. Be sure to select **[Hotbox Controls > Show All]** to display all of the menu sets at once.

Each tool usually has several optional settings available. In order to prevent confusion and keep things simple, this chapter will only explain the options that will be used in the assignments. However, it is always a great idea to open the option boxes on all of these tools and explore the optional settings to see what they do.

 ALWAYS work at the **origin** when modeling. The people who designed these tools assumed that modeling takes place at the origin.

Basic Toolbox

If you walk into a home improvement store and visit the tool section, you will notice a wide variety and range of equipment. Some tools are basic but get the job done (like a hammer and nails). Other tools are much more complicated and expensive but accomplish the same job (like a nail gun, which needs a compressor and special nails).

Equipping yourself with the fancier tools is truly not necessary, because you can still hang a painting or build a house with a simple hammer and nail.

Maya is also full of tools. Just like the tools in the home improvement store, there are multiple tools that lead to the same goal. The first set of tools, which I have grouped into your basic toolbox, will be sufficient to model your character.

The following tools are used in combination to create your character's head, neck and torso, arm, leg, eyes, hands, feet, hair, and other accessories (Assignment 2.1–2.7). Here is a brief explanation of those tools and how to find them.

EP Curve Tool [Create > EP Curve Tool]
The EP Curve Tool creates curves by clicking a series of points, much like the game of connect the dots. The line that is created between the points will be a curve when using the default settings. A reference drawing can be traced using this tool to create a profile, or silhouette, curve.

The EP Curve Tool can be found on the Curves shelf.

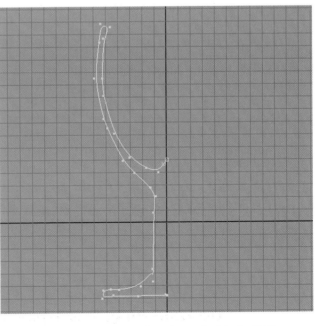

The EP Curve Tool can be found under the Create menu.

The profile curve of a wine glass created with the EP Curve Tool.

Revolve Tool [Surfaces > Revolve]

The Revolve Tool creates a surface around the chosen axis of a selected curve (such as the profile curve created with the EP Curve Tool). A NURBS surface is created by default around the Y axis, which works wonderfully for the head, neck, torso, and leg. The arm will need to be revolved around the X axis, which can be chosen by opening the option settings window.

The Revolve Tool can be found on the Surfaces shelf.

The Revolve Tool can be found in the Surfaces menu set by pressing (F4) on the keyboard under the Surfaces menu.

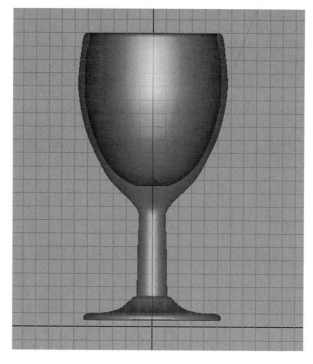

The surface of a wine glass created from the profile curve with the Revolve Tool.

NURBS Cylinder [Create > NURBS Primitives > Cylinder]

A NURBS cylinder is not a tool, but rather a menu item that creates a surface in the shape of a cylinder (one of several primitive, or pre-built, pieces of geometry available in Maya). I list it here because it can be used to create your legs and arms, in lieu of using the EP Curve Tool and Revolve Tool. The cylinder is defined in sections (vertical lines) and spans (horizontal lines). The default settings will create a cylinder with only one span, so you must increase the number of spans to about twelve to allow the geometry to bend in areas such as the knees and elbows. You can change the spans in the option settings or in the input section of the channel box by clicking on *makeNurbCylinder1*, and changing the spans there. You can then scale and rotate the geometry into the place of the leg or arm.

The NURBS cylinder can be found on the Surfaces shelf.

The NURBS cylinder can be found under the Create menu.

Lattice Deformer [Create Deformers > Lattice]

A **deformer** is a tool that is used to change the shape of an object and can be used during modeling to speed up the process on all types of geometry. Once created, a lattice deformer surrounds the geometry to be deformed and looks almost like scaffolding around a building. When moving a point on the lattice, the geometry it surrounds moves as well.

The Lattice Deformer can be found on the Deformation shelf.

The Lattice Deformer can be found in the Animation menu set by pressing (F2) on the keyboard under the Create Deformers menu.

Much of the NURBS and polygonal modeling process relies on the ability to move points around to shape the geometry into the desired form. This can become a tedious procedure, so we want to minimize moving points as much as possible. The benefit of using a lattice (or any other deformer) is that it affects multiple points on the geometry at the same time, which speeds up your work.

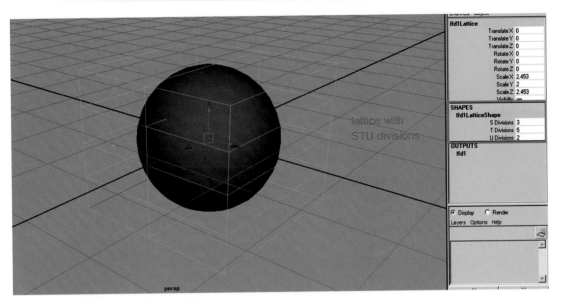

The Lattice Deformer applied to a Sphere. Notice there are 3 S divisions (left to right), 5 T divisions (top to bottom), and only 2 U divisions (front to back).

The STU divisions of the lattice can be added to or changed in the Shapes section of the channel box. STU is a special coordinate system for lattices (equivalent to XYZ where $S = X$, $T = Y$, and $U = Z$).

NURBS Sphere [Create > NURBS Primitives > Sphere]

A NURBS sphere is another primitive geometry shape, like the cylinder discussed earlier, and is often used as the beginning shape when modeling things such as eyes, hair, ears, and fingers. In order to shape the sphere, the default sections and spans will need to be increased, and should be evaluated on a case by case basis, depending on the detail needed for the object being modeled. Change the number of sections and spans in the option settings or in the input section of the channel box, click on *makeNurbSphere1*, and change them there. There is also a start sweep and end sweep which opens the sphere and can be used to create eyelids that blink.

The NURBS sphere can be found on the Surfaces shelf.

The NURBS sphere can be found under the Create menu.

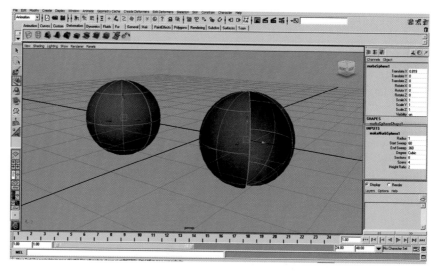

These NURBS spheres have 8 sections (vertical or longitude) and 4 spans (horizontal or latitude). The sphere on the right has a start sweep of 60 degrees, which opens the sphere.

Construction History and Deleting History [Edit > Delete by Type > History]

As you build geometry in Maya, most of what you do to that geometry is added to a list and remembered by Maya so that you can alter an earlier step in the phase if

needed. For example, after the revolved surface is created, you can still move the original points along the curve and the surface will automatically update its shape based on the new shape of the curve.

This list is referred to as **construction history**, and it can be seen in the input section of the channel box. While this can be handy, sometimes the current tool affecting the geometry can be interfered with by something done earlier in the modeling process. Because of this, it is important to delete the history often, especially when completing a major phase of the entire character creation process, such as when you are finished modeling and after you are finished texturing. Another rule of thumb that I follow is to delete the history if the current tool is yielding undesirable results. However, be aware that there are times that you want to KEEP your history, such as using a NURBS sphere to create an eyelid that blinks. Once it is deleted, there is no way to bring it back. It is wise to save a version of the scene file prior to deleting history if you are unsure.

The command to delete History can be found under the Edit menu.

Inserting Isoparms [Edit NURBS > Insert Isoparms]

Isoparms are the lines that you see when a surface is selected. Additional isoparms can be added to the surface in order to create detail in the geometry, or to ensure adequate geometry in bend areas (such as elbows, knees, and the torso). When adding isoparms, be careful not to overdo it. Too many will result in heavy geometry, which will slow down animation and rendering. To insert a single isoparm, RMB (right mouse button) and hold over a surface (which brings up the marking menu), choose Isoparms (which brings you into component level), click and drag on an isoparm on the surface near to where you want to add one, drag it into position, then [**Edit NURBS > Insert Isoparms**].

The Insert Isoparms command can be found on the Surfaces shelf.

The Insert Isoparms command can be found in the Surfaces menu set by pressing (F4) on the keyboard under the Edit NURBS menu.

Sculpt Geometry Tool [Edit NURBS > Sculpt Geometry Tool – option box]

This tool is a much more artistic approach to modeling geometry. Using the artisan brush, you can paint on a surface wherever points exist to sculpt it by pushing, pulling, erasing, and smoothing. This tool is much more effective if using a pressure-sensitive tablet and pen. However, it is helpful for constructing noses and eye sockets, even with a mouse. This tool also affects polygonal and subdivision surfaces.

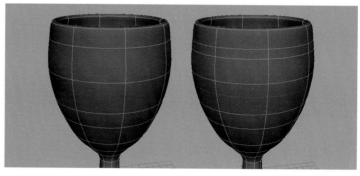

Adding additional Isoparms.

The Sculpt Geometry Tool can be found on the Surfaces shelf. It can also be found on the Polygons shelf and the Subdivisions shelf.

Using the Sculpt Geometry Tool to add facial details to a sphere.

The Sculpt Geometry Tool can be found in the Surfaces menu set by pressing (F4) on the keyboard under the Edit NURBS menu.

Moving Individual CV

A control vertex, or CV is the point where two isoparms intersect. For some details and shapes, adjusting individual CV is the only way to reach the desired look. RMB and hold over a surface (which brings up the marking menu), choose CVs (which brings you into component level), click on a CV and use the move tool by pressing (**w**) on the keyboard to click drag the CV into position.

You can also choose component mode and select points in the selection mask area in order to easily select and move CVs.

Additional Tools for Your Toolbox

You can create an entire character from the tools discussed in Chapter 2 of the book, or if you would like to create a seamless character and have better control over texturing, you will need to convert your character into polygonal surfaces. The next set of menu items and tools can be used to achieve this goal. You can see by the length of this next section that there are many more tools needed for this process, and it will take more time to achieve the look desired.

> **!** Make sure your selection preferences are set to whole face!! Otherwise, you will always have to click on the little dot that appears in the center of the polygon. With this selected, you can click anywhere on the polygonal face to select it. (Go to [Window > Settings/Preferences > Preferences] and click on **selection**. Set the following: Polygon selection – whole face.)
>
> When blocking in your model, remember that your polygonal faces should be as close to square shaped as possible. This will ensure that the geometry deforms better.

Polygonal Cube [Create > Polygon Primitives > Cube]

Like the NURBS primitives, Maya has several polygonal primitives available. Many modelers begin with the polygonal cube and create their entire seamless character from a single cube. This method is called box-modeling. This approach should be used to create the hands and feet if a single polygonal body is desired.

The Polygonal cube can be found on the Polygons shelf.

The Polygonal cube can be found under the Create menu.

Splitting Polygons [Edit Mesh > Split Polygon Tool]

This tool is great for dividing polygons to add more geometry when detail is needed. Be careful not to create Ngons in the process. Simply click on an edge (and drag with your mouse to position the first point) then click on another edge (and drag with your mouse to position the second point). Continue clicking on additional edges if necessary, until you have made the split desired. Then hit enter to complete the split.

The Split Polygon tool can be found on the Polygons shelf.

Edit Mesh

Keep Faces Together

Extrude ⬚

Bridge ⬚

Append to Polygon Tool ⬚

Cut Faces Tool ⬚

Split Polygon Tool ⬚

Insert Edge Loop Tool ⬚

Offset Edge Loop Tool ⬚

Add Divisions ⬚

Transform Component ⬚

Flip Triangle Edge

Poke Face ⬚

Wedge Face ⬚

Duplicate Face ⬚

Detach Component

Merge ⬚

Merge To Center

Merge Edge Tool ⬚

Delete Edge/Vertex

Chamfer Vertex ⬚

Bevel ⬚

The Split Polygon tool can be found in the Polygons menu set by pressing (F3) on the keyboard under the Edit Mesh menu.

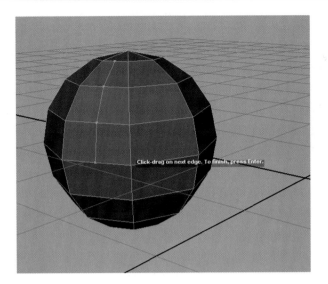

The Split Polygon tool.

> **Why quads?**
>
> When modeling in polygons, it is important to keep the faces as quadrilaterals (four sided polygons) and stay away from tris (three sided polygons) or Ngons (more than four sided polygons). There are several reasons for this. First, when texturing, you will have an easier time when unwrapping UVs (which is outside of the scope of this book). Second, when smoothing your character, you will avoid pinching that occurs in the presence of tris and Ngons. And third, if you are deforming your geometry, you will get nicer results.

Extrude Polygons [Edit Mesh > Extrude]

If faces or edges are selected in component mode, this tool allows you to pull those components out or push them in, while creating additional faces, which then builds the geometry into the desired shape.

If the faces are at an angle, the extrusion will be made at an angle. If you click on the little blue circle, you will change from local space to world space and your extrusion will then be made perpendicular to the graph.

Many modelers use the box modeling method and begin with a polygonal cube, then shape it roughly, and extrude the polygonal faces to form the torso and arms. I find as a beginner, this is a difficult method to use when trying to achieve an organic shape. For some reason, beginners do not spend enough time shaping the form with this method, and the end result remains too angular and not smooth.

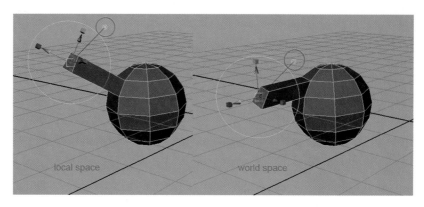

local space world space

The Extrude Polygon tool has a little blue circle which toggles between world space and local space, changing the direction of the extrusion.

Polygons

The Extrude Polygon command can be found on the Polygons shelf.

The Extrude Polygon tool can be found in the Polygons menu set by pressing (F3) on the keyboard under the Edit Mesh menu.

Keep Faces Together [Edit Mesh > Keep Faces Together]

If this option is unchecked, extruded faces will be separate pieces of geometry. This can be helpful, for example, when creating fingers from a palm. However, most of the time this option should be checked before extruding polygons or there will be interior faces as a result of polygonal faces that lie parallel to each other, which in turn, causes nonmanifold geometry.

The Keep Faces Together option can be found in the Polygons menu set by pressing (F3) on the keyboard under the Edit Mesh menu.

Extruding polygonal faces with Keep Faces Together option checked (left sphere) and extruding polygons with Keep Faces Together option unchecked (right sphere).

Converting NURBS to Polys [Modify > Convert > NURBS to POLYS]

This menu item will change an existing selected NURBS surface into polygonal geometry. It is perfectly fine to leave your models as NURBS surfaces. However, sometimes it is necessary to use polygons (creating one seamless piece of geometry or finer control in the texturing process), so this is a simple way of making them. Once converted, you can use other tools to make separate polygonal pieces into one.

The NURBS to polys command can be found under the Modify menu.

It is extremely important to open the option box and change the tessellation method to control points in order to create clean polygonal geometry, as the default settings do not provide a usable result. It may be necessary to add additional Isoparms to the NURBS surface BEFORE converting to ensure organic shape is maintained once polygonal. However, realize the polygonal geometry will eventually be smoothed, and the addition of too many Isoparms will result in an extremely heavy model. Any overlapping NURBS surfaces may result in polygonal geometry that may need additional cleanup (deleting of faces and rebuilding).

The Convert NURBS to polygons Options.

Delete Half of Your Model [RMB over geometry > FACES, select the faces and hit delete]

In order to save time, delete half of the character and model just one side. MAKE SURE that the points in the center of the character stay lined up with the origin. This will make MIRRORING the geometry over to the other side predictable. Otherwise, your mirrored side will not be even and result in a character that is wider than expected, or overlapping.

Combining Separated Polygonal Pieces into One [Mesh > Combine]

Once the NURBS surfaces have been converted into polygons, the polygons need to be combined and overlapping or extra faces need to be deleted. Combining polygons will make two or more polygonal surfaces act as one. HOWEVER, they are truly not one piece and can be separated again. You MUST merge vertices in order for the two surfaces to become one. Make sure to delete any overlapping faces, as these are not needed.

Selecting polygonal faces and deleting them to leave half of the object (in this image, half of a sphere.

The Combine command can be found on the Polygons shelf.

The Combine command can be found in the Polygons menu set by pressing (F3) on the keyboard under the Mesh menu.

On the left are two separate polygonal cubes, on the right, they have been combined into polySurface1. Notice that the outliner still shows nodes pCube1 and pCube2 because of construction history.

Aligning Vertices with the Snap to Points Tool [Move tool and v hotkey]

After combining polygons and removing extraneous faces, the vertices should be snapped together to perfectly align the disjoined faces. Additional geometry may need to be added in order to have each face remain a quad and not become an Ngon. RMB over the surface and choose vertex. Select a point with the move tool, hold down the (v) key and MMB drag over the point you want to snap it to.

Snapping vertex points together using the Move tool and the (v) hotkey on the keyboard.

Closing Gaps or Holes [Edit Mesh > Append Polygon Tool]

After selecting this tool, pink arrows will appear on the edges of polygons that surround a hole or gap. Simply click on one edge, then click on another edge and hit the enter key to finish the process.

The Append Polygon tool can be found in the Polygons menu set by pressing (F3) on the keyboard under the Edit Mesh menu.

Inserting Additional Edges [Edit Mesh > Insert Edge Loop Tool]

This tool is used for dividing faces in order to create additional divisions in the geometry. It is really helpful when ensuring enough geometry in areas that bend, such has ankles, knees, hips, wrists, forearms, elbows, shoulders, the torso, and the neck.

Creating a new polygon to fill a hole using the append polygon tool.

Again, be careful not to add too much geometry. Generally eight divisions around the length (such as vertical lines in the legs and torso and horizontal lines in the arms) are adequate. Five to seven cross divisions around each bend point is usually sufficient.

Edit Mesh

Keep Faces Together

Extrude
Bridge
Append to Polygon Tool

Cut Faces Tool
Split Polygon Tool
Insert Edge Loop Tool
Offset Edge Loop Tool
Add Divisions

Transform Component
Flip Triangle Edge

Poke Face
Wedge Face
Duplicate Face

Detach Component

Merge
Merge To Center
Merge Edge Tool
Delete Edge/Vertex

Chamfer Vertex
Bevel

The Insert Edge Loop tool can be found in the Polygons menu set by pressing (F3) on the keyboard under the Edit Mesh menu.

The Insert Edge Loop tool inserts edges completely around the polygonal object.

Merging Vertices [Edit Mesh > Merge]

To ensure the faces actually become connected, the overlapping vertices are selected and merged. Your polygons MUST have been combined before you can merge vertices, otherwise it will not work. (There is no warning that this does not work. The only way to test is to click on a single vertex and move it around. Just make sure to undo by pressing (z) on the keyboard after testing.)

The Merge command can be found on the Polygons shelf.

Mirror Geometry [Mesh > Mirror Geometry]

Once you have half of the body modeled, you can simply mirror the geometry to obtain a complete model. HOWEVER, it is important to remember that all of the interior vertices must line up and be on the origin. If not, your mirrored geometry result will be undesirable. Make sure to open the option box and select the correct axis. If you have created your first half on the left side of the screen (your character's right side) you can use the default settings. If you have created the character's left side first, you would need to open the option box to change the axis appropriately, to negative X.

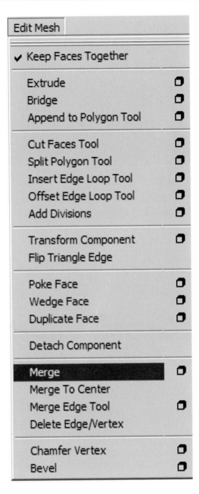

The Merge command can be found in the Polygons menu set by pressing (F3) on the keyboard under the Edit Mesh menu.

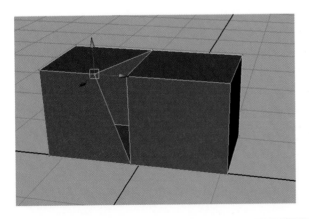

Clicking and moving a vertex that has been snapped on top of another shows that these two overlapping vertices are not merged together.

The Mirror Geometry command can be found on the Polygons shelf.

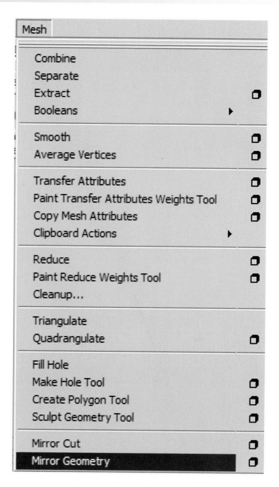

The Mirror Geometry command can be found in the Polygons menu set by pressing (F3) on the keyboard under the Mesh menu.

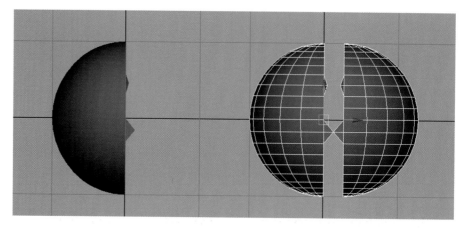

If any vertex points are not lined up with the origin, you will not achieve a desired mirror.

Showing Your Polygonal Normals [Display > Polygons > Face Normals]

During the process of modeling in polygons, you may notice some areas that appear darker than others. This is because your normals have been probably flipped inward. To confirm this, with the object selected, you can display your face normals using this menu command. To hide these again, simply repeat the command with the object selected: **[Display > Polygons > Face Normals]**.

The Face Normals can be displayed using the command found under the Display menu. The polygonal object must be selected before applying this command. The Face Normals can be hidden again by applying the same command.

Making Sure All Normals Face in the Same Direction [Normals > Conform]

Once you can see the normals, you can select the entire object in object mode and use this menu item to make all of the normals face in the same direction. The direction that they face depends on the current majority.

The Conform command can be found in the Polygons menu set by pressing (F3) on the keyboard under the Normals menu.

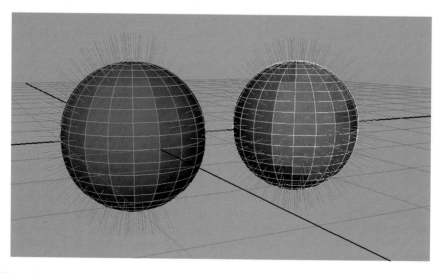

The sphere on the left has some normals that are flipped inside, the sphere on the right is the same sphere after the Conform command has been applied. You can see the selected faces have had their normals flipped back to the outside.

Making Sure All Normals Face toward the Camera [Normals > Reverse]

Sometimes, the CONFORM command does not always work. If this happens, you can select individual faces pointing inward and use this menu item to make them point outward.

If the CONFORM command makes all of the normals point inward (remember, it depends on the direction that the majority already faces), you can select the entire object in object mode and use this menu item to make all of the normals face outward.

Averaging the Distance Between the Normals [Normals > Average Normals]

Once you have all of the normals facing outward, you can select the entire object in object mode and use this menu item to average the distance between normals, which makes the geometry appear smoother without adding more physical geometry.

The Reverse command can be found in the Polygons menu set by pressing (F3) on the keyboard under the Normals menu.

The Average Normals command can be found in the Polygons menu set by pressing (F3) on the keyboard under the Normals menu.

The sphere on the left has had normals flipped, which can cause the faces to be viewed sharply. The sphere on the right is the same sphere after the Average Normals command has been applied. Notice how much smoother the sphere on the right appears.

Smoothing [Mesh > Smooth]

By smoothing your polygonal geometry, the geometry becomes more organic in shape. This procedure adds divisions and rounds out the surface. THIS PROCEDURE SHOULD NOT BE DONE to your character at this stage of the character creation process because it adds too much geometry and causes the character model to become heavy and extremely difficult to work with, when creating blendshapes (Chapter 3) and in the skinning process (Chapter 8). If you want to see what your character will look like smoothed, make sure to **UNDO** by pressing (z) the smooth procedure before moving on.

The Smooth command can be found on the Polygons shelf.

The Smooth command can be found in the Polygons menu set by pressing (F3) on the keyboard under the Mesh menu.

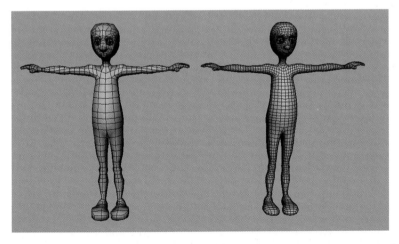

The character on the left is the low poly version, which doesn't look very polished. The character on the right has been smoothed. MAKE SURE TO UNDO the smooth at this point by pressing (z) on the keyboard if you are testing to see your result.

! NEW IN MAYA 2008

You can preview what your model will look like when it is smoothed. With the polygonal object selected, press (2) on the keyboard to preview a smoothed polygonal object with a wireframe cage of the original. Press (3) on your keyboard to preview just the smooth polygonal object. Press (1) to turn off the preview and return back to the actual polygonal object.

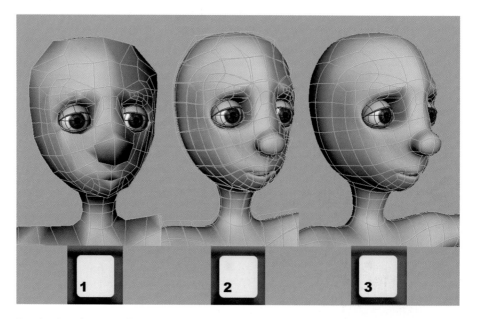

Previewing the smooth on a polygonal model.

! *Remember:* As you work make sure to delete history and label your geometry. Check your outliner and hypergraph after deleting history to see what appears in the scene, and label your nodes appropriately.

Be sure to create a layer in the Layer Editor and add the character's geometry to that layer.

Make sure to freeze transformations on finished geometry to return the translation and rotation values to 0 and the scale values to 1.

Former Student Spotlight: Chris Grim

Character modeling is essentially the pedestal on which the animated short is built. Once the model is completed it will be rigged, animated and rendered out. A solid 3D

short relies on one's ability to correctly model topology and understand the esthetic look intended.

Producing a biped character from scratch can be a daunting task. The artist must create a visually appealing character that is "animatable" and will correctly deform during the rigging stage. The balance between esthetic form and function is a challenge in itself. In order to achieve a great model the artist must successfully mesh form with function. If either over powers the other, the 3D short will suffer.

Within my work on character development, I noticed my skills improving at different rates. As my ability to create esthetically pleasing characters improved, my knowledge of topology and deformation was only a step behind. It is important that you have a strong knowledge in both aspects in order to create a beautiful model that can be animated correctly.

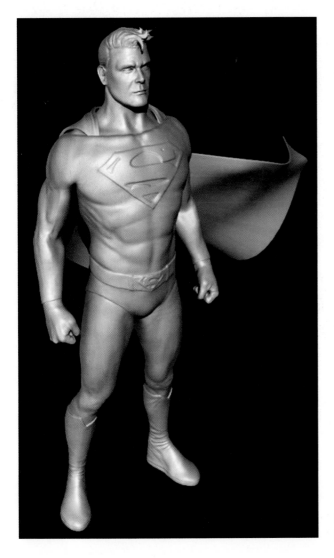

Superman by Chris Grim (2006).

Chris Grim received his BFA from Savannah College of Art and Design with honors and is currently finishing his MFA in animation. In 2006, he was awarded an honorable mention for modeling by Rhythm and Hues. He completed an internship at Gentle Giant Studios and after graduating, started working for Blur Studios. His work can be viewed at: www.chrisgrim.com.

Summary

2.1 Once again, we are reminded to KEEP IT SIMPLE. The simpler the character design, the easier it will be to model character.

2.2 Don't be afraid to explore tools and experiment. Sometimes it is best to scrap your first attempt and start over.

2.3 While working, it is suggested to use X-ray mode and wireframe on shaded so that you can see what you're doing while modeling.

2.4 Object mode and component mode are generally the two levels that are used during the character creation process. Object mode allows you to affect the entire object, while component mode allows you to manipulate finer details, or pieces of the object.

2.5 The type of geometry, NURBS, polygons, or subdivision surfaces, used for your character model truly does not matter. However, subdivision surfaces can still be unreliable when performing during animation.

2.6 The EP Curve Tool creates curves by clicking a series of points, which then creates a line between the points.

2.7 The Revolve Tool creates a surface around the chosen axis of the selected curve, such as a profile curve created with the EP Curve Tool.

2.8 A NURBS cylinder is a primitive object that can be used to create other shapes.

2.9 A lattice deformer surrounds the object with a type of scaffolding, which can then be manipulated to change the shape of an object.

2.10 A deformer is used to speed up the process of modeling because it affects multiple points of geometry at the same time.

2.11 A NURBS sphere is another primitive object that can be used as a base to create other shapes.

2.12 Construction history is a list of processes used on an object during modeling. It is sometimes needed, but often it must be deleted. So that tools work predictably, construction history should be deleted often.

2.13 The Sculpt Geometry Tool provides an artistic approach to modeling and can be used on all types of geometry.

2.14 Sometimes the only way to get the desired shape when modeling is to move individual CVs.

2.15 To make polygons easy to select, change your selection preferences to whole face.

2.16 When modeling with polygons, make sure that the faces are square shaped. This provides deformation during the animation process.

2.17 A polygonal cube is a primitive object that is generally the starting point for a method called box modeling.

2.18 The Split Polygon Tool can be used to divide up the polygonal faces during the modeling process.

2.19 When modeling in polygons is important to keep faces as quadrilaterals, or four sided.

2.20 During the box modeling process, extrude polygons is used often as a tool to create more faces.

2.21 It is important to have the option for Keep Faces Together checked while extruding except in cases when the faces need to be separate such as in the fingers.

2.22 NURBS surfaces can be converted to polygonal surfaces in order to create one seamless piece of geometry. Make sure to convert using control points as the setting for the tessellation method.

2.23 When working with polygonal geometry, it can be more efficient to only model half of the character and mirror the geometry for the other side.

2.24 Separate pieces of polygonal geometry must be combined before the vertex points can be merged.

2.25 Vertex points can be aligned easily by holding down the (v) hot key on the keyboard while moving them.

2.26 The append polygon tool is perfect for filling gaps or holes in polygonal geometry.

2.27 The Insert Edge Loop Tool will divide polygonal faces completely around the entire piece of geometry.

2.28 Two overlapping vertices can be combined into one by using the merge command. Remember, if merging vertices on two separate pieces of geometry, they must first be combined.

2.29 When mirroring geometry, it is important to make sure that none of the interior vertices have crossed the origin line.

2.30 All polygonal normals should face outwards. Normals can be flipped during the modeling process. You can display them and then use some of the normal tools to flip them back out, if necessary.

2.31 Whilst smoothing the polygonal geometry may be desired, it should not be done at this point of the workflow. Simply press (3) on the keyboard for a smooth preview.

2.32 As you work, make sure to delete history and labeled geometry.

2.33 When completing your geometry, create a layer in the Layer Editor and add the character geometry to that layer.

2.34 Freeze transformations on finished geometry.

Assignments: Modeling a Character

When modeling a character in 3D space, it is important to make sure that your character faces front in the front view, side in the side view, and down in the top view in

order for all of the tools to work appropriately. The programmers created the character tools in Maya to work with your character facing in the positive Z direction.

Assignment 2.1: Model a Head, Neck and Torso

1. Open Maya and set your project.

 a. Go to [**Start > Programs**] and select Maya.

 b. Once Maya is open go to [**File > Project > Set...**] and browse to your project folder then click "OK".

2. Open your last saved file: go to [**File > Open**] and select *01_referenceImages.ma*.

3. Set all four view panels to X-ray mode and wireframe on shaded.

 a. Turn on hardware texturing (**press 6**) on the keyboard so that you can see your reference images.

 b. In the top view panel, go to [**Shading > X-Ray**], and then [**Shading > Wireframe**] on shaded.

 c. In the perspective view panel, go to [**Shading > X-Ray**], and then [**Shading > Wireframe**] on shaded.

 d. In the front view panel, go to [**Shading > X-Ray**], and then [**Shading > Wireframe**] on shaded.

 e. In the side view panel, go to [**Shading > X-Ray**], and then [**Shading > Wireframe**] on shaded.

4. Draw a profile curve of your character's head, neck and torso. If your character has clothing, it should be part of this profile curve. Clothing does not need to be separate, unless your character is going to change clothing in the animation.

 a. Go to [**Create > EP Curve Tool**] and open the option box, click **Reset Tool** and close the option box.

 b. In the front window, trace your drawing by clicking points along the outline on the right side of your character (your left side), starting at the center of the head and ending in the crotch. Hit enter when finished. Ignore the arms for now.

 c. You can adjust the positions of the points on the curve by RMB on top of the curve and choose **Control Vertex**. Use your move tool by pressing (**w**) to select points and move them around to refine the shape of your curve. You can also delete extra points by selecting them and hitting the delete key.

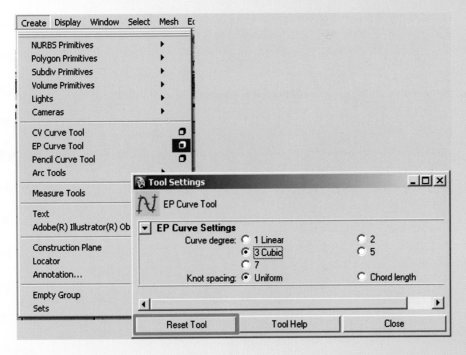

Create > EP Curve Tool.

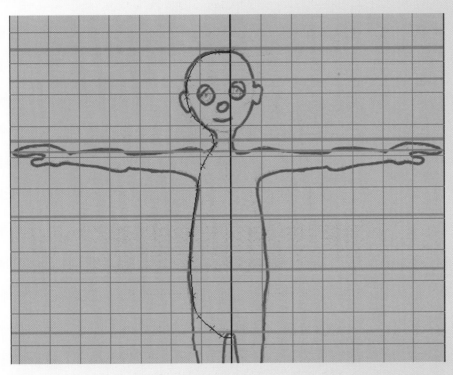

Tracing your drawing with the EP Curve Tool. An X marks each click of the mouse and becomes a point on the curve.

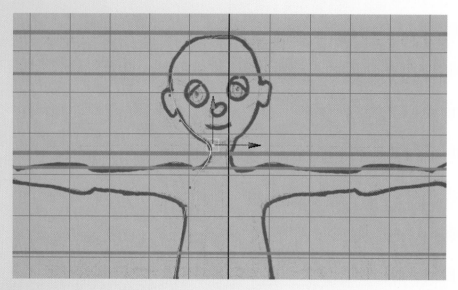

Refining the curve by adjusting the positions of the points on the curve with the move tool.

5. Create the surface for your character's head, neck and torso.

 a. Select *curve1*, the curve you created, and go to [**Surfaces > Revolve**]. This process creates *revolvedSurface1*, a NURBS surface in the shape of the profile curve.

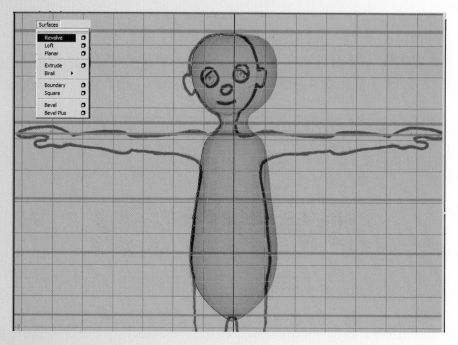

Creating the surface for you character's head and torso using the revolve command.

b. Open the outliner [**Window > Outliner**] and select *curve1*, the curve you
 created. In the perspective view panel, **RMB** to the left of the curve (in a blank
 area of the window NOT touching the curve or the surface) and choose **Control
 Vertex** (this will show the CV points only on the curve). Use your move tool by
 pressing (**w**) on the keyboard to select points and move them around to refine
 the shape of your surface. Because Maya has construction history, each
 operation you perform is connected to the preceding operation, and moving the
 points on the curve will automatically affect the surface and change its shape.

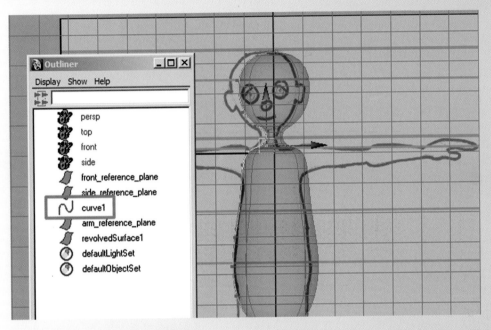

**Refining the surface by adjusting the positions of the points on the curve with the
move tool.**

c. Select *revolvedSurface1*, go to [**Create Deformers > Create Lattice**] and with the
 lattice selected, in the **Shapes** section of the channel box, increase the T
 divisions from 5 to about 10–14.

d. In the side view panel, **RMB** on top of the lattice and choose **Lattice Point**.
 Use your move tool by pressing (**w**) on the keyboard to click drag (or marquee
 drag) over points on the lattice (this ensures that you are selecting the points
 on both sides of the lattice) and move them around to refine the shape of
 your surface. In the perspective view panel, continue to move and scale (if
 adjusting 2 or 4 points on the same row) the points on the lattice to refine
 the shape of your surface. Your reference drawings are just a reference.
 Feel free to make artistic changes while modeling in order to achieve the look
 you want.

e. Select *revolvedSurface1* then go to [**Edit > Delete by Type > History**]. This will
 remove the lattice, but any changes that have been made are now permanent.
 This also removes the connection to *curve1*.

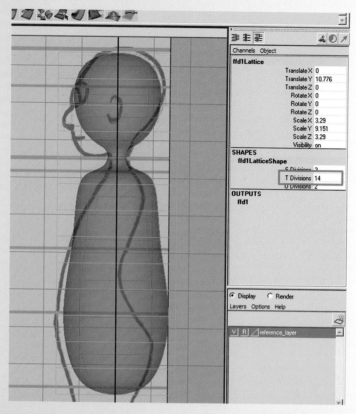

Adding a lattice deformer to your head and torso shape. Using a lattice allows even distribution and the changes to affect the entire piece of geometry.

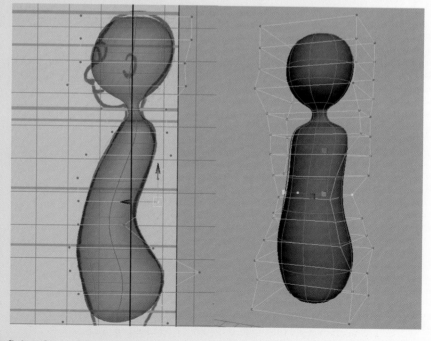

Refining the surface by adjusting the positions of the lattice points with the move and scale tools.

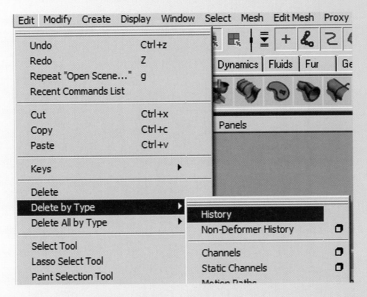

Edit > Delete by type > History.

f. In the outliner, select *curve1* and hit **delete**.

g. Select *revolvedSurface1* and rename to *body_geo* by clicking on the name and typing in the channel box.

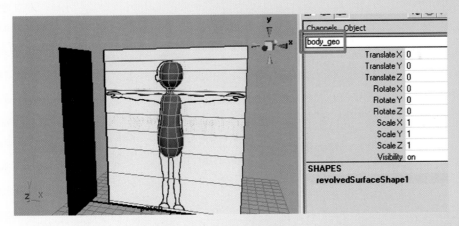

Renaming the torso and head shape in the channel box.

h. In the Layer Editor of the channel box, create a new layer. Double click on the new layer (layer1) and rename this layer *geometry_layer*, then click **save**. Select *body_geo*, **RMB** click and hold on top of the *geometry_layer* and choose Add Selected Objects. To make the objects non-selectable, click in the empty box between the V (visibility) and the layer name. An R (reference) should appear. This keeps any objects assigned to a layer visible but not selectable.

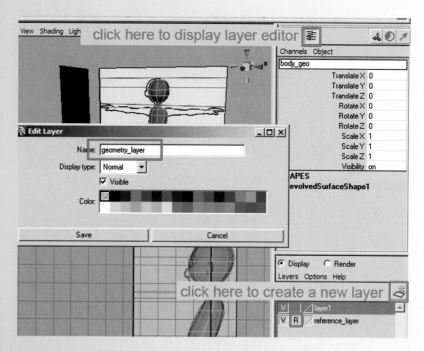

Click on the "create a new layer" button in the Layer Editor and rename it geometry_layer.

6. Save your scene file.

 a. Go to [**File > Save as**]. This should open the scenes folder of your project (assuming you set the project as in step 1).

 b. Name your scene *02_asgn01_body_geo.ma*.

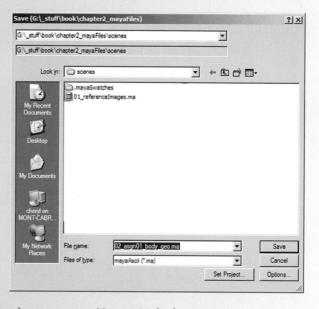

Saving and naming your scene *02_asgn01_body_geo.ma*.

Assignment 2.2: Model a Leg

1. Open Maya and set your project.

 a. Go to [**Start > Programs**] and select Maya.

 b. Once Maya is open go to [**File > Project > Set...**] browse to your project folder and click **OK**.

2. Open your last saved file. Go to [File > Open] and select *02_body_geo.ma*.

3. Continue working in X-ray mode and wireframe on shaded.

4. Go to [**Create > NURBS Primitives > Interactive Creation**] to uncheck this option and turn it off. (Interactive creation allows you to click and drag on the grid to create the size and shape of a primitive.)

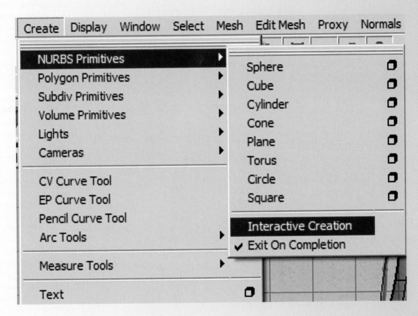

Turning off interactive creation.

5. Create a NURBS cylinder [**Create > NURBS Primitives > Cylinder**].

 a. Move and scale the cylinder over the character's right leg.

 b. In the **INPUTS** section of the channel box, click on *makeNurbCylinder1* and change **Spans** to 12.

6. With the *NurbCylinder1* still selected, create a Lattice Deformer [**Create Deformers > Lattice**].

 a. With the lattice selected, in the **Shapes** section of the channel box, increase the T Divisions from 5 to about 12.

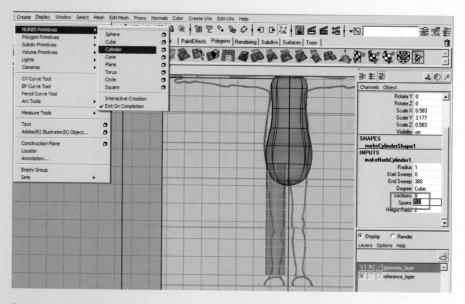

Creating a NURBS cylinder, positioning it for the leg, and dividing it for adequate deformation later.

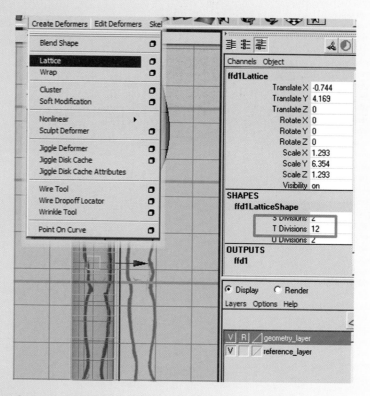

Adjusting the lattice for additional divisions. Using a lattice allows even distribution and the changes to affect the entire piece of geometry.

b. In the front view panel, **RMB** on top of the lattice and choose **Lattice Point**.
(You may need to **RMB** in the perspective window if your lattice is close to the
geometry, in order to see the correct marking menu.) Starting at the hip area, in
the front view panel, use your move tool by pressing (**w**) on the keyboard to
click drag (or marquee drag) over points on the lattice (this ensures that you are
selecting the points on both sides of the lattice) and move them around to refine
the shape of your surface. Then starting at the hip area, in the side
view panel, continue to move the points on the lattice to refine the shape of
your surface. Make sure to check the shape in the perspective window.
Your reference drawings are just a reference. Feel free to make
artistic changes while modeling in order to achieve the look you want.

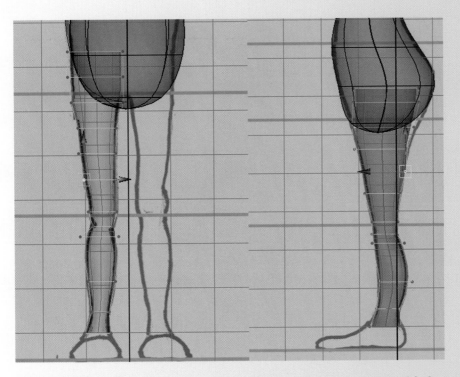

**Refining the shape of the leg by adjusting the positions of the lattice points with the
move and scale tools.**

c. Select *NurbCylinder1* then go to [**Edit > Delete by Type > History**]. This will
remove the lattice but any changes that have been made are now permanent.

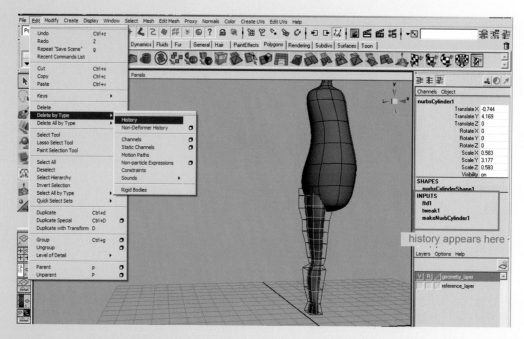

Deleting history to remove the lattice and bake the changes to the shape of the cylinder.

d. Rename *NurbCylinder1* to *rightLeg_geo* by clicking on the name and typing in the channel box.

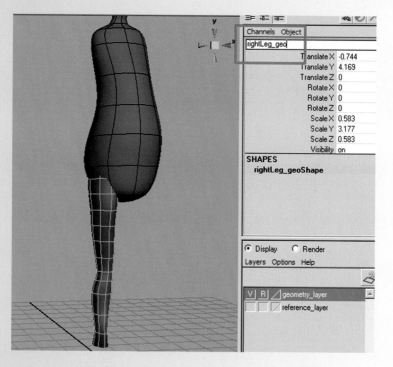

Keep your scene organized by labeling your geometry appropriately.

e. Duplicate *rightLeg_geo* [Edit > Duplicate] or press (ctrl + d) on the keyboard. In the channel box, rename *rightLeg_geo1* to *leftLeg_geo*, change the **TranslateX** value to positive (which positions the leg onto the other side of the origin) and change the **ScaleX** value to negative (which makes the leg invert).

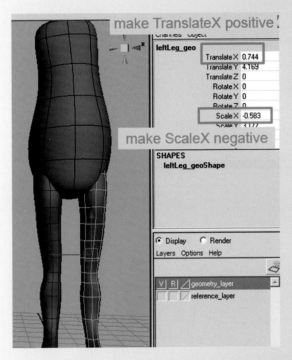

Duplicating the geometry and changing the ScaleX value to the negative inverts the shape. Changing the TranslateX value to positive positions the leg evenly on the opposite side of the origin.

f. Select *rightLeg_geo* and *leftLeg_geo* [Modify > **Freeze Transformations**]. Freeze transformations on finished geometry will return the translation and rotation values to 0 and the scale values to 1.

Freezing transformations makes the geometry transformation values return to 0 for translations and rotations and 1 for scale.

g. In the Layer Editor of the channel box, **RMB** click and hold on top of the *geometry_layer* and choose "**Add Selected Objects**".

7. Save your scene file.

a. Go to [**File > Save as**]. This should open the scenes folder of your project (assuming you set the project as in step 1).

b. Name your scene *02_asgn02_leg_geo.ma*.

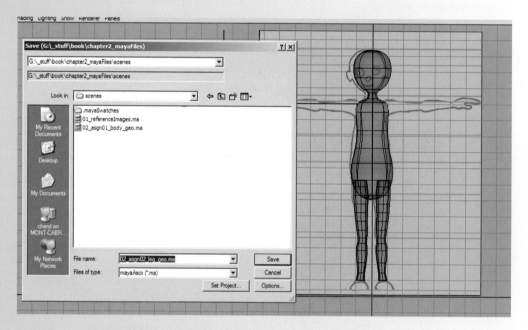

Saving and naming your scene *02_asgn02_leg_geo.ma*.

Assignment 2.3: Model an Arm

1. Open Maya and set your project.

a. Go to [**Start > Programs**] and select Maya.

b. Once Maya is open go to [**File > Project > Set...**] browse to your project folder and click **OK**.

2. Open your last saved file. Go to [**File > Open**] and select *02_asgn02_leg_geo.ma*.

3. Continue working in X-ray mode and wireframe on shaded.

4. Continue working with Interactive Creation unchecked [**Create > NURBS Primitives > Interactive Creation**]

5. Create a NURBS cylinder. [**Create > NURBS Primitives > Cylinder**].

a. In the channel box, change **RotateZ** to 90.

b. Move and scale the cylinder over the character's right arm.

c. In the **INPUTS** section of the channel box, click on *makeNurbCylinder1* and change **Spans** to 10.

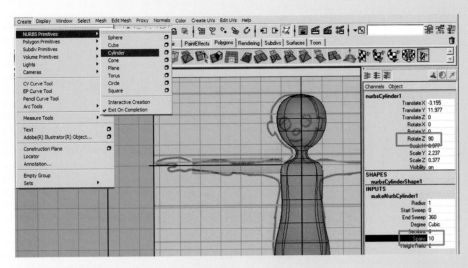

Creating a NURBS cylinder, positioning it for the arm, and dividing it for adequate deformation later.

6. With the *NurbCylinder1* still selected, create a Lattice Deformer [**Create Deformers > Lattice**].

 a. With the lattice selected, in the **Shapes** section of the channel box, increase the **T divisions** from 5 to about 8.

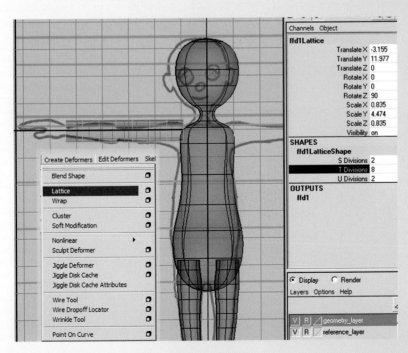

Adjusting the lattice for additional divisions. Using a lattice allows even distribution and the changes to affect the entire piece of geometry.

b. Starting at the shoulder area, in the front view panel, **RMB** on top of the lattice and choose **Lattice Point**. (You may need to **RMB** in the perspective window if your lattice is close to the geometry, in order to see the correct marking menu.) In the front view panel, use your move tool by pressing (**w**) on the keyboard to click drag (or marquee drag) over points on the lattice (this ensures that you are selecting the points on both sides of the lattice) and move them around to refine the shape of your surface. Then starting at the shoulder area, in the top view panel, continue to move the points on the lattice to refine the shape of your surface. Make sure to check the shape in the perspective window. Your reference drawings are just a reference. Feel free to make artistic changes while modeling in order to achieve the look you want.

Refining the shape of the arm by adjusting the positions of the lattice points with the move and scale tools.

c. *Optional*: For better deformation in the forearm later, you can rotate the last three rows of lattice points incrementally to total 45 degrees forward (starting with the row closes to the elbow, rotate slightly, then the next row, and the row at the wrist should have the points even again.) To see what I am talking about, hold your arm out parallel to the floor and palm forward, then rotate your arm so that the palm is facing the floor, Notice how your skin moves with your forearm during this rotation.

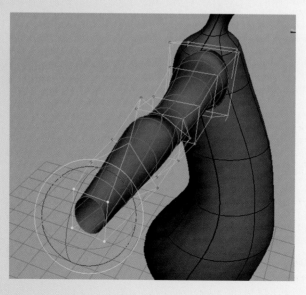

Rotating the forearm for better deformation when the hand twists.

d. Select *NurbCylinder1* then go to [**Edit > Delete by Type > History**]. This will remove the lattice but any changes that have been made are now permanent.

e. Rename *NurbCylinder1* to *rightArm_geo* by clicking on the name and typing in the channel box.

Deleting history to remove the lattice and bake the changes to the shape of the cylinder, then renaming the geometry appropriately.

f. **Duplicate** *rightArm_geo* [**Edit > Duplicate**] or press (**ctrl+d**) on the keyboard. In the channel box, rename *rightArm_geo1* to *leftArm_geo*, change the **TranslateX** value to **positive** (which positions the arm onto the other side of the origin) and change the **ScaleY** value to **negative** (which makes the arm invert).

g. Select *rightArm_geo* and *leftArm_geo* [**Modify > Freeze Transformations**]. Freeze transformations on finished geometry will return the translation and rotation values to 0 and the scale values to 1.

h. In the Layer Editor of the channel box, **RMB** click and hold on top of the *geometry_layer* and choose Add Selected Objects.

Freezing transformations on the arm geometry.

7. Save your scene file.

 a. Go to [**File > Save as**]. This should open the scenes folder of your project (assuming you set the project as in step 1).

 b. Name your scene *02_asgn03_arm_geo.ma*.

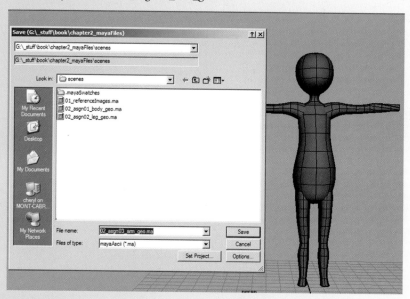

Saving and naming your scene *02_asgn03_arm_geo.ma*.

Assignment 2.4: Model a Hand

1. Open Maya and set your project.

 a. Go to [**Start > Programs**] and select Maya.

 b. Once Maya is open go to [**File > Project > Set...**] browse to your project folder and click **OK**.

2. Open your last saved file. Go to [**File > Open**] and select *02_asgn03_arm_geo.ma*.

3. Continue working in X-ray mode and wireframe on shaded.

4. Continue working with Interactive Creation unchecked [**Create > NURBS Primitives > Interactive Creation**].

5. Create a NURBS sphere [**Create > NURBS Primitives > Sphere**].

 a. In the channel box, change "**RotateZ**" to 90.

 b. Move and scale the sphere over the character's right palm.

 c. In the **INPUTS** section of the channel box, click on *makeNurbSphere1* and change **Spans** to 8.

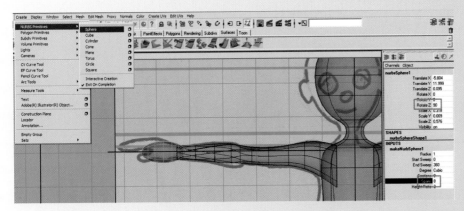

Creating a NURBS cylinder, positioning it for the palm, and dividing it for adequate deformation.

6. With the *NurbSphere1* still selected, create a Lattice Deformer [**Create Deformers > Lattice**].

 a. Starting at the wrist area, in the front view panel, **RMB** on top of the lattice and choose **Lattice Point**. (You may need to **RMB** in the perspective window if your lattice is close to the geometry, in order to see the correct marking menu.) In the front view panel, use your move tool by pressing (**w**) on the keyboard to click drag (or marquee drag) over points on the lattice (this ensures that you are selecting the points on both sides of the lattice) and move them around to refine the shape of your surface. Then starting at the wrist area, in the top view panel, continue to move the points on the lattice to refine the shape of your surface. Make sure to check the shape in the perspective window. Your reference drawings are just a reference. Feel free to make artistic changes while modeling in order to achieve the look you want.

 b. Select *NurbSphere1* then go to [**Edit > Delete by Type > History**]. This will remove the lattice, but any changes that have been made are now permanent.

 c. Rename *NurbSphere1* to *rightPalm_geo* by clicking on the name and typing in the channel box.

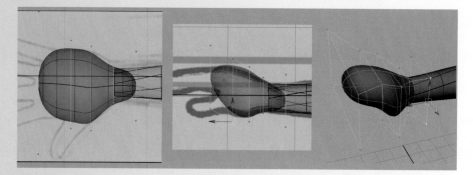

Adjusting the lattice for additional divisions and reshaping the lattice to make the sphere into a palm.

7. Create another NURBS sphere. [**Create** > **NURBS Primitives** > **Sphere**].

 a. In the channel box, change "**RotateZ**" to 90.

 b. Move and scale the sphere over the character's right index finger.

 c. In the **INPUTS** section of the channel box, click on *makeNurbSphere1* and change **Spans** to 8.

8. With the *NurbSphere1* still selected, create a Lattice Deformer [**Create Deformers** > **Lattice**].

 a. Starting at the palm area, in the front view panel, **RMB** on top of the lattice and choose **Lattice Point**. (You may need to **RMB** in the perspective window if your lattice is close to the geometry, in order to see the correct marking menu.) In the front view panel, use your move tool by pressing (**w**) on the keyboard to click drag (or marquee drag) over points on the lattice (this ensures that you are selecting the points on both sides of the lattice) and move them around to refine the shape of your surface. Then starting at the palm area, in the top view panel, continue to move the points on the lattice to refine the shape of your surface. Make sure to check the shape in the perspective window. Your reference drawings are just a reference. Feel free to make artistic changes while modeling in order to achieve the look you want.

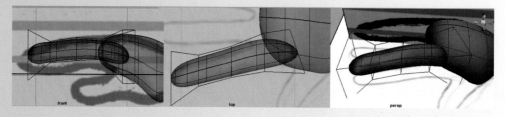

Making the index finger.

b. Select *NurbSphere1* then go to [**Edit > Delete by Type > History**]. This will remove the lattice but any changes that have been made are now permanent.

c. Rename *NurbSphere1* to *rightIndex_geo* by clicking on the name and typing in the channel box.

9. Repeat steps 7–8 for each finger and the thumb, renaming them *rightMiddle_geo, rightRing_geo, rightPinky_geo, and rightThumb_geo.*

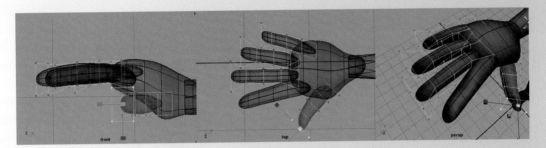

Making the fingers and thumb.

10. Duplicate the hand for the left side.

a. Select *rightPalm_geo* and duplicate [**Edit > Duplicate**] or press (**ctrl+d**) on the keyboard. In the channel box, rename *rightPalm_geo1* to *leftPalm_geo*, change the **TranslateX** value to **positive** (which positions the arm onto the other side of the origin) and change the **ScaleY** value to negative (which makes the palm invert).

11. Repeat this process for each finger.

12. Select *rightPalm_geo, rightIndex_geo, rightMiddle_geo, rightRing_geo, rightPinky_geo, rightThumb_geo, leftPalm_geo, leftIndex_geo, leftMiddle_geo, leftRing_geo, leftPinky_geo, and leftThumb_geo* [**Modify > Freeze Transformations**]. **Freeze Transformations** on finished geometry will return the translation and rotation values to 0 and the scale values to 1.

13. In the Layer Editor of the channel box, **RMB** click and hold on top of the *geometry_layer* and choose **Add Selected Objects**.

14. Save your scene file.

a. Go to [**File > Save as**].

b. Name your scene 02_assgn04_hand_geo.ma.

Assignment 2.5: Model a Foot

1. Open Maya and set your project.

a. Go to [**Start > Programs**] and select Maya.

b. Once Maya is open go to [**File > Project > Set…**] browse to your project folder and click **OK**.

2. Open your last saved file. Go to [**File > Open**] and select *02_asgn04_hand_geo.ma.*

3. Continue working in X-ray mode and wireframe on shaded.

4. Continue working with Interactive Creation unchecked [**Create > NURBS Primitives > Interactive Creation**].

5. Create a NURBS sphere [**Create > NURBS Primitives > Sphere**].

 a. Move and scale the sphere over the character's right foot.

 b. In the **INPUTS** section of the channel box, click on *makeNurbSphere1* and change **Spans** to 6.

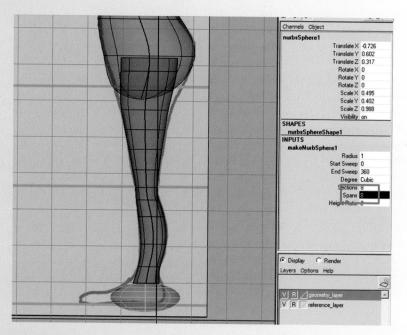

Creating a NURBS sphere, positioning it for the foot, and dividing it for adequate deformation.

6. With the *NurbSphere1* still selected, create a Lattice Deformer. [**Create > Deformers > Lattice**].

 a. In the **Shapes** section of the channel box, change the **T** divisions to 2 and the **U** divisions to 5.

Starting at the ankle area, in the side view panel, **RMB** on top of the lattice and choose **Lattice Point**. (You may need to RMB in the perspective window if your lattice is close to the geometry, in order to see the correct marking menu.) In the front view panel, use your move tool by pressing (**w**) on the keyboard to click drag (or marquee drag) over points on the lattice (this ensures that you are selecting the points on both sides of the

lattice) and move them around to refine the shape of your surface. Check the shape in the perspective window. Reshape the front of the foot. Your reference drawings are just a reference. Feel free to make artistic changes while modeling in order to achieve the look you want.

b. Select *NurbSphere1* then go to [**Edit > Delete by Type > History**]. This will remove the lattice, but any changes that have been made are now permanent.

c. Rename *NurbSphere1* to *rightFoot_geo* by clicking on the name and typing in the channel box.

Adjusting the lattice for additional divisions and reshaping the lattice to make the sphere into a foot.

d. Select *rightFoot_geo* and duplicate [**Edit > Duplicate**] or press (**ctrl+d**) on the keyboard. In the channel box, rename *rightFoot_geo1* to *leftFoot_geo*, change the **TranslateX** value to positive (which positions the foot onto the other side of the origin) and change the **ScaleX** value to negative (which makes the foot invert).

e. Select *rightFoot_geo* and *leftFoot_geo* [**Modify > Freeze Transformations**]. Freeze transformations on finished geometry will return the translation and rotation values to 0 and the scale values to 1.

f. In the Layer Editor of the channel box, **RMB** click and hold on top of the *geometry_layer* and choose Add Selected Objects.

g. Save your scene file: Go to [**File > Save as**].

h. Name your scene *02_asgn05_foot_geo.ma*.

Duplicating the right foot to create the left foot.

Assignment 2.6: Model Eyes

1. Open Maya and set your project.

 a. Go to [**Start** > **Programs**] and select Maya.

 b. Once Maya is open go to [**File** > **Project** > **Set…**] browse to your project folder and click **OK**.

2. Open your last saved file. Go to [**File** > **Open**] and select *02_asgn05_foot_geo.ma*.

3. Continue working in X-ray mode and wireframe on shaded.

4. Continue working with Interactive Creation [**Create** > **NURBS Primitives** > **Interactive Creation**].

5. Turn your *geometry_layer* to invisible by clicking and hiding the **V** next to the layer.

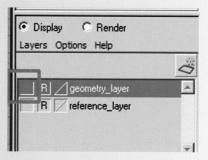

Turn the geometry layer invisible by hiding the V in the Layer Editor.

6. Go to [**Create** > **NURBS Primitives** > **Sphere – option box**]. Change the **Axis** to Z and the **Spans** to 6. Click **Create**.

7. Rename *NurbSphere1* to *eyeball_geo* by clicking on the name and typing in the channel box.

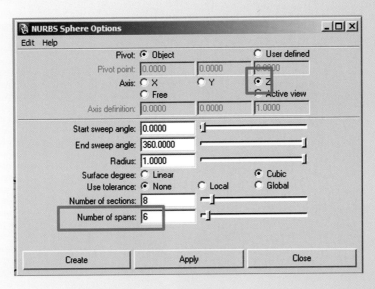

The NURBS sphere option box.

8. Hold your cursor over the sphere and **RMB**, click and hold, select [**Assign New Material > Phong**] (Phong is a reflective material when rendered. You may want to try a different material to achieve your desired look.) The attribute editor will open. Rename the material eye_phong.

 a. In Attribute Material window, click on the **checkered square** next to the Color. Create Render Node will appear. Select **2D Textures – Ramp**. Press **(6)** to see how the material looks on the Sphere.

 b. Change the **Ramp Attribute Type** to a **U Ramp**.

 c. Click on the blue circle of color, then click on the blue box in the **Selected Color** section, this opens the color picker where you can change the color to a very dark blue, almost black. You really should never use black, as black is very flat and creates a visual death on the screen.

 d. Click on the red circle of color, then click on the red box in the **Selected Color** section, this opens the color picker where you can change the color to a very pale orange, almost white. For the same reasons as black, you really should never use white either.

 e. Click on the green circle of color, then click on the green box in the **Selected Color** section, this opens the color picker where you can change the color to the color chosen for your character's eye color. You will also need to click inside of the ramp rectangle to create a fourth circle of color, which allows you to make your eyes two toned for more interest.

 f. Click and drag the circles up and down to adjust their position. The closer the circles are to each other, the sharper the edge of color.

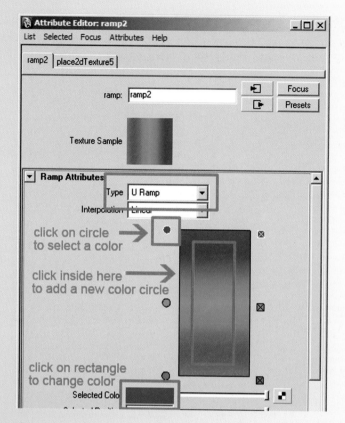

Adjusting the ramp attributes.

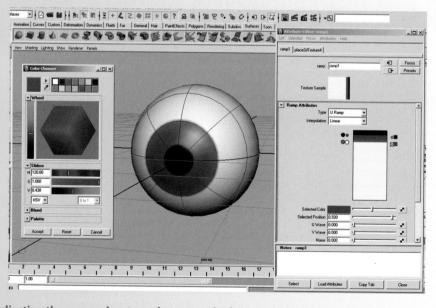

Adjusting the ramp colors to make an eye shader.

! Don't be afraid to add more detail or your own ideas. For example, all eyes have a thin dark ring around the outside of the iris called a limbus line. You could add this detail because it also adds quite of bit of visual interest.

9. Go to [Create > NURBS primitives > Sphere – option box] Change the **Axis** to **X**, the **Start sweep angle** to **55**, and the **End sweep angle** to **355**. Click **Create**.

10. In the channel box, in the **INPUTS** section, click on the *makeNurbSphere* which reveals additional attributes including *Start Sweep* and *End Sweep*, which will allow your character to blink. You can test this out by clicking on the **WORD Start Sweep**, then click and drag the **MMB** (middle mouse button) in a view panel to see the eye blink. Make sure to undo this motion by pressing (**z**) on the keyboard.

 a. Rename *NurbSphere1* to *eyelid_geo* by clicking on the name and typing in the channel box.

 b. In the channel box, change **RotateX to 206** (your value may be different), and **ScaleX, ScaleY, ScaleZ to 1.02**.

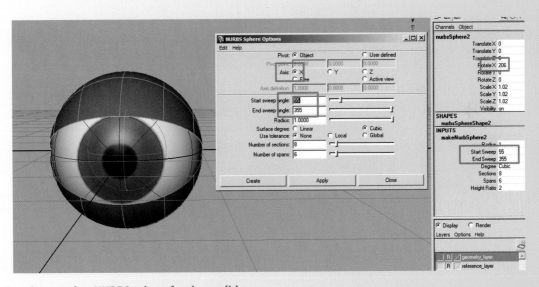

Creating another NURBS sphere for the eyelid.

 c. Add dimension to the eyelid. Add a couple additional horizontal isoparms to the eyelid. To insert a single isoparm, **RMB** and hold over a surface (which brings up the marking menu), choose **Isoparms** (which brings you into component

level), click and drag on an isoparm on the surface near to where you want to add one, drag it into position, then [**Edit NURBS > Insert Isoparms**].

d. RMB on top of the eyelid and choose **HULLS**.

e. Select a hull near the edge of the upper eyelid, then shift select a hull near the edge of the lower eyelid.

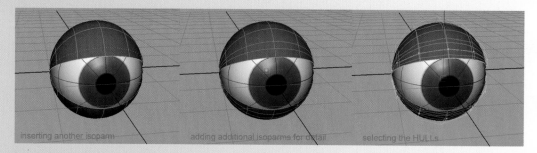

inserting another isoparm adding additional isoparms for detail selecting the HULLs

Inserting isoparms and selecting the HULLS.

f. RMB on top of the eyelid and choose **Control Vertex**.

g. Hold down the **ctrl key** and drag select each pole to deselect it.

h. Use the scale tool to scale out a lip around the edge of the eyelid.

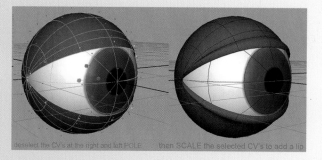

deselect the CV's at the right and left POLE then SCALE the selected CV's to add a lip

Reshaping the eyelid to add dimension.

i. If you want to reshape your eye to something other than spherical, you can now add a lattice. Select both *eyeball_geo and eyelid_geo*, then [**Create Deformers > Lattice**].

i. Open the outliner and select both *fftd1Lattice* and *fftd1Base*. You will need to scale these up so that reshaping them doesn't cause intersection problems between the eyelid and eyeball when the eyelid closes.

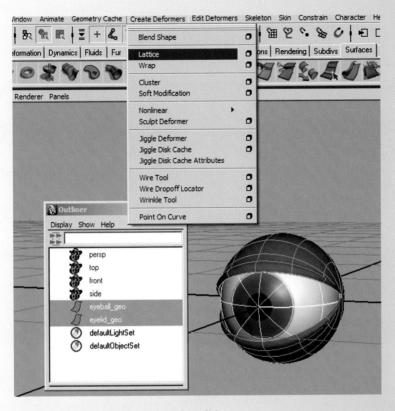

Adding a lattice deformer to the eye and eyelid.

Scaling both the lattice and the base larger.

ii. You can reshape the lattice by **RMB** on the lattice and moving the lattice
 points with the move tool by pressing (**w**) on the keyboard. If the eyeball
 starts to intersect the eyelid, you can scale the eyelid up slightly.

Exposing part of the eyeball while reshaping the lattice (left) can be alleviated by scaling the eyelid slightly larger (right).

 j. Open the outliner, [**Windows > Outliner**] Select the *eyeball_geo, eyelid_geo, fftd1Lattice,* and *fftd1Base* and (if you have a Lattice and Base) **ctrl + g** to group them together. Rename *group1* to *right_eye_geo* by clicking on the name and typing in the channel box.

Grouping the eye parts and renaming the group to right_eye_geo.

 k. Turn your *geometry_layer* to visible by clicking on the first empty box and **V** will appear next to the layer.

 l. Select the *right_eye_geo* group in the outliner and move the eye into place. You can also scale this group if necessary. Adjust the lattice if needed as well, once the **EYE GROUP** is in position. Make sure that you do not move the individual pieces of the eye, as this will cause problems when the eye needs to rotate later.

Repositioning the right_eye_group.

m. Duplicate the eye [**Edit > Duplicate Special – option box**]. Check **Duplicate input graph**. Rename *right_eye_geo1 to left_eye_geo*. This keeps the input (makeNurbSphere) which is necessary for blinking.

The Duplicate Special option box with the Duplicate input graph option checked.

n. Change the **TranslateX** value of *left_eye_geo* to positive (which positions the eye onto the other side of the origin) and change the **ScaleX** value to negative (which makes the eye invert).

o. Select both lattice and hide them by pressing (**ctrl + h**).

p. DO NOT FREEZE TRANFORMATIONS OR DELETE HISTORY on your eyes. Doing so will remove the shape changes and the lattice, as well as the INPUTS for *makeNurbSphere* which is needed to create eye blinks.

q. Select *right_eye_geo* and *left_eye_geo*. In the Layer Editor of the channel box, **RMB** click and hold on top of the *geometry_layer* and choose **Add Selected Objects**.

11. Save your scene file.

a. Go to [File > **Save as**].

b. Name your scene *02_asgn06_eye_geo.ma*.

Assignment 2.7: Adding Detail to the Face

You can continue to add additional spheres that are shaped by lattices to create the nose, mouth, and eyebrows. The technique that follows shows how to create those features and keep them as part of the head, instead of separate geometry.

1. Open Maya and set your project.

a. Go to [**Start > Programs**] and select Maya.

b. Once Maya is open go to [**File > Project > Set...**] browse to your project folder and click **OK**.

2. Open your last saved file. Go to [**File > Open**] and select *02_asgn06_eye_geo.ma*.

3. Continue working in X-ray mode and wireframe on shaded.

4. Continue working with Interactive Creation [**Create > NURBS Primitives > Interactive Creation**].

5. To add detail to the head:

a. Add a couple additional vertical isoparms where the eyes would be. To insert a single isoparm, **RMB** and hold over a surface (which brings up the marking menu), choose Isoparms (which brings you into component level), click and drag on an isoparm on the surface near to where you want to add one, drag it into position, then [**Edit NURBS > Insert Isoparms**].

Adding an isoparm.

b. Add additional horizontal isoparms as needed. You can add multiple isoparms at the same time by RMB and hold over a surface, choose Isoparms, and shift selecting two isoparms. Open the [**Edit NURBS > Insert Isoparms – option box**]. Choose **Between Selections** and then type in the # of isoparms to insert.

Adding additional isoparms using the option for between selections.

c. Use the Sculpt Geometry Tool [**Edit NURBS > Sculpt Geometry Tool – option box**] to pull out a nose for your character.

Creating a nose shape.

d. With the view panel active, hold the mouse over the surface, hold down the "b" key and **MMB** click and drag to interactively adjust the size of the brush.

e. You can use the reflection option under the **Stroke** tab for creating the same changes on both sides of the face at once. This can be helpful for pulling out eyebrows. Also make sure you reduce the **maximum displacement** from 1 to 2 so that the eyebrows are not pulled out as far.

Use the reflection option to create eyebrows.

f. Continue to add **ISOPARMS** as necessary to create the detail necessary. The more detail you want, the more isoparms are needed.

g. **RMB** over the geometry and choose **Control Vertex** in order to select **CVs** in the mouth area and pull them into make a mouth.

6. Save your scene file.

a. Go to [**File > Save as**]. This should open the scenes folder of your project (assuming you set the project as in step 1).

b. Name your scene *02_asgn07_faceDetail_geo.ma*.

Optional Assignment 2.8: Model Ears, Hair, and Accessories

This is an optional assignment, as not all characters have hair or ears. However, the ears a can change the appearance of your character and add an element that allows for character, personality, and a way of conveying expression.

This is not a step by step tutorial. Rather, you can use techniques learned so far to create ears and hair. A simple way of creating an ear is to begin with a sphere on the Z axis with 8 spans, position it near the head and scale it on the X axis to create the proper thickness. Add a lattice deformer, and reshape the lattice points to create an ear. Delete history and duplicate for the other side, changing the TranslateX value to positive, the ScaleX to negative, and rotate to position as needed.

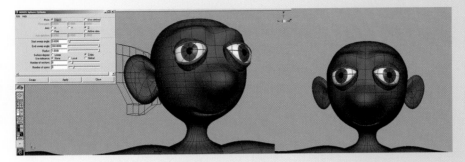

Creating an ear using a NURBS sphere.

A similar approach using a NURBS sphere and a lattice can be used to create the hair.

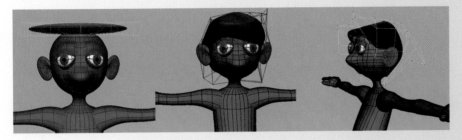

Creating hair using a NURBS sphere.

Try experimenting with a NURBS cone and nonlinear deformers, such as bend and twist. Make sure to add adequate spans to the cone BEFORE adding the deformer, so that the geometry will bend properly.

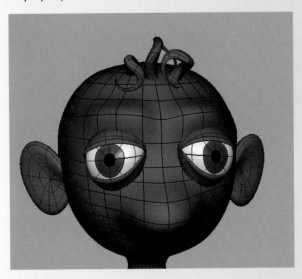

Curly hair using a NURBS cone.

Accessories, such as hats, ties, and other props can be modeled in similar ways. Hats, for example, can be created using a profile curve and revolving a surface, much like we did for the head and neck.

Optional Assignment 2.9: Combining Everything into a Single Polygonal Shape with Additional Approaches to Modeling Hands and Feet

1. Open Maya and set your project.

 a. Go to [START > PROGRAMS] and select Maya.

 b. Once Maya is open go to [File > Project > Set ...] browse to your project folder and click OK.

2. Open your last saved file. Go to [File > Open] and select *02_asgn07_faceDetail_geo.ma.*

3. Continue working in X-ray mode and wireframe on shaded.

4. Select all the body geometry. Use the outliner [Window > Outliner] or the hypergraph [Window > Hypergraph: Hierarchy] to verify that all body geometry is selected. Do not select the eyes and eyelids.

 [Modify > Convert > NURBS to POLYS] except for the eyes and eyelids.

5. Delete history on all converted polygons. [Edit > Delete by Type > History].

6. Delete NURBS geometry except for the eyes and eyelids.

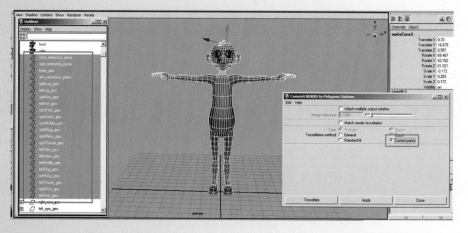

Converting NURBS to polygons.

7. Delete half of your model [RMB over geometry > FACES, select the faces and hit delete] all except the eyes and hair, if any.

8. With the geometry still selected, combine separate polygonal pieces into one [Mesh > Combine].

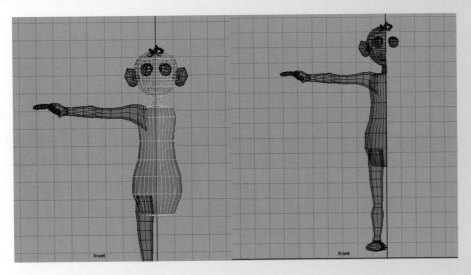

Selecting half of the faces of your polygonal face and torso.

Note: You may want to review the box modeling section that follows for the hands and feet. It is easier to delete the NURBS geometry at this time rather than deleting the polygonal faces after combining.

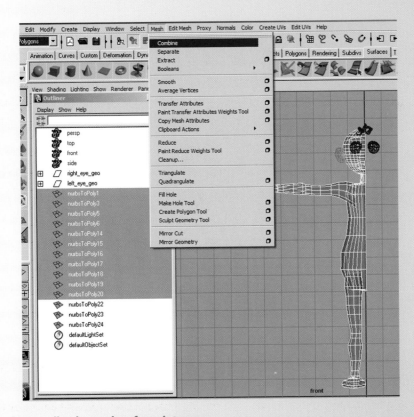

Combining all polygonal surfaces into one.

9. Delete history on *polySurface1* and rename *polySurface1* to *body_geo*.

10. Determine if there are equal numbers of edges on the two areas that need to be attached, and add additional geometry where needed. [**Edit Mesh > Insert Edge Loop Tool**]. Click on an edge and drag the new edge into place.

Click-drag on edges.

Add a new edge in order to align the torso with the leg.

11. Delete any overlapping geometry **RMB** over the geometry, choose **FACES**, select the faces that you want to remove and hit the **DELETE** key.

12. Using the move tool by pressing **(w)** on the keyboard hold down the '**v**' key and move snap vertex points to line up with the other point nearby.

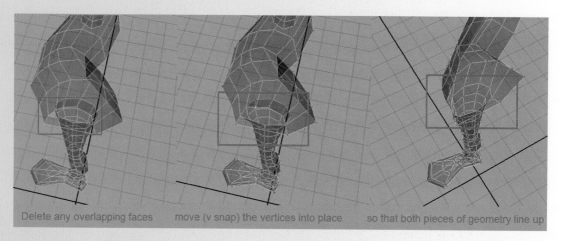

Delete any overlapping faces move (v snap) the vertices into place so that both pieces of geometry line up

Aligning the torso vertices with the leg vertices.

13. Select the row of overlapping vertices and merge vertices. [**Edit Mesh > Merge**].

Merging the overlapping vertices.

14. Save your scene file: Go to [**File > Save as**].

15. Name your scene *02_asgn09_01_convert_to_polys_geo.ma*.

You can repeat the process of deleting overlapping geometry, adding additional edges, v snapping vertex points, and merging vertices for each separate body part. However, in the case of the foot and the hand, it is easier to delete the existing parts and remodel them using the box modeling technique as shown in the following tutorials. Remember, deleting the foot and hand should be done BEFORE combining polygonal surfaces, as it is more difficult to select the overlapping geometry then it is to delete an entire, uncombined object.

Tutorial 2.9.a: Box Modeling a Foot

1. If you have not deleted the foot as suggested earlier, remove the existing foot geometry if it was converted and combined. **RMB** over the foot geometry, choose **FACES**, select the faces that you want to remove and hit the **DELETE** key.

2. Create a polygonal cube [**Create > Polygon Primitives > Cube – option box**] and divide the width and depth to 2. Reposition it to where the foot should be, scaling as needed.

Creating a polygonal cube to become the foot.

3. RMB over the cube, choose **FACES**, and select the top faces and hit the **DELETE** key.

4. Select the cube, shift select the *body_geo*, and combine them into one piece [**Mesh > Combine**].

5. RMB over the cube, and choose **VERTEX**. Using the move tool by pressing **(w)** on the keyboard hold down the 'v' key and select a vertex to move snap vertex points to line up with the other point nearby.

Snapping the vertices of the cube to those of the leg.

6. Delete history on *polySurface1* and rename *polySurface1* to *body_geo*.

7. Select the row of overlapping vertices and merge vertices [**Edit Mesh > Merge**].

Merging the overlapping vertices of the foot and leg.

8. In the SIDE view panel, RMB over the foot geometry, choose VERTEX, select and move the bottom row of vertices to line up with your reference drawing.

Adjusting the bottom row of vertices.

9. RMB over the foot geometry, choose **FACES**. In perspective view panel, select the two front faces and go to [**Edit Mesh > Extrude**]. Click on the little blue circle, and drag the arrow forward which will extrude your polygons in world space, perpendicular to the graph. Do not extrude all the way to the tip of the foot, rather, extrude only about a third of the way there.

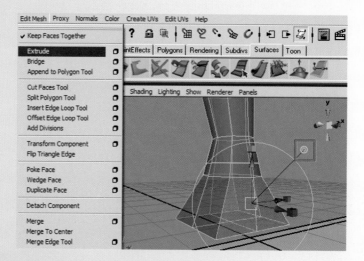

Extruding the foot parallel can occur if first clicking on the blue circle (shown yellow in this image because it is already selected) then clicking on the arrow to drag the extrusion forward.

10. Hit the (g) key to extrude again, and click on the blue circle before dragging the arrow forward, about halfway to the tip of the foot.

11. Hit the (g) key to extrude again, and click on the blue circle before dragging the arrow forward, to the tip of the foot.

12. RMB over the foot geometry, choose **VERTEX**, and use the move tool to reshape the vertices into the shape of the foot. Be sure NOT to cross the origin line.

Reshaping the extruded faces into a foot.

Tutorial 2.9.b: Box Modeling a Hand

1. If you have not deleted the hand as suggested earlier, remove the existing hand geometry if it was converted and combined. RMB over the hand geometry, choose FACES, select the faces that you want to remove and hit the DELETE key.

2. Create a polygon cube and divide the width, height and depth to 2 and reposition it to where the hand should be, scaling as appropriate.

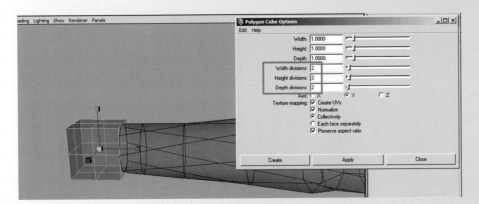

Creating a polygonal cube to become the hand.

3. RMB over the cube, choose FACES, and select the side faces closest to the wrist and hit the DELETE key.

4. In the FRONT and TOP view panel, RMB over the hand geometry, choose VERTEX, select and move the vertices to line up with your reference drawing.

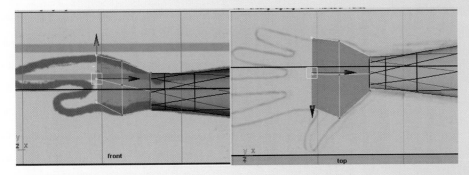

Reshaping the cube into a palm.

5. Determine where the fingers will be and add additional geometry where needed [Edit Mesh > Insert Edge Loop Tool]. Click on an edge and drag the new edge into place (It might be a great idea to limit your character's fingers to a thumb and two fingers for the first time you create one, as it takes additional time to create and control four fingers and a thumb).

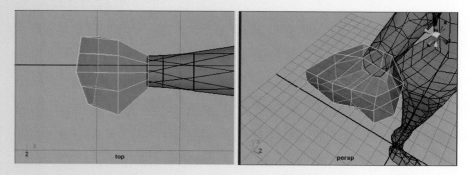

Adding additional edges to divide the geometry for fingers.

6. Extrude the fingers:

a. Before we extrude the fingers, we want to make sure we get separate faces during the extrusion. Make sure to uncheck [**Edit Mesh > Keep Faces Together**] RMB over the hand geometry, choose **FACES**. In perspective view panel, select the faces where the fingers will be.

Making sure Keep Faces Together is unchecked.

b. [**Edit Mesh > Extrude**] In the **TOP** view panel, drag the arrow forward which will extrude your polygons. Do not extrude all the way to the tip of the fingers; rather, extrude only about a third of the way there (to the first knuckle). Then click on one of the scale boxes.

c. Then click on the center scale box, and **MMB** click and drag to scale the fingers slightly and separate the end faces. This will make it easier to reposition the vertices because they will not be overlapping.

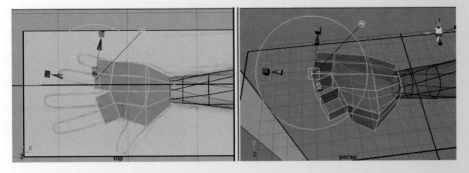

Extruding the fingers to the first knuckle.

Scaling the extrusion to separate the fingers.

d. Using the move tool by pressing **(w)** on the keyboard, in the **TOP** and **FRONT** view panel, reposition the end row of vertices for each finger.

Adjusting the positions of the finger geometry.

e. **RMB** over the hand geometry, choose **FACES**. In perspective view panel, select the end faces of each finger and go to [**Edit Mesh > Extrude**]. In the **TOP** view panel, drag the arrow forward which will extrude your polygons. Do not extrude all the way to the tip of the fingers; rather, extrude only about a half of the way there (to the second knuckle).

Extruding the fingers to the second knuckle.

f. Using the move tool by pressing **(w)** on the keyboard, in the **TOP** and **FRONT** view panel, reposition the end row of vertices for each finger.

g. **RMB** over the hand geometry, choose **FACES**. In perspective view panel, select the end faces of each finger and go to [**Edit Mesh > Extrude**].

h. In the **TOP** view panel, drag the arrow forward which will extrude your polygons, all the way to the tip of the fingers.

i. Using the move tool by pressing **(w)** on the keyboard, in the **TOP** and **FRONT** view panel, reposition the end row of vertices for each finger.

Extruding the fingers to the tip.

7. Extrude the thumb:

a. **RMB** over the hand geometry, choose **FACES**. In perspective view panel, select the face where the thumb will be and go to [**Edit Mesh > Extrude**].

b. In the **TOP** view panel, drag the arrow forward which will extrude your polygons. Do not extrude all the way to the tip of the thumb; rather, extrude only about a half of the way there (to the first knuckle).

c. Using the move tool by pressing **(w)** on the keyboard, in the **TOP** and **PERSPECTIVE** view panel, reposition the end row of vertices for the thumb.

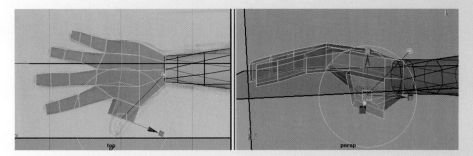

Extruding the thumb to the first knuckle.

d. RMB over the hand geometry, choose **FACES**. In perspective view panel, select the end face of the thumb and go to [**Edit Mesh > Extrude**].

e. In the **TOP** view panel, drag the arrow forward which will extrude your polygons all the way to the tip of the thumb.

f. Using the move tool by pressing **(w)** on the keyboard, in the **TOP** and **PERSPECTIVE** view panel, reposition the end row of vertices for the thumb.

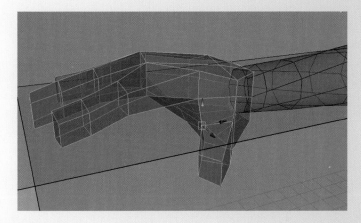

Extruding the thumb.

8. Combine the hand with the existing *body_geo*:

a. Determine if there are equal numbers of edges on the two areas that need to be attached, and add additional geometry where needed [**Edit Mesh > Insert Edge Loop Tool**]. Click on an edge and drag the new edge into place.

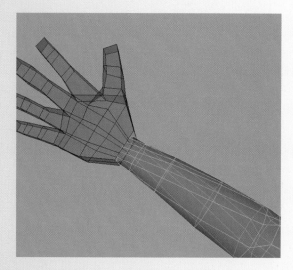

Inserting a new edge in order to align the arm with the hand.

b. In object mode – press **(F8)** on the keyboard, with the selection tool – press **(q)**, select the hand, shift select the *body_geo*, and combine them into one piece [**Mesh > Combine**].

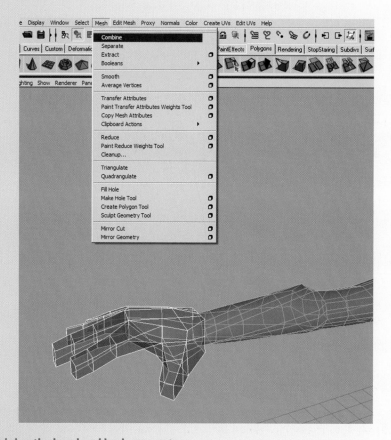

Combining the hand and body geometry.

c. RMB over the hand, choose **VERTEX**, then **RMB** over the arm and choose
 VERTEX. Using the move tool by pressing **(w)** on the keyboard, hold down the
 'v' key and select a vertex to move snap vertex points to line up with the other
 point nearby.

d. Select the row of overlapping vertices and merge vertices **[Edit Mesh > Merge]**.

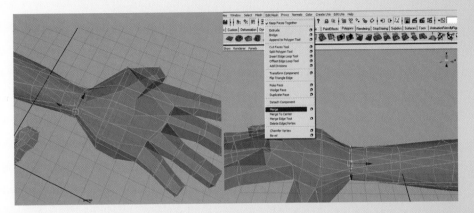

Aligning the hand and arm vertices, then merging them.

e. Delete history on *polySurface1* and rename *polySurface1* to *body_geo*.

Deleting construction history.

9. Save your scene file: Go to **[File > Save as]**. Name your scene
 02_asgn09_02_convert_to_polys_geo.ma.

 Ears and hair will also need to be deleted and remodeled using the box modeling
 approach, as this method is less tedious than trying to combine the spheres and
 cones originally used in the NURBS model with the polygonal topology of the head.

It is perfectly fine to keep the hair separate. It really depends on how much time you want to dedicate to your model. Do not combine any accessories, such as ties or hats. These geometry pieces should remain separate so that they can be removed or controlled independently from the character's body.

Once you have combined everything into one half of your character, you will want to create the other side. Make sure that all of the interior vertices are lined up on the origin. When you mirror, you will notice immediately if there is a problem. You will probably need to delete the faces at the top of the head, near the pole, and then append them using **[Edit Mesh >Append Polygon Tool]**. Click on one edge, then click on another edge and hit the Enter key to finish the process. Remember to keep everything as quadrangles. In order to do this, you may also need to use the **[Edit Mesh > Split Polygon Tool]**.

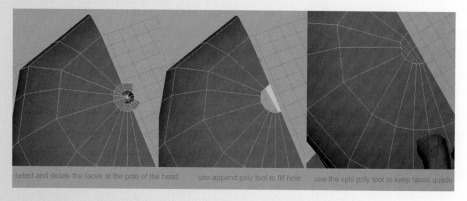

select and delete the faces at the pole of the head use append poly tool to fill hole use the split poly tool to keep faces quads

Fixing the pole at the head into fewer quads.

1. Select *body_geo* and go to [Mesh > Mirror Geometry].

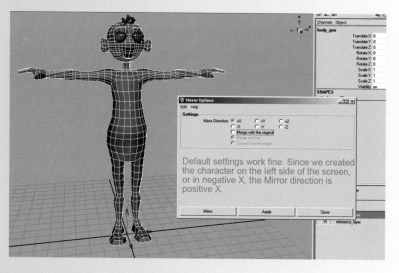

Default settings work fine. Since we created the character on the left side of the screen, or in negative X, the Mirror direction is positive X.

Mirroring the right side to create the left side.

2. Pay close attention to the mouth area. You may need to separate the vertices (using the move tool) before merging so that they do not merge the mouth shut in the center, then reposition them after the mirror is successful.

Mirroring usually causes the mouth vertices to pinch.

3. Once the mirroring is complete, check your normals to verify their position [**Display > Polygons > Face Normals**].

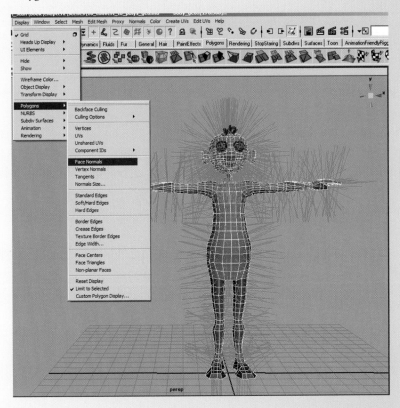

Checking the position of the Face Normals.

4. If any are flipped inward, you will need to change their direction by selecting the geometry and first going to [**Normals > Conform**]. This usually solves the problem, however you may have to reverse them all if they now ALL face inward. If so, then [**Normals > Reverse**] will correct their direction. To hide the normals again, go to : [**Display > Polygons > Face Normals**].

5. Once you have all of the normals facing outward, you can select the entire object in object mode and go to [**Normals > Average Normals**] to make the geometry appear smoother without adding more physical geometry.

6. Delete history on *body_geo* [**Edit > Delete by Type > History**].

7. Save your scene file.

a. Go to [**File > Save as**].

b. Name your scene *02_asgn09_03_convert_to_polys_geo.ma*.

As mentioned earlier in the chapter, a NURBS character is quick and easy with the approach covered Assignments 2.1–2.8. However, if you would like to create a seamless character or have better control over texturing, you will need to convert your character into polygonal surfaces.

Remember, the first time you model your character, you may not end up with the desired look. Do not be afraid to scrap the areas that are not working and start again.

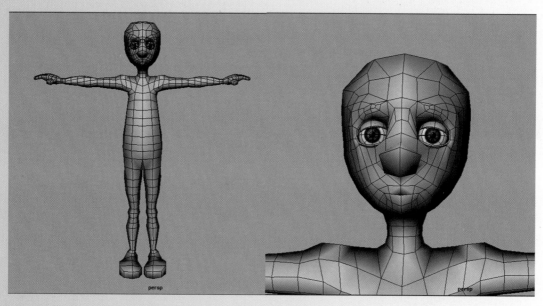

In this character, I remodeled the head all over again in polygons.

Creating Your First Biped Character: Facial Expressions

3

- ➢ **Former Student Spotlight: Katie Folsom**
- ➢ **Workflow**
- ➢ **Introduction**
- ➢ **Blend Shapes as an Approach to Creating Facial Expressions**
- ➢ **Tools Used for Modeling Blend Shapes**
- ➢ **Deformation Order**
- ➢ **Summary**
- ➢ **Assignments: Facial Expressions for a Character**

The many faces of Tiko, by Josh Burton.

A few facial expressions of Tiko in Much Ado About Breakfast, by Josh Burton (2003).

Former Student Spotlight: Katie Folsom

The one thing that I'm still finding out – especially with rigging and animation – is that there will always be surprises, no matter how much you think you have things planned out. There is no way to avoid them, especially in the beginning. The good news is they do become less over time. However, I feel the best way to keep the number of surprises to a minimum is through consistency, organization, and just understanding. It sounds like a no-brainer, but you would be surprised at how easy it is to get lost in the process. Whether it's your naming conventions, the order in which you work … you will find that anything you might have avoided in an earlier stage will not leave you alone unless the problem is solved right away. In the end it can really affect the quality of your work.

I think I had the most trouble with my blend shapes. I thought that I could just fix them when I got to that part of the animation, and I just really wanted to move on. Without going into too much detail, I ended up doing the second half of my project twice. Time I could have been spending on fine tuning and making my animation look better. Another thing I had to spend a lot of time getting right was rigging the hands. I had 10 fingers and a lot of hand movement in my first short so they had to be right. The orientation of the joints and the joint placement … it was something I had to keep going back and forth with. A lot of it is trial and error. With that being said, take the time to really understand what it is you're doing and whether or not it's the best way. Don't just go through the motions and think it's going to work to its full potential. Don't let the technical part of the process affect the artistic part. If you do breeze through it the first time, you got lucky.

From 1999 to 2001, Katie Folsom was a student at the University of Cincinnati in DAAP and graduated from Savannah College of Art and Design in 2004 with a BFA in computer art. Her professional experience includes the feature film, "Barnyard," released August 2006. You can see some of her work at: www.katiefolsom.com.

Sticky by Katie Folsom (2003).

Workflow

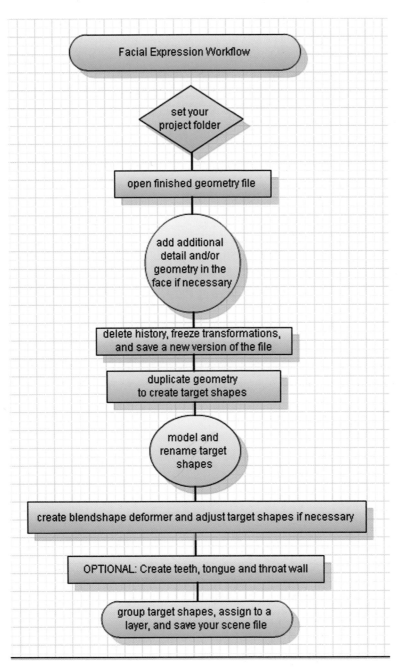

Facial Expression Workflow
- set your project folder
- open finished geometry file
- add additional detail and/or geometry in the face if necessary
- delete history, freeze transformations, and save a new version of the file
- duplicate geometry to create target shapes
- model and rename target shapes
- create blendshape deformer and adjust target shapes if necessary
- OPTIONAL: Create teeth, tongue and throat wall
- group target shapes, assign to a layer, and save your scene file

Facial Expression Workflow.

Introduction

Facial expressions are a crucial part of your character's ability to communicate. Most of what your character feels will be articulated by using facial expressions. Face language is universal. For example, we can instantly tell when someone is worried, happy, or sad based on the position of their eyebrows, cheeks, and mouth, no matter what language is spoken.

The concept expressions for Bernie, by David Leonard.

Depending on the amount of time allotted to preparing your character's facial expressions, you can create different levels of complexities. For example, you could create a worried face with eyebrows that are pinched together and lowered, and lips that are slightly pursed. Instead of creating a single worried expression, you could separate the eye and eyebrows as a separate shape from the mouth shape. For even further control, you could create asymmetrical poses for the left and right sides, ending up with four separate shapes, that when combined, create the worried expression.

Now, you might be thinking to yourself, "Why spend time separating these single expressions into four or more partial shapes that need to be combined in order to achieve a single expression?" Well, the answer is fairly simple. When you create independent pieces, you can assemble those pieces with others to create new facial expressions that were not necessarily planned.

The following facial expressions are the ones that I recommend you create. This is a list that I feel gives you the most possibilities with a minimum amount of work. I've divided them into eye, nose, and mouth areas. The eyebrows should be broken into left and right, for greater control.

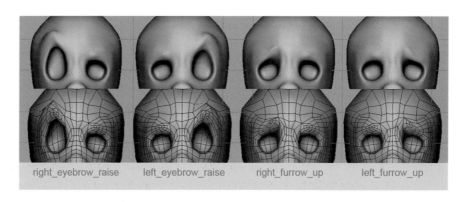

right_eyebrow_raise left_eyebrow_raise right_furrow_up left_furrow_up

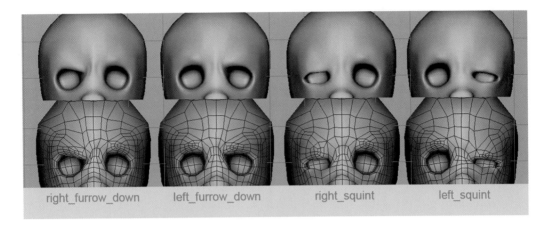

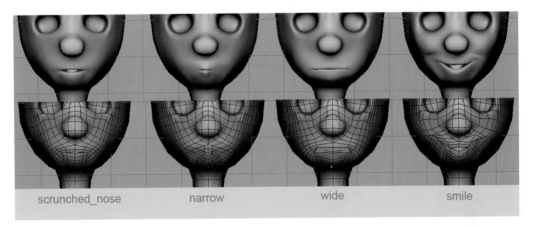

The top image shows the geometry smoothed. The bottom image shows wireframe on shaded on the low poly model, prior to smoothing.

Blend Shapes as an Approach to Creating Facial Expressions

There are two common approaches primarily used when creating facial expressions: **blend shape** driven poses and joint driven poses. In this chapter, we will be focusing on the former, as the joint driven process assumes you already have an understanding of joints and skin deformers, which we won't address until later chapters. The joint driven process is the approach used for animation in the gaming field, because at this time, game engines do not support blend shapes.

A blend shape is a deformer that changes the shape of one piece of geometry to look like the shape of another. This deformer has also been referred to as a morph, because

its concept is based on a metamorphosis. Blend shapes can be used for pretty much any type of morphing. While this chapter will focus on facial expressions, they can also be used in the rest of the body, such as muscle motion and making sure the body geometry bends appropriately in areas such as elbows and knees, a process known as corrective blend shapes.

! Once you do understand joints and the skinning process, you can actually use joints to create your blend shapes.

Before creating blend shapes, it is extremely important to finalize the geometry. Your finished geometry is considered your base shape. The base shape is duplicated into the target shapes (as many times as necessary), and each target shape is remodeled (with certain limitations) to reflect the desired facial expressions. Blend shapes work by comparing the positions based on the order of individual points in the surface (points such as vertices or CVs). Each point is numbered, so if you alter the geometry by adding or subtracting points, the blend shape will no longer work and an error message will be given. For this reason, you must finish the face model before creating blend shapes. The more refined and detailed the facial expression, the more geometry is needed in the area (more isoparms or edges are necessary to provide more CVs or vertices that can be pushed and pulled). However, you can get some basic facial expressions from very simple geometry.

A NURBS head with simple geometry can still be used to create a facial expression.

! NEVER FREEZE TRANSFORMATIONS on blend shapes. You can freeze the base shape BEFORE creating your target shapes. However, once the target shapes are created, DO NOT freeze transformations on the base or target shapes. If you do, the base shape will fly back to the origin when animating.

When modeling your face, it is always best to have geometry that is modeled along the muscle lines of the face. If you did not spend enough time during the modeling process, you may want to devote a little more time now to add adequate geometry before trying to make your facial expressions. It is also important to understand the movement of facial muscles and what effects they have on the face. Be sure to refer to anatomy books for images to study these patterns of muscle placement. The closer you can mimic these patterns, the more accurate your character's facial expressions will be, providing a level of believability even to the most stylized characters.

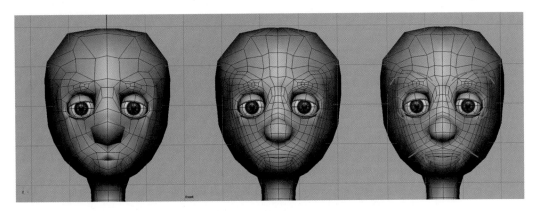

This polygonal face needed more edges to create a more believable series of facial expressions. Understanding facial muscle structure will assist in making these expressions.

Tools Used for Modeling Blend Shapes

The most commonly used tool for modeling blend shapes is the Move Tool – keyboard shortcut **(w)** or the Scale Tool – keyboard shortcut **(r)**. You can use the move tool in component mode (right mouse buttons, **RMB**) over the surface or hit **(F8)** for pushing and pulling points around just as you would when modeling to create the desired shape. Make sure to rename each target shape as they are created. This section focuses on three tools that can simplify much of this process.

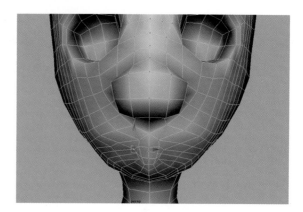

Using the move tool to create pursed lips for a target blend shape.

You cannot create a blend shape by scaling or moving on the object level. A change on the object level of the target shape does not affect the base shape.

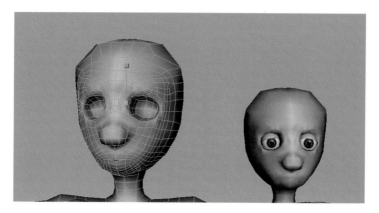

Simply scaling your geometry does not make a deformable object. You must make changes on the component level by selecting the vertices or CV's first, then scale them.

Soft Modification Tool [Create Deformers > Soft Modification] (It is also found under the tool manipulators).

The soft modification tool is a deformer that allows you to click on an area and push and pull points, much like you do with the move tool, but it affects the surrounding points as well as the point initially clicked. This tool is more intuitive for artists than the move tool, as it simulates the pushing and pulling of clay. The greatest affect is on the area clicked, and the gradual drop off can be adjusted for greater control. Color feedback is turned on by default, which is visually helpful when adjusting the drop off rate. You can also select an area of points (vertices or CVs) and then apply the soft

modification, which limits the deformers to only those points. Make sure to open the option box and turn on Preserve history, so that you can modify changes later if necessary.

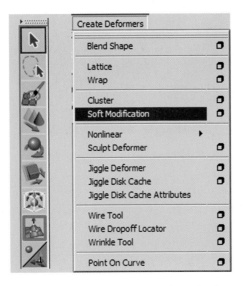

The Soft Modification tool can be found with the Tool Manipulators and in the Animation menu set (F2) under the Create Deformers menu.

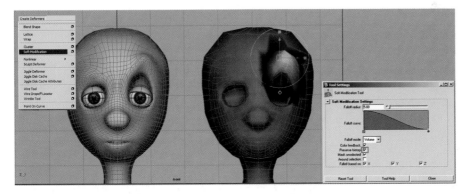

Using the soft modification tool to create an eyebrow raise. Make sure to turn Preserve History ON in the option box before using the tool so that you can adjust the position of the Soft Modification deformer later if necessary.

The Lattice deformer **[Create Deformers > Lattice]** and the Sculpt Geometry tool **[Edit NURBS > Sculpt Geometry Tool – option box]**, which were discussed in Chapter 2, are also helpful for creating additional facial expressions.

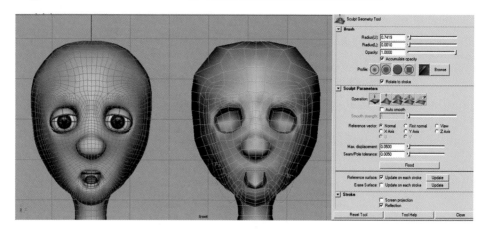

After moving vertices in place, the sculpt geometry tool can be used to help shape the open mouth position.

Add Blend Shapes [Create Deformer > Blend Shape]

Once the target shapes (facial expressions) have been created, you must apply them to your base shape (neutral pose) using the blend shape deformer. Holding down the shift key, click select on each target shape(s) then select your base shape. (Make sure they have been renamed appropriately, i.e. smile, frown, left_eyebrow_raise, etc. BEFORE applying the deformer.) When defining a blend shape, the base shape MUST be selected last. To test your blend shapes, open the blend shape animation editor **[Window > Animation Editors > Blend Shapes]**. This will open up the blend shape editor which has a slider for controlling the movement between the shapes. You can also access the blend shape by clicking on the input node in the channel box and changing the value of the field. This attribute is accessible through the Attribute Editor [ctrl+a] as well. It is also a really good idea to set up another control system for your blend shape sliders, which will be covered later in Chapter 7 of this book, so that they can be animated more easily.

The blend shape deformer can be found on the Deformation shelf.

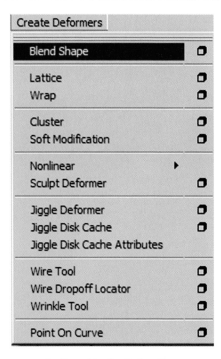

The blend shape deformer can be found in the Animation menu set (F2) on the keyboard under the Create Deformers menu.

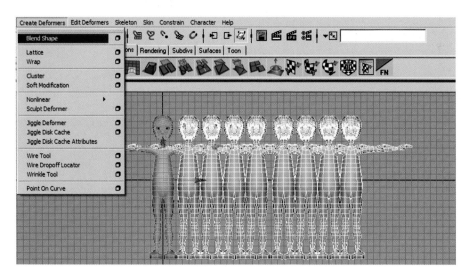

Creating the blend shape deformer.

! Make sure to rename each target shape BEFORE applying the deformer. If you relabeled them afterwards, Maya would not recognize them and your target shapes would not affect the base shape.

! Do NOT delete history on the geometry after the blend shape deformer has been created. Doing so will delete the blend shape deformer. If this happens, you will have to recreate the deformer again.

! Have I mentioned? NEVER freeze transformations on Blend shapes!

Update Topology on Blend Shapes
[Edit Deformers > Bake Topology to Targets]

This is a relatively new tool in Maya, as it was introduced to allow for **topology** changes to the base shape to be updated on the pre-existing target shapes. For example, if more edges needed to be added to create a particular expression, the existing target shapes would need to be applied to the base shape using **[Create Deformers > Blend Shape]**. Once the existing target shapes work, the base model can be modified (i.e. more geometry added). This command will pass the modifications on to the target shapes.

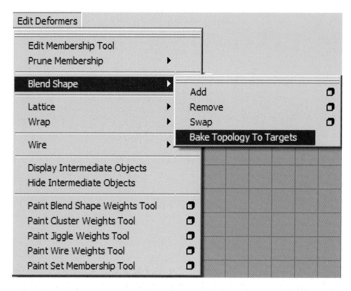

Bake Topology to Targets can be found in the Animation menu set (F2) on the keyboard under the Edit Deformers menu.

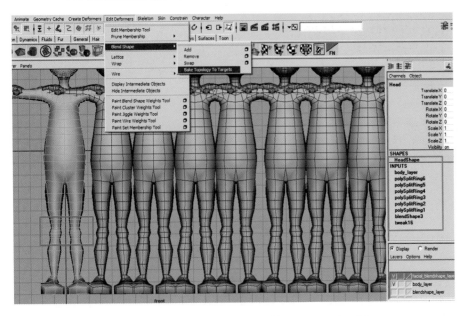

Adding additional edge loops around the knees adds construction history.

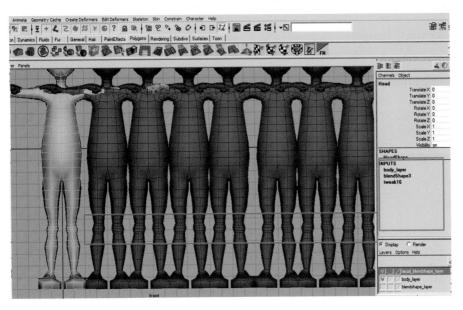

Bake Topology to Targets updates the target shapes and removing the associated construction history.

> **!** Not all changes to the geometry will work reliably. For example, you cannot delete faces. Therefore, make sure to incrementally save your work, in case of unpredictable results. Bake topology to targets works best with polygonal geometry.

Deformation Order

When working with deformers, especially for use with animation, it is important to know that history affects how a particular deformer affects the geometry. Multiple deformers can be applied to the same piece of geometry, and some deformers have to be applied before others, in order to get the desired result. The order in which deformers are created makes up the deformation order for that object, and Maya evaluates them in that order. Creating deformers out of order is not a problem, as the deformation order can be changed.

When creating characters for animation using blend shapes, the blend shape deformer should be the first deformer created, as Maya must evaluate blend shapes before any other deformer. If not, bizarre things happen, like your character's geometry will fly off of its skeleton. Remember, if you apply blend shapes after skinning, you must change the deformation order so that the blend shapes are evaluated first.

To change the deformation order, with the geometry selected, **RMB** (right mouse button) over the base shape geometry and, from the popup marking menu, select **[Inputs > All Inputs]**. This opens up a window name *List of Input Operations* that shows you a list of the deformers currently affecting this surface. Use the **MMB** (middle mouse button) button to click and drag the blend shape below any other deformers listed, or to the bottom of the list. This reorders the deformers. Maya evaluates the deformers on the list from the bottom up.

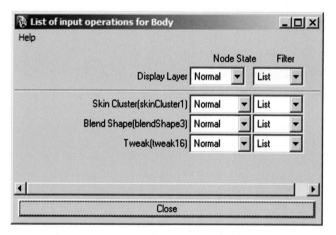

The list of input operations that shows the correct order for the skin deformer and blend shape inputs.

 Just in case you forget, NEVER FREEZE TRANSFORMATIONS on blend shapes! Have you figured out how important this is yet?

Summary

3.1 Facial expressions are crucial for your character's ability to communicate.

3.2 It is best to divide each facial expression into parts that create the expression. Separating each expression into eyes, nose, and mouth areas provides a palette of options that can be combined while animating. The minimum suggested are the following:

eye target shapes:

left_eyebrow_raise

right_eyebrow_raise

left_furrow_up

right_furrow_up

left_furrow_down

right_furrow_down

left_squint

right_squint

nose target shapes:

scrunched_nose

nose_up (optional)

mouth target shapes:

narrow_pucker

wide

smile (which includes raising the cheeks)

open (which includes dropping the jaw)

sad_frown

3.3 There are two basic approaches for creating facial expressions: blend shapes and joint driven.

3.4 Blend shapes are a deformer that change geometry shapes using a morph process.

3.5 Once you understand joints and skinning, you can use joints to create the blend shapes.

3.6 Before creating blend shapes, it is extremely important to finalize the geometry.

3.7 You can get basic facial expressions from very simple geometry.

3.8 Never freeze transformations on blend shapes!

3.9 Research muscle structure for facial expressions as an aid to creating believable motion.

3.10 The same tools used for modeling your character can be used to model the blend shapes.

3.11 All geometry changes must be on the component level when modeling blend shapes.

3.12 The most common tools for modeling blend shapes are the following: the move tool (to move components such as points), the soft modification tool, the lattice deformer, and the sculpt geometry tool.

3.13 Be sure to label each target shape as they are created.

3.14 Deleting history on target shapes is unnecessary.

3.15 To create a blend shape, first select all target shapes, then shift select the base shape.

3.16 Do not delete history on that base shape geometry after the blend shape deformer has been created. Doing so will delete the blend shape deformer.

3.17 If there is a need for more geometry while creating the blend shapes. It is possible to add more divisions to the base shape and then update the topology to blend shapes that have already been applied. However, this process is not always reliable. Therefore, be sure to finalize your geometry before modeling your blend shapes.

3.18 As always, there is a certain workflow and order of operations that exists. Blend shapes should be applied before the skinning deformer is applied. However there is a list of input operations that allows the change of deformation order, if necessary.

Assignments: Facial Expressions for a Character

Assignment 3.1: Create Facial Expressions

1. Your finished geometry is your base shape. (This is the neutral pose for you face.) This can be one entire piece of geometry (the whole body) or a separate head. If your head is separated, do NOT combine it (if polygonal) after making your blend shapes, as this will make your blend shape targets not work any longer.

2. Duplicate your base shape 15 times and create your target shapes. Move them above or below your base shape. Rename the target shapes appropriately.

 eyebrow target shapes:

 left_eyebrow_raise

 right_eyebrow_raise

 left_furrow_up

 right_furrow_up

 left_furrow_down

 right_furrow_down

 left_squint

 right_squint

 nose target shapes:

 scrunched_nose

 nose_up (optional)

mouth target shapes:

narrow_pucker

wide

smile (which includes raising the cheeks)

open (which includes dropping the jaw)

sad_frown

1. Use the following tools to reshape these into the facial expressions: *Move tool, scale tool, soft modification tool, sculpt geometry tool, lattice deformer.*

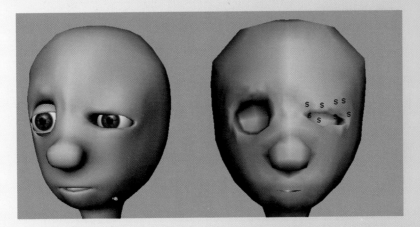

Using the soft modification tool to create the left_squint eyebrow target shape. It may take several clicks of this tool to get the desired shape.

> ! *The soft modification tool* can be used effectively to create all of the eyebrow target shapes, as well as the nose target shapes. To create the mouth shapes, you will probably need to start with the *move and scale tools*, then refine the shapes with the *sculpt geometry tool*.

Assignment 3.2: Create the Blend Shape Deformer

1. Select your Target shapes then shift select your base shape.

2. Select Create Deformer [**Create Deformers > Blend Shape**].

3. In the Layer Editor of the Channel Box, create a new layer. Double-click on the new layer (layer1) and rename this layer *blend shape_layer*, then click **save**. Shift select all of the target shapes you have made, **RMB** click and hold on top of the *blend shape_layer* and choose Add Selected Objects. To make the objects invisible, click on the V (visibility) to turn it off.

> ! When defining a blend shape, the base shape MUST be selected last.

After creating the blend shape deformer, you should test the blend shape:

1. Select [**Windows > Animation Editors > Blend Shape**]. This will open up the blend shape editor which has a slider for controlling the movement between the shapes.

Opening the blend shape editor.

The blend shape editor.

2. You can also access the blend shape by clicking on the input node in the channel box and changing the value of the field. This attribute is accessible through the Attribute Editor as well.

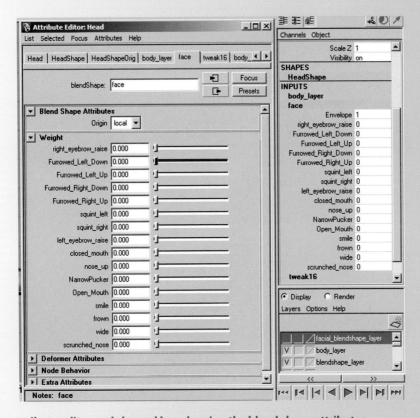

The attribute editor and channel box showing the blend shape attributes.

3. Make changes as necessary to the target shapes. You can update them as needed and they will automatically update the deformer. To make it easier to make changes, move the target shape right next to your base shape and make the changes with the slider turned on.

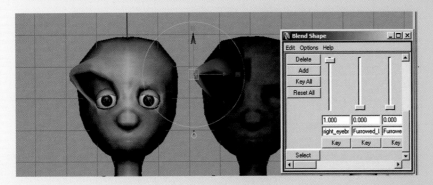

If you push the slider up, you can make adjustments to the target shape and see the changes automatically on the base shape.

Assignment 3.3: Create Teeth and Tongue (Optional)

If you plan on opening your character's mouth for any facial expressions or plan to have your character speak, you will need to model teeth and a tongue. This can be done with not much detail.

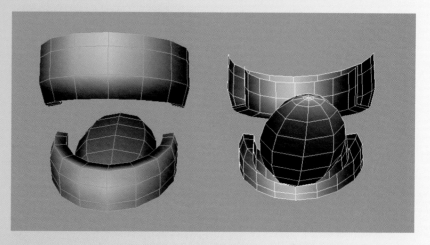

The teeth and tongue front view and back view.

The tongue is simply a sphere created on the Z-axis and reshaped using a lattice. The teeth can be made by creating a profile curve in the front view, performing a revolve and changing the start sweep of the revolve to 180 in the channel box.

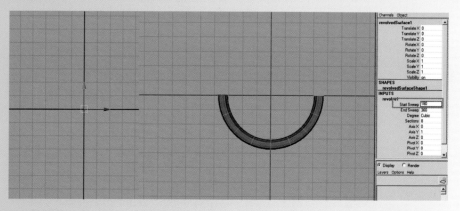

The profile curve of the teeth in the front view and the top view showing the revolve start sweep beginning at 180.

A lattice deformer can be used to create the narrower shape. The teeth can be duplicated and flipped to create the bottom row. Be sure to also add a shaped plane to act as the throat wall.

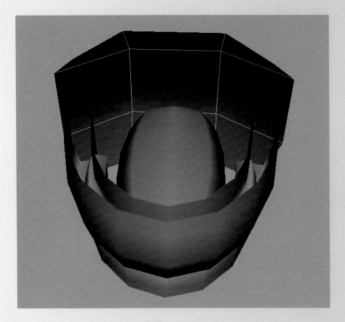

A shaped plane added for the throat wall.

Creating Your First Biped Character: Shading and Texturing Basics

"Eddie" by Adam Levine (2004).

Former Student Spotlight: Nathan Engelhardt

Being a newcomer to an intimidating 3D software packages like Maya, Max, Lightwave, etc. can be a frightening and frustrating experience. I remember the first day I opened Maya on a school computer. I was so afraid that I'd melt my computer or something if a wrong button was pushed. To be honest I think most people feel this way when first opening a major 3D package. It's important as a newbie to not get overwhelmed by the mass information that's infused in the software. Take your time, stumble, learn from your mistakes, and don't be afraid of pushing that wrong button over and over again (I've pushed it many times with still no success of melting my computer, if that's what you also worry about).

Secondly, and ironically more important than the first, is to be aware of what you are interested in. So often I hear about students who want to learn everything and anything about their preferred 3D software package, me included. They become knowledgeable in many aspects of the package but a master of none (I.E. animation, rigging, texturing, lighting, effects, etc.). Although, being a jack-of-all-trades may be considered a valuable asset to smaller companies and productions, large animation and visual effects houses (Pixar, Dreamworks, Blue Sky, ILM, Sony, etc.) like a strict study in one category of interest. A focus! Becoming a generalist or a specialist is simply a matter of personal preference. The sooner you realize which you'd like to be, the better.

And lastly, which again is the most important; understand that these software packages will come and go in time. Sounds easy enough, I know. Make sure you don't spend *all* your time learning Maya, its interface, its functionality, etc. because when Maya is eventually bought out by The Melting Computers of America Association Inc. and all the menus change and things that use to be familiar disappear … what then? A classically trained painter would easily side with the argument that knowing the process, techniques, and basic fundamental principles of lighting, composition, etc. are much more useful than knowing how to use a brush. Although the understanding of

Traffic Light by Nathan Engelhardt (2007).

how to use a brush (Maya) helps an artist fully utilize a tool, it does not, however, MAKE an artist out of anyone. Learn the principals of whatever it is you are interested in, and no matter what the newest and greatest tool is, YOU will never become outdated.

Nathan Engelhardt graduated from the Savannah College of Art and Design in Spring of 2007 with a BFA in Animation. His first position after graduation was as an animator at Blue Sky, working on Horton Hears a Who. He recently enrolled in online classes to further his animation studies at Animation Mentor.com and expects to graduate from their program sometime in 2008 with an advanced study in animation. More of Nathan's work can be viewed at: www.nathanengelhardt.com.

Workflow

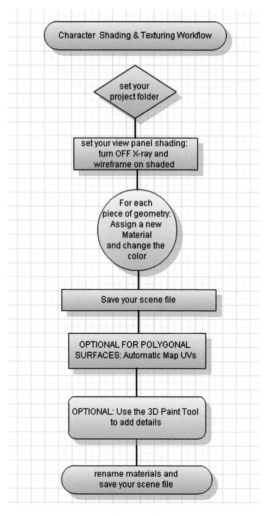

Shading and Texturing Modeling Workflow.

Introduction

With the theme of keeping things simple, this chapter is going to focus on an easy way to add color and a bit of artistic detail to your character. The topic of shading and texturing is a lengthy one, and it could easily be expanded to create an entire book (and has been by several other authors). However, since the focus of this book is on the skeletal system and controls, this one short chapter will provide enough information to get you started with shading and texturing.

The easiest solution for adding color to your character is by simply adding a *material*, or **shader**, to your geometry. Maya has several surface *materials* available, and the chosen *material* depends on how much light is reflected or absorbed by the surface. The *material* applied to an object can also control its transparency.

Of course, there are many more qualities to a surface **shader** than color, transparency, and reflectivity. Additional detail can be added if textures are used. For this detail we will be using the 3D Paint Tool, which allows an interactive level of painting directly on your 3D model. Other details, such as the consideration of how rough or smooth the surface is that you are trying to create, involves the use bump or displacement maps, which is beyond the scope of this chapter. Once again, this chapter only covers the tools that I feel give you the easiest ability to add color and some detail.

The Hypershade

The *hypershade* is a work area that allows you to create and edit the materials and textures necessary for your geometry. To create a *material* in the *hypershade*, simply click on the desired surface and it will appear in the work area. To apply it to the geometry, you can **MMB** (middle mouse button) click and drag it onto your geometry

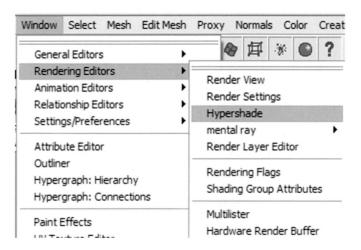

The *hypershade* can be found under the **Windows** menu in the **Rendering Editors** submenu.

in the view panel. Another option is to select the geometry first, then **RMB** (right mouse button) over the *shader* in the *hypershade* and choose *assign material to selection* from the marking menu that appears. While the *hypershade* is a great place for organizing and keeping track of all of your materials needed in the Maya scene, the easiest way to add a *material* to an object is simply to **RMB** click and hold over the object and choose *assign new material* from the marking menu that appears. If working in polygons, a *material* can be applied to selected polygonal faces, allowing one surface to be defined into separate areas such as skin color or clothing. Once a *material* has been added to the geometry, it is a good idea to rename the *material*. With the *material* selected, the attribute editor can then be opened **[ctrl+a]** and attributes such as color can be changed for the desired look.

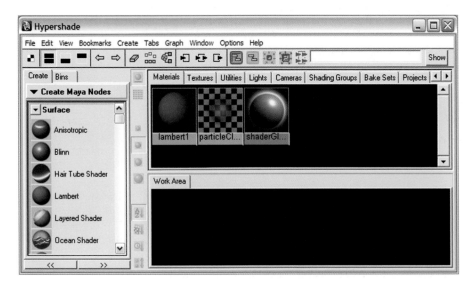

The *hypershade* window.

Materials

Each *material* defines itself by the amount of light that is reflected by the surface. The following materials are most commonly used as follows.

Lambert

This *material* does not have *specular highlights* and is perfect for matte surfaces, such as rubber or objects painted with matte paint. This *material* is the one I suggest for your character's skin and most cotton fabrics. This *material* is based on the Beer–Lambert law, which defines the relationship of how light is absorbed based on the properties of the *material* that the light is hitting.

Blinn

This *material* is great for simulating objects that are made of glass or metal. This *material* was developed by Jim Blinn.

Phong

This *material* is used mainly for glossy surfaces such as hard shiny plastic. It is a pretty good shader to use for eyeballs. This *material*, and the *Phong E*, was developed by Bui Tuong Phong.

Phong E

This *material* has a softer highlight than that of the *Phong material*. Great for materials such as frosted glass, brushed metal, or any other *material* with complicated highlights.

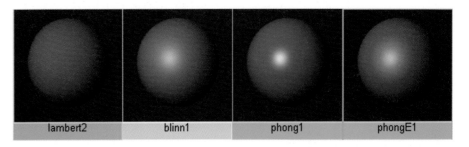

The different Materials in the *hypershade*.

Automatic Mapping

Using the 3D Paint Tool allows the creation of the texture to fit the object. If you are working in polygons, before you can use the 3D Paint Tool to texture your model you

The Automatic Mapping command can be found in the Polygons menu set by pressing (F3) on the keyboard under the Polygons menu in the Create UV's submenu.

will have to lay out the UVs first. For most polygon models, the Automatic Mapping option serves quite nicely. NURBS models do not need to be mapped; NURBS utilize their Control Vertices as UVs.

The 3D Paint Tool

The 3D Paint Tool is a relatively quick and simple means of adding a *file texture* (or marking areas for more detailed texturing in Photoshop or another painting program). This tool allows you to paint color (or transparency, or any channel available in the *material* attributes) directly onto your model using the artisan brush (the same brush used earlier for the sculpt geometry tool). The brush size, shape, feather, and opacity can be changed easily. Simple tasks such as erase, clone, smear, and blur can be applied directly onto your model. Maya's 3D Paint Tools encompass enough options to create a basic texture beyond simply applying single-color shaders to selected faces. As you are working, make sure hardware texturing is turned on [**6**] in order to see what and where you'll be painting later.

The 3D Paint Tool can be found in the Rendering menu set by pressing (F6) on the keyboard under the Texturing menu.

When working with the 3D Paint Tool, it is extremely important that you set your project so that Maya knows where to save the file textures. (To do this, go to [File > Project > Set] and choose your project folder.) This will keep all of your project related assets in the same folder and keep your paths relative.

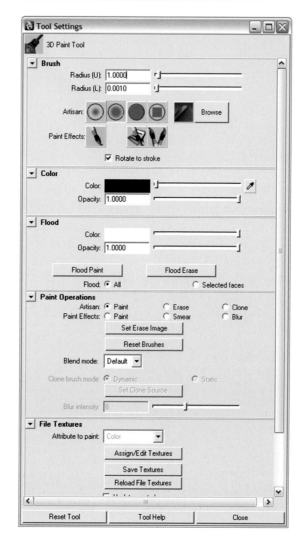

The 3D Paint Tool options Window.

Summary

4.1 Texturing and shading can be a lengthy topic, but it can also be approached in a simpler way.

4.2 The *hypershade* is the work area that allows you to create and edit materials and textures.

4.3 A *material* defines how a surface is seen when the computer creates a rendered image.

4.4 The most commonly used materials for character shading are: Lambert, Blinn, Phong, and Phong E.

4.5 When texturing polygons, it is necessary to lay out the UVs for the geometry for first.

4.6 The 3D Paint Tool provides a quick and simple method for adding detail by an interactive creation of a file texture on your model.

Assignments: Shading and Texturing a Character

Assignment 4.1: Apply a colored material to your character

1. **Open** Maya and **set** your project.

 a. Go to [**Start** > **Programs**] and select Maya.

 b. Once Maya is open go to [**File** > **Project** > **Set …**] browse to your project folder and click **OK**.

2. **Open** your last saved file. Go to [**File** > **Open**] and select *03_asgn03.ma*.

3. **Set** all four view panels to turn off X-ray Mode and wireframe on shaded.

4. Turn hardware texturing on by pressing (**6**) on the keyboard so that you can see your reference images.

5. Make sure that your geometry layer is set to **Normal** so that you are able to select the geometry.

The work area with the geometry layer set to Normal.

6. **Select** the piece of geometry you wish to color.

7. **RMB** click and hold over the object and choose *assign new material* from the marking menu that appears. Once the *material* has been added to the geometry, the attribute editor is opened. **Rename** the *material* (something like body_lambert should do). **Change** the color by clicking on the color box. This opens the color chooser window and allows you to **select** any color desired.

Choosing a color for the body lambert *Material.*

8. **Save** your scene file.

 a. Go to [**File > save as**]. This should open the scenes folder of your project (assuming you set the project as in step 1).

 b. **Name** your scene *04_asgn01.ma*.

Assignment 4.2: Add Details Using the 3D Paint Tool (Optional)

For best results, use a pressure-sensitive graphics pen and tablet for this process, instead of your mouse.

1. **Open** Maya and **set** your project.

 a. Go to [**Start > Programs**] and **select** Maya.

 b. Once Maya is open go to [**File > Project > Set ...**] browse to your project folder and click **OK**.

2. **Open** your last saved file. Go to [**File > Open**] and **select** *04_asgn01.ma*.

3. **Select** the object you wish to texture. If your geometry is **NURBS**, skip to step 8.

4. Go to [**Polygons > Create UVs > Automatic Mapping**]. The default settings should work fine. If necessary, you can open the option box and reset the settings.

5. In the orthographic view panels, **resize** the projected planes to fit your geometry.

Resizing the UV Automatic Mapping projection planes.

6. To view the layout of the map, look under **[Window > UV Texture Editor]**. The
 Automatic Mapping has created several sections of UVs. All of the shapes should be
 within the 0–1 texture space (the square colored by the *material*).

The UV Texture Editor.

7. Go back into object mode (F8) on the keyboard, because Automatic Mapping placed you into component mode.

8. Now we can paint directly on our model. Select the object you wish to texture. Go to **[Texturing > 3D Paint Tool – option box]**. This will open the tool settings window.

9. If you place your mouse cursor over your model, you will see a red X in the paintbrush circle. Before you can paint you must first assign an image file texture to paint upon. **Scroll** down the tool settings window to the File Textures section. **Choose** which attribute you wish to paint (**Color, Transparency, Bump, etc.**), as well as which image format you want (default is set to Maya **.iff,** but if you want to edit the image outside of Maya, .tga would be better). Then click *Assign/Edit Textures*. This will open the Assign/Edit Textures window.

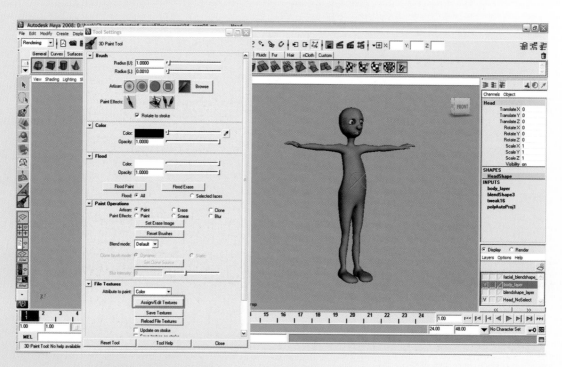

Assigning a texture file.

10. Decide how large your image needs to be. If painting an entire character's body, I suggest making the file size for X and Y 1024. This number represents the pixel dimension of the file that is applied to your model. Larger pixel dimensions will be necessary for larger models, so that the quality of the resulting texture is not pixilated. However, too large of an image will slow down the painting process and add expensive render time (a good rule of thumb is to keep the file size dimensions 2048 or smaller). *Keep Aspect Ratio* should remain checked, since your map occupies a square; also, keep the size as a power of 2, since computer calculations are based on the binary system (128, 256, 512, 1024, 2048).

Defining the file texture size.

11. Click **Assign/Edit Textures**

12. Now, you can paint! The base color of your model is the color you chose when you assigned the *material* in Assignment 4.1; when you erase, you will actually be erasing back to this base color. If you want to change color from the color you chose when you first assigned the *material*, go to the Flood section and change the Color. Before doing any other painting, click Flood Paint. However, this does not change your base color. If you click Flood Erase, the area will return to the base color.

Painting with the 3D Paint Tool.

13. Under the Brush section, you can adjust the upper and lower brush radius, choose between a Gaussian brush, soft brush, hard brush, square brush, or load different brush shapes from Artisan's Browse box (these include charcoal, hatched, marker, and even skin-bump brushes). You can even choose a paint effects brush and paint a 2D image of the paint effects brush. The hotkey to change the brush size interactively is **(b)**. Simply hold down the **(b)** key, place your brush over your model, and (left mouse button) **LMB** click and drag left to right to change the brush size smaller and larger.

14. Under the Color menu, you can change the color of the brush, as well as adjust the opacity.

15. Under the Paint Operations Menu, you will find both Artisan and Paint Effects operations, including Paint, Erase, Clone, and Blur. You can even change the blend mode, working with lighten, darken, multiply, screen, and overlay modes. (These work in a very similar manner to blend modes in Photoshop.)

16. Once you have painted your model, make sure to scroll down the tool settings window to the File Textures section. Click Save Textures. This should create and save the file into a 3DPaint Textures folder in your project folder, (assuming you set the project as in step 1).

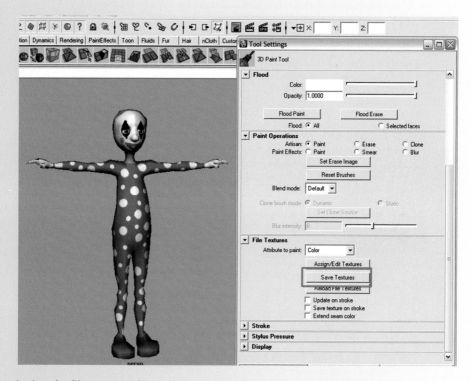

Saving the file texture when painting is complete with the 3D Paint Tool.

17. **Save** your scene file. Name your scene *04_asgn02.ma*

5

Skeleton Setup for a Biped Character: Joint Placement

➢ **Former Student Spotlight: David Bokser**
➢ **Workflow**
➢ **Introduction**
➢ **File Referencing**
➢ **Setting Up Your Work Area**
➢ **Working with Joints**
➢ **Former Student Spotlight: Sean Danyi**
➢ **Summary**
➢ **Assignments: Joint Placement in a Character**

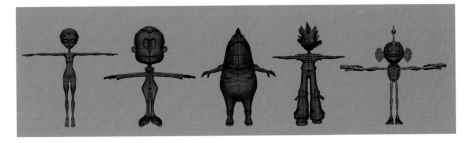

Characters by Faye Helfer, Nathan Englehardt, Dan Nichols, Nick DuBois, and Mark McDonald.

Former Student Spotlight: David Bokser

Creating a 3D short is a fairly linear process. As such, the problems you have in the first stages will come back and haunt you in the later ones. If you skimp on the modeling phase and make your model too complicated or too simple, you'll have problems in the rigging phase, and that will lead to problems in the animating phase, and so on and so forth. Spend a bit of extra time cleaning up your models, making sure your blend shapes work together, and testing out your rig. If everything works, then you shouldn't have too much trouble going into animating and rendering.

On my short, for instance, I didn't put enough geometry in elbow and knee cross sections so deformations looked a bit weird. During rigging, I didn't test out my rig fully and had a pretty big problem with the spine rotation, so during animation I constantly had to counter-animate to compensate for a simple problem I could have fixed at an earlier stage.

I would recommend creating an animated short, because as a beginner, an animated short film will allow you to experiment with every part of the 3D process and will allow you to know what aspect you should focus on your next project. My suggestion would be to keep it simple. Don't try to create an epic with your first film. A 30 to 60 second short would be great. Try to use it as a learning process instead of "your great contribution to the art world."

David Bokser graduated from the Savannah College of Art and Design (SCAD) with a BFA in Computer Art and a minor in Animation. His student short films have been screened many festivals, including the SIGGRAPH Animation Festival, the Cannes Short Film Corner Market, and the ANIMEX Student Animation Festival. He has won numerous awards including the Grand Prize in Digital Cinema award from the Digital Art Awards 2004 in Tokyo, Japan, second place in the Non-Traditional Animation category from the Academy of Television Arts and Sciences Foundation College Awards, and nominated for a Student Academy Award from the Academy of Motion Picture Arts and Sciences for his short film "Old Man and the Fish." His work can be seen at: www.davidbokser.com.

Traffik **by David Bokser (2003).**

Workflow

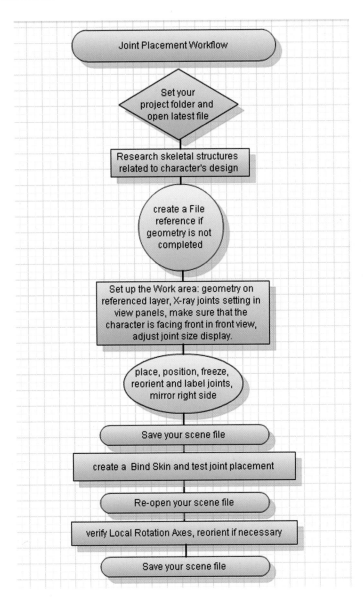

Joint Placement Workflow.

Introduction

A skeletal structure is the support system for our bodies, and the same type of structure is needed for our digital characters. This structure is built in Maya using joints. Joints are connected to each other visually with bones, but bones do not really exist in Maya. They are simply a visual connection from one joint to the next. If you select a bone, you are actually selecting the joint above that bone in the **hierarchy**.

As joints are created, each subsequent joint is automatically connected as part of a hierarchy (unless you hit enter which ends the joint chain). This hierarchical system looks much like your family tree. The main difference is that there are only single parents in the Maya environment. While a joint can have many children, the children, however, can only have one parent. When you create two joints, the first joint is considered the parent and the second joint is considered the child of that parent. Each additional joint created becomes a child to the preceding joint. A series of connected joints is called a joint chain.

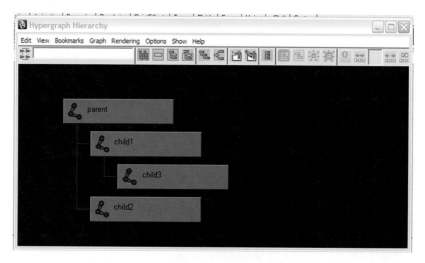

The hierarchy of a joint chain as seen in the Hypergraph.

! The hierarchical system is present in Maya in other ways as well, not just with the joint chains. For example, when objects are grouped together, the group node that is created becomes the parent of all the objects in that group.

Before creating your joint chains, your character geometry should be as finished as possible. It is unnecessary to complete fine details in the geometry, but the main proportions of the character should be in place before beginning the joint placement process. If modeling with polygons, it is important not to smooth the finished model at this point in the rigging process as this will create extra geometry which will slow down the entire process of rigging and skinning.

When placing joints in your character's geometry, it is important to study the physical shape of the character that you will be rigging. Depending on the type of character design for which you are creating controls, the first place to start would be to research the skeletal structure to ensure proper joint placement. For a biped character, this is a simple process since you are sitting in the best research available, which is your own skeleton. If you need to know how something moves or bends, you simply have to look at yourself.

If the character is a creature or something that may not exist in real life, it sometimes takes multiple existing animal parts to create a skeletal structure that may work for the

creature that you are setting up. For example, a dragon is part reptile and bird, so you may want to study the skeletal structures of both reptiles and birds in order to create a basis for the dragon.

When you are placing joints in your character, think about each appendage as an individual joint chain. Create separate chains for each leg, arm, finger, torso, and head. These will all be connected into a single skeletal structure. You can also add chains for other body parts such as ears, tails, or antennae. You can even add joints and joint chains for articles of clothing or props, such as neckties or skirts, for better control when animating.

Frog Ballerina by Sarah Pitz.

File Referencing

Many times during the production process, the geometry for a character is not finished when it is time to begin the rigging process. Perhaps the textures are not completed or the blend shapes have not been modeled yet. In my classroom, the students have only 10 short weeks to not only learn and create a character, but also to animate their character. Once their character geometry is finished, we begin the rigging process in class, while outside of class they work on creating their textures and blend shapes. Because of the overlapping workflow, file referencing is utilized so that the latest version of the character model can easily be updated in the rig file.

File	Edit	Modify	Create	Display	V

New Scene Ctrl+n □
Open Scene... Ctrl+o □

Save Scene Ctrl+s □
Save Scene As... □
Save Preferences

Optimize Scene Size □

Import... □
Export All... □
Export Selection... □

View Image...
View Sequence...

Create Reference... Ctrl+r □
Reference Editor
Project ▸

Recent Files ▸
Recent Increments ▸
Recent Projects ▸

Exit Ctrl+q

Create Reference can be found under the File menu.

Creating a *file reference* does not actually make the file data PART OF the current scene. Referencing files only points Maya to a different file by creating a path and saving the path information. When your current scene file is saved, it is NOT including any data from the referenced file. It just tells Maya where to look when you open the file again. This reference can easily be removed or replaced as you are working. It can even be imported into the scene so that it eventually does become part of the scene file. File referencing can be used during the creation of assets (we'll be using it during rigging and skinning), but it can also be used when animating.

If your character model scene file is large (2000 KB+), your rig scene files can be VERY SMALL in size, sometimes under 100 KB, if *file referencing* is used. This can be helpful if your disk space is limited and you are following the practice of saving versions of your files as you work. Instead of resaving the geometry every time you save, the only thing Maya is saving is the rig information.

To create a referenced file, open a new scene in Maya and go to [File > Create Reference – option box] In the option box under "Name Clash Options" make a check in the box next to "Use Namespaces." This will ensure that the names of the nodes of the referenced file will not conflict with any that already exist in the current file. This is extremely important when referencing in several characters for animation. It is good to get in the habit of using namespaces. Maya will use a colon (:) in front of the node name to signify that the node is from another file. The default setting is to use the file name.

So, if you are referencing a file named "model.mb" and there is a node called "Left_Arm", the referenced name will look like "model:Left_Arm". If you set "Resolve all nodes with this string", you are able to type something instead of using the lengthy name of a file (I suggest using this option and typing in your character's name as the string).

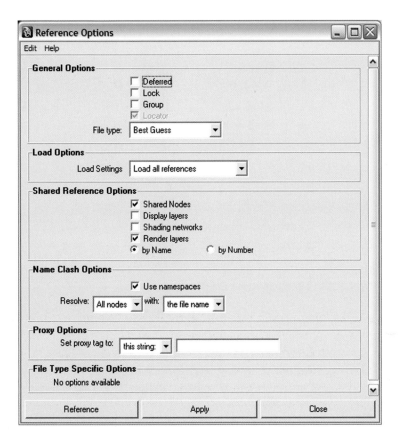

The Create Reference options window.

Changing the Referenced File [File > Reference Editor]

If you make changes to your model and need to replace the referenced file, go to [File > Reference Editor…]. A dialog box will appear. Click on the file name to highlight it, then go to [Reference > Replace Reference]. This will open a dialog box that will allow you to browse for a new file. This will temporarily remove the reference from your scene, and then reload the new referenced file into the scene. By clicking [Reference > Remove Reference], you can PERMANENTLY remove the reference from your scene. By clicking [File > Import Objects from Reference], you can PERMANENTLY import the reference file into your scene. Be sure to delete history, once the objects are imported.

Create Reference can be found under the File menu.

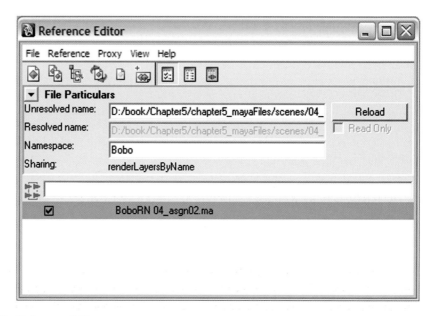

The Reference Editor.

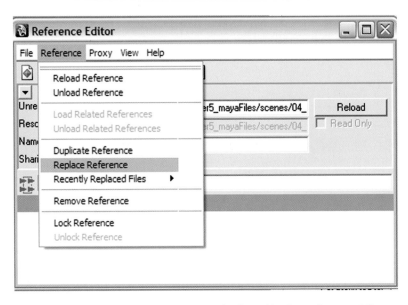

Replace Reference and Remove Reference can be found in the Reference Editor under the Reference menu.

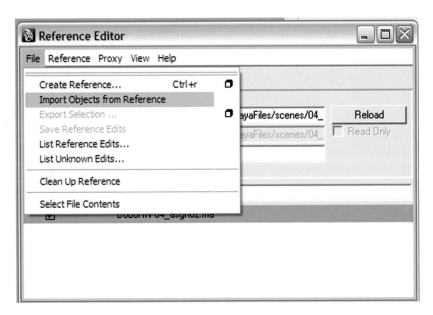

Import Objects from Reference can be found in the Reference Editor under the File menu.

Setting Up Your Work Area

Before placing joints, make sure your character is facing front in the front view and in the top view, he should be facing down. This may sound obvious to some, but it is my experience that some students do not pay attention to the direction their character is facing. The tools in Maya were created with the assumption that the character is facing

forward in the front view or in other words, toward the positive Z axis in 3D space. If for some reason, your character is not facing forward in the front view panel, you will need to rotate the geometry. You will need to make a group of your geometry if your character is made up of multiple pieces of geometry before being able to rotate them together.

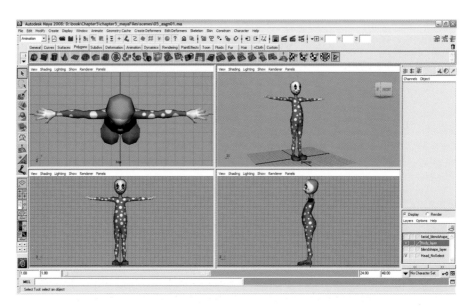

Proper Character Placement for rigging.

The scale of your character is another important consideration. One square on the Maya grid is 1 cm by default. I have had students model their entire character to fit inside a single 1 cm grid square. Many of the tools used in Maya are based off of mathematical calculations. The problem with keeping your character so small is that these tools must calculate results using fractions in the thousandths or smaller. This creates a greater margin for error. My general rule is to keep the character arm span the width of the entire grid in the perspective window, at a minimum. If, for some reason, your character does not have an arm span that is the width of the perspective window grid, you will need to scale the geometry. Again, you will need to make a group of your geometry if your character is made up of multiple pieces of geometry before being able to scale them together. (If you had to group them for rotational purposes, you can scale the same group, another group is not necessary.)

! DO NOT parent geometry pieces to other geometry pieces unless you have done so to create the blend shapes for the face. This causes **double transformations** after the skinning process.

Remember that when your character is facing you, his left side is your right side. This is important so that as you label all of your joints, you label the left and right sides correctly. Make sure to label all joints as this will make an organized and clean workflow and save time later. As you work, save versions of your work and save often.

The image of the character on the left looks similar in scale to the image of the character on the right. However, on closer look, the character on the left is actually the scale of the image in the middle. Make sure that your character is not too small, as it will cause problems with some tools and when animating.

When using a tool in Maya, always open the option box and reset the tool when using it for the first time that day. This ensures that the tool is working appropriately and is not based on the tool settings when it was last used.

It is a good idea to place the geometry for your character on a layer as discussed earlier. Set the layer to reference, so that you are unable to select the geometry by mistake when working. I recommend working with shading options set to X-Ray Joints (NEW IN MAYA 2008) so that you can still see your joints through your geometry. This is a personal preference, as others like working in wireframe.

Shading > X-Ray Joints.

Working with Joints

The Joint Tool [Skeleton > Joint Tool]

The joint tool allows you to create joints by clicking on a grid. For this reason, you should always use the orthographic view panel (front, side, or top) when placing your joints. You can create a joint by moving your mouse cursor where you would like to position the joint and clicking with the **LMB** (left mouse button). A single joint appears as a circle with a crosshair in the center. A new joint is created every time you click the mouse. Subsequent joints are connected with bones, which look like a triangle with a line down the center pointing toward the new joint. To complete a chain of joints, simply hit the enter key on your keyboard. If you would like to create another chain, select the joint tool again by pressing the (**y**) key.

The Joint tool can be found in the Animation menu set (F2) on the keyboard under the Skeleton menu.

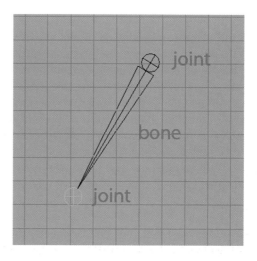

Two joints are connected visually with a bone.

! Remember, a bone doesn't really exist in Maya. It is simply a visual connection of one joint to the next.

You will notice that the closer you click the joints to each other, the smaller the joints appear. The further away the joints are from each other, the larger the joints appear. This can cause visual clutter in your scene file. This setting can be changed by opening the option box on the tool and changing the long bone radius to 0.5000. By changing the long bone radius to equal the short bone radius, all of the joints will be created as the same display size.

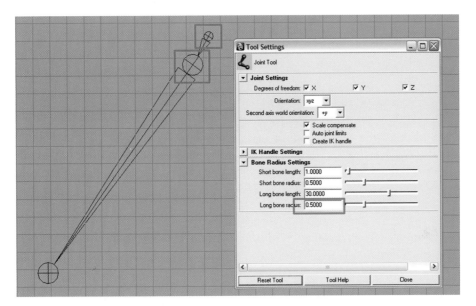

The long bone radius changes the size of the joint based on the distance it is from the following joint. Changing the long bone radius to 0.5 will prevent this.

Display Size [Display > Animation > Joint Size...]

As you are drawing your joints, you might notice that they are small or large compared to the size of your character model. You can change the display size of the joints in order to see what you are doing more clearly. First, you may want to click out a few joints in one of the orthographic view panels. Then after opening in the joint display scale window, you can enter any numeric value or use the adjustable slider to interactively change the size of the joints.

Adjusting the display size of the joint will not affect how the joint works. You will notice that the position of the center point of the joint does not change regardless of the display size.

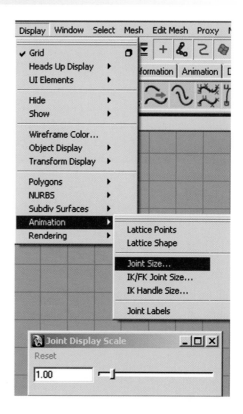

Joint Size options.

Local Rotational Axes [Display > Transform Display > Local Rotation Axes]

To understand **local rotation axis**, it is important to understand the 3D coordinate system and the differences between world space, object space, and local space. It's time to think back to math class when you were first introduced to the Cartesian coordinate system. In the Cartesian coordinate system there are three intersecting perpendicular lines called axes. A point in the coordinate system is defined by three **real numbers** (an infinite decimal representation) and each number reveals the position of the point on each axis, X Y Z. The point of their intersection is referred to as the origin, and it is at the position of 0 0 0.

In Maya, we use a right-handed Cartesian coordinate system, where the X axis points left to right on your screen, the Y axis points up and down, and the Z axis points forward and backward. This coordinate system is considered world space.

If you create an object in Maya, such as a sphere, it is placed in world space at the origin. Imagine the XYZ axes lines sticking to the sphere.

Now imagine the sphere is moved away from the world space origin and rotated. The XYZ axes of the object (sphere) would be pointing in a different direction

The Cartesian coordinate system and its point of origin.

 A sphere that has been created at the origin and is in World space.

and no longer aligning with the world. This coordinate system is referred to as object space. The origin is at the object's pivot point (currently at the center of the sphere), and its axes are rotated with the object. The origin can be moved by using the move pivot mode (select the move tool **(w)** and then press the **(insert)** key). **Object space** changes for each object in Maya, based on its rotation and translation values.

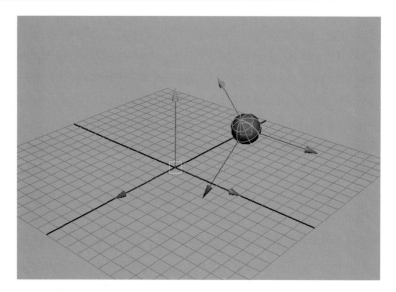

A sphere that has been moved from the origin and rotated shows a different coordinate system called Object space.

If the object's transformations are frozen, the axes will return to align with world space, but the origin remains where it is currently located, still in Object space.

If an object is the child of another, and its parent is transformed, the object uses the origin and axes of its parent for its position in **local space**. This is especially important for translation values, as you can move an object based on its object, local, or world space, and it is particularly noticeable if the object has been rotated separate from its parent.

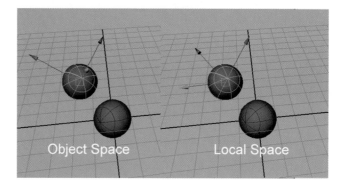

A sphere (left) that has been moved from the origin and rotated with its parent shows a different coordinate system called Object space. The same sphere (right) showing Local space.

The local rotation axis is a separate coordinate system for joints. The local rotation axis of a joint is determined by the position of its child. If a joint does not have a child, its

local rotation axis aligns with world space. If a joint has a child, by default its X axis points toward that child and the Y axis will point upward (or as close to up as it can possibly go, based on its relationship to the X axis). We do have to be concerned when the joint chain is vertical or semi-vertical, because the X axis points toward up or down (depending on the direction of the children), therefore the Y axis cannot point up at the same time. Maya will arbitrarily point the Y in any direction, and the joint chain does not have the same local rotation axis throughout.

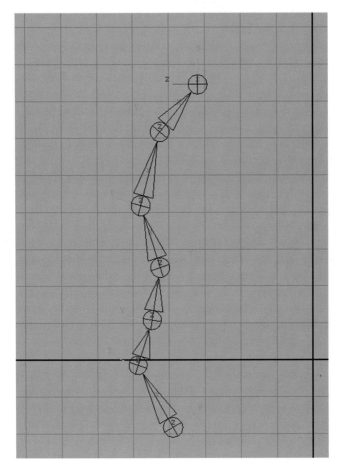

Local rotation axis set to XYZ on a vertical joint chain, where the axis does not line up from one joint to the next.

When do you worry about the local rotation axis? To ensure that joints rotate uniformly and predictably when using IK (**inverse kinematics** will be covered in Chapter 6), any joint chain created should be oriented properly for IK. This means that the X axis should be pointing toward the child joint, and the Y and Z axis are the same throughout the chain. This ensures that the IK tools will work as the creators defined them to do so.

However, to ensure that joints rotate correctly using FK, (**forward kinematics** will also be covered in Chapter 6) the joint orientation must align closely to world space. For the arms, we can achieve this alignment when drawing out the joints, but for the spine, neck, and head, we will run into trouble (and for the ankles and feet, but we won't be setting up FK in the legs for this rig). It is impossible to have the X and Y axis pointing in the same direction. This means that the Y axis should be pointing toward the child (up in the spine), and the Z axis should be pointing forward. To solve this problem, we create multiple joint chains for the different types of control systems needed, and switch between the two. We must reorient the FK chain to match world axis.

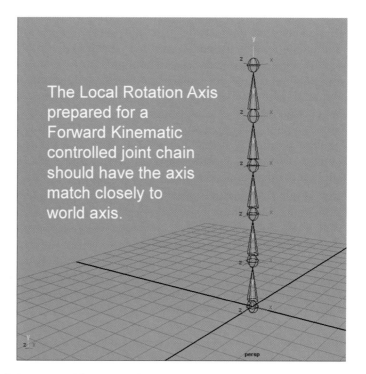

A spine chain prepared for Forward Kinematic control.

! The last joint of any chain will not rotate and therefore the local rotation axis position does not matter for that joint.

Placing joints with orientation set to XYZ will always ensure the X axis points toward the child joint, but the direction of the YZ axis depends on the direction of the child joint, especially in vertical or semi-vertical chains. If the X axis is going up or down,

then the Y axis is unable to do so as well. This confuses Maya and it's not sure which direction to place the Y. Sometimes the YZ axes will be flipped in different directions. You will need to ensure that they are all pointing in the same direction so that the joints are aligned. To solve this unpredictable behavior, change the tool settings whenever creating joint chains for a biped character so that the joints are created with the orientation XZY and second axis orientation is +Z. (You could also reorient the joints after positioning them.)

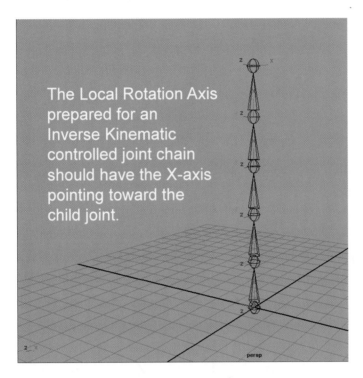

A spine chain prepared for Inverse Kinematic control.

There are two ways to check the directions of the local rotation axes in your character's joints:

1. Object mode: Select the joints you would like to display then go to [Display > Transform Display > Local Rotation Axes].
2. Component mode: Press (**F8**) on the keyboard to change to component mode or click on the component mode button. *In the selection mask tool bar, place your cursor over the "?" button, RMB (right mouse button) click and hold, and then select Local Rotation Axes from pop-up menu that appears.* In the perspective view panel, select the root of the chain you would like to display. Every joint in the selected hierarchy will display its own local rotation axis.

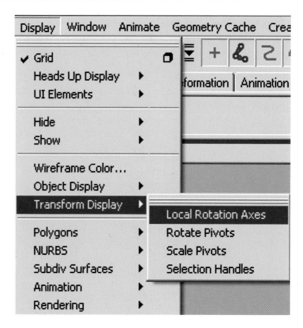

Displaying the Local Rotation Axes in Object Mode requires that each and every joint be selected.

Displaying the Local Rotation Axes in Component Mode requires that the top of the hierarchy be selected to see all of the Local Rotation Axes for that hierarchy.

Placing Joints

The joint transforms around the position of its center point. It is important to make sure that the joint is positioned in the exact place in order to control your character appropriately. As you begin to place joints, you may find that you have misplaced them in the process. You can **[Edit > Undo]** or press **(z)** on the keyboard and continue to recreate joints. While placing joints, you can click and hold the **LMB**, then drag the joint into the correct position.

Repositioning Joints

Once you place joints in one of the orthographic views, such as the side, front, or top, it is important to look at the perspective view panel to ensure correct and proper placement in 3D space. You may notice that the joints are not in the proper place and need to be repositioned. Repositioning the joints can be done by using the move, rotate, or scale tools.

Moving Joints (AKA – translating joints)

The move tool – keyboard shortcut **(w)** – will move the selected joint and any joints below it in the hierarchy. If the selected joint is the first chain in the hierarchy, then the entire chain will move. To move an individual joint, you must first select the move tool by pressing **(w)** and then press the **(insert)** key on the keyboard to toggle into the move pivot mode. The move pivot mode will allow you to move only the selected joint.

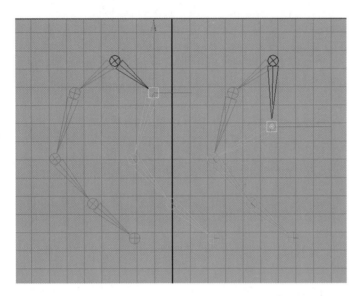

Moving a joint into place will also move any joints below it in the hierarchy (left), unless the move pivot mode is toggled on by pressing the *Insert* key on the keyboard (right).

 If you use the move tool to move joints into position, the local rotation axis of the translated joint stays at the orientation in which it was created. This means that it will no longer be aligned with the child joint. If you must move a joint, make sure to reorient the joints.

Rotating and Scaling Joints

The rotate tool – keyboard shortcut **(e)** – and the scale tool – keyboard shortcut **(r)** – can be used to rotate or scale a joint into place. If a joint is rotated or scaled, you MUST freeze transformations on the joint to reset rotation values back to zero and scale values back to one. To do this, select the top joint of the hierarchy and go to **[Modify > Freeze Transformations – option box]**.

 Translate values will not freeze on joints. There will always be a value in one or all translation channels for a joint. Maya must have translation values for a joint so that it knows where that joint is located in world space or in relation to its parent joint.

Rotating or scaling joints into place requires the Freeze Transformation command to reset the values.

Reorienting Joints [Skeleton > Orient Joint – option box]

After you have finished placing your joints, I recommend displaying your local rotational axes and reorienting them if necessary. There will be special circumstances (such as the thumb joints) that will require the need for manually rotating the local rotational axis into position. Also, if you used the move tool reposition the joints into place, the local rotational axis of the translated joint is no longer aligned with its child. If you must move a joint, make sure to reorient them.

> **!** It is not necessary to reorient a joint if the entire joint chain was moved.

Warning signs for non-zero rotations appear during the reorientation process if the joint's transformations have not been frozen.

Remember, if you rotated a joint into place, you must first freeze transformation **[Modify > Freeze Transformations]** on that joint before you reorient. Avoiding this step will result in an error message during some commands with a Hot Pink Alert: Joint has non-zero rotations, and sometimes the joint will be skipped when trying to reorient.

To reorient a joint or joint chain, select the joint in object mode OR select the axis in component mode and go to **[Skeleton > Orient Joint – option box]**. UNCHECK Hierarchy to orient only one joint, or CHECK Hierarchy to orient that joint and ALL child joints (this option only affects the entire hierarchy in object mode, in component mode, you must shift + select each joint axis that needs to be reoriented). Choose the orient joint options and then choose the second axis orientation. Click APPLY. If you are in component mode, make sure to press **(F8)** to change back to object mode or click on the component mode button in the Status Line.

If necessary, you can manually rotate the local rotational axis into position when you are in component mode. Select the desired axis with the rotate tool by pressing the **(e)** and adjust in place. When finished, press **(F8)** to change back to object mode or click on the component mode button.

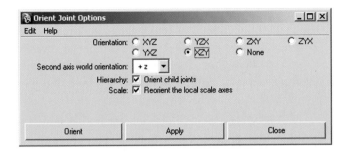

Orient joint option box.

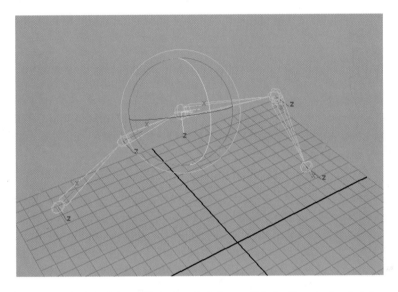

Manual rotation of a joint's Local Rotation Axis is possible for fine tuning joint rotation.

You can also change the rotational axis by **MEL** (Maya Embedded Language) command. In component mode, select the desired axis and enter in the Command Line the following command (change the numbers and axis as necessary) and press enter:

rotate -r -os 0 180 0 (these particular values will rotate the axis exactly 180 degrees in Y)

where -r stands for relative, -os stands for object Space, 0 180 0 are values of X Y Z coordinates.

A MEL command can be used for precise rotation of the axis.

Former Student Spotlight: Sean Danyi

Creating a well rounded skill set will not only help you by opening more venues to display your skill, but it will allow you to focus more readily on and augment your strengths. It is incredibly important to not only understand how to make your character move, but what is making him move that way. If you know beforehand what motions you will need for a particular shot, you can make sure that your setup can accommodate anything you will need.

Case in point: I am, by nature, an animator, so my points will come from this perspective. In school I focused primarily on developing my tradition and digital animation techniques. However, I also knew that it would be absolutely critical for me to gain at least a moderate skill set in rigging. Though daunting at first, this paid off for me as I applied for my (now) current job.

After several weeks of emails, phone calls and interviews, they gave me one final task to accomplish. I had to take a character the studio gave me, and perform three animation cycles for them. However, the character they supplied me with was far too limited to create any kind of believable motion, which they even warned me about. So, I took the first day, and nearly dismantled the entire thing, and rebuilt him with all the abilities I knew he was going to require. This simple step allowed me to then focus on my strengths in animating, and not fighting with a limited rig.

I would suggest creating a very simple character, with a very specific task, and attempt to rig him specifically for that. If he needs to flip, make him flip. If he needs to pick something up, rig him up to do so. Try to solve one problem at a time. The better equipped you can be before going to your first gig, the better. As animators, we are in essence actors. And rigging can be likened to singing. You don't have to be able to sing to get a part, but if you can, there are many more unique opportunities out there for you.

Sean Danyi graduated from the Savannah College of Art and Design (SCAD) in 2005 with a BFA in Animation. In 2004, he completed an internship with Will Vinton Studios where he worked in collaboration with seven other interns to create the short film, "Hellp!" He is currently employed as an animator with Human Head Studios in Madison, WI.

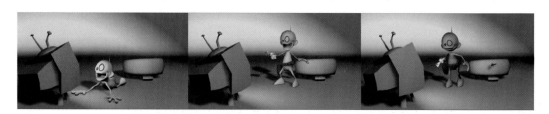

***Little Billy* by Sean Danyi (2003).**

Summary

5.1 A skeletal structure is built in Maya using joint hierarchies.

5.2 Bones are visual connections from one joint to the next but do not physically exist in the Maya scene file.

5.3 The main proportions of the character geometry should be in place before beginning the skeletal structure.

5.4 If a character is made of polygons, it is important not to smooth the geometry at this point, as it adds unnecessary problems later in the skinning process.

5.5 A character's skeletal structure should be based on reality. Research is crucial for proper motion. Sometimes it is necessary to combine skeletal structures from multiple animals in order to create a skeleton that works for your character.

5.6 Each appendage should be considered as a separate control system, so separate joint chains should be created for each leg, arm, finger, torso, head, ears, or tails.

5.7 File referencing is a tool that can be used to expedite workflow. File referencing provides the ability to overlap areas of the production pipeline.

5.8 Files that are referenced into another scene file are not physically part of current scene. Instead, a path is made that points to the referenced scene file so that Maya can display it.

5.9 When using file referencing, make sure to utilize the name clash options so that multiple nodes with the same name are not confused.

5.10 Files that are referenced can be removed, replaced, or even imported into the current scene file.

5.11 Remember that when your character is facing you, his left side is your right side. This is important so that you label left and right sides correctly.

5.12 Make sure to always open the tool option box to reset the tool before using it for the first time every day.

5.13 Geometry should be placed on its own layer so that it can be referenced. This makes it more difficult to accidentally select the geometry, making it easier to work with joints.

5.14 Using X-Ray Joints in the shading options of each view panel provides the ability to see the joints through your geometry.

5.15 Joints can only be created on a grid, and for this reason, joints are placed only in orthographic view panels.

5.16 Joints can be displayed at different sizes without affecting their functionality.

5.17 Maya uses a right-handed Cartesian coordinate system in order to define the position of objects in world space, where the X axis points left to right, the Y axis points up and down, and the Z axis points forward and backward.

5.18 Object space is a coordinate system based on the translation and rotation of a particular object. Each object exists in its own object space.

5.19 Local space is a coordinate system that determines an object's position based on its position and how it relates to the position of its parent.

5.20 Local rotation axis is a separate coordinate system that applies to joints. The local rotation axis of a joint is determined by the position of its child.

5.21 The default setting of the local rotation axis is XYZ, where X points to the child joint and Y points in an upward direction.

5.22 The local rotation axis for joints being controlled by an IK chain must have X pointing toward the child.

5.23 The local rotation axis for joints being controlled by FK must have the local rotation axis matching closely to world space.

5.24 You can display the local rotational axes in object mode or component mode.

5.25 If a mistake is made when positioning joints, simply undo the mistake and continue with the placement.

5.26 Joints can be moved, rotated, or scaled into place. If rotated or scaled, joint transformations must be frozen. If moved, joint orientation must be reoriented.

5.27 A warning sign is displayed when reorienting if a joint's rotations are not frozen at zero.

5.28 Manual rotation of the local rotational axis must sometimes occur. This can be accomplished in component mode using the rotate tool.

5.29 The following MEL command can be used for precise rotations of the local rotation axis: rotate -r -os 0 180 0.

Assignments: Joint Placement in a Character

 Remember, your body is your best reference for joint placement. If you are unsure where a joint should be placed, stand in front of a mirror for observation and put your hand on the area in question to feel how your skeleton moves.

Assignment 5.1: Creating a Spine, Neck, and Head Skeleton

Set up your work environment by doing the following:

1. Open Maya and set your project.

 a. From your computer's desktop, go to [**Start > Programs**] and select Maya.

 b. Once Maya is open go to [**File > Project > Set...**] and browse to your project folder then click **OK**.

2. Create a reference to your last saved file:

 a. Go to [**File > Create Reference**] and select *04_asgn02.ma*. This will insure that your model will be updated easily if you are still working on modeling, texturing, or blend shapes.

3. Set all four view panels to **X-Ray Joints** mode. This will allow you to see your joints easily and still be able to see the volume of your geometry.

 a. In the top, front, side, and perspective view panels, go to [**Shading > X-Ray Joints**].

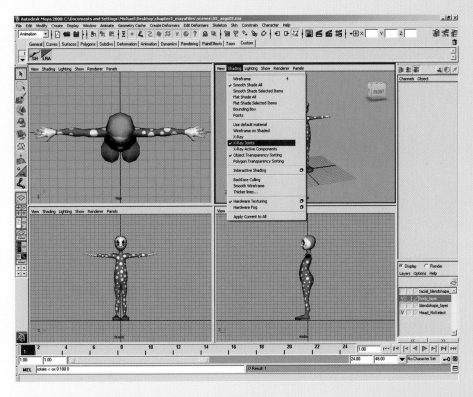

Setting all four view panels to X-Ray Joints mode.

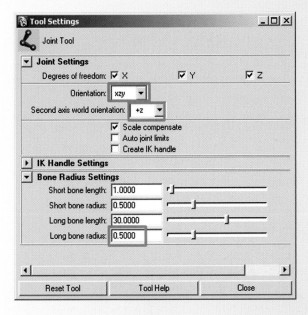

The Joint tool option settings.

4. Make sure that your geometry layer is set to **R** for reference. This ensures that you are unable to select the geometry by mistake when working.

5. Select the **[Skeleton > Joint Tool – option box]**, or double click on the icon on the shelf. In the option window, click on RESET TOOL, then set the following:

 a. change the orientation to **XZY**.

 b. change the second axis world orientation to **+Z**.

 c. click close.

6. Select [**Skeleton > Joint Tool**] and click out a few joints in the orthographic view near your character. Go to [**Display > Animation > Joint Size**] and adjust the slider to adjust the size of the joint. Select the joints using the select tool – by pressing (**q**), and hit the delete key, as these joints were only created to set the joint display size.

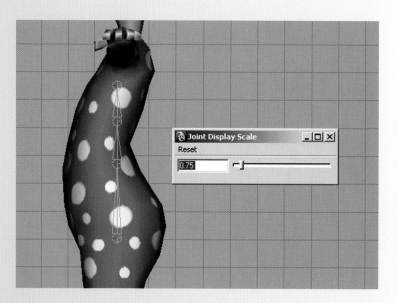

Adjusting the display size of the joints.

If the textures become distracting, press the (**5**) key to turn off hardware texturing.

7. Create the spine joint hierarchy by doing the following:

a. In the FRONT orthographic view, **place 6 joints** for the spine as follows:

Click the **first joint** in the waist area, hold down the **shift key** and click the **second joint** just above the first, and continue to the shoulder area. One joint is placed at the base of the rib cage, and the sixth joint is placed in the center of the shoulders. Hit **enter** to finish the chain. (It is important to keep the joints in the spine straight, even if your character has an exaggerated posture or curved back. Holding down the shift key as you click your joints ensures that they are drawn in a straight line.)

b. Rename these joints *spine1*, *spine2*, *spine3*, *spine4*, *spine5*, and *spine6*.

You can rename the joints easily by selecting joint1 and opening [Modify > Search and Replace Names...] then enter the following: Search for: **joint** Replace with: **spine**.

c. In the SIDE orthographic view, select the **spine1** joint and adjust the position in the torso geometry if necessary.

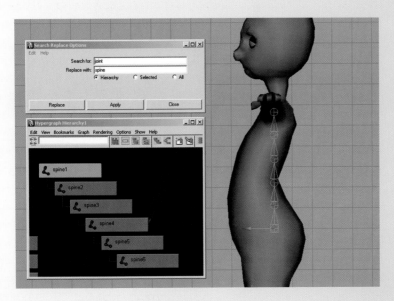

Positioning and renaming the *spine* joints.

d. In the SIDE view, **place 1 joint** below the spine1 joint, rename this joint *pelvis*.

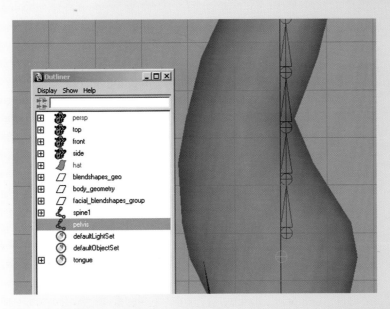

Placing the *pelvis* joint.

1. Create the neck and head joint hierarchy by doing the following:

a. Select [Skeleton > Joint Tool]

b. In the SIDE orthographic view **place 3 joints** for the neck and head as follows:

Click the **first joint** in the center of the neck, hold down the **shift key** and click the **second joint** at the base of the head. Keep the shift key held down and click the **third joint** at the top of the head. Hit **enter** to finish the chain.

c. Double-click on each joint in the outliner to rename them as follows: *neck*, *head*, and *headTip*.

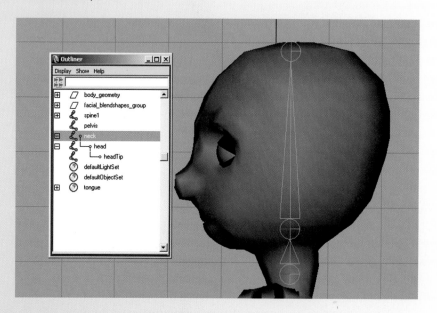

Placing and renaming the *neck* and *head* joints.

! If your character has a mouth, you can control the mouth opening and closing with joints instead of blend shapes. Some prefer this control as it looks more natural, since our mouth opens from the rotation of our jaw.

2. Create the jaw joint hierarchy by doing the following (optional):
 a. Select the joint tool by pressing **(y)** on the keyboard.
 b. In the SIDE orthographic view, click FIRST on the *head* joint to begin a new chain that is branching from the *head* joint. Place **2 joints** for the jaw as follows:

 Click the **first joint** at the base of the ear where the jaw hinges and the **second joint** in the chin. Hit **enter** to finish the chain.

 c. Rename these joints *jaw* and *chin*.

3. Create tongue joint hierarchy by doing the following (optional):
 a. Select the joint tool by pressing **(y)** on the keyboard.
 b. In the SIDE orthographic view, click FIRST on the *jaw* joint to begin a new chain. Then **place 3 joints** for the tongue as follows:

 Click the **first joint** at the back of the tongue, the **next** in the middle, and the **third** on the tip. Hit enter to finish the chain.

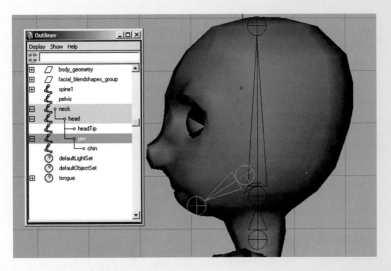

Placing and renaming the *jaw* joints.

 c. Rename these joints *tongue1*, *tongue2*, and *tongueTip*.

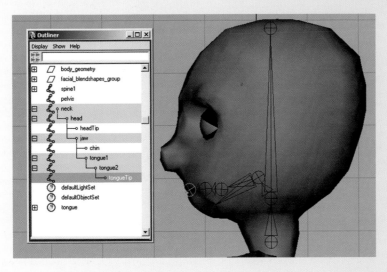

Placing and renaming the *tongue* joints.

4. Save your scene file. Name your scene *05_asgn01.ma*.

> **!** The number of joints is suggested and what I would consider the minimum amount needed. You can always add more joints for more flexibility or necessity. For example, if your character has a big nose, you may want to add a two or three joint chain stemming from the head joint so that you can control the nose movement. A *blend shape* can also be used for the nose movement. In summary, it is better to have a few extra joints than not enough at all.

Assignment 5.2: Creating an Arm and Hand Skeleton

1. Continue working on scene *05_asgn01.ma*.

2. Create the arm joint hierarchy by doing the following:

 a. Select [**Skeleton > Joint Tool**]. Keep the *orientation* to **XZY** and the *second axis world orientation* to **+Z**.

 b. In the FRONT orthographic view **place 5 joints** for the arm as follows:

 Click the **first joint** in the shoulder.

 > ! The shoulder is probably the toughest joint to position properly. Placing it too far into the arm geometry makes your arm bend bizarrely at the bicep instead of the shoulder. Placing it too far into your body geometry concaves your torso and breaks the shoulder. After we place all of our joints, we will test the position to see how things look when they bend. Fine tuning the position of the shoulder will occur at that time.

 c. While holding down the **shift key** click the **second joint** in the elbow, the **third joint** in the forearm, the **fourth joint** in the wrist, and the **fifth joint** in the palm of the hand. Hit enter to finish the chain. Holding the shift key ensures that the arm is drawn in a straight line.

 d. Rename these joints *shoulder, elbow, forearm, wrist, and palm*.

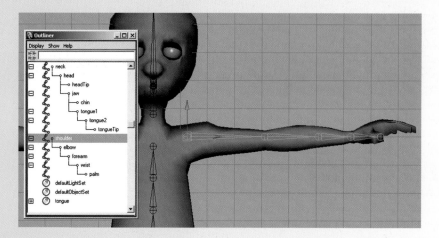

Placing and renaming the *arm* joints.

 e. In the TOP orthographic view, select the **shoulder joint** and adjust the position in the arm geometry if necessary. Remember, it is not necessary to reorient a chain if it is moved in its entirety. (Our arms do not actually have a forearm joint. What we do have is a radius and an ulna that allows rotation of the forearm. The forearm joint will act as the radius and ulna, which will allow for rotation of the forearm without rotation of the elbow.)

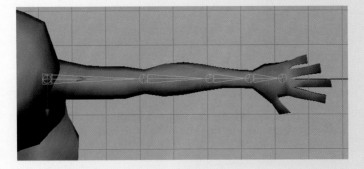

Repositioning the *arm* joints.

f. In the FRONT orthographic view **place 2 joints** for the clavicle.

Click the **first** near the spine, at the base of the clavicle. While holding down the **(v) key**, click the **second** joint in the existing shoulder joint. The **(v) key** turns the point snap, which will snap the new joint into the same position as the existing shoulder joint. Hit enter to finish the chain.

g. Rename these joints *left_clavicle* and *left_clavicleTip*.

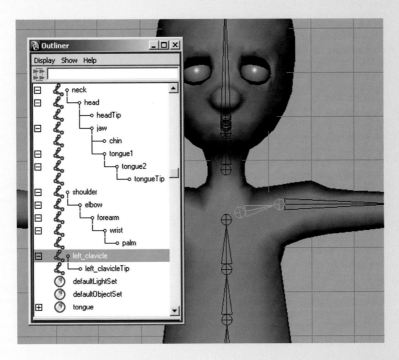

Placing and renaming the *clavicle* joints.

h. In the PERSPECTIVE view, check for proper alignment. Select the *left_clavicle* joint, and with the move pivot tool, translate the joint to the front of the geometry. (To get to the move pivot tool, press **(w)** then hit the insert key.)

i. Since we moved the joint we must reorient. With the *clavicle* joint selected, go to [Skeleton > Orient Joint – option box]. Choose orientation: **XZY** and second world orientation: **+Z** then click **ORIENT**.

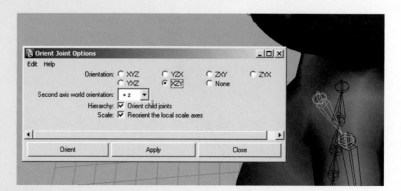

Repositioning and reorienting the *clavicle* joints.

 After creating the hands, we will mirror the left arm to create the right arm.

3. Create the hand joint hierarchy by doing the following:

a. Select [Skeleton > **Joint Tool**]

 While it is not necessary to have four fingers and a thumb for your character, I recommend a minimum of a thumb and middle finger, or mitt. Since our hands are such an expressive part of our body, it is important to be able to gesture with them.

b. In the TOP orthographic view, click FIRST on the ***palm*** joint to begin a new chain for a finger that is branching from the *palm* joint. **Place 4 joints** for the middle finger, placing 1 at each knuckle (observe your own hand for clues about joint placement) and one on the tip of the finger (the last joint is placed to allow the prior joint to bend, the last joint never rotates). Hit **enter** to finish the chain.

c. Rename the finger joints as follows: *middle1, middle2, middle3, middleTip* (You can rename the joints easily by selecting joint1 and opening [Modify > **Search and Replace Names…**] then enter the following: Search for: **joint** Replace with: **middle**, and then relabel *middle4* as *middleTip*).

d. Repeat this process for the index and ring finger, if your character has them. Press the **(y) key** to choose our last tool – the joint tool. Click FIRST on the ***palm*** joint, and then **place 4 joints** for the index finger. Hit **enter** to finish the chain.

Rename the finger joints as follows: *index1, index2, index3, indexTip* (You can rename the joints easily by selecting joint1 and opening [Modify > **Search and Replace Names…**] then enter the following: Search for: **joint** Replace with: **index**, and then relabel *index4* as *indexTip*).

e. Press the **(y)** key to choose our last tool, click FIRST on the *palm* joint, and then **place 4 joints** for the ring finger. Hit **enter** to finish the chain. Rename the finger joints as follows: *ring1, ring2, ring3, ringTip* (You can rename the joints easily by selecting joint1 and opening [**Modify** > **Search and Replace Names...**] then enter the following: Search for: **joint** Replace with: **ring**, and then relabel *ring4* as *indexTip*).

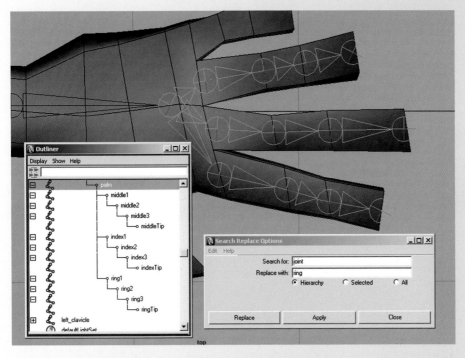

Placing and renaming the *middle, index,* and *ring* finger joints.

> ! The pinky and thumb joints will be a little different than the index and ring fingers in that they will start down near the base of the hand at the wrist. You are not stemming the pinky finger or thumb from the palm because you want them to work independently of the three middle fingers, allowing you to pose the hand into a cupped position.

f. Press the **(y) key** to choose our last tool, click FIRST on the *wrist* joint, and then **place 5 joints** for the pinky finger as follows: place 1 joint for the pinky side of the palm as well as 4 joints for the pinky finger. Hit **enter** to finish the chain.

Rename the finger joints as follows: *pinkyPalm, pinky1, pinky2, pinky3, pinkyTip.*

Press the **(y) key** to choose our last tool, click FIRST on the *wrist* joint, and then **place 4 joints** for the thumb as follows: place 1 joint for the thumb side of the palm as well as 3 joints for the thumb. Hit **enter** to finish the chain. Rename the finger joints as follows: *thumbPalm, thumb1, thumb2, thumbTip.*

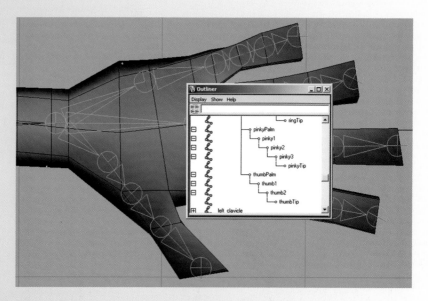

Placing and renaming the *thumb* and *pinky* finger joints.

g. In the PERSPECTIVE view, move or rotate the finger joints so that they line up on the top edge of the geometry. By doing this, your character's geometry will bend and deform more realistically. The first knuckle of each finger should be set back slightly in the hand. Look at your own hand for reference and notice where the knuckles are.

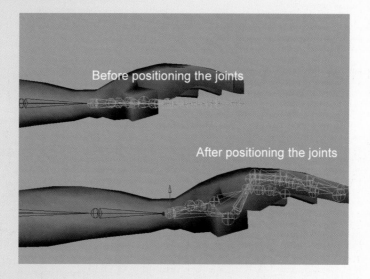

Repositioning the *finger* joints in the perspective window.

! DO NOT MOVE THE PALM JOINT. It is important that the palm stay in line with the wrist so that the hand works predictably with the control rig.

h. If you rotated any of the joints, you should freeze transformations on the rotations. Select the *wrist* joint and go to [**Modify > Freeze Transformations**]. Don't forget to open the option box and reset the options to default settings before applying.

i. If you moved any joints, make sure to reorient the joints in the hand once they have all been moved into place. Select the *wrist* joint and go to [Skeleton > Orient Joint – option box]. Choose orientation: **XZY** and second world orientation: **+Z** then click **ORIENT**.

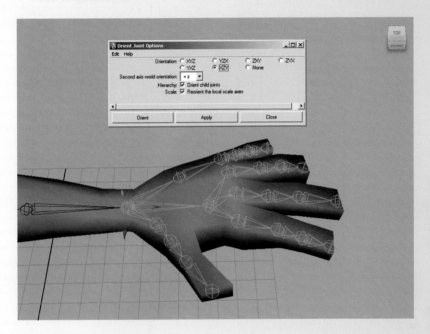

Reorienting the joints in the hand.

j. Rename your arm chain to include left_ prefix by selecting the *shoulder* joint, then go to [**Modify > Prefix Hierarchy Names…**]. Enter **left_** in the text field and click **OK**.

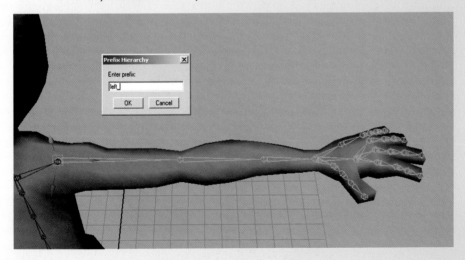

Adding the *left* prefix to the arm chain.

k. Mirror the left arm to create the right arm by selecting the *left_shoulder joint*, then go to [Skeleton > Mirror Joint – option box] and enter the following:

Mirror Across: choose **YZ axis** (Mirroring across the YZ axis will mirror from left to right – on the X axis. This can be slightly confusing at first. An easier way to think about the direction is to establish a line on the missing axis (X in this case) and that is the direction of your mirrored skeleton. Another way is to imagine a flat plane created by the stated axis YZ – up and down PLUS front to back (hey … imagine a mirror … like a full length one that you have on your wall). THE mirrored skeleton is the reflection on that axis (or in that mirror).)

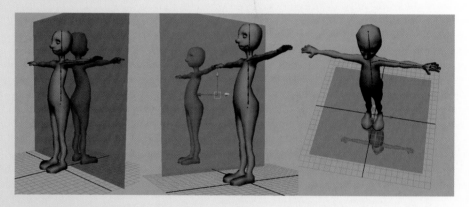

Establishing the mirror direction as a *reflection*. Mirroring on the XY (left), mirroring on the YZ (middle), and mirroring on the XZ (right).

Mirror Function: choose **behavior** (Mirroring your joints with "behavior" allows for the animator to choose both elbows and rotate them simultaneously in the same direction. This usually means that the X axis is rotated 180 degrees, pointing away from the child joint. Mirroring your joints with **orientation** keeps the X axis pointing toward the child joint. Either will give you the results needed, but **behavior** seems to be most popular with animators because it speeds up the posing process when animating in FK.)

Replacement names for duplicated joints:

Search For: enter **left**

Replace With: enter **right**

Then click **mirror** to execute the command.

l. Mirror the left clavicle to create the right clavicle by selecting the *left_clavicle joint*, then go to [Skeleton > Mirror Joint] or hit the **(g) key** to repeat the last command.

4. Save your scene file. Name your scene *05_asgn02.ma*.

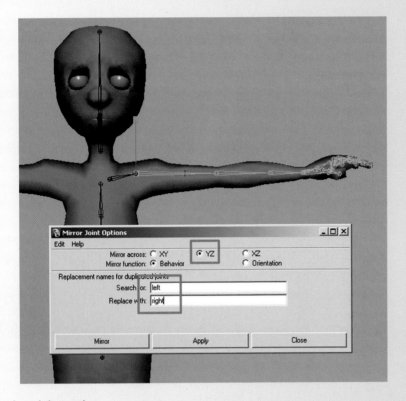

The mirror joint options.

Assignment 5.3: Creating a Leg Skeleton

1. Continue working on scene *05_asgn02.ma*.

2. Create the leg joint hierarchy by doing the following:

 a. Select [**Skeleton > Joint Tool**]. Keep the *orientation* to **XZY** and the *second axis world orientation* to **+Z**.

 b. In the SIDE orthographic view, **place 5 joints** for the leg as follows:

 Click the **first joint** in the hip.

 c. Click the **second joint** in the knee, the **third joint** in the ankle, the **fourth joint** in the ball of the foot, and while holding down the **shift key**, click the **fifth joint** at the tip of the toe. Hit **enter** to finish the chain. Holding the shift key ensures that the toe is drawn in a straight line from the ball. (If your character's leg geometry is bent, be sure to draw the knee in a bent position. However, be careful not to overdo the bend as this will cause hyperextension of the knee when the leg is straightened. For this reason, if your character's leg geometry is straight, make sure to draw the knee and ankle straight down from the hip. Holding the shift key ensures that the joints are drawn straight.)

 d. Rename these joints *hip, knee, ankle, ball, and toe.*

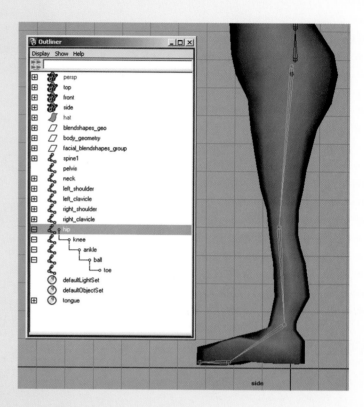

Placing and renaming the *leg* joints.

e. In the FRONT orthographic view, select the ***hip* joint** and move the joint chain along the **X axis (the red arrow)** into the left leg of your character's geometry. Remember, it is not necessary to reorient a joint chain if it is moved in its entirety.

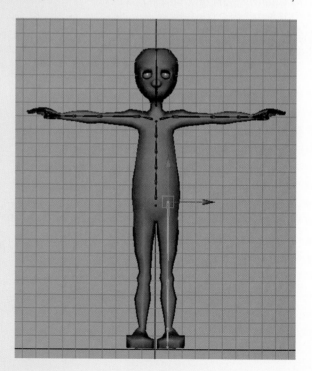

Repositioning the *leg* joints in the FRONT orthographic view panel.

! DO NOT move the *knee* or *ankle* out of alignment in the front view. The entire leg must be straight in the front view for predictable IK movement. If necessary, you can ROTATE the entire chain from the *hip* joint to align the leg. Remember to go to [Modify > Freeze Transformations] if rotations are used to position the joint chain.

 f. Rename your leg chain to include left_ prefix by selecting the *hip* **joint**, then go to [**Modify > Prefix Hierarchy Names…**]. Enter *left_* in the text field and click **OK**.

 g. Mirror the left hip to create the right hip by selecting the *left_hip* **joint**, then go to [**Skeleton > Mirror Joint**].

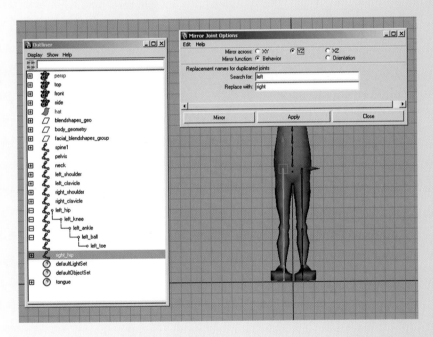

Mirroring the left leg to create the right leg.

3. Save your scene file. Name your scene *05_asgn03.ma*.

Assignment 5.4: Test the Joint Placement

1. Continue working on scene *05_asgn03.ma*.

2. Select all joints by going to [**Edit > Select All By Type > Joints**].

Selecting all of the joints.

3. Make sure that your geometry layer is set to *normal* by clicking on the **R** until the box is empty so that you are able to add the geometry to the selection.

4. Hold down the **shift key** and click on the character geometry piece(s).

5. Create a test skin bind by going to [**Skin > Bind Skin > Smooth Bind**].

6. Return your geometry layer back to *reference* by setting the layer to **R** so that you are unable to select the geometry by mistake when testing the joints.

7. Select a **shoulder joint** and rotate it so that the arm is down. Check the movement on the elbows, the knees, and the hips. These areas are the most problematic. What we are looking for is proper joint placement and verification that

Changing the geometry layer to *normal*.

Changing the geometry layer back to *reference*.

Creating a skin deformer.

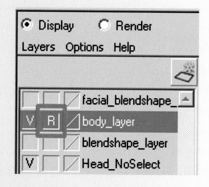

the bending of the shoulder, elbow, knee, and hips provide natural deformation that holds the shape. Refer to the images below to verify what is acceptable, and what is not.

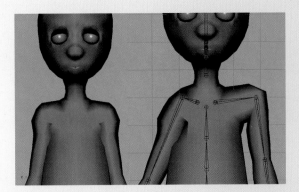

Good deformations on the character's shoulders on the left, and bad deformations caused by improper joint positions on the character's shoulders on the right. The right image shows two common problems. The left shoulder (right image) has a joint that is placed too far into the bicep. The right shoulder (right image) has a joint that is placed too far into the body.

The area around the waist may look like it is cracking and indenting. This is not a joint placement issue, but rather, the skin deformer needs to be smoothed in this area (covered in Chapter 8). The elbows and the knees are pinching because there are not enough divisions in the geometry to make a smooth bend.

Think about the difference between a regular straw and a flexi-straw. A regular straw pinches when it bent (left). A flexi-straw can bend more smoothly because of the added divisions allowing it to bend (right).

 If you move a joint and the geometry is pulled bizarrely or pushed into the body, note that this is NOT a joint placement problem. Any indentions and pulling of geometry can be fixed during the *Paint Skin Weights* process covered in Chapter 8.

8. **DO NOT SAVE THE FILE.**

9. If no changes are necessary, reopen the file *05_asgn03.ma, save the file as 05_asgn04.ma* and continue with Assignment 5.5.

10. If changes are necessary, reopen the file *05_asgn03.ma*, take your move pivot tool – press the **(w)** then press the **insert key** and move the joints ONLY on the **X axis (the red line)** to place them into a better position. Adjust the left side only.

Repositioning joints in the shoulder.

11. With the joint chain selected, reorient by going to [**Skeleton > Orient Joint –
 option box**]. Choose orientation: **XZY** and second world orientation: **+Z** then
 click **ORIENT**.

12. If there is a problem with the left arm or leg, then the right arm and leg will also
 need to be fixed. Simply delete the right chain in question (select in the outliner and
 hit the delete key) and select the left joint chain and go to [**Skeleton > Mirror Joint**]
 to re-mirror the right side.

13. If there is a problem with the geometry due to inadequate divisions, you must update
 the character model. Since your file is still referenced, you must open the referenced
 model file and make changes there by doing the following:

 a. Delete the non-deformer history first by going to [**Edit > Delete by
 Type > Non-Deformer History**]. (This ensures that the blend shape deformer is
 not removed.)

 b. Then add extra geometry in the troubled areas using the [**Edit NURBS > Insert
 Isoparms**] tool for NURBS surfaces (refer to Chapter 2 for more details on
 how to insert isoparms). Use the [**Edit Mesh > Insert Edge Loop Tool**] for
 Polygons.

 c. Since the geometry has a Blend Shape deformer applied, be sure to [**Blend
 Shape > Bake Topology to Targets**]. (Refer to Chapter 3 for more details on
 how to add topology to your blend shapes.)

14. Save your scene file *05_asgn04.ma*.

15. Follow the steps above until the proper movement is achieved.

> **!** There is a new tool in Maya 2008 called the *Move Skinned Joints Tool*. It provides the
> ability to reposition joints quickly while the character is still bound to the skin. This tool
> is helpful to promptly check to see if the new position will work for the skin deformer.
> Don't forget to reorient the joint chain while the tool is still in use, and to [Skin > Detach
> Skin] the geometry when completed, if you use this tool to reposition the problem joints.

Assignment 5.5: Verifying the Joint Local Rotation Axis

Your joint local rotational axes should already be correct for your skeleton, assuming
that you placed your joints correctly (with orientation: XZY and second world orientation:
+Z), froze transformations when necessary (when you rotated or scaled joints into
position), and reoriented them if they were moved after the original placement. The
thumb joints are the only joints that will definitely need tweaking for their position. The
wrist joints might need a slight adjustment, also.

It is a great idea to verify that all of the joint local rotational positions are correct before
beginning to build your controls in Chapter 6.

1. Continue working on scene *05_asgn04.ma*.

2. Let's first evaluate the axes and determine if any need to be fixed.

 a. Select all joints by going to [**Edit > Select All By Type > Joints**].

 b. Then go to [**Display > Transform Display > Local Rotation Axes**].

c. The torso, neck, head, left arm, hand, and leg should have the X axis pointing toward the child and the Z axis coming forward.

The proper Local Rotation Axis for the joints.

d. The right arm, hand, and leg should be mirrored on behavior, and therefore the X axis should be pointing away from the child and the Z axis pointing backward.

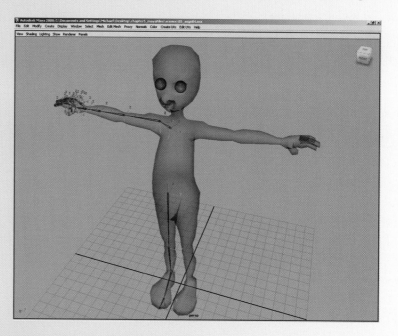

The proper Local Rotation Axis for the right arm and leg.

! Remember, the last joint of any chain will not rotate and therefore the local rotation axis position does not matter for that joint.

3. If there is a problem with the orientation on the torso, neck, head, left arm, hand, or leg, simply select the top of the joint chain by opening the outliner [**Window > Outliner**] and choose the top joint, then reorient by going to [**Skeleton > Orient Joint – option box**]. Choose orientation: **XZY** and second world orientation: **+Z** then click **ORIENT**.

4. If there is a problem with the left arm, hand, or leg, then the right arm, hand, or leg will also need to be fixed. Simply delete the right chain in question (select in the outliner and hit the delete key) and select the left joint chain and go to [**Skeleton > Mirror Joint**] to re-mirror the right side.

5. Turn off the Local Rotation Axes Display as follows:

 a. Select all joints by going to [**Edit > Select All By Type > Joints**].

 b. Then go to [**Display > Transform Display > Local Rotation Axes**].

6. The wrist joints and the thumb joints will need to be adjusted manually as follows:

 a. Select the *left_wrist* joint, then shift select the *right_wrist* joint.

 b. Press (**F8**) on the keyboard to change to component mode or click on the **component mode button**. In the selection mask tool bar, **LMB** click on the points button to turn it off and **RMB** click and hold the "**?**" button and select **Local Rotation Axes** from the marking menu that appears.

Displaying the Local Rotation Axis in component mode.

c. Starting with the left thumb, use the selection tool – **press (q)** – to click on the *thumb_palm* **axis**. Holding down the shift key, click the *thumb1* **axis**, and the *thumb2* **axis**. Rotate – **press (e)** – the *thumb_palm, thumb1,* **and** *thumb2* axes so that the Y axis is intersecting the joint in the direction the bend will occur.

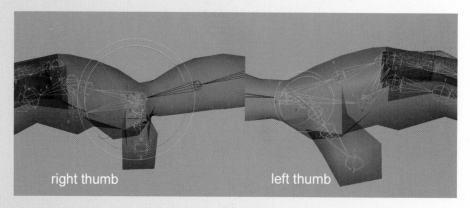

right thumb left thumb

Rotating the thumb Local Rotation Axis into position.

d. Repeat this for the right thumb. On the right side, the Y axis comes out the underside of the thumb.

! To visualize this, hold your hand in the same position that your character's hand is modeled. Pick up a pen or pencil and IMAGINE – do not really do this – IMAGINE that pen or pencil being jabbed into your thumb knuckle and coming out of the other side. That pen would be the Y axis.

Visualizing the direction of the Y axis by using a pen.

7. In the TOP orthographic view, verify that the wrist local rotational axis is aligned straight with the graph. To do this, click on the wrist axis and select the rotate tool by pressing **(e)** on the keyboard. The inside of the tool should appear as a **+** and be even with the graph. If not, carefully rotate the **Y axis (the green part of the rotate tool)** until the **+** aligns with the graph.

Verifying that the wrist Local Rotation Axis is straight.

8. Save your scene file *05_asgn05.ma*.

> **!** At any time you can go back and fine tune your joint orientations if necessary.

Assignment 5.6: Adding Additional Joint Chains for Clothing, Tails, Antennae, or Other Areas

With the techniques you have learned in this chapter, you can add additional joint chains for anything else on your character that needs control: neckties, ponytails, skirts, tails, antennae, or ears, etc. Just remember, any joint chains that are vertical and have FK control need the Y axis pointing toward the child joint. Any joint chains that are horizontal (front to back) and have FK control need the Z axis pointing toward the child joint (like a tail). Any joint chains that are horizontal (side to side) and have FK control need the X axis pointing toward the child joint. Any joint chains controlled by IK need to have the X axis pointing toward the child joint. If the control is created using Set Driven Key (like the fingers), it really doesn't matter which axis points to the child, as long as the axes for the joints in the chain are consistently the same.

6

Control Rig Setup for a Biped Character: IK and FK

- ➢ **Former Student Spotlight: Ryan Yokley**
- ➢ **Workflow**
- ➢ **Kinematics**
- ➢ **Attribute Control**
- ➢ **Former Student Spotlight: Ben Willis**
- ➢ **Summary**
- ➢ **Assignments**

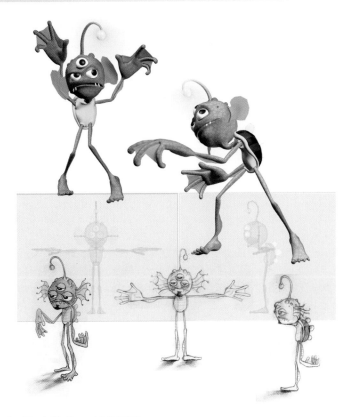

Character **by Mark McDonald (2007).**

Former Student Spotlight: Ryan Yokley

Zen and the Art of Rig Planning

When creating a rig for their own personal short films, most animators tend to grant themselves a large amount of wiggle room when it comes to laying out controls and custom interfaces to interact with their rigs. If you're the only person who is ever going to be fiddling around with the character, you can just modify the controls as you're going along, right? I mean, what problems could that *possibly* generate 6 months from now when you're animating scene 35 of 60 of your thesis masterwork? Ok, you probably sensed the regret there.

Granted, there is a level of rigging that remains protean by necessity; it's difficult to predict all of the functionality an animator or, help us, a team of them will need during the production cycle. But planning ahead, especially working within a studio production pipeline, is probably the most vital step when creating a comprehensive rig/control scheme for a character – one that will keep things moving smoothly under a tight deadline and won't require the pipeline to come to a screeching halt every time a tiny change needs to be made to the character. In other words, taking the time to plan out your control scheme is a good habit to get into.

While tricks like file referencing have given some leeway to the once extreme rigidity of initial character setup, it's important to keep in mind how fast things often have to flow in a production pipeline to meet deadlines. In my limited experience, this is key in the game industry. Large changes to the rig often dictate adjusting massive amounts of in-game animation. So in whatever project you've got planned, get the animators together with the script and figure out what they are going to need. If it's just you, sit down with your script and figure out what *you* are going to need before you dive into animation.

Unfortunately, in the game industry, changes are often dictated outside of the framework of the animation team. Sometimes memory, programming, or engineering complexities require late changes to the skeleton. However, as suggested by a senior co-worker of mine, aim high when creating your rig and your skeleton, because it's actually easier to downsize complexity later than it is to try to add functionality.

Ryan Yokley received his Bachelor's degree in Studio Art from Florida State University in 2002 and his MFA in Animation at the Savannah College of Art and Design in 2006. He has contributed his animation and rigging work to several award winning animated shorts including "The Machine" (Siggraph 2004 SPACE second place in Visual Effects category) and "The Audition" (Siggraph 2005 SPACE first place for Visual Effects category). Ryan did his internship at Vinton Studios (now Laika) in Portland, Oregon, in 2004. The project created by the intern team at Vinton was featured in the October 2004 issue of Animation Magazine. Since then Ryan has been working as a character animator at Rainbow Studios, a division of THQ, in Phoenix, Arizona. His work can be seen at: www.lineofaction.com.

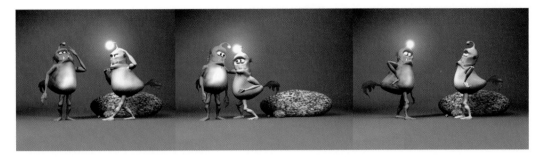

Trigger by Ryan Yokley (2002).

Workflow

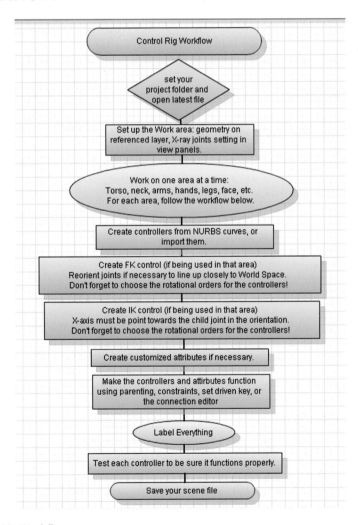

Control Rig Workflow.

Now that there is a skeletal structure inside of the character, a control system will be needed to make the animation process easier. Setting a **keyframe** on joints directly while animating can be cumbersome, making productive animation both difficult and time-consuming. Maya has a series of tools that can be used to build a customizable control system, or rig. The goal of a good character rig is to give animators simplified, intuitive control over their character's skeleton, so that the character can be posed and animated easily. This chapter will introduce several approaches and discuss how they are commonly used to create the character rig. The assignments that follow will utilize these techniques to create a basic rig, with a few extras that make the animation process easier. It is important to remember that the approaches shown in this book are not the only way to create a rig. My goal is to give you a variety of approaches that can be adapted for different needs. Before you can explore more advanced control systems, I hope to provide the good foundation necessary for a more complex rig later.

Before we can create controls, however, there needs to be a basic understanding of how things work during the animation process. Animation, by definition, is the ability to make something appear alive through movement. Movement can be created by calculating a change from one position in space to another, using translate, rotate, and scale. Joints are usually rotated to achieve a natural motion when animating a skeleton. When a hierarchy exists, such as with a joint chain, these rotations must be calculated not only for the joint rotated, but for the rest of the hierarchy as well. There are two methods for calculating the positions of the hierarchy during animation – forward kinematics or inverse kinematics. Each method affects the hierarchy differently.

Eyeball man by **Neil Helm (2005).**

Kinematics

In a nutshell, kinematics is the study of motion. More specifically, it is the section of physics that deals with motion without any application of force and mass. Kinematics is not only movement, but the consideration of how things move. In animation, there are two kinematical systems in place – forward kinematics and inverse kinematics.

Forward Kinematics

Forward kinematics, or FK, is a method where a hierarchy of joints (or objects) is rotated one at a time to create a pose. A key is then set on the rotation channels for each joint (or object). The position of a joint in the hierarchy is calculated based on the positions of each and every joint above. For example, in order to position the wrist, the animator must first consider the position of the torso, the shoulder, and the elbow (from the top of the hierarchy down, in a forward direction). If a character's arm is moving, the wrist is affected by the elbow, which is affected by the shoulder. Any movement in the character's spine would also affect the position of the entire arm.

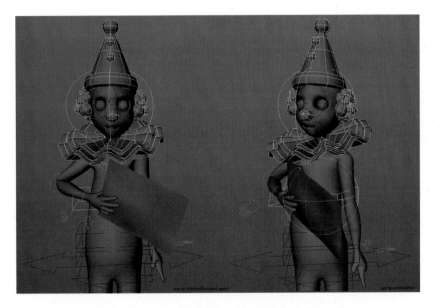

Rotating the spine (right image) with an FK arm repositions the entire arm.

One of the biggest challenges for FK is that it is pretty much impossible to fix a joint in space, as any movement above that joint in the hierarchy would move the joint out of place.

Because it is difficult to **select** joints when animating, a control system is created to make the selection easier. A NURBS curve is usually used, and the curve is used to control the joint. There are several tools available (discussed later in this chapter) that allow the curve to control the joint. The best way that I have come across, however, is to use a MEL command to parent the shape of a NURBS curve to the transform node of a joint. (I first heard of this during Jason Schliefer's Maya Masterclasses on Animator Friendly Rigging, but I have done some research and found multiple sources for this approach, so I'm not actually sure where this idea originated. Check out his DVD series available on Autodesk's website, a great step after understanding this book!) This MEL script actually makes the NURBS curve the shape node of the joint (joints do not have

shape nodes associated with them, so we have the ability to assign one with the MEL command). The MEL command is as follows:

parent -add -shape nurbsCircleShape1 joint1;

where *nurbsCircleShape1* is the name of the NURBS curve and *joint1* is the name of the joint.

Inverse Kinematics

Inverse kinematics, or IK, is a mathematical system that calculates the rotations of a joint chain from the identified start joint all the way to the established end joint of the chain. An IK handle is created at the end of the chain that allows the animator to position the location of the end of a limb. Because of this, IK is a more intuitive way of positioning a character, much like a digital puppet. Once the handle is positioned, the calculations then occur to position the rest of the chain based on the location of the end joint, all the way back up to the start joint (from the bottom of the hierarchy up, or in an inverse direction).

IK enables a character the ability to plant its feet on the ground and remain there when moving the body. This is commonly referred to as stickiness, which is very difficult to achieve using FK. When animating, IK is used when stickiness is needed or when movement is driven from the bottom of the limb; that is, feet planted on the ground (feet stick because of the IK solver in the legs and feet), character pushing against something (hands stick because of the IK solver in the arms and hand), a character throwing a ball (a wrist driven motion with IK in the arms).

IK in the legs and feet provide the ability to keep the feet planted on the ground when moving the torso down (right image).

Because IK solvers have a tendency to break, or stop solving, while animating, IK handles should never be keyframed directly. Always control IK handles indirectly with a control system. The single chain (SC) or rotate plane (RP) solvers can be controlled by constraining or parenting the IK handle to an object, such as a group node, locator, or a

NURBS curve. The Spline IK curve can be controlled using deformers, such as joints or clusters, which can also be parented to a NURBS controller. These approaches will be explored during the assignments for this chapter.

When creating IK handles, Maya automatically creates an IK/FK blend system, which allows you to switch back and forth between IK and FK while animating. This built-in blend system is not 100% reliable and sometimes causes awkward flipping of the joint chain during the blend. We will not be covering the built-in system in this edition. Instead, we will look at building a three joint chain blend, which is a much more traditional and reliable way of switching between IK and FK.

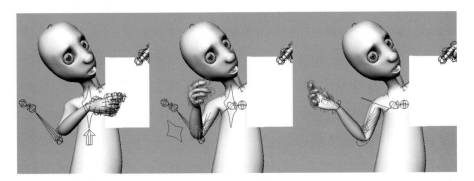

A three joint chain blend. The image on the left is the IK control, the image in the middle is the mid-blend position, and the image on the right is the FK control. The geometry is controlled by the third joint chain, which blends between the IK and the FK control arms.

Usually, a series of IK chains are used through a single joint hierarchy in order to create the control necessary for a limb. For example, a single IK chain from the hip to the toe would not work for the control needed in the leg and foot. The toes, the ankle, and the leg need to be able to move independently from each other. In order to accomplish this, three separate IK chains need to be created and then parented into a hierarchy for maximum control.

The most commonly used IK solvers in Maya for biped setup are the SC solver, the RP solver, and the Spline IK solver. It is important to understand the differences as well as when and why to use each solver.

The SC and the RP solvers are similar in that they both calculate the rotations of all of the joints in an IK chain. The major difference is that the RP solver includes additional control for the ability to change the orientation of the joint chain from the start joint. To demonstrate the difference, imitate the pictures below. Hold your arm out straight and parallel to the floor (the beginning joint chain). Bend your elbow so that your wrist moves toward your shoulder keeping your elbow parallel to the floor (this demonstrates the rotations of the joint chain for both SC and RP solvers). Now rotate your shoulder and bring your elbow down (this demonstrates the change in the orientation of the joint chain for the RP solver by rotating the plane from the

shoulder – the start joint of the chain). The SC solver is usually used in the hands and feet, while the RP solver is usually used in the arms and legs.

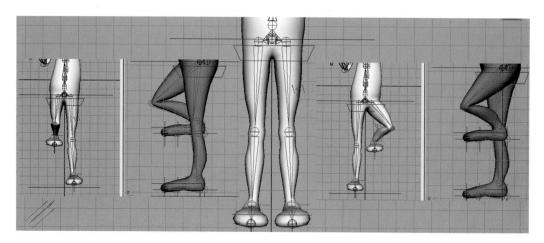

The character's right leg (your left) has an SC solver running through the joint chain. The character's left leg (your right) has an RP solver, which provides the additional ability of rotating the knee from the hip joint.

! Make sure to set preferred angles in joints where you are running SC or RP IK. A preferred angle tells Maya which direction the joint should bend when an IK solver runs through it. If you do not, when you move the IK handle, the joint will bend in the wrong direction, or not bend at all. To set a preferred angle, **select** the joint in the center of the chain (such as an elbow or knee), rotate it in the direction it should bend, choose the joint ABOVE that joint in the hierarchy, then go to [Skeleton > Set Preferred Angle]. You can then return the rotated joint back to zero by clicking on it and typing 0 in the rotation channels of the channel box.

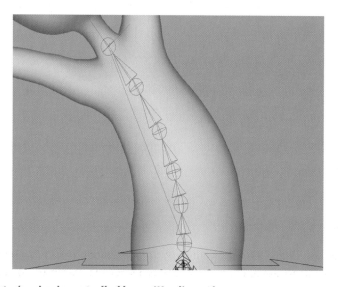

The character's spine is controlled by an IK spline solver.

The Spline IK solver is a completely different solver than the RP or SC. The Spline IK handle does NOT directly control the position of the chain. Instead, a NURBS spline curve runs through the identified joint chain. By moving the curve, or control vertices (CVs) on the curve, the solver then positions the joints based on the new shape or position of the curve. This solver is best used for long joint chains such as those needed in the neck, spine, or tail.

Attribute Control

Creating controllers from NURBS curves seems to be the most popular way to control a character rig. By using all NURBS curves, it is possible to drag select all controllers simultaneously which can speed up the keyframing process when animating. Additional attributes can be added to the curves for customizable control. There are several ways of linking the NURBS curves with attributes that need control.

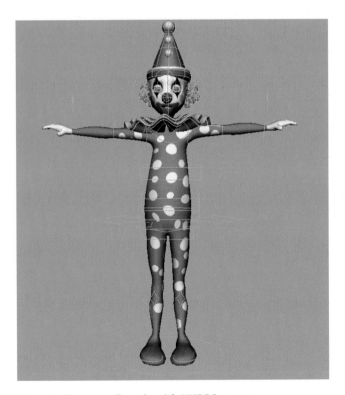

The character's controllers are all made with NURBS curves.

Rotation Order

Before beginning any discussion about creating associations for control, there really needs to be an understanding about rotation order. Having the correct rotation order on controllers is probably the most important thing when it comes to actually

animating with a control rig. To make sure that everything works properly, rotation order needs to be established for joints and FK controls in the very beginning of the setup process. FK control should always be set up before IK, especially if it is an FK/IK control system. The reason for this is that IK begins to place rotations on the joints the moment the solver is placed. This can lead to problems with the FK control setup. So, what exactly is rotation order and why is it so important?

Objects in a 3D environment rotate in either a **quaternion** rotation method or **Euler rotation** method. The default method (which we will be using) is Independent Euler-Angle Curves, which calculates the rotation according to the degree set along the X, Y, and Z axis but evaluates the rotation based on the chosen rotation order. The rotation order establishes how the object orients when rotating the object from one position to the next. The default rotational order on all objects in Maya is XYZ.

In order to see how the rotations work you must change your rotate tool mode to **Gimbal** by **double-clicking** on the rotate tool button to open the tool settings window and set the rotate tool rotate mode to "**Gimbal**". The rotate tool options have three rotate modes: Local, World, and Gimbal. When an object is selected, the rotate tool allows interactive rotation by **click-holding** on a colored ring and dragging the mouse to rotate.

The rotate tool settings window.

However, in Local and World modes, this rotation is not accurate along the specified colored rings. We don't always truly rotate along the specified axis for that color (X:red, Y:green, Z:blue). Sometimes more than one rotational value of the object being rotated may change in the XYZ channels in the channel box. When animating, this can be a serious problem and cause all kinds of unpredictable rotational behavior. In Gimbal mode, only a single X, Y, or Z rotation axis value in the channel box will change when

clicking on the specified color ring. Gimbal mode is the ONLY mode that shows you exactly what happens.

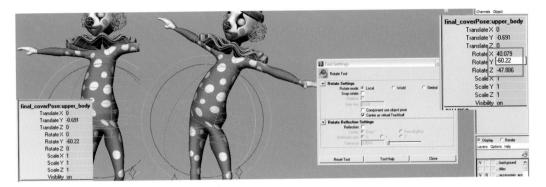

After rotating the character in Local mode on the Y axis, further rotation on the Z axis also causes the X axis to rotate.

To see what on earth I am talking about, create a sphere in Maya. With the sphere selected, change your rotate tool to Gimbal, and **click** on the X axis (red ring) of the rotate tool ring and rotate it. You will notice that nothing is affected. The rotate tool looks exactly the same as before we rotated the X axis. Because X is first in the rotation order, it does not affect any of the other axes.

Rotating the sphere in Gimbal mode on the X axis.

If you rotate the Z axis (blue ring), it carries both the X and Y axes with it because it is last in the rotation order, so it affects both of the other axes.

Now, if you rotate the Y axis (green ring) you will notice that the X is carried with the Y, and if the Y axis is rotated 90 degrees, the X axis now lines up with the Z axis. At this point you are now unable to rotate the sphere toward the front or back of 3D space because both the X and Z axes rotate the sphere side to side. This is what is referred to as **Gimbal lock**, and it can cause some pretty huge frustrations for an animator. Changing the tool back to Local or World mode seems to solve the ability to rotate, but

Rotating the sphere in Gimbal mode on the Z axis carries both the X and Y axis rings with it.

then we are back to inaccurate rotations in multiple axes, which causes crazy flipping during the animation and much more frustration for the animator.

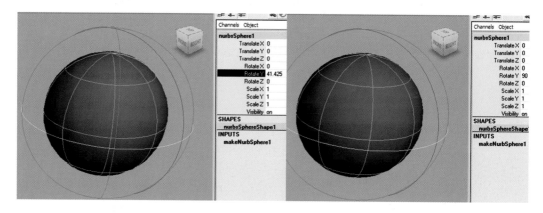

Rotating the sphere in Gimbal mode on the Y axis (left) carries the X axis ring with it – all the way to Gimbal lock (right).

So what is an animator to do? Knowing what to do to fix the issue is helpful, but here is where workflow is a huge concern. The correct rotation order must be chosen while the FK controls are being set up, otherwise the other tools (like constraints, set driven keys, and IK) that were used to make the rig easier to work with simply won't work anymore. FK Rotational Orders must be established before the other things are set up.

So when you create your FK controls, it is important to think about how that control will be used during animation then set the joint and controller appropriately. The easiest way to figure out which order you will need is to try it out on a sample skeleton and change the orders around. There really is no "only" way of setting these. There is simply preference. In my opinion, the most important rotation should go last (all the way to the right), since it carries the other two rotations with it. The first axis (all the way to the left) should be the least important as it affects only itself.

So, think about which direction the object moves the most. For example, a head turns left to right most often, so that would be rotating on the Y axis. Then I would say for the next motion, the head goes up and down most frequently (or rotating on the X axis). Lastly, the head tilts left to right, rotating along the Z axis. So I would choose a rotation order of ZXY for the head controller.

Don't worry too much if this is getting a bit confusing. This is one concept that does take some time to sink into your brain and understand. I have included my preferences in the assignments, but feel free to change them as you deem necessary.

Connection Editor [Window > General Editors > Connection Editor]

The connection editor allows you to take one attribute (referred to as the INPUT or upstream) to control one or more attributes of any objects (referred to as the OUTPUT or downstream) in the scene. An easy way to think about how the connection editor works would be to think about how shopping cart wheels rotate. By pushing the cart (translate), the wheels rotate. If the same motion would be duplicated in the Maya environment, the connection editor could be used to connect the input translation value on the Z axis (if the cart faced toward +Z) to the output rotate X value of the wheels. It is important to make sure that the objects that are going to be connected have frozen transformations because making a connection forces the output value to match the input value. A connection turns the attributes that it controls yellow in the channel box.

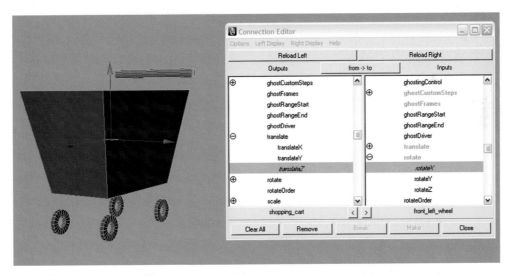

The connection editor can be used to make a direct connection from one attribute to another.

However, this means for every one Maya unit translated in Z, the wheel will rotate only one degree in X. The wheels rotate very slowly with this direct connection. So this is probably not the best way to create this control system. During character setup, the connection editor can be used to connect the NURBS curve controller rotations to the joint or object rotations that they are controlling.

The connection editor can be found in the Window menu under the General Editors submenu.

Expressions [Window > Animation Editors > Expression Editor]

The expression editor also offers the ability to control attributes, but provides even greater control using expressions that contain specific mathematical equations, conditional statements (if, then), or MEL commands. An expression turns the attributes that it controls purple in the channel box.

Returning to our shopping cart example, an expression can be created that gets exactly the same result in a mathematical equation using MEL:

$$wheel.rotateX = cart.translateZ$$

However, the great thing here is that we can add more math to make the wheel rotate faster. We can add a multiplier that allows us to increase the speed of the rotation:

$$wheel.rotateX = cart.translateZ * 45$$

This equation now rotates the wheel 45 degrees for every Maya unit that the cart is translated.

The above example is just a taste of what can be done with expressions. During character setup, expressions can be used to automate motion, such as a character's breathing (which will be done in Chapter 8).

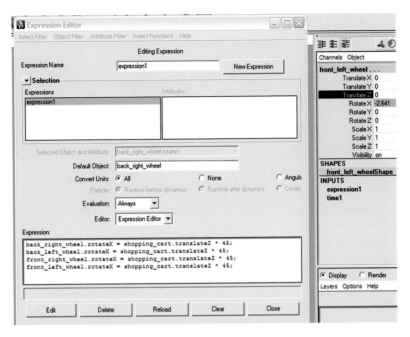

The expression editor can use mathematical equations to create attribute control.

The Expression Editor can be found in the Window menu under the Animation Editors submenu.

Set Driven Key [Animate > Set Driven Key > Set...]

Set Driven Key is another tool that creates a control relationship between attributes in a scene file. The difference here is that a range of motion can be established by using keyframes. Set Driven Key is usually used for repetitive motion so that these motions do not need to be animated by hand every time they are needed. Much like the animation process, key poses can be created and keyframed. However, Set Driven Key creates keys which are not dependent on time. Instead, these keys are dependent on the relationship between two attributes. These keys can be manipulated in the Graph Editor. A set driven key turns the attributes that it controls orange in the channel box.

An easy way to think of this relationship is the comparison of a car and a driver. When driving down the street and coming to the corner where the car needs to turn, the driver doesn't stick his arm out of the window to turn the wheels! Instead, when a driver gets behind the wheel of a car to steer, the driver turns the steering wheel, which then, in turn, is connected to the tire rotation of the car. By turning the steering wheel, the driver can then control the car wheels and their direction.

Set Driven Key works in a similar way. You must first identify the driver (the object that is doing the controlling – also referred to as the *driver* in Maya), the steering wheel (the specific attribute that will be the controller), the tires (the object, or objects, that are being controlled – referred to as the driven in Maya), and the rotation of the direction of the tires (the specific attribute or attributes being controlled).

During character setup, Set Driven Key is usually used for foot control, finger control, and hand motion.

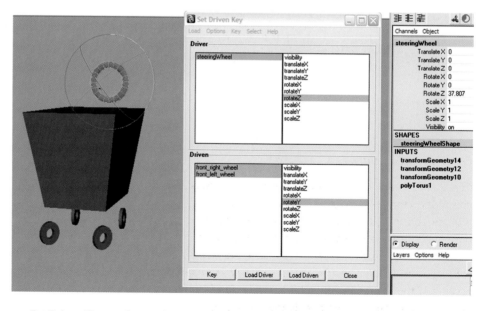

Set Driven Key can be used to create animated motion linked to other attributes. In the shopping cart example, I have added the ability to steer the front wheels by turning the steering wheel on the Z axis.

When creating Set Driven Keys, it is important to first make sure that your **tangents** are set in the Preferences to clamped. To do this, go to [Windows > Settings/Preferences > Preferences] **click** on the Animation category. In the TANGENTS section, choose "clamped" from the dropdown menu for "Default in" and "Default out".

Set Driven Key can be found in the Animation menu set by pressing (F2) on the keyboard in the Animate menu under the Set Driven Key submenu.

Constraints [Constrain]

Constraints are yet another way to control attributes. One of the benefits of a constraint is that it can be turned off, which proves to be beneficial when creating multiple control options and switching between them. Another benefit is that it can have multiple leaders. A constraint restricts the attributes of one object (follower) to the attributes of another (leader). A constraint turns the attributes that it controls blue in the channel box. If a keyframe is set on the object constrained, the channels will turn green, and the constraint will no longer work. For this reason, group nodes (discussed in the next section) are used to hold the constraint.

There are several different constraints available, but only the following will be used in setup of the character controls.

Constrain	Character	Help	
Point			❏
Aim			❏
Orient			❏
Scale			❏
Parent			❏
Geometry			❏
Normal			❏
Tangent			❏
Pole Vector			❏
Remove Target			❏
Set Rest Position			
Modify Constrained Axis...			

Constraints can be found in the Animation menu set by pressing (F2) on the keyboard under the Constrain menu.

Point [Constrain > Point]

A point constraint constrains the translation values of an object (follower) to another object (leader). Once the constraint is applied, the **pivot** of the follower will move to the exact position as the pivot of the leader. To avoid any repositioning, open the option box and choose "maintain offset" before applying the constraint. Once the constraint has been applied, when the leader is moved, then the follower moves also. During character setup, point constraints are often used to control IK handles.

Orient [Constrain > Orient]

An orient constraint constrains the rotation values of an object (follower) to another object (leader). Once the constraint is applied, the rotation of the follower will match to the current rotation values of the leader. To avoid any repositioning, either freeze transformations on both leader and follower, or open the option box and choose "maintain offset" before applying the constraint. Once the constraint has been applied, when the leader is rotated, then the follower rotates along its local axis also. During character setup, orient constraints are often used with a multiple joint chain control system to control joint rotations during the FK/IK switch (this will be explored in the assignments for the arm control rig). Orient constraints can also be used to control the rotations of joints using NURBS curves (leader) and joints (follower).

Parent [Constrain > Parent]

A parent constraint constrains both the translation and rotation values of an object (follower) to another object (leader). The rotational axis for a parent constraint is based on the world axis, not the local axis as with the orient constraint. Because of this, the follower acts as if it were a child to the leader, without actually being part of the hierarchy. Multiple leaders provide the workability of providing multiple parents,

which is impossible in a true parent–child relationship. The ability to turn the constraint off provides the keyframing option of "unparenting" during the animation process, which is also impossible in a true parent–child relationship. "Maintain offset" is on by default for this constraint.

During character setup, parent constraints are often used to create parenting relationships that need to be switched during animation (such as having the ability to choose whether the hands follow the body during movement, or stay in place to create stickiness). During the animation process, parent constraints are used also for object interactivity (such as when a character picks up something).

Aim [Constrain > Aim]

An aim constraint constrains the rotation values of an object (follower) to translation position of another object (leader) by establishing an aim vector in the options. To avoid any flipping of the object during the constraining process, open the option box and choose "maintain offset" before applying the constraint. Once the constraint has been applied, when the leader is translated, then the follower rotates along its local axis in order to follow the leader's position. During character setup, aim constraints are often used for creating eye control.

Pole Vector [Constrain > Pole Vector]

A pole vector constraint constrains the pole vector values of an RP IK solver (follower) to the translation position of another object, or controller (leader). Once the constraint has been applied, when the leader is translated, then the follower will rotate the joint chain through which the IK solver is running. This makes the control of the IK solver interactive and intuitive. During character setup, a pole vector constraint is used only with an RP IK solver.

Geometry [Constrain > Geometry]

A geometry constraint constrains the translation position of an object (follower) to a NURBS surface, NURBS curve, or polygonal surface (leader). It does not lock the translation values of the follower, as other constrains do, so this allows the ability to add a point constraint to follow another leader. Once the constraint has been applied, when the follower is translated, then the follower slides across the geometry (leader). During character setup, geometry constraints can be used with normal constraints for creating eye control for eyes that have separate pupils.

Normal [Constrain > Normal]

A normal constraint constrains the rotation, or orientation, of an object (follower) to a NURBS surface or polygonal surface (leader). Once the constraint has been applied, when the follower is translated, then the follower rotates with the alignment of the normal vectors of the surface geometry (leader). During character setup, normal constraints are used most effectively with geometry constraints for objects that need to slide across a surface, such as pupils that slide across a non-spherical eyeball, or a teardrop rolling down the cheek.

Group Nodes or Null [Edit > Group]

A group node in Maya is a transform node that becomes the parent of the items grouped. It allows you to move, scale, or rotate multiple objects at the same time. However, it can be used for much more.

When we think of a group, we usually think about a collection of items or people, such as a group of desks or a group of children. In Maya, however, a group can be multiple objects, one object, or nothing at all. I like to think of a group node as an invisible box. The "box" can be empty, contain one item, or multiple items. When animating, the "box" can be animated, and the items inside will move along with it. The objects inside the "box" can be animated as well while inside the "box" itself.

An empty group, a group of one object, or a group of several objects as seen in the Hypergraph.

Whenever an object is parented to a joint, group nodes provide a buffer transform node between the joint and the object. Joints, by nature, always contain transform information so that Maya knows where they are positioned in 3D space. When an object is parented to a joint, the object inherits this transform information. This can be a problem, especially when you want to keep transform information frozen on the object. By placing a group node above the object before parenting at the joint, the group node inherits the information from the joint instead of the object. This is especially important when parenting with NURBS curve controllers to joints. By keeping translation and rotation attributes at zero, it is easy to position the character back where they started in the T-pose.

Whenever constraints are used, group nodes provide the ability to continue animating the object constrained. Usually, the constraint is placed on the group node, which is made as the parent of the object being constrained. This way the object itself does not have any of the translation or rotation channels locked, and can still be animated.

! If a mistake has been made while setting up attribute controls, simply **click** on the word of the attribute in the channel box, hold down the RMB (right mouse button) and choose "break connections". This will remove the link between the attribute controller and the attribute.

Clusters [Create Deformers > Clusters]

A cluster deformer provides the ability to control individual or groups of points (CVs, vertices, or lattice points). By creating the cluster node, it is then possible to create a more intuitive control system. During character setup, clusters are usually used to control the NURBS spline curve that runs through the identified joint chain for the Spline IK.

Clusters can be found in the Animation menu set by pressing (F2) on the keyboard in the Create Deformers menu.

Former Student Spotlight: Ben Willis

Short films are stories: Stories about characters: Characters that have wants, desires, needs, emotions.

You are a storyteller. Even as a rigger, you are a storyteller. You define limitations. You define boundaries. But with boundaries there is freedom for expression.

Whether skinning or modeling, take your time to build the character right. Understand what the character needs. If you take the time now, you will see the freedom it will allow you later on, and how much better your short film will be.

The greatest piece of advice I could ever think to give a first time short film maker is keep things simple. Find that one idea with the most potential for expression in a short amount of time and dedicate all your efforts to that endeavor. Give yourself the best opportunity to see a project from conception to completion. There will always be time to be more ambitious. You WILL make mistakes. Nothing will ever turn out exactly as you intended. But in those "flaws" comes the beauty of making a film. You will learn and you will grow.

Ben Willis graduated from the Savannah College of Art and Design with a BFA in Animation. His first professional project after graduation was working at Charlex as an animator on a short film entitled "One Rat Short", which won Best in Show and People's Choice at SIGGRAPH '06 Electronic Theater. He currently works for Dreamworks Animation as an animator. You can see more of his work on his website: www.benjaminwillis.net.

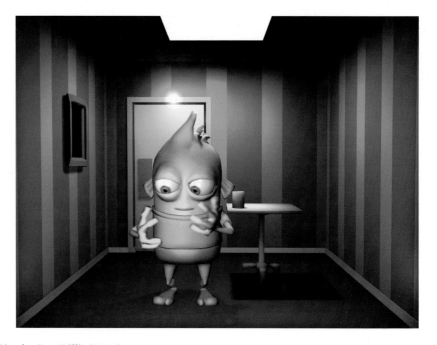

Ping **by Ben Willis (2004).**

Summary

6.1 The purpose of a control rig is to simplify the animation process, making it easier for animators to pose their characters in a 3D environment.

6.2 Animation, by definition, is the ability to bring something to life through movement.

6.3 Kinematics is the study of motion.

6.4 FK is a method where a hierarchy of joints or objects is rotated into a position and keyframed at every point of the hierarchy.

6.5 IK is a mathematical system that calculates the rotations of joints in a predefined chain.

6.6 When animating, IK provide the ability for stickiness.

6.7 Maya has three different IK solvers: the SC solver, the RP solver, and the spline solver.

6.8 Since IK solvers have a tendency to break and stop solving, a control system is used so that keyframes are not lost during animation.

6.9 It is common to create multiple control chains for different areas of the body for maximum control.

6.10 Maya uses an Euler rotation method when calculating the rotations of joints during an animation. When evaluating a joints rotation from one position to the next, the rotations are considered by a specific order dependent on the X, Y, or Z axis.

6.11 Gimbal lock occurs when two of the joint axes align during a rotation causing the inability to rotate in a particular direction.

6.12 It is important to animate in Gimbal mode so that you know exactly what type of rotations are occurring.

6.13 The connection editor is a tool that allows you to create a direct connection from one attribute to another.

6.14 The expression editor provides a place where MEL programming language can be used to create mathematical expressions within the scene environment.

6.15 Set Driven Key is a powerful tool unique to Maya that provides attribute control using keyframes set on one or more attributes as they relate to the value of the attribute in control.

6.16 Constraints are a leader and follower relationship, where one object's attribute leads while another object's attributes follows. Constraints can be keyframed on and off.

6.17 A point constraint controls the translation values of an object.

6.18 An orient constraint controls the rotation values of an object.

6.19 A parent constraint controls both the translation and rotation values based on the world axis.

6.20 An aim constraint controls the rotational values of an object and points them toward another object using an aim vector.

6.21 A pole vector constraint controls the pole vector values of an RP IK solver.

6.22 A geometry constraint constrains the translation position of an object to the surface of another.

6.23 A normal constraint constrains the rotation orientation of an object to the surface of another.

6.24 A group node is an empty transform node, or a transform node above one or more objects in a hierarchy. Think about group nodes as invisible boxes that can be empty or have one or more objects inside.

6.25 Group nodes can be placed above any object when constraints are used.

6.26 Clusters are deformers that provide the ability to control CVs or vertices. In character setup, they are used to help control the Spline IK solver.

Assignments

Assignment 6.1: Creating a Control System for the Spine Skeleton

Most of the controllers used in these assignments are made from the NURBS circle. In the companion DVD, I have provided some different shapes that can be used instead. If you would like to use the control shapes that I have provided, simply go to [**File > Import**] and find the Maya file on the DVD to import it into your scene file.

Set up your work environment by doing the following:

1. Open Maya and set your project.

 ● From your computer's desktop, go to [**Start > Programs**] and **select** Maya.

 ● Once Maya is open go to [**File > Project > Set...**] and browse to your project folder then **click OK**.

2. Open your last saved file: Go to [**File > Open**] and **select** *05_asgn05.ma*.

3. Continue working in X-ray Joints mode.

4. Make sure that your geometry is placed on a layer and that the layer is set to R for reference so that you are unable to **select** the geometry by mistake when working.

5. To make selection easier, open your outliner by going to [**Windows > Outliner**]. (In order to control the spine and still keep it flexible and natural looking, we will create an FK chain that controls an IK chain.)

6. Create an FK joint chain and an IK joint chain for the spine by doing the following:

 ● **Select** the *spine1* joint.

 ● Rename the original chain by adding the IK_prefix. Select [**Modify > Prefix Hierarchy Names...**] and set the following:

 i. **Enter** prefix: "IK_".

 ii. **Click OK**.

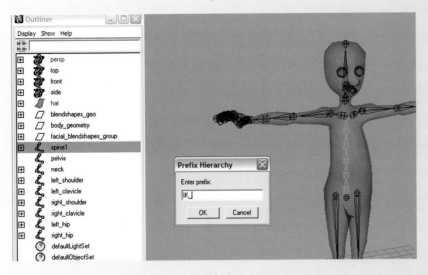

Adding the IK prefix to the spine joint chain.

- Duplicate the IK chain by going to [**Edit > Duplicate**] or press (**ctrl+d**). (The duplicated joint chain begins with IK_*spine7*. Since there already is an IK_*spine1* joint that begins the original joint chain, Maya places the next number as to not label with the same joint name. Having two IK_*spine1* joint chains would cause confusion in Maya. Maya will not use the exact name for multiple nodes. However, be careful NOT to use the exact name for multiple nodes when the nodes are in different hierarchies.)

- **Select** the IK_spine7 joint chain and rename the hierarchy by going to [**Modify > Search and Replace Names...**] and set the following:

 i. **Search** for: "IK".

 ii. **Replace** with: "FK".

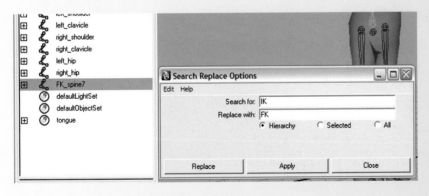

Renaming the duplicated IK chain as an FK chain using search and replace.

- **Select** FK_spine7 and in the channel box, rename it to FK_spine1.

You should now have two joint chains for the spine – one FK chain (beginning with FK_spine1) and one IK chain (beginning with IK_spine1).

7. We will now create the FK spine first. Remember, the FK spine should be created first so that the correct rotational orders can be set. It is very helpful to HIDE the *IK_spine1* joint chain so that it does not get in the way while creating the FK controls.

> To hide something in Maya, **select** the object and press (**ctrl+h**). You will notice that it turns blue in the OUTLINER. To make it visible again, **select** the object in the OUTLINER and press (**shift+h**).

8. In the OUTLINER, **select** the *IK_spine1* joint chain and press (**ctrl+h**) to hide the chain.

9. For the FK chain, we will not need all six joints – four should be plenty. We can remove the extra joints from the FK chain one at a time:

 ● **Select** the *FK_spine2*.
 ● Go to [Skeleton > Remove Joint].
 ● **Select** the *FK_spine5*.
 ● Press the (**g**) key to repeat the last command of removing a joint.

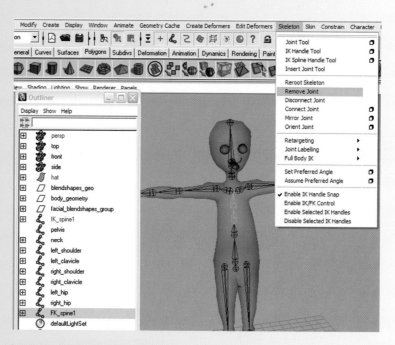

Removing extra joints in the FK spine.

10. **Select** the move tool by pressing (**w**), press the (**insert**) key on the keyboard, and **reposition** the *FK_spine3* joint on so that it is level at the waist of your character. Reposition the *FK_spine4* joint (up or down) so that it is level at the base of where your character's rib cage would be located.

Repositioning the FK spine joints.

11. Create a NURBS control for the upper body by doing the following:

● Go to [**Create > EP Curve Tool – option box**].

● Under *EP Curve Settings*, **change** the following:

Curve degree: choose "1 linear".

● In the top view, use the grid snap tool by holding the (**x**) key and **click** to **draw** a square around the body of your character. Hit "**enter**" when completed.

● In the channel box, **rename** the square *upperBody_ctrl*.

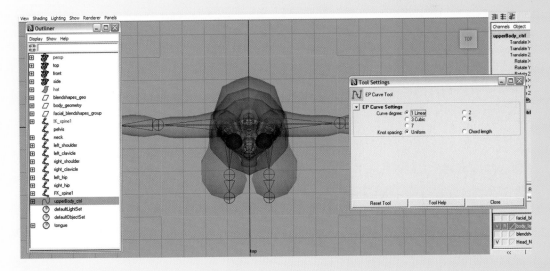

Creating the upperBody_ctrl.

● In PERSPECTIVE view, **select** the move tool by pressing (**w**), hold down the (**v**) key, position your cursor over the *FK_spine1* joint, and **click** the MMB (middle

mouse button) and drag it slightly to snap the *upperBody_ctrl* into place. (This is an easy way to ensure that the pivot of the square is snapped precisely in place. It might not seem easy at first, but after you have done this a few times, it will be easy. The important thing to remember is to place your mouse cursor over the joint that you want the controller to control. Do not **click** on the move tool when using the snap key.)

● Use the scale tool by pressing **(r)** and **resize** the square if necessary. (This control should be scaled large enough that it is far OUTSIDE of the character's geometry to make it easy to **select**.)

● With the *upperBody_ctrl* selected, go to [Modify > Freeze Transformations]. (To return the translate values to 0 and the scale values to 1.)

● In the OUTLINER, hold down the **MMB, click** on the *FK_Spine1* joint and **drag** it onto the *upperBody_ctrl*. (This makes the *FK_Spine1* child to the *upperBody_ctrl*. *By moving or rotating this controller, the entire Upper Body will move with it.*)

● **Change** the rotation order for the *upperBody_ctrl* by doing the following:

 i. With the *upperBody_ctrl* selected, **open** the attribute editor by pressing **(ctrl+a)**.

 ii. **Select** the *upperBody_ctrl* tab.

 iii. Under *Transform Attributes* **set** the following:

 1. Rotate order: choose "**ZXY**".

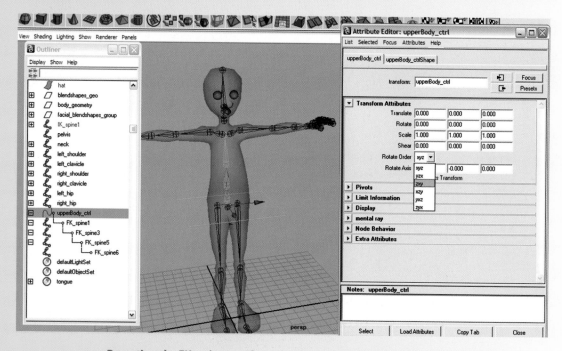

Parenting the FK_spine1 to the upperBody_ctrl, then changing the rotate order to ZXY.

12. **Create** controls for the FK spine by doing the following:

- First, we must reorient the FK spine by **selecting** the *FK_spine1* joint and going to [Skeleton > Orient Joint – option box]. **Set** the following:

 i. Orientation: choose **"YZX"**.

 ii. Second axis world orientation: choose **+Z**.

 (This will ensure that the joint orientation aligns with the world axis, which is necessary for FK control.)

 iii. **Click Orient.**

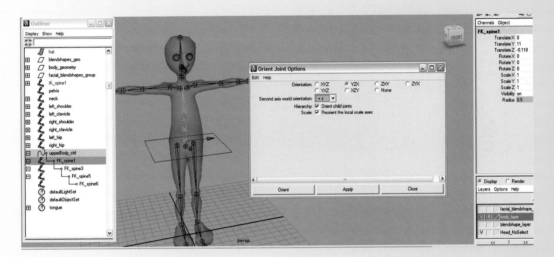

Reorienting the *FK_spine1* joint chain.

- Go to [**Create > NURBS Primitives > Circle**].
- In the MEL command line, **type** the MEL script below:

 parent -add -shape nurbsCircleShape1 *FK_spine3*;

 (This command gives a NURBS shape to the joint, making it easier to **select** during animation. It will appear that there are two NURBS circles in the scene.)

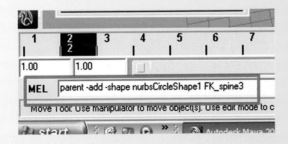

Typing a MEL script in the MEL command line.

- **Resize** the circle to fit around your character's geometry by doing the following:

 i. Press the **(F8)** key.

 ii. Choose the "**select** point components" button in the Status Line.

 iii. Using the scale tool by pressing **(r)**, **click** and drag around the points of the circle and scale them larger so that it extends beyond the character's body to make it easier to **select** when animating. (This affects both circles visible.)

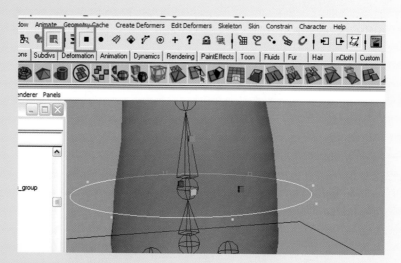

Scaling the nurbsCircleShape1 to fit around the character's geometry.

- Press the **(F8)** key to go back into object mode.
- **Select** the *FK_spine3* joint, and in the channel box, **rename** *FK_spine3* to *lower_spine_ctrl*.
- **Change** the rotation order for the *lower_spine_ctrl* by doing the following:

 i. With the *lower_spine_ctrl* selected, open the attribute editor by pressing **(ctrl+a)**.

 ii. **Select** the *lower_spine_ctrl* tab.

 iii. Under *Transform Attributes* **set** the following:

 1. Rotate order: choose "**ZXY**".

- In the OUTLINER, go to **[Display]** and make sure there is a check mark next to *shapes*. If not, **click** on the word *shapes*.

Displaying the shapes in the OUTLINER.

- In the OUTLINER, hold down the **shift key** and **click** on the plus sign (**+**) next to the *upperBody_ctrl* to open the hierarchy and display the children.

- **Double-click** on *nurbsCircleShape1* and **rename** it *LowerSpineShape*. (We must rename the *nurbsCircleShape1* so that Maya does not get confused if we create more NURBS circles later.)

> ! Feel free to turn the shape option off again later, as displaying shapes can clutter up the OUTLINER and make it confusing when trying to find objects. Just remember to turn it back on when necessary to **select** shapes.

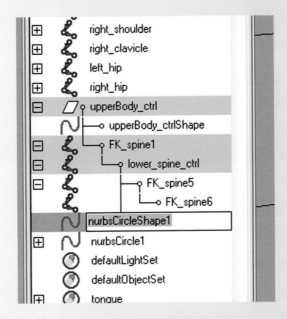

Renaming the *nurbsCircleShape1* to *LowerSpineShape*.

- In the OUTLINER, **select** nurbsCircle1 hit the **delete** key. (We no longer need the NURBS curves – we only needed the shape node.)

13. **Repeat** this process for the next joint in the spine by doing the following:

- Go to [**Create > NURBS Primitives > Circle**].

- In the MEL command line, **type** the MEL script below:

 parent -add -shape nurbsCircleShape1 FK_spine4;

- **Resize** the circle to fit around your character's geometry by doing the following:

 i. Press the (**F8**) key to go into component mode.

 ii. **Choose** the "**select** point components" button in the Status Line.

 iii. Using the scale tool by pressing (**r**), **click** and drag around the points of the new circle and **scale** them larger so that it extends beyond the character's body to make it easier to **select** when animating.

- Press the (**F8**) key to go back into object mode.

- **Select** the *FK_spine4* joint, and in the channel box, **rename** *FK_spine4* to *upper_spine_ctrl*.

- **Change** the rotation order for the *upper_spine_ctrl* by doing the following:

 i. With the *upper_spine_ctrl* selected, open the attribute editor by pressing **(ctrl+a)**.

 ii. **Select** the *upper_spine_ctrl* tab.

 iii. Under *Transform Attributes* **set** the following:

 1. Rotate order: choose **"ZXY"**.

- **Double-click** on *nurbsCircleShape1* and **rename** it *UpperSpineShape*. (We must rename the *nurbsCircleShape1* so that Maya does not get confused if we create more NURBS circles later.)

- In the OUTLINER, **select** nurbsCircle1 hit the **delete** key.

14. Now that we are finished with the FK spine, we can hide it to work on the IK spine. In the OUTLINER, **select** the *upperBody_ctrl* and **press (ctrl+h)** to hide it.

15. In the OUTLINER, **select** the *IK_spine1* joint chain and press **(shift+h)** to display the chain.

16. **Create** the IK spine by doing the following:

- Go to [Skeleton > **IK Spline Handle Tool – option box**] and **click "reset tool"** then **click** close.

- In the PERSPECTIVE window, **click** on the *IK_spine1* joint (the bottom spine IK joint) to define the start of the IK joint chain then **click** on the *IK_spine6* joint (the top spine IK joint) to define the end of the chain. (An IK handle appears at the end of the chain.)

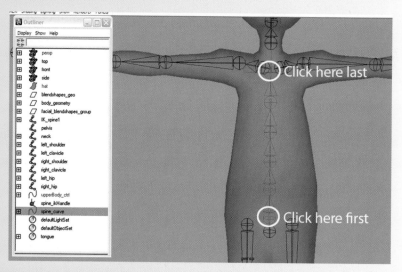

Creating the *spine ikHandle*.

- A Spline IK system is created with a curve running through the selected joints. You can then control this joint system by **selecting** the CVs of this curve and moving them. It is awkward, however, to **select** individual CVs (as CVs can only

be selected in component mode) and keyframe them (as CVs only have positions not based on the X, Y, and Z coordinates). We will create cluster deformers on each CV to make them easier to **select**, move, and keyframe on the X, Y, and Z coordinate systems.

As you place an IK handle, you can adjust the display size to see it better by doing the following:

Select [Display > Animation > IK Handle Sizes...].

Adjust the slider so that the IK handle is an appropriate size.

- In the OUTLINER, **double-click** on *ikHandle1* and **rename** it *spine_ikHandle*.

- In the OUTLINER, **double-click** on *curve1* and **rename** it *spine_curve*. (Curve1 is the spline curve that controls the IK solver.)

17. **Create** a control system for the IK spine by doing the following:

- In the PERSPECTIVE view panel, go to [**Show > None**], then [**Show > Curves**] and [**Show > Deformers**].

- In the OUTLINER, **select** the *spine_curve*.

- Change to component mode by pressing (**F8**). Make sure that the "**select** point components" button is depressed in the Status Line.

- **Select** the top CV point by **click** dragging across the spine to first display the CVs, then **click** dragging around the top CV point.

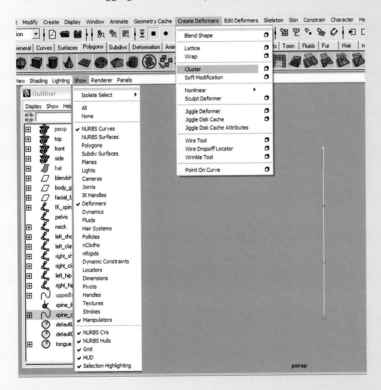

Selecting a CV on the *spine_curve*.

- **Select [Create Deformers > Cluster]**. (A green highlighted "C" will appear at the top of your FK spine joint chain. If it is not at the top, it usually indicates that more than one CV was selected. If this is your situation, simply undo by pressing **(z)** and reselecting only the top point.)

- **Select** the next point on the curve. Remember, if you are having trouble seeing it, first **select** the curve by **click** dragging across the spine to first display the CVs, then **click** dragging around the second CV point from the top.

- With the second CV selected, press the **(g)** key to repeat the last command of **[Create Deformers > Cluster]**.

- **Repeat** this process for the third and fourth CV points.

- In the OUTLINER, **double-click** on *cluster1handle* and **rename** it *spine_cluster1handle*.

- In the OUTLINER, **double-click** on *cluster2handle* and **rename** it *spine_cluster2handle*.

- In the OUTLINER, **double-click** on *cluster3handle* and **rename** it *spine_cluster3handle*.

- In the OUTLINER, **double-click** on *cluster4handle* and **rename** it *spine_cluster4handle*.

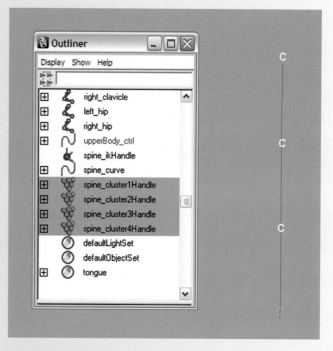

Creating the clusters on the *spine_curve*.

- In the PERSPECTIVE view panel, go to [**Show > All**].

! It is still difficult to **select** clusters. To make control of the clusters easier, we will parent them to NURBS controllers.

- Go to [**Create** > **NURBS Primitives** > **Circle**].

- In the channel box, **rename** the circle *spine_shoulder_ctrl*.

 Set the **RotateZ** channel to "90".

- In PERSPECTIVE view, **select** the move tool by pressing (**w**), hold down the (**v**) key, position your cursor over the *IK_spine6* joint, and **click** the MMB and drag it slightly to snap the *spine_shoulder_ctrl* into place.

- Use the scale tool by pressing (**r**) and **resize** the circle if necessary. (This control should be scaled large enough that it is far OUTSIDE of the character's geometry to make it easy to **select**.)

- With the *spine_shoulder_ctrl* selected, go to [**Modify** > **Freeze Transformations**]. (To return both translate and rotate values to 0 and the scale values to 1.)

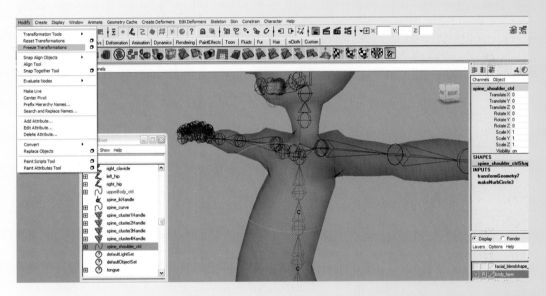

Creating the *spine_shoulder_ctrl*.

- Go to [**Create** > **NURBS Primitives** > **Circle**].

- In the channel box, **rename** the circle *hip_ctrl*.

- In PERSPECTIVE view, **select** the move tool by pressing (**w**), hold down the (**v**) key, position your cursor over the *pelvis* joint, and **click** the MMB and drag it slightly to snap the *hip_ctrl* into place.

- Use the scale tool by pressing (**r**) and **resize** the circle if necessary. (This control should be scaled large enough that it is OUTSIDE of the character's geometry to make it easy to **select**.)

- With the *hip_ctrl* selected, go to [**Modify** > **Freeze Transformations**]. (To return both translate and rotate values to 0 and the scale values to 1.)

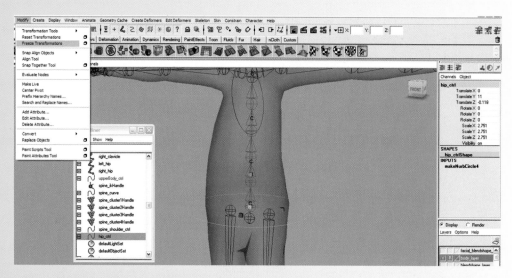

Creating the *hip_ctrl*.

- In the OUTLINER, **click** on the *spine_cluster1handle* cluster; then holding down the **ctrl key, click** on the *spine_cluster2handle* cluster and the *spine_shoulder_ctrl*. Press the **(p)** key to parent them. (This makes the *spine_cluster1handle* and *spine_cluster2handle* child to the *spine_shoulder_ctrl*. When you parent the clusters, they are automatically grouped. Maya displays a warning for notification, and is nothing to worry about.)

- In the OUTLINER, **click** on the *spine_cluster3handle* cluster; then holding down the **ctrl key, click** on the *spine_cluster4handle* cluster and the *hip_ctrl*. Press the **(p)** key to parent them. (This makes the *spine_cluster3handle* and *spine_cluster4handle* child to the *hip_ctrl*.)

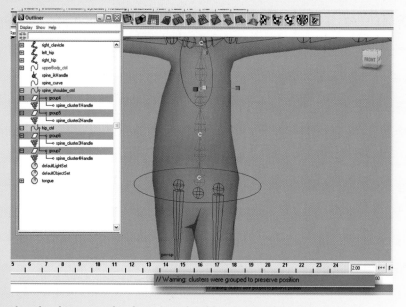

Parenting the clusters to the the *spine_shoulder_ctrl* and *hip_ctrl*.

- (When *spine_ikHandle* is selected, notice that there is an attribute named *Twist*. If you **click** on the word *Twist* in the channel box, place your cursor over the PERSPECTIVE view panel, and **MMB click** and drag left to right, you will notice that the joint rotation is tapered down to the beginning of the IK chain at the *IK_spine1* joint. We can control this *Twist* attribute interactively with the *Advanced Twist* options in the attribute editor to provide natural left to right rotation of the spine when the shoulders rotate.)

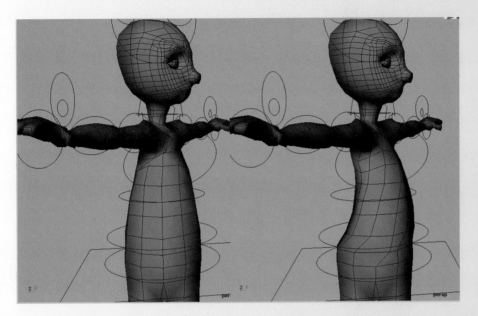

Notice the wireframe of the skinned character on the left as compared to the character on the right. The character on the left is simply rotating the top of the spine, while the character on the right shows how the twist attribute creates natural rotations down the spine when the character turns from right to left.

- **Select** the *spine_ikHandle* and press (**ctrl+a**) to open attribute editor.
- **Scroll** down to the *IK Solver Attributes* and **click** on the arrow (**>**) to open the section.
- **Scroll** down to the *Advanced Twist Controls* and **click** on the arrow (**>**) to open the section.
- Under *Advanced Twist Controls* section, put a **check** next to "Enable Twist Controls" and **set** the following:

 World Up Type: choose "Object Rotation Up (Start/End)".

 Up Axis: choose "Negative Z".

 Up Vector: type "0" "0" "–1".

 Up Vector 2: type "0" "0" "–1".

 World Up Object: type "hip_ctrl".

 World Up Object 2: type "spine_shoulder_ctrl".

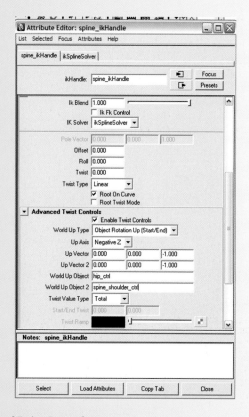

Setting the Advanced Twist Controls.

- **Change** the rotation order for the *hip_ctrl* by doing the following:

 i. With the *hip_ctrl* selected, open the attribute editor by pressing (**ctrl+a**).

 ii. **Select** the *hip_ctrl* tab.

 iii. Under *Transform Attributes* **set** the following:

 1. rotate order: choose "**ZXY**".

- **Change** the rotation order for the *spine_shoulder_ctrl* by doing the following:

 i. With the *spine_spine_shoulder_ctrl* selected, open the attribute editor by pressing (**ctrl+a**).

 ii. **Select** the *spine_spine_shoulder_ctrl* tab.

 iii. Under *Transform Attributes* set the following:

 1. Rotate order: choose "**ZXY**".

18. Integrate the IK spine into the existing spine controls by doing the following:

- In the OUTLINER, **select** the *upperBody_ctrl* and press (**shift+h**) to display it.

- In the OUTLINER, **hold down** the **shift** key and **click** on the plus sign (**+**) next to the *upperBody_ctrl* to open the hierarchy and display the children.

- **Select** the *spine_shoulder_ctrl* and press (**ctrl+g**) to group the *spine_shoulder_ctrl* node. (We must group the *spine_shoulder_ctrl* to add a buffer between the joint and the controller as discussed earlier in this chapter.)

- In the OUTLINER, **double-click** on the group node and **rename** it *spine_shoulder_ctrl_pad*.

- In the OUTLINER, **hold down** the MMB, **click** on the *spine_shoulder_ctrl_pad* and **drag** it onto the *FK_spine6* joint. (This makes the *spine_shoulder_ctrl_pad* child to the *FK_spine6* joint.)

- In the OUTLINER, **hold down** the MMB, **click** on the *hip_ctrl* and **drag** it onto the *upperBody_ctrl*. (No group is necessary when the parent is a NURBS curve.)

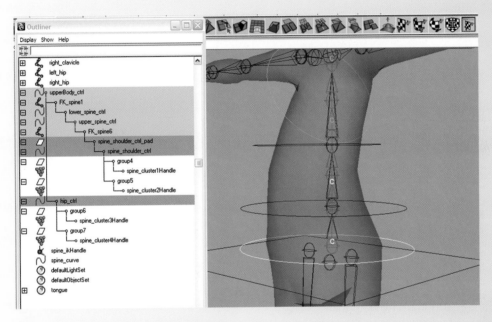

Integrating the IK spine into the FK spine.

19. **Save** your scene file. Name your scene *06_asgn01.ma*.

Assignment 6.2: Creating a Control System for the Neck and Head Skeleton

1. **Open** Maya and set your project.
 a. From your computer's desktop, go to [**Start > Programs**] and **select** Maya.
 b. Once Maya is open go to [**File > Project > Set...**] and browse to your project folder then **click** "OK".

2. **Open** your last saved file: Go to [**File > Open**] and **select** *06_asgn01.ma*.

3. Continue working in X-ray mode.

4. Make sure that your geometry layer is set to R for reference so that you are unable to **select** the geometry by mistake when working.

5. To make selection easier, open your OUTLINER by going to [**Windows > Outliner**].

6. First, we must reorient the neck for FK control by

 a. **Select** the *neck* joint and go to **[Skeleton > Orient Joint – option box]**. Set the following:

 i. Orientation: choose "**YZX**".

 ii. Second axis world orientation: **choose +Z**.

 (This will ensure that the joint orientation aligns with the world axis.)

 iii. **Click orient.**

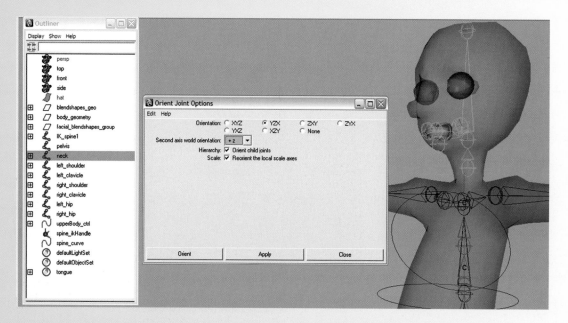

Reorienting the *neck* joint chain.

 b. Go to **[Create > NURBS Primitives > Circle]**.

 c. In the MEL command line, **type** the MEL script below:

 parent -add -shape nurbsCircleShape1 neck;

 (This command gives a NURBS shape to the joint, making it easier to **select** during animation. It will appear that there are two NURBS circles in the scene.)

 d. **Resize** the circle to fit around your character's neck geometry by doing the following:

 i. Press the **(F8)** key.

 ii. **Choose** the "**select point components**" button in the Status Line.

 iii. Using the scale tool by pressing **(r)**, **click** and **drag** around the points of the circle and **scale** them larger so that it extends beyond the character's neck

to make it easier to **select** when animating. (This affects both circles visible.)

e. Press the **(F8)** key to go back into object mode.

f. **Select** the *neck* joint, and in the channel box, **rename** *neck* to *neck_ctrl*.

g. **Change** the rotation order for the *neck_ctrl* by doing the following:

 i. With the *neck_ctrl* selected, **open** the attribute editor by pressing **(ctrl+a)**.

 ii. Under *Transform Attributes* **set** the following:

 1. Rotate order: choose "**ZXY**".

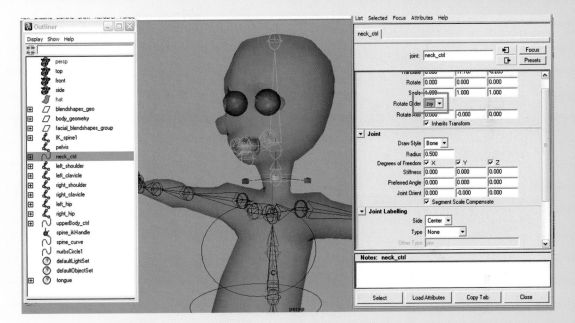

Adding a *nurbsCircleShape1* to the *neck* joint.

h. In the OUTLINER, go to **[Display]** and make sure there is a check mark next to *shapes*. If not, **click** on the word *shapes*.

i. In the OUTLINER, **hold down the shift key** and **click** on the plus sign **(+)** next to the *neck_ctrl* to open the hierarchy and display the children.

j. **Double-click** on *nurbsCircleShape1* and **rename** it *neckShape*. (We must rename the *nurbsCircleShape1* so that Maya does not get confused if we create more NURBS circles later.)

k. In the OUTLINER, **select** nurbsCircle1 and hit the **delete** key. (We no longer need the NURBS curves – we only needed the shape node.)

Finding the *nurbsCircleShape1* in the OUTLINER.

7. **Repeat** this process for the head joint by doing the following:

 a. Go to [**Create > NURBS Primitives > Circle**].

 b. In the MEL command line, type the MEL script below:

 parent -add -shape nurbsCircleShape1 head;

 c. **Resize** the circle to fit around your character's head geometry by doing the following:

 i. Press the **(F8)** key to go into component mode.

 ii. **Choose** the "**select point components**" button in the Status Line.

 iii. Using the scale tool by pressing **(r)**, **click** and **drag** around the points of the new circle and **scale** them larger so that it extends beyond the character's head to make it easier to **select** when animating. (Some students like using the move tool by pressing **(w)** and moving the points up around the forehead area, like a head band, because the area around the neck is starting to get a bit congested with controllers – or you could rotate the points into a different direction, like in the image below.)

d. Press the **(F8)** key to go back into object mode.

e. **Select** the *head* joint, and in the channel box, **rename** *head* to *head_ctrl*.

f. **Change** the rotation order for the *head_ctrl* by doing the following:

i. With the *head_ctrl* selected, open the attribute editor by pressing **(ctrl+a)**.

ii. Under *Transform Attributes* **set** the following:

1. Rotate order: choose "ZXY".

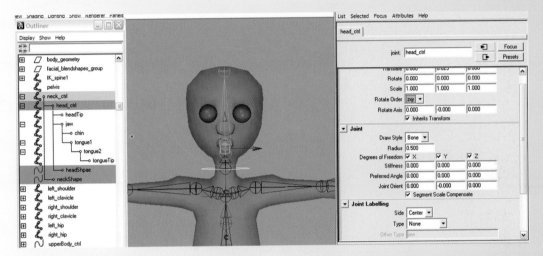

Adding a *nurbsCircleShape1* to the *head* joint.

g. In the OUTLINER, **select** nurbsCircle1 and hit the **delete** key.

h. **Double-click** on *nurbsCircleShape1* and **rename** it *headShape*.

8. Integrate the neck and head into the existing spine controls by doing the following:

a. In the PERSPECTIVE window, **select** the *neck_ctrl*, hold down the **(shift)** key and **click** the *shoulder_spine_ctrl*, and press **(p)** to parent.

9. Save your scene file. Name your scene *06_asgn02.ma*.

Assignment 6.3: Creating a Control System for the Clavicle

1. **Open** Maya and **set** your project.

a. From your computer's desktop, go to [**Start** > **Programs**] and **select** Maya.

b. Once Maya is open go to [**File** > **Project** > **Set...**] and browse to your project folder then **click** "OK".

2. Open your last saved file: Go to [**File** > **Open**] and **select** *06_asgn02.ma*.

3. Continue working in X-ray mode.

4. Make sure that your geometry layer is set to R for reference so that you are unable to **select** the geometry by mistake when working.

5. To make selection easier, open your OUTLINER by going to [**Windows** > **Outliner**].

6. In the OUTLINER, **select** the *left_shoulder* joint chain and the *right_shoulder* joint chain – then press **(ctrl+h)** to hide the chain so that it is not in the way as we set up the arm.

7. **Create** the IK clavicle by doing the following:

 a. Go to [Skeleton > **IK Handle Tool** – option box] and set the following:

 i. **Click** "reset tool" then under *IK Handle Settings* **change** the following:

 Current solver: choose "**ikSCsolver**".

 Place a check mark in the box next to **Sticky**.

 Then **click** "close".

 b. In the PERSPECTIVE window, **click** on the *left_clavicle* joint (to define the start of the IK joint chain) then **click** on the *left_clavicleTip* joint (to define the end of the chain. An IK handle appears at the end of the chain).

 c. In the OUTLINER, **double-click** on *ikHandle1* and **rename** it *leftClavicle_ikHandle*. (This chain will control the clavicle movement.)

 d. **Repeat** for the right clavicle.

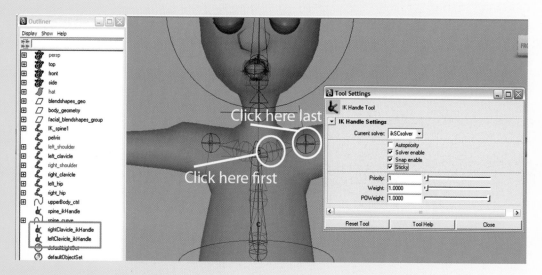

Creating the Clavicle_ikHandles.

8. **Create** a control system for the IK clavicle by doing the following:

 a. First **create** the controllers by doing the following:

 i. Go to [Create > **EP Curve Tool** – option box]

 1. Under *EP Curve Settings*, **change** the following:

 Curve degree: choose "**1 linear**".

 ii. In the FRONT view, use the grid snap tool by holding the **(x)** key and **click** to draw an arrow around the shoulder of your character. Hit "**enter**" when completed.

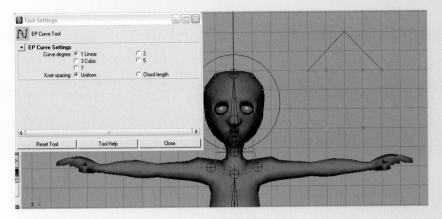

Drawing an arrow shaped curve using the EP curve tool.

 iii. In the channel box, **rename** the arrow *left_clavicle_ctrl*.

 iv. With the *left_clavicle_ctrl* selected go to [Modify > Center Pivot].

 v. In PERSPECTIVE view, **select** the move tool by pressing (w), hold down the (v) key, position your cursor over the *left_clavicleTip* joint, and **click** the MMB and **drag** it slightly to snap the *left_clavicle_ctrl* into place.

 vi. **Move and scale** the arrow by doing the following:

 1. Press the (F8) key.

 2. Choose the "**select** point components" button in the Status Line.

 vii. Using the scale tool by pressing (r), **click** and drag around the points of the arrow and scale them. This control should be scaled large enough that it is ABOVE the character's shoulder to make it easy to **select** when animating. Use the rotate tool by pressing (e) and rotate the arrow slightly away from the neck.

 viii. With the *left_clavicle_ctrl* selected, go to [Modify > Freeze Transformations]. (To return both translate and rotate values to 0 and the scale values to 1.)

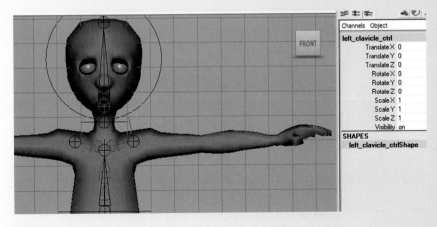

Positioning the *left_clavicle_ctrl*.

ix. **Duplicate** the *left_clavicle_ctrl* by going to [**Edit > Duplicate**] or press (**ctrl+d**).

x. In the **OUTLINER, double-click** on *left_clavicle_ctrl1* and **rename** it *right_clavicle_ctrl*.

xi. In PERSPECTIVE view, **select** the move tool by pressing **(w), click** on the X axis **(red arrow)**, hold down the **(v)** key, position your cursor over the *right_clavicleTip* joint, and **click** the MMB and **drag** it slightly to snap the *right_clavicle_ctrl* into place.

xii. With the *right_clavicle_ctrl* selected **set** the following in the channel box: **RotateY:** *type* "180".

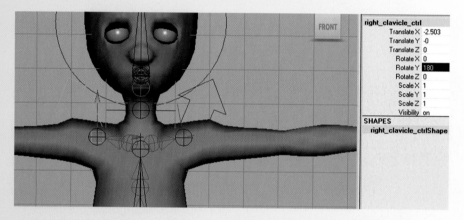

Duplicating the arrow and positioning the *left_clavicle_ctrl*.

xiii. Use the scale tool by pressing **(r)** and resize the arrow if necessary. With the *right_clavicle_ctrl* selected, go to [**Modify > Freeze Transformations**]. (To return both translate and rotate values to 0 and the scale values to 1.)

xiv. The rotation order does not need to be changed on this controller, because rotations are not necessary for control.

10. **Create** control between the controllers and the IK handles by doing the following:

a. In the OUTLINER, **click** on the *leftClavicle_ikHandle* with the MMB and **drag** it onto the *left_clavicle_ctrl*. (This makes the *leftClavicle_ikHandle* child to the *left_clavicle_ctrl*.)

b. In the OUTLINER, **click** on the *rightClavicle_ikHandle* with the MMB and **drag** it onto the *right_clavicle_ctrl*. (This makes the *rightClavicle_ikHandle* child to the *right_clavicle_ctrl*.)

11. Integrate the clavicles into the existing spine controls by doing the following:

a. In the PERSPECTIVE window, **select** the *left_clavicle* joint, hold down the **(shift)** key and **click** the *right_clavicle* joint, the *left_clavicle_ctrl*, the *right_ clavicle_ctrl*, the *shoulder_spine_ctrl*, and then press **(p)** to parent.

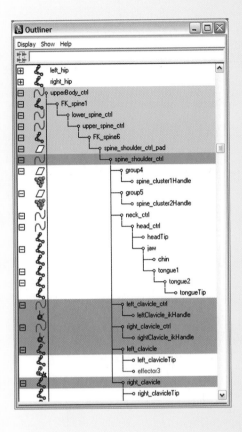

**The new OUTLINER hierarchy
after integrating the clavicles
into the existing spine controls.**

12. In the OUTLINER, **select** the *left_shoulder* joint chain and *right_shoulder* joint chain
 and press **(shift+h)** to display them.

13. **Save** your scene file. Name your scene *06_asgn03.ma*.

Assignment 6.4: Creating a Control System for the Arm

1. **Open** Maya and **set** your project.

 a. From your computer's desktop, go to **[Start > Programs]** and **select** Maya.

 b. Once Maya is open go to **[File > Project > Set...]** and browse to your project
 folder then **click** "OK".

2. Open your last saved file: Go to **[File > Open]** and **select** *06_asgn03.ma*.

3. Continue working in X-ray mode.

4. Make sure that your geometry layer is set to **R** for reference so that you are unable
 to **select** the geometry by mistake when working.

5. To make selection easier open your OUTLINER by going to **[Windows > Outliner]**.

6. In the OUTLINER, **select** the *upperBody_ctrl* and press **(ctrl+h)** to hide the chain, so
 that it is not in the way as we set up the arm.

We will be creating 3 joint chains for the arm. One chain will control the geometry, and
two chains will have control systems – one for FK and one for IK. A switch will be

implemented for the chain that controls the geometry so that the animator can choose which control system it will follow.

7. **Create** an FK joint chain for the arm by doing the following:

 a. **Select** the *left_shoulder* joint.

 b. **Duplicate** it by going to [Edit > **Duplicate**] or press (**ctrl+d**).

8. **Add** FK_ prefix to duplicated chain by **selec**ting [Modify > **Prefix Hierarchy Names...**] and set the following:

 a. **Enter** prefix: "FK_".

 b. **Click OK.**

 (The duplicated joint chain now begins with the *FK_left_shoulder1*.)

9. In the OUTLINER, **double-click** on *FK_left_shoulder1* and **remove** the 1, renaming it to *FK_left_shoulder*.

10. In the OUTLINER, **hold down the shift key** and **click** on the plus sign (**+**) next to the *FK_left_shoulder* to open the hierarchy and display the children.

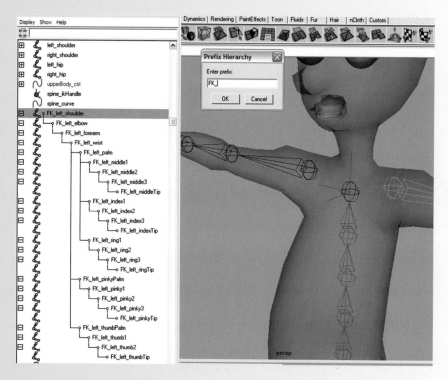

The new FK_left_shoulder hierarchy as seen in the OUTLINER.

11. For the FK chain, we will not need the *FK_left_forearm* joint. We can remove the extra joint from the chain by doing the following:

 a. **Select** the *FK_left_shoulder* joint.

 b. Go to [Skeleton > **Remove Joint**].

12. In the OUTLINER, **hold down the shift key** and **click** on the plus sign (**+**) next to the *FK_left_wrist* to open the hierarchy and display the children.

13. For the FK chain, we will not need the *finger* joints. We can remove the extra joints from the chain by doing the following in the OUTLINER:

 a. **Select** the *FK_left_middle1* joint and hit the **(delete)** key on the keyboard.

 b. **Select** the *FK_left_ring1* joint and hit the **(delete)** key on the keyboard.

 c. **Select** the *FK_left_index1* joint and hit the **(delete)** key on the keyboard.

 d. **Select** the *FK_left_pinkyPalm* joint and hit the **(delete)** key on the keyboard.

 e. **Select** the *FK_left_thumbPalm* joint and hit the **(delete)** key on the keyboard.

 Your joint chain should be left with only four joints:

 FK_left_shoulder, FK_left_elbow, FK_left_wrist, and *FK_left_palm.*

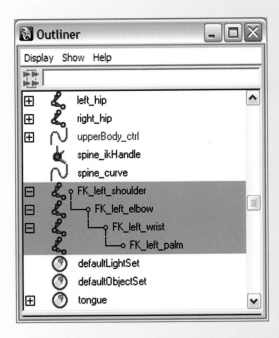

The FK_left_shoulder hierarchy after removing the unnecessary joints.

14. **Create** an IK joint chain for the arm by doing the following:

 a. **Select** the *FK_left_shoulder* joint.

 b. **Duplicate** it by going to [**Edit > Duplicate**] or press (**ctrl+d**).

15. **Select** the *FK_left_shoulder1* joint and **rename** the hierarchy by going to [**Modify > Search and Replace Names...**] and set the following:

 a. Search for: "**FK**".

 b. Replace with: "**IK**".

 (The duplicated joint chain now begins with the *IK_left_shoulder1*.)

16. In the OUTLINER, **double-click** on *IK_left_shoulder1* and **remove** the 1, renaming it to *IK_left_shoulder*.

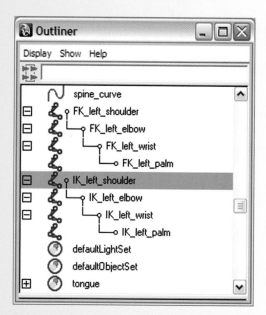

The new IK_left_shoulder hierarchy as seen in the OUTLINER.

17. At this time, we can mirror this chain for the right side by doing the following:

 a. **Select** the *IK_left_shoulder* joint, then go to [Skeleton > Mirror Joint – option box] and **enter** the following:

 Mirror Across: choose "**YZ**" axis.

 Mirror Function: choose "**behavior**".

 Replacement names for duplicated joints:

 Search for: **enter** "**left**".

 Replace with: **enter** "right".

 Then **click** "**mirror**" to execute the command. (We will not mirror the FK arm at this time. Instead, we will now create the FK arm controls first and then mirror, saving time, and some repetition.)

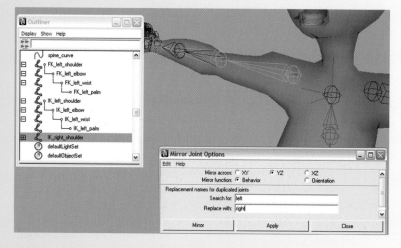

Mirroring the *IK_left_shoulder* joint for the right arm.

Remember, the FK arm should be created first so that the correct rotational orders can be set. It is very helpful to HIDE the joint chains that you don't need so that they do not get in the way while creating the FK controls.

18. In the OUTLINER, **select** the *IK_left_shoulder* joint chain and the *IK_right_shoulder* joint chain – then press **(ctrl+h)** to hide them.

19. In the OUTLINER, **select** the *left_shoulder* joint chain and the *right_shoulder* joint chain – then press **(ctrl+h)** to hide them.

20. **Create** controls for the FK arm by doing the following:

 a. Go to **[Create > NURBS Primitives > Circle]**.

 b. In the MEL command line, **type** the MEL script below:

 > parent -add -shape nurbsCircleShape1 FK_left_shoulder;

 c. **Resize** the circle to fit around your character's upper arm geometry by doing the following:

 > i. Press the **(F8)** key.
 >
 > ii. Choose the "**select point components**" button in the Status Line.
 >
 > iii. Using the scale tool by pressing **(r)**, the move tool by pressing **(w)**, and the rotate tool by pressing **(e)**, **click** and **drag** around the points of the circle and **scale** them larger so that it extends beyond the character's arm. **Position** it over the upper arm, and **rotate** to face forward to make it easier to **select** when animating.

 d. Press the **(F8)** key to go back into object mode.

 e. **Select** the *FK_left_shoulder* joint, and in the channel box, **rename** *FK_left_shoulder* to *FK_left_shoulder_ctrl*.

 f. **Change** the rotation order for the *FK_left_shoulder_ctrl* by doing the following:

 > i. With the *FK_left_shoulder_ctrl* selected, open the attribute editor by pressing **(ctrl+a)**.
 >
 > ii. Under *Transform Attributes* set the following:
 >
 > > 1. Rotate order: choose "XZY".

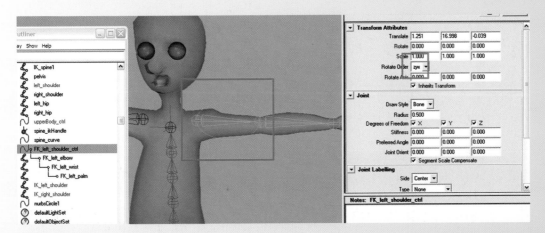

Adding a *nurbsCircleShape1* to the *FK_left_shoulder* joint.

21. Repeat this process for the elbow joint by doing the following:

 a. Go to [**Create > NURBS Primitives > Circle**].

 b. In the MEL command line, type the MEL script below:

 > parent -add -shape nurbsCircleShape2 FK_left_elbow;

 c. Resize the circle to fit around your character's forearm geometry by doing the following:

 > i. Press the (**F8**) key to go into component mode.

 > ii. Choose the "**select** point components" button in the Status Line.

 > iii. Using the scale tool by pressing (**r**), the move tool by pressing (**w**), and the rotate tool by pressing (**e**), **click** and drag around the points of the circle and scale them larger so that it extends beyond the character's forearm, position it over the upper arm, and rotate to face forward to make it easier to **select** when animating.

 d. Press the (**F8**) key to go back into object mode.

 e. **Select** the *FK_left_elbow* joint, and in the channel box, rename *FK_left_elbow* to *FK_left_elbow_ctrl*.

 f. Change the rotation order for the *FK_left_elbow_ctrl* by doing the following:

 > i. With the *FK_left_elbow_ctrl* selected, open the attribute editor by pressing (**ctrl+a**).

 > ii. Under *Transform Attributes* set the following:

 > > 1. Rotate order: choose "XZY".

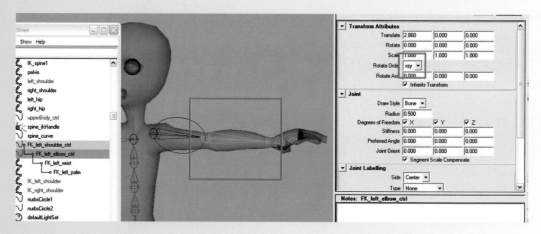

Adding a *nurbsCircleShape2* to the *FK_left_elbow* joint.

22. Repeat this process for the wrist joint by doing the following:

 a. Go to [**Create > NURBS Primitives > Circle**].

 b. In the MEL command line, type the MEL script below:

 > parent -add -shape nurbsCircleShape3 FK_left_wrist;

c. Resize the circle to fit around your character's hand geometry by doing the following:

 i. Press the **(F8)** key to go into component mode.

 ii. Choose the "**select** point components" button in the Status Line.

 iii. Using the scale tool by pressing **(r)**, the move tool by pressing **(w)**, and the rotate tool by pressing **(e)**, **click** and drag around the points of the circle and scale them larger so that it extends beyond the character's hand, position it over the upper arm, and rotate to face forward to make it easier to **select** when animating.

d. Press the **(F8)** key to go back into object mode.

e. **Select** the *FK_left_wrist* joint, and in the channel box, rename *FK_left_wrist* to *FK_left_hand_ctrl*.

f. Change the rotation order for the *FK_left_hand_ctrl* by doing the following:

 i. With the *FK_left_hand_ctrl* selected, open the attribute editor by pressing **(ctrl+a)**.

 ii. Under *Transform Attributes* set the following:

 1. Rotate order: choose "ZYX".

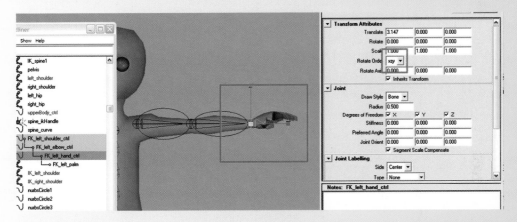

Adding a *nurbsCircleShape3* to the *FK_left_wrist* joint.

g. In the OUTLINER, **select** nurbsCircle1, nurbsCircle2, and nurbsCircle3 and hit the delete key. (We no longer need the NURBS curves – we only needed their shape nodes.)

h. In the OUTLINER, go to **[Display]** and make sure there is a check mark next to *shapes*. If not, **click** on the word *shapes*.

i. In the OUTLINER, hold down the shift key and **click** on the plus sign **(+)** next to the *FK_left_spine_shoulder_ctrl* to open the hierarchy and display the children.

j. Double-**click** on *nurbsCircleShape1* and **rename** it *leftShoulderShape* (we must rename the *nurbsCircleShape1* so that Maya does not get confused if we create more NURBS circles later.

k. Double-**click** on *nurbsCircleShape2* and **rename** it *leftElbowShape*.

l. Double-**click** on *nurbsCircleShape3* and **rename** it *leftHandShape*.

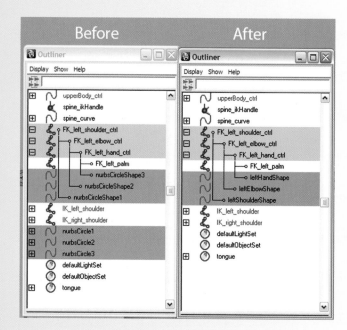

Renaming
nurbsCircleShape1,
nurbsCircleShape2,
nurbsCircleShape3
in the OUTLINER,
and deleting the
NURBS circle
curves.

23. At this time, we can mirror this chain for the right side by doing the following:

 a. **Select** the *FK_left_shoulder_ctrl* joint, then go to **[Skeleton > Mirror Joint –**
 option box] and **enter** the following:

 Mirror Across: choose "YZ" axis.

 Mirror Function: choose "behavior".

 Replacement names for duplicated joints:

 Search for: **enter** "left".

 Replace with: **enter** "right".

 Then **click** "mirror" to execute the command.

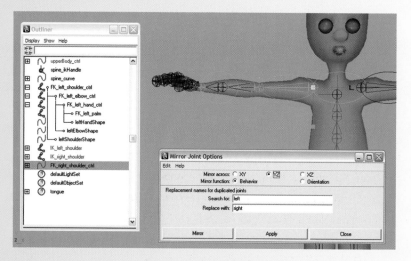

Mirroring the *FK_left_shoulder_ctrl* for the right arm.

b. When the arm is mirrored, the NURBS shapes do not. We must move them into the correct area of the arm. To do this, **select** the *FK_right_hand_ctrl* and reposition the curve by doing the following:

 i. Press the **(F8)** key.

 ii. Choose the "**select** point components" button in the Status Line.

 iii. Using the move tool by pressing **(w)**, **click** and drag around the points of the circle and position them over the right hand.

 iv. In the channel box, rename.

c. **Select** the *FK_right_elbow_ctrl* and reposition the curve by doing the following:

 i. Press the **(F8)** key.

 ii. Choose the "**select** point components" button in the Status Line.

 iii. Using the move tool by pressing **(w)**, **click** and drag around the points of the circle and position them over the right forearm.

d. **Select** the *FK_right_shoulder_ctrl* and reposition the curve by doing the following:

 i. Press the **(F8)** key.

 ii. Choose the "**select** point components" button in the Status Line.

 iii. Using the move tool by pressing **(w)**, **click** and drag around the points of the circle and position them over the right upper arm.

Positioning the mirrored curves over the right arm.

24. Because there still might be problems with Gimbal lock, we can add one more control above the shoulder to add another level of control to position the FK arm.

a. First create the controller by doing the following:

 i. Go to **[Create > NURBS Primitives > Circle]**.

 ii. In the channel box, rename the circle *left_FKarm_ctrl*.

 iii. In PERSPECTIVE view, **select** the move tool by pressing **(w)**, hold down the **(v)** key, position your cursor over the *FK_left_shoulder* joint, and **click** the MMB and drag it slightly to snap the *left_FKarm_ctrl* into place.

iv. Use the scale tool by pressing (**r**) and resize the circle if necessary. (This control should be scaled large enough that it is OUTSIDE of the character's arm to make it easy to **select**.)

v. With the *left_FKarm_ctrl* selected, go to [**Modify > Freeze Transformations**]. (To return both translate and rotate values to 0 and the scale values to 1.)

vi. Duplicate the *left_FKarm_ctrl* by going to [**Edit > Duplicate**] or press (**ctrl+d**).

vii. In the OUTLINER, **double-click** on *left_FKarm_ctrl1* and rename it *right_FKarm_ctrl*.

viii. In PERSPECTIVE view, **select** the move tool by pressing (**w**), hold down the (**v**) key, position your cursor over the *FK_right_shoulder* joint, and **click** the MMB and drag it slightly to snap the *right_FKarm_ctrl* into place.

ix. With the *right_FKarm_ctrl* selected, go to [**Modify > Freeze Transformations**]. (To return both translate and rotate values to 0 and the scale values to 1.)

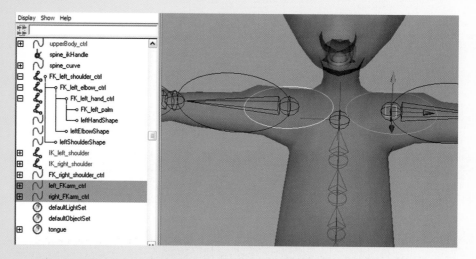

Creating the left and right FKarm_ctrl to aid in the prevention of Gimbal lock.

b. In the OUTLINER, **click** on the *FK_left_shoulder_ctrl* with the MMB and drag it onto the *left_FKarm_ctrl*.

c. In the OUTLINER, **click** on the *FK_right_shoulder_ctrl* with the MMB and drag it onto the *right_FKarm_ctrl*.

25. Now that we are finished with the FK arm, we can hide it to work on the IK arm. In the OUTLINER, **select** the *left_FKarm_ctrl* and the *right_FKarm_ctrl* – then press (**ctrl+h**) to hide them.

26. In the OUTLINER, **select** the *IK_left_shoulder* joint chain and the *IK_right_shoulder* joint chain – then press (**shift+h**) to display the chain.

27. Create the left IK arm by doing the following:

 a. Set a preferred angle in the left arm by doing the following:

 i. **Select** the *IK_left_elbow* joint and in the channel box set the following: RotateY: type "−25".

 ii. **Select** the *IK_left_shoulder* joint, then go to [**Skeleton > Set Preferred Angle**].

 iii. **Select** the *IK_left_elbow* joint and in the channel box set the following: RotateY: type "0". (MAKE SURE YOU DO THIS to make the elbow straight again.)

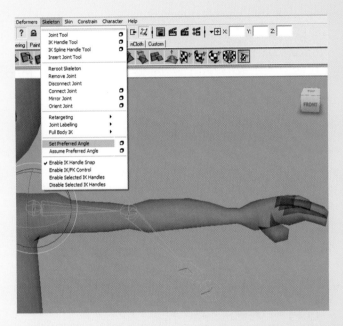

Setting a preferred angle on the left arm.

! We must first set a **preferred angle** in the arm so that Maya knows which direction to bend the arm when we run the IK solver through the joints. Be sure to straighten the arm again afterward.

 b. Go to [**Skeleton > IK Handle Tool – option box**] and set the following:

 i. **Click** "reset tool" then under *IK Handle Settings* change the following:

 Place a check mark in the box next to *Sticky*.

 Then **click** "close".

 c. In the PERSPECTIVE window, **click** on the *IK_ left_shoulder* joint (to define the start of the IK joint chain) then on the *IK_ left_wrist* joint. (To define the end of the chain. An IK handle appears at the end of the chain.)

 d. In the OUTLINER, double-**click** on *ikHandle1* and rename it *leftArm_ikHandle*. (This chain will control the arm movement.)

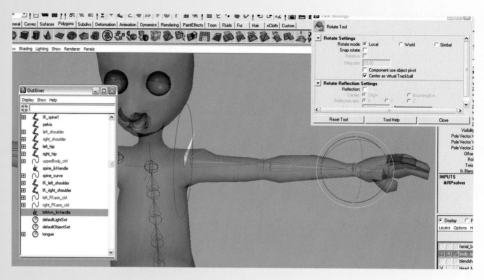

Creating an RP IK solver in the left arm.

e. It is a great idea to check to make sure the IK handle moves correctly along the X axis. You can do this by doing the following:

f. **Select** the *leftArm_ikHandle* and move the IK handle along the X axis **(red arrow)** toward the body to confirm that the arm bends in the correct direction. Be sure to press the **(z)** key to undo the move.

Moving the leftArm _ikHandle along the X axis to make sure the arm bends correctly.

g. Go to [**Skeleton > IK Handle Tool – option box**] and set the following:

i. Under *IK Handle Settings* change the following:

Current solver: choose "ikSCsolver".

Keep a check mark in the box next to *Sticky*.

Then **click** "close".

h. In the PERSPECTIVE window, **click** on the *IK_ left_wrist* joint (to define the start of the IK joint chain) then on the *IK_ left_palm* joint. (To define the end of the chain. An IK handle appears at the end of the chain.)

i. In the OUTLINER, double-**click** on *ikHandle1* and rename it *leftWrist_ikHandle*. (This chain will control the wrist movement.)

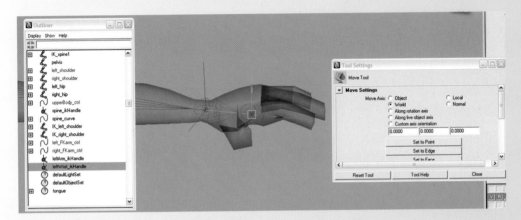

Creating a Single Chain IK solver in the left wrist.

! Unfortunately, IK solvers do not mirror the way we would like them to behave, so we will need to repeat the steps for the right side. You can repeat the right arm when suggested to do so, or wait until the end to redo the right side all at once.

28. Repeat the above to create the right IK arm.

29. Now that we are finished with the IK arm, we make everything visible again. In the OUTLINER, **select** the *left_FKarm_ctrl*, hold down the **(ctrl)** key and **select** the *right_FKarm_ctrl*, the *left_shoulder* joint chain, the *right_shoulder* joint chain, and the *UpperBody_ctrl* – then press **(shift+h)** to display them.

Displaying the hidden arms in the OUTLINER.

30. Create a control system for the IK arm by doing the following:

a. First create the controllers by doing the following:

i. Go to [**Create > NURBS Primitives > Circle**].

ii. In the channel box, rename the circle *left_IKhand_ctrl*.

iii. In PERSPECTIVE view, **select** the move tool by pressing (**w**), hold down the (**v**) key, position your cursor over the *IK_left_wrist* joint, and **click** the MMB and drag it slightly to snap the *left_IKhand_ctrl* into place.

iv. Use the scale tool by pressing (**r**) and resize the circle if necessary. (This control should be scaled large enough that it is OUTSIDE of the character's arm to make it easy to **select**.)

v. With the *left_IKhand_ctrl* selected, go to [**Modify > Freeze Transformations**]. (To return both translate and rotate values to 0 and the scale values to 1.)

vi. **Select** the *left_IKhand_ctrl* and reposition the curve around the hand by doing the following:

1. Press the (**F8**) key.

2. Choose the "**select** point components" button in the Status Line.

3. Using the move tool by pressing (**w**), **click** and drag around the points of the circle and position them over the right wrist.

vii. Change the rotation order for the *left_IKhand_ctrl* by doing the following:

1. With the *left_IKhand_ctrl* selected, open the attribute editor by pressing (**ctrl+a**).

2. Under *Transform Attributes* set the following:

a. Rotate order: choose "ZYX".

Creating and positioning the left_IKhand_ctrl to control the leftArm_ikHandle.

viii. Duplicate the *left_IKhand_ctrl* by going to [**Edit > Duplicate**] or press (**ctrl+d**).

ix. In the OUTLINER, **double-click** on *left_IKhand_ctrl1* and rename it *right_IKhand_ctrl*.

x. In PERSPECTIVE view, **select** the move tool by pressing (**w**), hold down the (**v**) key, position your cursor over the *IK_right_wrist* joint, **click** the MMB and drag it slightly to snap the *right_IKhand_ctrl* into place.

xi. With the *right_IKhand_ctrl* selected set the following in the channel box: RotateZ: type "180" (this will flip the controller over the right hand).

xii. With the *right_IKhand_ctrl* selected, go to [**Modify > Freeze Transformations**]. (To return both translate and rotate values to 0 and the scale values to 1.)

xiii. Go to [**Create > NURBS Primitives > Circle**].

xiv. In the channel box, rename the circle *left_IKelbow_ctrl*.

xv. In PERSPECTIVE view, with the *left_IKelbow_ctrl* selected, **select** the move tool by pressing (**w**), hold down the (**v**) key, position your cursor over the *IK_left_elbow* joint, **click** the MMB and drag it slightly to snap the *left_IKelbow_ctrl* into place.

xvi. With the move tool, **click** on the Z axis (**blue arrow**) and move the controller arm distance behind the character.

xvii. With the *left_IKelbow_ctrl* selected set the following in the channel box: RotateX: type "90".

xviii. Use the scale tool by pressing (**r**) and resize the circle if necessary.

xix. With the *left_IKelbow_ctrl* selected, go to [**Modify > Freeze Transformations**]. (To return both translate and rotate values to 0 and the scale values to 1.)

Creating and positioning the left_IKelbow_ctrl to control the leftArm_ikHandle's pole vector.

xx. The rotation order does not need to be changed on this controller because rotations are not necessary for control.

xxi. Duplicate the *left_IKelbow_ctrl* by going to [**Edit > Duplicate**] or press (**ctrl+d**).

xxii. In the OUTLINER, **double-click** on *left_IKelbow_ctrl1* and rename it *right_IKelbow_ctrl*.

xxiii. In PERSPECTIVE view, **select** the move tool by pressing (**w**) and **click** on the X axis (**red arrow**), hold down the (**v**) key, position your cursor over the *IK_right_elbow* joint, **click** the LMB (left mouse button) and drag it slightly to snap the *right_IKelbow_ctrl* into place. (By **select**ing the X axis first, the move is constrained to that axis only.)

xxiv. With the *right_IKelbow_ctrl* selected, go to [**Modify > Freeze Transformations**]. (To return both translate and rotate values to 0 and the scale values to 1.)

31. Create control between the controllers and the IK handles by doing the following:

 a. In the OUTLINER, **click** on the *left_IKhand_ctrl* (the leader), hold down the (**ctrl**) key and **click** on the *leftArm_ikHandle* (the follower), then go to [Constrain > **Point – option box**] and set the following:

 1. Go to [**Edit > Reset Settings**].

 2. Place a check mark in the box next to *Maintain Offset*.

 Then **click** "add".

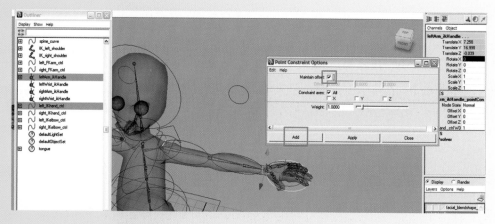

Creating a point constraint between the left_IKhand_ctrl (leader) and the leftArm_ikHandle (follower).

> This point constraint constrains the arm IK handle's translations to the controller so that when you move the controller, the IK handle follows it, BUT, when you rotate the controller, the IK handle does not. This is important in the arm setup because we don't want the entire arm to rotate when we rotate the hand.

 b. In the OUTLINER, **click** on the *leftWrist_ikHandle* with the **MMB** and drag it onto the *left_IKhand_ctrl*. (This makes the *leftWrist_ikHandle* child to the *left_IKhand_ctrl* so that it moves and rotates with the *left_IKhand_ctrl*, which is desirable in this case so that the wrist rotates with the forearm.)

c. In the OUTLINER, **click** on the *left_IKelbow_ctrl* (the leader), hold down the **(ctrl)** key and **click** on the *leftArm_ikHandle* (the follower), then go to **[Constrain > Pole Vector]**.

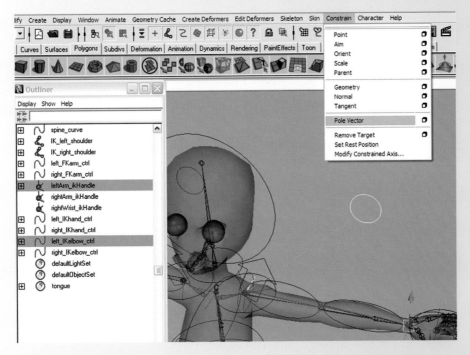

Creating a pole vector constraint between the *left_IKelbow_ctrl* **(leader) and the** *leftArm_ikHandle* **(follower).**

d. Repeat the constraints and parenting for the right arm.

e. Integrate the elbow controls into the existing spine controls by doing the following:

 i. In the PERSPECTIVE window, **select** the *left_IKelbow_ctrl*, shift **select** the *right_IKelbow_ctrl*, the *spine_shoulder_ctrl*, and press **(p)** on the keyboard to parent.

> **!** You can now test out your arm controls. **Select** the left_IKhand_ctrl and move it around toward the body so that the elbow bends. You can also rotate this control to control the wrist. **Select** the left_IKelbow_ctrl and move it up and down to control the position of the elbow. Be sure to press the **(z)** key several times to undo the moves.

32. The next part will create an integrated arm where the joint chain that will eventually control the geometry has a switch to choose between the FK control arm and the IK control arm. Do the following:

a. Create a constraint system with two leaders, the FK control arm and the IK control arm. To set this up, do the following:

 i. In the OUTLINER, **select** the *left_shoulder*, and while holding down the **(ctrl)** key, **select** the *left_FKarm_ctrl* and the *IK_left_shoulder*.

ii. Press (**ctrl+g**) to create a group of the three arms to make it easier to select.

iii. In the OUTLINER, **double-click** on *group1* and rename it *leftArm_grp*.

iv. In the OUTLINER, **select** the *right_shoulder*, and while holding down the (**ctrl**) key, **select** the *right_FKarm_ctrl* and the *IK_right_shoulder*.

v. Press (**ctrl+g**) to create a group of the three arms to make it easier to select.

vi. In the OUTLINER, **double-click** on *group1* and rename it *rightArm_grp*.

vii. In the OUTLINER, hold down the shift key and **click** on the plus sign (+) next to the *leftArm_grp* to open the hierarchy and display the children. (You might want to collapse the *palm*, *pinkyPalm*, and *thumbPalm* joints so that the arm hierarchy is not as long – you can do this by clicking on the negative sign (−) next to them.)

viii. In the OUTLINER, **click** first on the *FK_left _shoulder_ctrl*, and while holding down the (**ctrl**) key, **click** second on the *IK_left_shoulder* and **click** third on the *left_shoulder*, then go to [**Constrain** > Orient – option box] and set the following:

 1. Go to [**Edit** > **Reset Settings**].

 2. Place a check mark in the box next to *Maintain Offset*.

 Then **click "add"**.

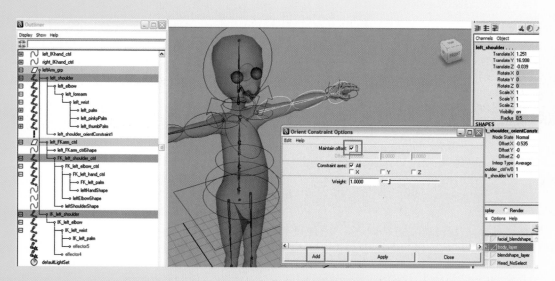

Creating an orient constraint between the *FK_left_shoulder_ctrl*, **the** *IK_left shoulder* **(both leaders) and the** *left_shoulder* **(follower).**

ix. In the OUTLINER, **click** first on the *FK_left_elbow_ctrl*, and while holding down the (**ctrl**) key, **click** second on the *IK_left_elbow* and **click** third on the *left_elbow*, then press the (**g**) key to repeat the last command of applying an orient constraint.

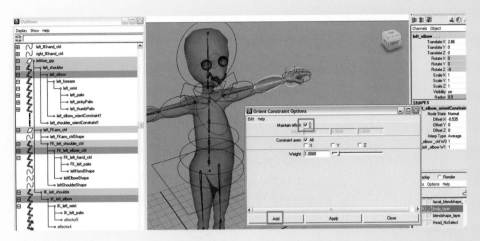

Creating an orient constraint between the *FK_left_elbow_ctrl*, the *IK_left elbow* (both leaders) and the *left_elbow* (follower).

x. In the OUTLINER, **click** first on the *FK_left_hand_ctrl*, and while holding down the **(ctrl)** key, **click** second on the *IK_left_wrist* and **click** third on the *left_wrist*, then press the **(g)** key to repeat the last command of applying an orient constraint.

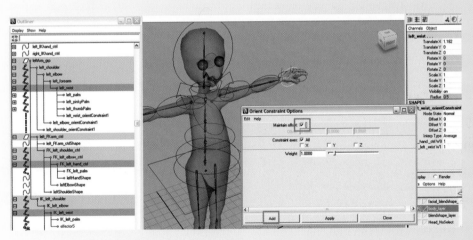

Creating an orient constraint between the *FK_left_hand_ctrl*, the *IK_left wrist* (both leaders) and the *left_wrist* (follower).

xi. In the OUTLINER, **click** first on the *FK_left_hand_ctrl*, and while holding down the **(ctrl)** key, **click** second on the *IK_left_wrist* and **click** third on the *left_forearm*, then go to **[Constrain > Orient – option box]** and set the following:

1. Go to **[Edit > Reset Settings]**.

2. Place a check mark in the box next to *Maintain Offset*.

3. Under Constraint axes: place a check mark in the box next to X.

 Then **click** "**add**".

(This constrain for the forearm is different from the other joints because we only want the forearm to twist with the wrist. It would look like the character's arm is broken if the forearm bent with the wrist. Because of this we only constrain the X axis.)

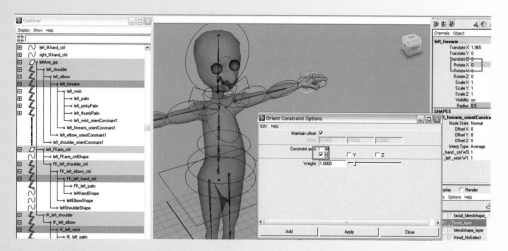

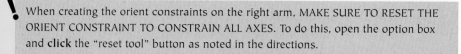

Creating an orient constraint between the *FK_left_hand_ctrl*, the *IK_left wrist* (both leaders) and the *left_forearm* (follower).

33. Repeat the constraints on the right arm.

! When creating the orient constraints on the right arm, MAKE SURE TO RESET THE ORIENT CONSTRAINT TO CONSTRAIN ALL AXES. To do this, open the option box and **click** the "reset tool" button as noted in the directions.

34. Create a switch to change the leader between the FK control arm and the IK control arm. To set this up, do the following:

 a. Go to [**Create > NURBS Primitives > Circle**].

 b. In the channel box, rename *nurbsCircle1* to *left_FKIK_switch*.

 c. In PERSPECTIVE view, with the *left_FKIK_switch* selected, **select** the move tool by pressing **(w)**, hold down the **(v)** key, position your cursor over the *left_wrist* joint, and **click** the **MMB** and drag it slightly to snap the *left_FKIK_switch* into place.

 i. With the move tool, **click** on the Y axis **(green arrow)** and move the controller slightly above the wrist.

 ii. With the *left_FKIK_switch* selected, **select** the scale tool by pressing **(r)** and scale the *left_FKIK_switch* smaller.

 iii. With the *left_FKIK_switch* selected set the following in the channel box: RotateX: type "90".

 iv. The rotation order does not need to be changed on this controller, because rotations are not necessary for control.

Creating and positioning the left_FKIK_switch to control the ability to turn the orient constraints on and off between the control arms.

 v. Duplicate the *left_FKIK_switch* by going to [**Edit** > **Duplicate**] or press (**ctrl+d**).

 vi. In the OUTLINER, **double-click** on *left_FKIK_switch1* and rename it *right_FKIK_switch*.

 vii. In PERSPECTIVE view, **select** the move tool by pressing (**w**) and **click** on the X axis (**red arrow**), hold down the (**v**) key, position your cursor over the *IK_right_wrist* joint, and **click** the LMB and drag it slightly to snap the *left_FKIK_switch1* into place. (By **select**ing the X axis first, the move is constrained to that axis only.)

 d. In the OUTLINER, **hold down the shift key** and **click** on the plus sign (**+**) next to the *FK_left_shoulder_ctrl* to open the hierarchy and display the children.

 e. In the OUTLINER, hold down the **MMB**, **click** on the *left_FKIK_switch* and drag it onto the *left_wrist* joint. (This makes the *left_FKIK_switch* child to the *left_wrist* joint.)

 f. In the OUTLINER, **hold down the shift key** and **click** on the plus sign (**+**) next to the *FK_right_shoulder_ctrl* to open the hierarchy and display the children.

 g. In the OUTLINER, hold down the **MMB**, **click** on the *right_FKIK_switch* and drag it onto the *right_wrist* joint. (This makes the *right_FKIK_switch* child to the *right_wrist* joint.)

 h. With the *right_FKIK_switch* selected, hold down the (**shift**) key and **select** *left_FKIK_switch*, then go to [**Modify** > **Freeze Transformations**]. (To return both translate and rotate values to 0 and the scale values to 1.)

 i. With the *left_FKIK_switch* and *right_FKIK_switch* selected, go to [**Modify** > **Add Attribute**]. Using the default settings, **enter** the following:

 i. Attribute name: type "FKIK".

 ii. Under *Numeric Attribute Properties*.

 1. Minimum: type "0".

 2. Maximum: type "10".

 iii. **Click** "OK".

> Data Type to Float. (Floating point numbers (or floats) have a fractional part (decimal points), allowing us to set any value between a minimum value and a maximum value which allows a smooth transition from one number to the next. The only type of attributes that we will be using in this setup is a Float.)

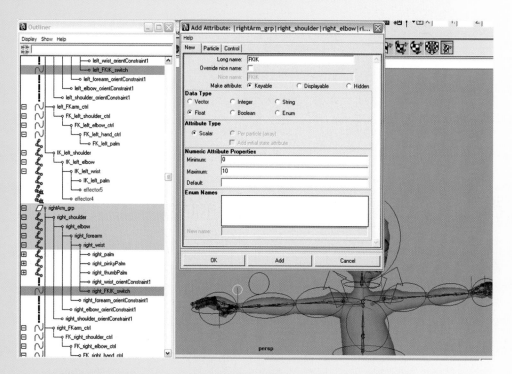

Adding a custom attribute to the FKIK_switch controllers using [Modify > Add Attribute].

35. Make the switch function. To set this up, we will use *Set Driven Key* to turn the constraints on and off. To sum things up, when the FKIK switch is set to 0, the FK constraints will be turned on and the IK constraints will be turned off so that the arm will follow the FK control arm. When the FKIK switch is set to 10, the IK constraints will be turned on and the FK constraints will be turned off so that the arm will follow the IK control arm. Do the following:

 a. In the OUTLINER, **select** the *left_shoulder_orientConstraint1* and go to [**Animate > Set Driven Key > Set...**]. (This places *left_shoulder_orientConstraint1* as the driven in the *Set Driven Key* window.)

 i. **Select** the *left_FKIK_switch* and **click** "Load Driver" in the *Set Driven Key* window.

 ii. In the *Driver* section of the *Set Driven Key* window, choose "FKIK" in the right column.

iii. In the *Driven* section of the *Set Driven Key* window, choose "FK_left_shoulder_ctrlW0" in the right column, hold down the **(shift)** key and also **click** on "IK_left_shoulderW1".

iv. In the *Driven* section of the *Set Driven Key* window, **click** on *left_shoulder_orientConstraint1* to **select** it.

v. In the channel box, change *IK_left_shoulderW1* to "0".

vi. In the *Set Driven Key* window, **click** "**Key**". (This **click** changes the *Driven* attributes to orange in the channel box, indicating a key has been set on the shoulder constraint.)

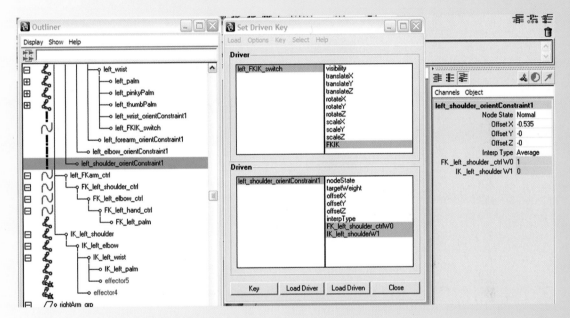

Loading the Set Driven Key window and setting the first key so that when the FKIK_switch is set to "0", the shoulder will follow the FK_controlled shoulder.

vii. In the *Driver* section of the *Set Driven Key* window, **click** on *left_FKIK_switch* to **select** it.

viii. In the channel box, change *FKIK* to "10".

ix. In the *Driven* section of the *Set Driven Key* window, **click** on *left_shoulder_orientConstraint1* to **select** it.

x. In the channel box, change *FK_left_spine_shoulder_ctrlW0* to "0" and *IK_left_shoulderW1* to "1".

xi. In the *Set Driven Key* window, **click** "**Key**".

b. Repeat these steps for the elbow, forearm, and wrist.

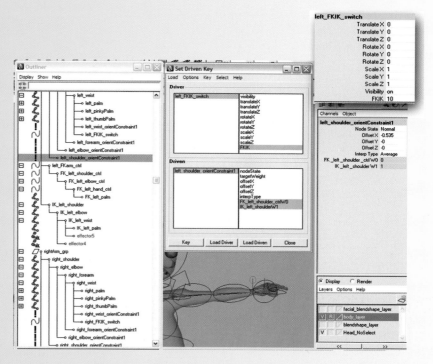

Setting the second key so that when the FKIK_switch is set to "10", the shoulder will follow the IK_controlled shoulder.

36. Make the switch also to control the visibility of the controllers. Since the IK controllers will only work when the FKIK switch is set to 10, we can hide them when IK has been turned off. Since the FK controllers will only work when the FKIK switch is set to 0, we can hide them when IK has been turned on. Do the following:

 a. We will start with the FK controls:

 i. In the OUTLINER, **select** the *left_FKarm_ctrl*, and then **click** "Load Driven" in the *Set Driven Key* window. (We only need the *left_FKarm_ctrl* since it is the parent of the other FK controls)

 ii. The *left_FKIK_switch* remains the *Driver* with "FKIK" chosen in the right column.

 iii. In the *Driven* section of the *Set Driven Key* window, choose "visibility" in the right column.

 iv. In the *Driven* section of the *Set Driven Key* window, **click** on *left_FKarm_ctrl* to **select** it.

 v. In the Channel Box, change *visibility* to "0" which turns the visibility off (since the last step ended with the FKIK switch on 10, we will key the FK visibility off first to save some steps.)

 vi. In the *Set Driven Key* window, **click** "Key"

 i. In the *Driver* section of the *Set Driven Key* window, **click** on *left_FKIK_switch* to **select** it.

 ii. In the channel box, change *FKIK* to "0".

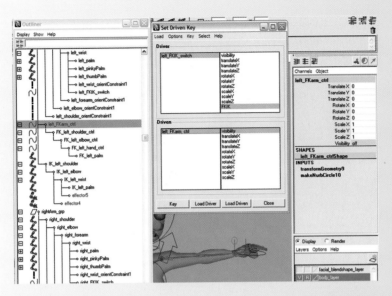

Loading the Set Driven Key window and setting the first key so that when the
FKIK_switch **is set to "10", the FK controllers are not visible.**

 iii. In the *Driven* section of the *Set Driven Key* window, **click** on *left_FKarm_ctrl* to **select** it.

 iv. In the channel box, change *visibility* to " I " which turns the visibility on.

 v. In the *Set Driven Key* window, **click** "Key".

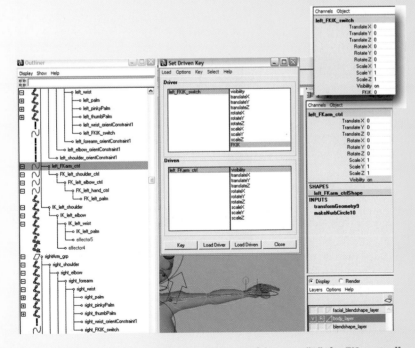

Setting the second key so that when the *FKIK_switch* **is set to "0", the FK controllers are visible.**

c. Repeat this process for the IK controls:

 i. In the PERSPECTIVE window, **select** the *left_IKhand_ctrl*, hold down the **(ctrl)** key and **click** *left_IKelbow_ctrl*, then **click** "Load Driven" in the *Set Driven Key* window.

 ii. The *left_FKIK_switch* remains the *Driver* with "FKIK" chosen in the right column.

 iii. In the *Driven* section of the *Set Driven Key* window, choose "visibility" in the right column.

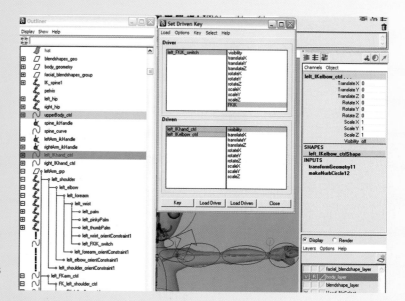

Loading the Set Driven Key window and setting the first key so that when the FKIK_switch is set to "0", the IK controllers are not visible.

 iv. In the *Driven* section of the *Set Driven Key* window, **click** on *left_IKarm_ctrl*, hold down the **(shift)** key and also **click** on *left_IKelbow_ctrl* to **select** them.

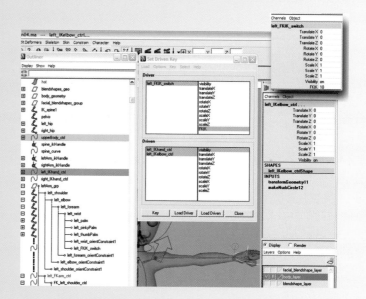

Setting the second key so that when the FKIK_switch is set to "10", the IK controllers are visible.

v. In the channel box, change *visibility* to "0".

vi. In the *Set Driven Key* window, **click** "Key".

vii. In the *Driver* section of the *Set Driven Key* window, **click** on *left_FKIK_switch* to **select** it.

viii. In the channel box, change *FKIK* to "10".

ix. In the *Driven* section of the *Set Driven Key* window, **click** on *left_IKarm_ctrl*, hold down the **(shift)** key and also **click** on *left_IKelbow_ctrl* to **select** them.

x. In the channel box, change *visibility* to "1".

xi. In the *Set Driven Key* window, **click** "Key".

xii. Repeat making the switch function for the right arm.

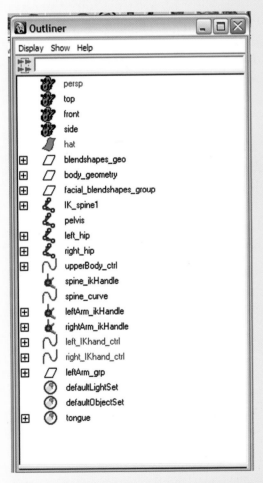

37. Integrate the FK and IK arms into the existing shoulder controls by doing the following:

a. In the PERSPECTIVE window, **click** on the *left_FKIK_switch*, hold down the **(shift)** key and **click** the *right_FKIK_switch*. In the channel box, set the FKIK attribute to "0" to turn IK off.

b. In the OUTLINER, **click** on the *leftArm_grp*, hold down the **(shift)** key on the keyboard and in the PERSPECTIVE window, **click** on the *left_clavicle_ctrl* and press **(p)** on the keyboard to parent them.

c. In the OUTLINER, **click** on the *rightArm_grp*, hold down the **(shift)** key on the keyboard and in the PERSPECTIVE window, **click** on the *right_clavicle_ctrl* and press **(p)** on the keyboard to parent them.

38. Save your scene file. Name your scene *06_asgn04.ma*.

The new OUTLINER hierarchy after integrating the arms into the existing spine controls.

Assignment 6.5: Creating a Control System for the Fingers

1. Open Maya and set your project.

 a. From your computer's desktop, go to [**Start > Programs**] and **select** Maya.

 b. Once Maya is open go to [**File > Project > Set...**] and browse to your project folder then **click** "OK".

2. Open your last saved file: Go to [**File > Open**] and **select** *06_asgn04.ma*.

3. Continue working in X-ray mode.

4. Make sure that your geometry layer is set to **R** for reference so that you are unable to **select** the geometry by mistake when working.

5. To make selection easier open your OUTLINER by going to [**Windows > Outliner**].

6. Create a control system for the fingers by doing the following:

 a. Go to [**Create > NURBS Primitives > Circle**].

 b. In the channel box, rename *nurbsCircle1* to *left_finger_ctrl*.

 c. In PERSPECTIVE view, with the *left_finger_ctrl* selected, **select** the move tool by pressing **(w)**, hold down the **(v)** key, position your cursor over the *left_wrist* joint, and **click** the MMB and drag it slightly to snap the *left_finger_ctrl* into place.

 i. With the *left_finger_ctrl* selected, set the following in the channel box: RotateZ: type "90".

 ii. With the move tool, **click** on the Y axis **(green arrow)** and move the controller slightly above the wrist, around the *left_FKIK_switch*.

 iii. With the *left_finger_ctrl* selected, **select** the scale tool by pressing **(r)** and scale the *left_finger_ctrl* larger than the *left_FKIK_switch*.

 iv. The rotation order does not need to be changed on this controller, because rotations are not necessary for control.

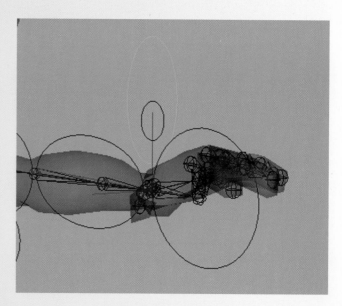

Creating and positioning the *left_finger_ctrl*.

v. Duplicate the *left_finger_ctrl* by going to [**Edit > Duplicate**] or press (**ctrl+d**).

vi. In the OUTLINER, **double-click** on *left_finger_ctrl1* and rename it *right_finger_ctrl*.

vii. In PERSPECTIVE view, **select** the move tool by pressing (**w**) and **click** on the X axis (**red arrow**), hold down the (**v**) key, position your cursor over the *right_finger_ctrl*, and **click** the **MMB** and drag it slightly to snap the *right_finger_ctrl* into place. (By **select**ing the X axis first, the move is constrained to that axis only.)

d. In the PERSPECTIVE window, **select** the *left_finger_ctrl*, hold down the (**shift**) key and **click** the *left_FKIK_switch*, and press (**p**) to parent.

e. In the PERSPECTIVE window, **select** the *right_finger_ctrl*, hold down the (**shift**) key and **click** the *right_FKIK_switch*, and press (**p**) to parent.

f. With the *right_finger_ctrl* selected, hold down the (**shift**) key and **select** *left_finger_ctrl*, then go to [**Modify > Freeze Transformations**]. (To return both translate and rotate values to 0 and the scale values to 1.)

7. Add attributes to the finger control for the finger movements by doing the following:

a. With the *left_finger_ctrl* and *right_finger_ctrl* selected, go to [**Modify > Add Attributes**] and using the default settings, **enter** the following:

i. Attribute name: type "**indexFlexCurl**".

ii. Under *Numeric Attribute Properties*

1. Minimum: type "−10".

2. Maximum: type "**10**".

3. **Click "Add".**

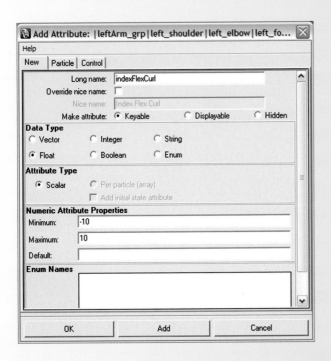

Adding custom attributes to the fingers using [Modify > Add Attribute].

b. **Enter** the following:

 i. Attribute name: type "**middleFlexCurl**".

 ii. Under *Numeric Attribute Properties*

 1. Minimum: type "−10".

 2. Maximum: type "10".

 3. **Click "Add"**

c. **Enter** the following:

 i. Attribute name: type "**ringFlexCurl**".

 ii. Under *Numeric Attribute Properties*

 1. Minimum: type "−10".

 2. Maximum: type "10".

 3. **Click "Add"**.

d. **Enter** the following:

 i. Attribute name: type "**pinkyFlexCurl**".

 ii. Under *Numeric Attribute Properties*

 1. Minimum: type "−10".

 2. Maximum: type "10".

 3. **Click "Add"**.

e. **Enter** the following:

 i. Attribute name: type "**thumbFlexCurl**".

 ii. Under *Numeric Attribute Properties*

 1. Minimum: type "−10".

 2. Maximum: type "10".

 3. **Click "Add"**.

f. **Enter** the following:

 i. Attribute name: type "**thumbSpread**".

 ii. Under *Numeric Attribute Properties*

 1. Minimum: type "−10".

 2. Maximum: type "10".

 3. **Click "Add"**.

g. **Enter** the following:

 i. Attribute name: type "**fingerSpread**".

 ii. Under *Numeric Attribute Properties*

 1. Minimum: type "−10".

 2. Maximum: type "10".

 3. **Click "OK"**.

h. **Enter** the following:

 i. Attribute name: type "**grab**".

 ii. Under *Numeric Attribute Properties*

 1. Minimum: type "**0**".

 2. Maximum: type "**10**".

 3. **Click** "Add".

These are the attributes that you will control with Set Driven Key. They now show up in the channel box for the *left_finger_ctrl*. For more control over the fingers, you might even want break apart the finger motion into two separate attributes for each finger: *a bend* attribute for the first knuckle of the finger and *a curl* attribute for the last two knuckles. If you make a mistake, you can go to [**Modify > Edit Attribute**] to make changes.

left_finger_ctrl	
Translate X	0
Translate Y	0
Translate Z	0
Rotate X	0
Rotate Y	0
Rotate Z	0
Scale X	1
Scale Y	1
Scale Z	1
Visibility	on
Index Flex Curl	0
Middle Flex Curl	0
Ring Flex Curl	0
Pinky Flex Curl	0
Thumb Flex Curl	0
Thumb Spread	0
Finger Spread	0
Grab	0

The left_finger_ctrl in the channel box, with all of the finger attributes added.

❗ When creating the poses for the fingers using Set Driven Key, you can do all the selecting and manipulating in the work area (PERSPECTIVE window) or use the OUTLINER or Hypergraph if selecting the joints in the view panel becomes too tedious. The joints can be selected from inside the Set Driven Key editor as well but make sure to reselect them all in the "Driven" section before pressing the "Key" button in the set driven window.

8. Use Set Driven Key to add functionality to the attributes by doing the following:

a. In the OUTLINER, **select** the *left_index1* joint, hold down the (**ctrl**) key and **click** *left_index2* joint and *left_index3* joint and go to [**Animate > Set Driven Key > Set...**]. (This places the joints as the driven in the *Set Driven Key* window.)

b. Add functionality to the *indexFlexCurl* attribute.

 i. **Select** the *left_finger_ctrl* and **click** "Load Driver" in the *Set Driven Key* window.

 ii. In the *Driver* section of the *Set Driven Key* window, choose "**indexFlexCurl**" in the right column.

 iii. In the *Driven* section of the *Set Driven Key* window, **click** on *left_index1* joint, hold down the **(ctrl)** key and **click** *left_index2* joint and *left_index3* to **select** them.

 iv. In the *Driven* section of the *Set Driven Key* window, choose "rotate Z" in the right column.

 v. In the *Set Driven Key* window, **click** "**Key**". (This sets a default finger pose position at attribute value of 0.)

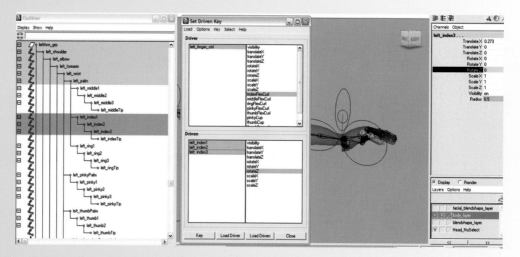

Loading the Set Driven Key window and setting the first key so that when the indexFlexCurl attribute is set to "0", the index finger is in the default (original) position.

 vi. In the *Driver* section of the *Set Driven Key* window, **click** on *left_finger_ctrl* to **select** it.

 vii. In the channel box, change *indexFlexCurl* to "10".

 viii. In the PERSPECTIVE window, **select** the rotate tool by pressing the **(e)** key, rotate the index finger joints (index1, index2, and index3) along the Z axis (the blue ring) into a curled bent position. (Notice how your finger bends when you make a fist and try to mimic the position.)

 ix. In the *Set Driven Key* window, **click** "**Key**". (This sets a keyed pose of the finger in a bent position at attribute value of "10".)

 x. In the *Driver* section of the *Set Driven Key* window, **click** on *left_finger_ctrl* to **select** it.

 xi. In the channel box, change *indexFlexCurl* to "−10".

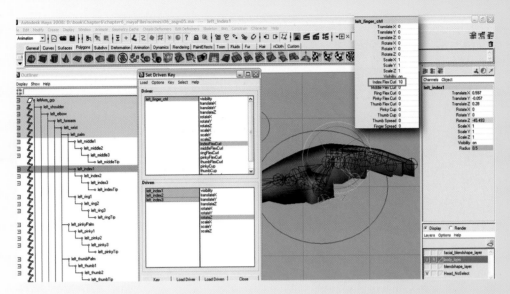

Setting the second key so that when the indexFlexCurl is set to "10", the index finger is in the curled position.

xii. In the PERSPECTIVE window, **select** the rotate tool by pressing the **(e)** key, rotate the index finger joints (index1, index2, and index3) along the Z axis (the blue ring) into a flexed position. (Notice how your finger flexes when you stretch your hand and try to mimic the position.)

xiii. In the *Set Driven Key* window, **click** "Key". (This **click** changes the *Driven* attributes to orange in the channel box, indicating a key has been set.)

xiv. To test and see if the control works, **click** on the word *indexFlexCurl* in the channel box, then in the PERSPECTIVE window, **MMB click** and drag your mouse left to right. You should see your character's index finger flex and curl.

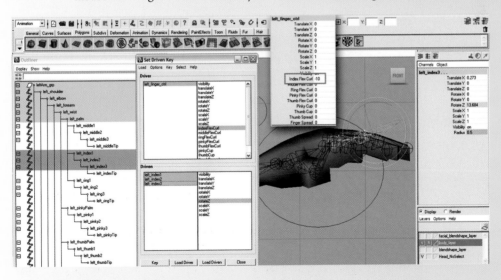

Setting the third key so that when the indexFlexCurl is set to "−10", the index finger is in the flexed position.

xv. In the channel box, change *indexFlexCurl* to "0".

> ❗ This exact procedure is repeated for the middle finger, the ring finger, the pinky, and the thumb. The important thing to remember is to make sure you change the driver attribute and reload the new joints as your driven.

c. Repeat these steps for the *middleFlexCurl*, *ringFlexCurl*, *pinkyFlexCurl*, and *thumbFlexCurl* attributes.

> ❗ This procedure is similar for the thumbSpread and fingerSpread attributes. The main differences are the direction of the rotations and that multiple joints need to be rotated to achieve the position. Each position will be slightly different depending on how the hand was modeled.

d. Repeat these steps for the *thumbSpread* attribute.

 i. In the *Driver* section of the *Set Driven Key* window, choose "thumbSpread" in the right column.

 ii. **Select** the **select** the *left_thumbPalm* joint, hold down the **(ctrl)** key and **click** *left_thumb1* joint, then **click** "Load Driven" in the *Set Driven Key* window.

 iii. In the *Driven* section of the *Set Driven Key* window, **click** on *left_thumbPalm* joint, hold down the **(ctrl)** key and **click** *left_thumb1* joint to **select** them.

 iv. In the *Driven* section of the *Set Driven Key* window, **click** "rotate Y, then hold down the **(ctrl)** key and **click** rotate Z" in the right column.

 v. In the *Set Driven Key* window, **click** "Key". (This sets a default finger pose position at attribute value of 0.)

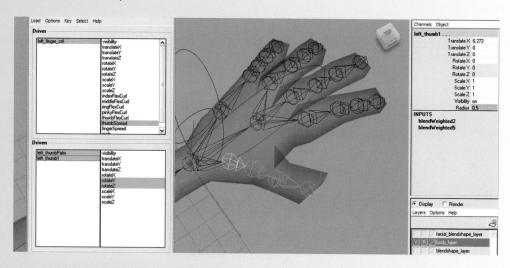

Loading the Set Driven Key window and setting the first key so that when the thumbSpread attribute is set to "0", the thumb is in the default (original) position.

 vi. In the *Driver* section of the *Set Driven Key* window, **click** on *left_finger_ctrl* to **select** it.

 vii. In the channel box, change *thumbSpread* to "10".

viii. In the PERSPECTIVE window, **select** the rotate tool by pressing the **(e)** key, rotate the thumb finger joints (*thumbPalm* and *thumb1*) along the Y or Z axis into a position next to the index finger.

ix. In the *Set Driven Key* window, **click** "Key". (This sets a keyed pose of the thumb in a cupped position at attribute value of "10".)

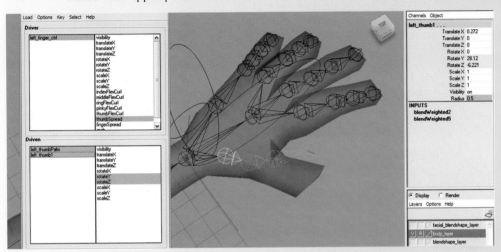

Setting the second key so that when the thumbSpread is set to "10", the thumb is near the index finger in a closed position.

x. In the *Driver* section of the *Set Driven Key* window, **click** on *left_finger_ctrl* to **select** it.

xi. In the channel box, change *thumbSpread* to "−10".

xii. In the PERSPECTIVE window, **select** the rotate tool by pressing the **(e)** key, rotate the thumb finger joints (*thumbPalm* and *thumb1*) along the Y or Z axis into a position away from the index finger.

xiii. In the *Set Driven Key* window, **click** "Key". (This sets a keyed pose of the thumb in a cupped position at attribute value of "−10".)

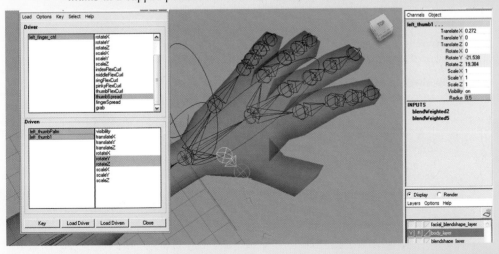

Setting the third key so that when the thumbSpread is set to "−10", the thumb is away from the index finger in a spread position.

xiv. To test and see if the control works, **click** on the word *thumbSpread* in the channel box, then in the PERSPECTIVE window, **MMB click** and drag your mouse left to right.

xv. In the channel box, change *thumbSpread* to "0".

e. Repeat these steps for the *fingerSpread* attribute.

 i. In the *Driver* section of the *Set Driven Key* window, choose "fingerSpread" in the right column.

 ii. **Select** the **select** the *left_index1* joint, hold down the **(ctrl)** key and **click** the *left_middle1* joint, the *left_ring1* joint, and the *left_pinky1* joint, **click** "Load Driven" in the *Set Driven Key* window.

 iii. In the *Driven* section of the *Set Driven Key* window, **click** the *left_index1* joint, hold down the **(ctrl)** key and **click** the *left_middle1* joint, the *left_ring1* joint, *and* the *left_pinky1* joint to **select** them.

 iv. In the *Driven* section of the *Set Driven Key* window, choose "rotate Y" in the right column.

 v. In the *Set Driven Key* window, **click** "Key".

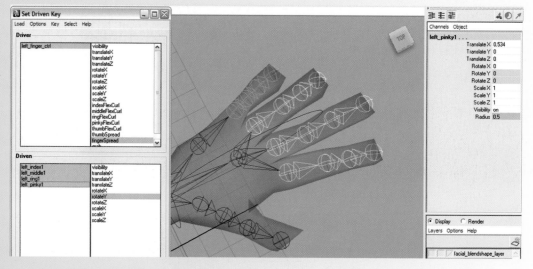

Loading the Set Driven Key window and setting the first key so that when the fingerSpread attribute is set to "0", the hand is in the default (original) position.

 vi. In the *Driver* section of the *Set Driven Key* window, **click** on *left_finger_ctrl* to **select** it.

 vii. In the channel box, change *fingerSpread* to "10".

 viii. In the PERSPECTIVE window, **select** the rotate tool by pressing the **(e)** key, rotate the finger joints (*left_index1*, *left_middle1*, *left_ring1*, and *left_pinky1*) along the Y axis (the green ring) into a squeezed closed position where all of the fingers would be touching.

 ix. In the *Set Driven Key* window, **click** "Key".

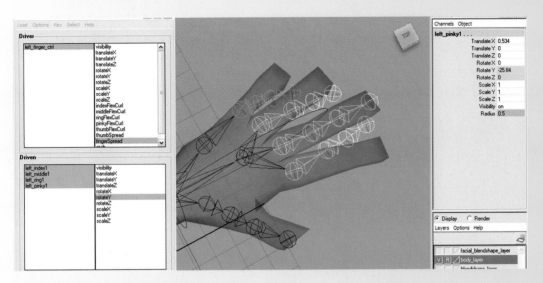

Setting the second key so that when the fingerSpread is set to "10", the fingers are in a closed position.

 x. In the *Driver* section of the *Set Driven Key* window, **click** on *left_finger_ctrl* to **select** it.

 xi. In the channel box, change *fingerSpread* to "−10".

 xii. In the PERSPECTIVE window, **select** the rotate tool by pressing the **(e)** key, rotate the finger joints (*left_index1*, *left_middle1*, *left_ring1*, and *left_pinky1*) along the Y axis (the green ring) into a spread open position.

 xiii. In the *Set Driven Key* window, **click** "Key".

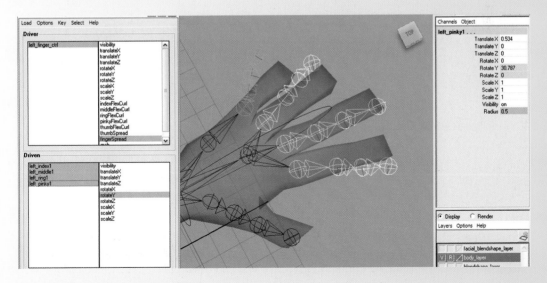

Setting the third key so that when the fingerSpread is set to "−10", the fingers are in a spread open position.

xiv. To test and see if the control works, **click** on the word *fingerSpread* in the channel box, then in the PERSPECTIVE window, **MMB click** and drag your mouse left to right. You should see your character's fingers spread and close.

xv. In the channel box, change *fingerSpread* to "0".

> **!** This last position is for grabbing. It's a position where the thumb and pinky are cupped forward with the rest of the hand. Think about a pose where the hand is reaching for a doorknob.

f. Repeat these steps for the *grab* attribute.

i. In the *Driver* section of the *Set Driven Key* window, choose "grab" in the right column.

ii. **Select** all of the joints in the hand (except for the Tip joints) and **click** "Load Driven" in the *Set Driven Key* window.

iii. In the *Driven* section of the *Set Driven Key* window, **click** on all of the joints to **select** them.

iv. In the *Driven* section of the *Set Driven Key* window, **click** "rotate X, then hold down the **(ctrl)** key and **click** rotate Y and rotate Z" in the right column.

v. In the *Set Driven Key* window, **click** "Key". (This sets a default finger pose position at attribute value of 0.)

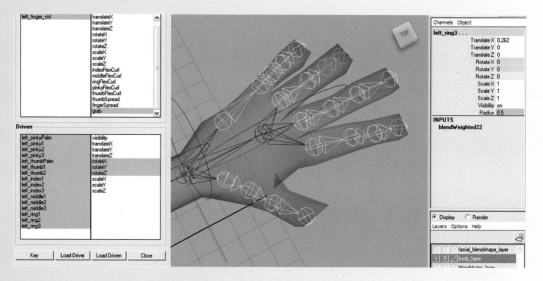

Loading the Set Driven Key window and setting the first key so that when the grab attribute is set to "0", the hand is in the default (original) position.

vi. In the *Driver* section of the *Set Driven Key* window, **click** on *left_finger_ctrl* to **select** it.

vii. In the channel box, change *grab* to "10".

viii. In the PERSPECTIVE window, **select** the rotate tool by pressing the **(e)** key, and rotate the finger joints along the X, Y, or Z axis into a cupped bent position. (The goal is to make it so that the hand can grab something, so they would be rotated slightly inward toward the palm.)

ix. In the *Set Driven Key* window, **click** "**Key**". (This sets a keyed pose of the fingers in a cupped position at attribute value of "10".)

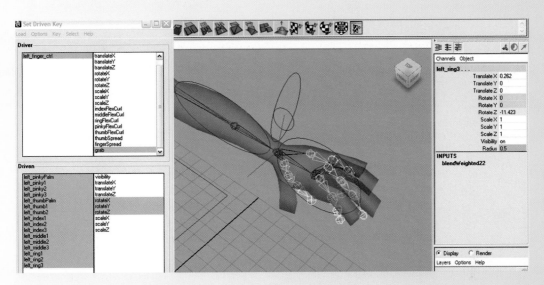

Setting the second key so that when the grab is set to "10", the fingers are in a cupped position.

x. To test and see if the control works, **click** on the word *pinkyCup* in the channel box, then in the PERSPECTIVE window, **MMB click** and drag your mouse left to right.

xi. In the channel box, change *pinkyCup* to "0".

9. Repeat adding functionality to the attributes for the right fingers.

10. Save your scene file. Name your scene *06_asgn05.ma*.

Assignment 6.6: Creating a Control System for the Legs and Feet

For the leg control, we will only be setting up an IK control system since most of the time our characters will be walking on something. If you think you need an FK control system, you can follow the setup for the arms and adapt it to the legs.

1. Open Maya and set your project.

a. From your computer's desktop, go to [**Start > Programs**] and **select** Maya.

b. Once Maya is open, go to [**File > Project > Set...**] and browse to your project folder then **click** "**OK**".

2. Open your last saved file: Go to [**File > Open**] and **select** *06_asgn05.ma*.

3. Continue working in X-ray mode.

4. Make sure that your geometry layer is set to R for reference so that you are unable to **select** the geometry by mistake when working.

5. To make selection easier open your OUTLINER by going to [**Windows > Outliner**].

6. Create the IK in the leg by doing the following:

 a. Set a preferred angle in the left leg by doing the following:

 i. **Select** the *left_knee* joint and the *right_knee* joint in the channel box set the following: RotateY: type "**40**".

 ii. **Select** the *left_hip* joint, then go to [**Skeleton > Set Preferred Angle**].

 iii. **Select** the *left_knee* joint and in the channel box set the following: RotateY: type "**0**" (this will make the knee straight again).

 (We must first set a preferred angle in the leg so that Maya knows which direction to bend the leg when we run the IK solver through the joints.)

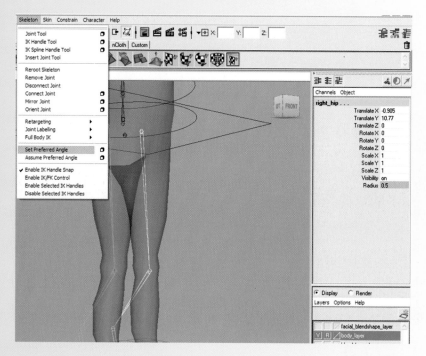

Setting a preferred angle on the legs.

 b. Go to [**Skeleton > IK Handle Tool – option box**] and set the following:

 i. **Click** "reset tool" then under *IK Handle Settings* change the following:

 Place a check mark in the box next to *Sticky*.

 Then **click** "close".

 c. In the PERSPECTIVE window, **click** on the *left_hip* joint (to define the start of the IK joint chain) then on the *left_ankle* joint (to define the end of the chain; an IK handle appears at the end of the chain.) See image on page 251

 d. In the OUTLINER, double-**click** on *ikHandle1* and rename it *leftLeg_ikHandle*. (This chain will control the leg movement.)

 e. It is a great idea to check to make sure the IK handle moves correctly along the Y axis. You can do this by doing the following:

 f. **Select** the *leftLeg_ikHandle* and move the IK handle along the Y axis (**green arrow**) toward the body to confirm that the leg bends in the correct direction. Be sure to press the (**z**) key to undo the move.

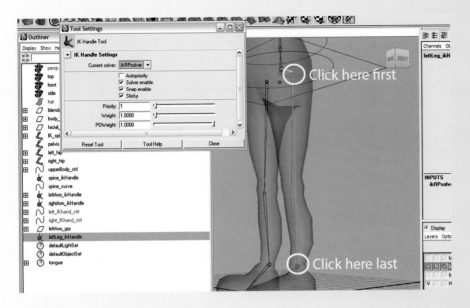

Creating an RP IK solver in the left leg.

The direction that the IK handle points is not relevant. Its direction does not have any effect on the solver.

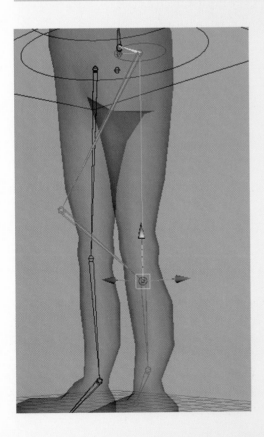

Moving the leftLeg_ikHandle along the Y axis to make sure the leg bends correctly.

g. Go to [**Skeleton > IK Handle Tool – option box**] and set the following:

 i. Under *IK Handle Settings* change the following:

 Current solver: choose "ikSCsolver".

 Keep a check mark in the box next to *Sticky*.

 Then **click** "close".

h. In the PERSPECTIVE window, **click** on the *left_ankle* joint (to define the start of the IK joint chain) then on the *left_ball* joint (to define the end of the chain. An IK handle appears at the end of the chain).

i. In the OUTLINER, double-**click** on *ikHandle1* and rename it *leftAnkle_ikHandle*. (This chain will control the ankle movement.)

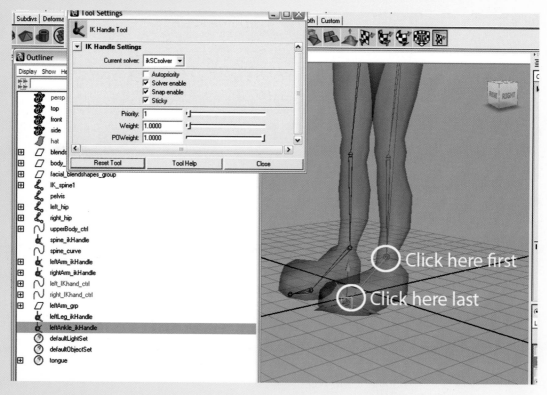

Creating an SC IK solver in the left ankle.

j. Press the (y) key to **select** the last tool used – in this case, the IK Handle Tool.

k. In the PERSPECTIVE window, **click** on the *left_ball* joint (to define the start of the IK joint chain) then on the *left_toe* joint (to define the end of the chain; an IK handle appears at the end of the chain).

l. In the OUTLINER, double-**click** on *ikHandle1* and rename it *leftToe_ikHandle*. (This chain will control the toe movement.)

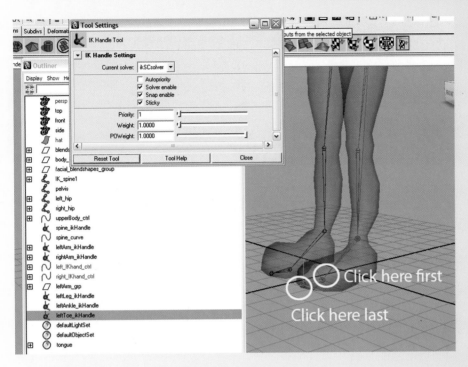

Creating an SC IK solver in the left toe.

 m. Repeat steps to create the IK for the right leg.

7. Create a control system for the IK leg by doing the following:

 a. First create the controllers by doing the following:

 i. Go to [**Create > NURBS Primitives > Circle**].

 ii. In the channel box, rename the circle *left_foot_ctrl*.

 iii. In PERSPECTIVE view, **select** the move tool by pressing **(w)** on the keyboard and reposition the curve around the foot. DO NOT make it even with the sole of the foot as the animator will have a hard time seeing it through the floor plane. Make sure the pivot of the controller is in the ankle by doing the following: With the curve and the move tool still selected, press the (insert) key on the keyboard, hold down the **(v)** key, then position your cursor over the *IK_left_ankle* joint, **click** the MMB, and drag it slightly to snap the *left_foot_ctrl* pivot into place in the ankle.

 iv. Use the scale tool by pressing **(r)** and resize the circle if necessary. (This control should be scaled large enough that it is OUTSIDE of the character's foot to make it easy to select.)

 v. With the *left_foot_ctrl* selected, go to [**Modify > Freeze Transformations**]. (To return both translate and rotate values to 0 and the scale values to 1.)

 vi. **Select** the *left_foot_ctrl* and reshape the curve around the foot by doing the following:

 1. Press the **(F8)** key.

 2. Choose the "**select** point components" button in the Status Line.

3. Using the move tool by pressing **(w)**, **click** and drag around the points of the circle and position them to reshape the curve into a shoeprint shape.

vii. Change the rotation order for the *left_foot_ctrl* by doing the following:

1. With the *left_foot_ctrl* selected, open the attribute editor by pressing **(ctrl+a)**.

2. **Select** the *left_foot_ctrl* tab.

3. Under *Transform Attributes* set the following:

a. Rotate order: choose "ZXY".

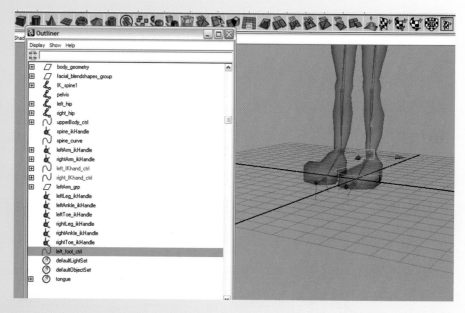

Creating and positioning the left_foot_ctrl.

viii. Duplicate the *left_foot_ctrl* by going to [**Edit > Duplicate**] or press **(ctrl+d)**.

ix. In the OUTLINER, **double-click** on *left_foot_ctrl1* and rename it *right_foot_ctrl*.

x. In PERSPECTIVE view, **select** the move tool by pressing **(w)**, hold down the **(v)** key, position your cursor over the *IK_right_ankle* joint, and **click** the MMB and drag it slightly to snap the *right_IKfoot_ctrl* into place.

xi. With the *right_foot_ctrl* selected set the following in the channel box: ScaleX: type "−1" (this will flip the controller over the right foot).

xii. With the *right_foot_ctrl* selected, go to [**Modify > Freeze Transformations**]. (To return both translate and rotate values to 0 and the scale values to 1.)

xiii. Go to [**Create > NURBS Primitives > Circle**].

xiv. In the channel box, rename the circle *left_knee_ctrl*.

xv. In PERSPECTIVE view, with the *left_knee_ctrl* selected, **select** the move tool by pressing **(w)**, hold down the **(v)** key, position your cursor over the *left*

 knee joint, and **click** the **MMB** and drag it slightly to snap the left_*knee_ctrl* into place.

xvi. With the move tool, **click** on the Z axis (**blue arrow**) and move the controller leg distance in front of the character.

xvii. With the *left_knee_ctrl* selected set the following in the channel box: RotateX: type "90".

xviii. Use the scale tool by pressing (**r**) and resize the circle if necessary.

xix. With the *left_knee_ctrl* selected, go to [**Modify > Freeze Transformations**]. (To return both translate and rotate values to 0 and the scale values to 1.)

xx. The rotation order does not need to be changed on this controller, because rotations are not necessary for control.

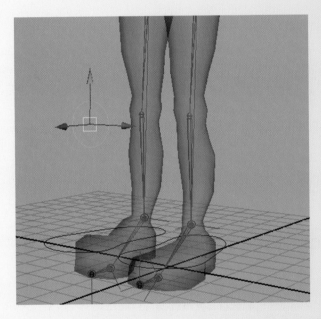

Creating and positioning the left_knee_ctrl to control the leftLeg_ikHandle's pole vector.

xxi. Duplicate the *left_knee_ctrl* by going to [**Edit > Duplicate**] or press (**ctrl+d**).

xxii. In the OUTLINER, **double-click** on *left_knee_ctrl1* and rename it *right_knee_ctrl*.

xxiii. In PERSPECTIVE view, **select** the move tool by pressing (**w**) and **click** on the X axis (**red arrow**), hold down the (**v**) key, position your cursor over the *right_knee* joint, and **click** the LMB and drag it slightly to snap the *right_knee_ctrl* into place. (By **select**ing the X axis first, the move is constrained to that axis only.)

xxiv. With the *right_knee_ctrl* selected, go to [**Modify > Freeze Transformations**]. (To return both translate and rotate values to 0 and the scale values to 1.)

8. You may notice that we have created three separate IK chains for the leg and foot. A biped is capable of moving their toes, their ankle, and their leg independently from each other. Because of this, a single IK chain from the hip to the toe would not work for the control needed. We are now going to create a hierarchal system that provides maximum control and protect the animator from losing their work if an IK handle stops solving. Create control between the controllers and the IK handles by doing the following:

 a. Go to [**Create > Locator**].

 i. In the channel box, rename the locator *left_heel_pivot*.

 ii. In PERSPECTIVE view, **select** the move tool by pressing (**w**), hold down the (**v**) key, then position your cursor over the *left_ball* joint (the joint in the ball of the foot), **click** the **MMB** and drag it slightly to snap the *left_heel_pivot* into place. **Click** on the Z axis (**blue arrow**) and move the locator to the heel of your character's foot or shoe geometry.

 iii. With the *left_heel_pivot* selected, go to [**Modify > Freeze Transformations**]. (To return both translate and rotate values to 0 and the scale values to 1.)

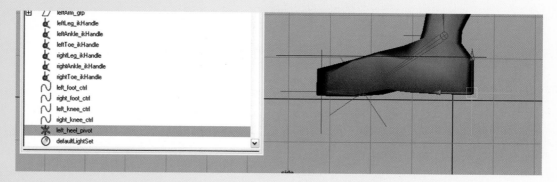

Creating and positioning a locator in the heel of the foot.

 b. Repeat this again. Go to [**Create > Locator**].

 i. In the channel box, rename the locator *left_toe_pivot*.

 ii. In PERSPECTIVE view, **select** the move tool by pressing (**w**), hold down the (**v**) key, then position your cursor over the *left_toe*, joint, **click** the **MMB** and drag it slightly to snap the *left_toe_pivot* into place.

 iii. With the *left_toe_pivot* selected, go to [**Modify > Freeze Transformations**]. (To return both translate and rotate values to 0 and the scale values to 1.)

 c. Repeat this again. Go to [**Create > Locator**].

 i. In the channel box, rename the locator *left_ball_pivot*.

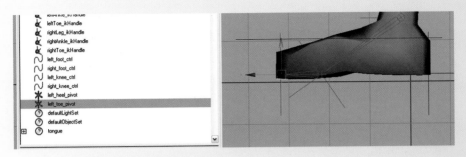

Creating and positioning a locator in the toe of the foot.

ii. In PERSPECTIVE view, **select** the move tool by pressing **(w)**, hold down the **(v)** key, then position your cursor over the *left_ball* joint, **click** the MMB and drag it slightly to snap the *left_ball_pivot* into place.

iii. With the *left_ball_pivot* selected, go to [**Modify > Freeze Transformations**]. (To return both translate and rotate values to 0 and the scale values to 1.)

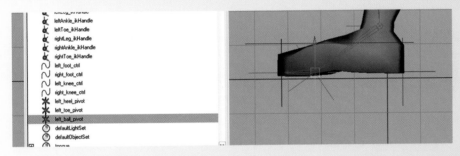

Creating and positioning a locator in the ball of the foot.

iv. Duplicate the *left_ball_pivot* locator by going to [**Edit > Duplicate**] or press **(ctrl+d)**.

v. In the OUTLINER, **double-click** on *left_ball_pivot1* and rename it *left_toe_wiggle*.

d. Repeat (or duplicate) for the right side.

e. In the OUTLINER, **click** on the *leftToe_ikHandle* with the **MMB** and drag it onto the *left_toe_wiggle* locator. (This makes the *leftToe_ikHandle* child to the *left_toe_wiggle* locator.)

f. In the OUTLINER, **click** on the *leftLeg_ikHandle* with the **MMB** and drag it onto the *left_ball_pivot* locator. (This makes the *leftLeg_ikHandle* child to the *left_ball_pivot* locator.)

g. In the OUTLINER, **click** on the *left_ball_pivot* locator, hold down the **(ctrl)** key on the keyboard and **click** on the *left_toe_wiggle* locator, **click** on the

leftAnkle_ikHandle, **click** on the *left_toe_pivot* locator and then press **(p)** on the keyboard. (This makes the *left_ball_pivot* locator, the *left_toe_wiggle* locator, and the *leftAnkle_ikHandle* child to the *left_toe_pivot* locator.)

h. In the OUTLINER, **click** on the *left_toe_pivot* locator with the **MMB** and drag it onto the *left_heel_pivot* locator. (This makes the *left_toe_pivot* locator child to the *left_heel_pivot* locator.)

i. In the OUTLINER, **click** on the *left_heel_pivot* locator with the **MMB** and drag it onto the *left_foot_ctrl*. (This makes the *left_heel_pivot* locator child to the *left_foot_ctrl*.)

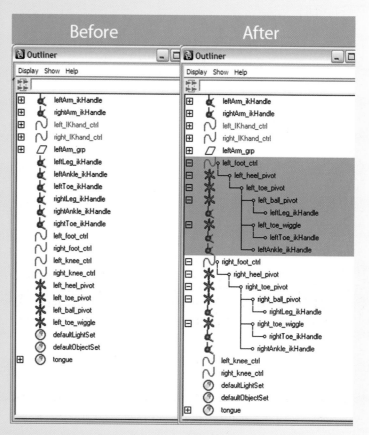

The OUTLINER hierarchy before and after parenting the IK handles with the locators to make the foot hierarchy.

j. In the PERSPECTIVE window, **click** on the *left_knee_ctrl* (the leader), hold down the **(ctrl)** key and **click** on the *leftLeg_ikHandle* (the follower), then go to **[Constrain > Pole Vector]**.

k. In the OUTLINER, **click** on the *left_IKknee_ctrl* with the **MMB** and drag it onto the *left_foot_ctrl*. (This makes the *left_IKknee_ctrl* child to the *left_ foot_ctrl*.)

l. Repeat for the right leg.

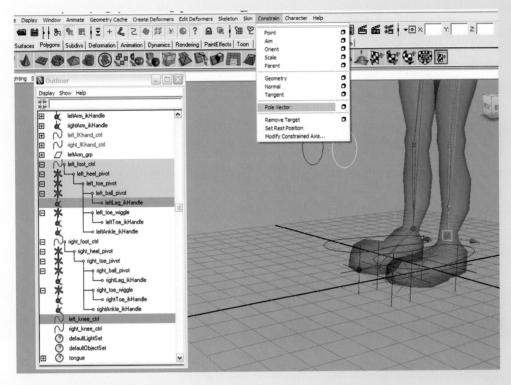

Creating a pole vector constraint between the *left_knee_ctrl* (leader) and the
leftLeg_ikHandle (follower).

> You can now test out some of your leg controls. **Select** the *left_foot_ctrl* and move it
> around toward the body so that the knee bends. You can also rotate this control to
> control the ankle. **Select** the *left_knee_ctrl* and move it left to right to control the
> position of the knee. Be sure to press the **(z)** key several times to undo the moves.

9. Add attributes to the foot control for the foot movements by doing the following:

 a. **Select** the *right_foot_ctrl*, hold down the **(shift)** key and **select** *left_foot_ctrl*, then
 go to [**Modify > Add Attribute**] and **enter** the following:

 i. Attribute name: type "footRoll".

 ii. Under *Numeric Attribute Properties*

 1. Minimum: type "−5".

 2. Maximum: type "10".

 3. **Click** "Add".

 iii. Attribute name: type "**heelTwist**"

 1. **Click** "Add".

iv. Attribute name: type "**toeTwist**"

1. **Click "Add".**

v. Attribute name: type "**toeWiggle**"

1. **Click "OK".**

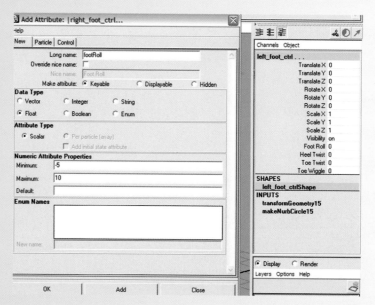

Adding custom attributes to the left_foot_ctrl and right_foot_ctrl using [Modify > Add Attribute].

10. Make the footRoll attribute function using *Set Driven Key* by doing the following:

a. In the OUTLINER, **select** the *left_heel_pivot* locator, hold down the **(ctrl)** key and **click** the *left_toe_pivot* locator and the *left_ball_pivot* locator, then go to [**Animate > Set Driven Key > Set...**].

! When you are using Set Driven Key, remember to change the driver first, then the driven, then set a key (you are changing the pose for each keyframe, much like you do in the timeline when animating, but this is an attribute value instead of a time position).

b. **Select** the *left_foot_ctrl* and **click** "Load Driver" in the *Set Driven Key* window.

i. In the *Driver* section of the *Set Driven Key* window, choose "footRoll" in the right column.

ii. In the *Driven* section of the *Set Driven Key* window, **click** on *the left_heel_pivot*, hold down the **(ctrl)** key and **click** the *left_toe_pivot* and *left_ball_pivot* to **select** them.

iii. In the *Driven* section of the *Set Driven Key* window, choose "RotateX" in the right column.

iv. In the *Set Driven Key* window, **click** "Key". (This sets a default position of the foot at the footRoll value of "0".)

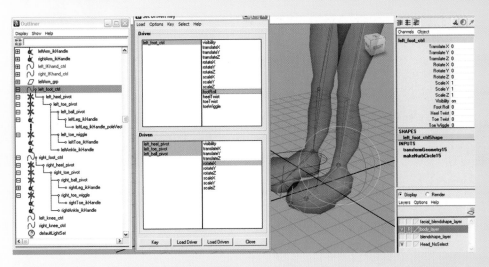

Loading the Set Driven Key window and setting the first key so that when the footRoll attribute is set to "0", the foot is in the default (original) position.

> v. In the *Driver* section of the *Set Driven Key* window, **click** on *left_foot_ctrl* to **select** it.
>
> vi. In the channel box, change *left_foot_ctrl* to "−5".
>
> vii. In the *Driven* section of the *Set Driven Key* window, **click** on *left_heel_pivot* to **select** it.
>
> viii. In the channel box, change *RotateX* to "−25".
>
> ix. In the *Set Driven Key* window, **click** "**Key**". (This sets the key for the first pose of the foot roll – the heel contacting the ground with the toe raised.)

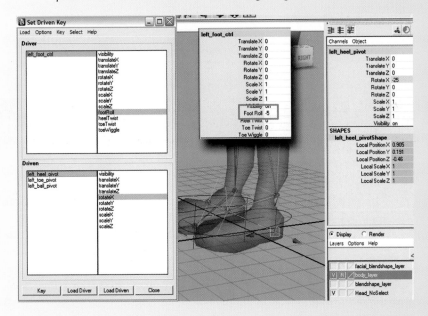

Setting the second key so that when the footRoll is set to "−5", the heel is planted on the ground and the toe is in the air.

x. In the *Driver* section of the *Set Driven Key* window, **click** on *left_foot_ctrl* to **select** it.

xi. In the channel box, change *left_foot_ctrl* to "5".

xii. In the *Driven* section of the *Set Driven Key* window, **click** on *left_ball_pivot* to **select** it.

xiii. In the channel box, change *RotateX* to "40".

xiv. In the *Set Driven Key* window, **click** "Key". (The second pose is already keyed at the default position, so this is the third pose of the foot roll – the heel leaving the ground with the ball on the ground.)

xv. In the *Driver* section of the *Set Driven Key* window, **click** on *left_toe_pivot* to **select** it.

xvi. In the *Set Driven Key* window, **click** "Key".

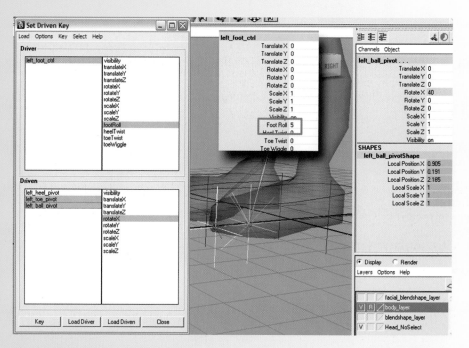

Setting the third key so that when the footRoll is set to "5", the ball is planted on the ground and the heel is in the air.

xvii. In the *Driver* section of the *Set Driven Key* window, **click** on *left_foot_ctrl* to **select** it.

xviii. In the channel box, change *left_foot_ctrl* to "10".

xix. In the *Driver* section of the *Set Driven Key* window, **click** on *left_toe_pivot* to **select** it.

xx. In the channel box, change *RotateX* to "20".

xxi. In the *Set Driven Key* window, **click** "Key".

xxii. In the *Driven* section of the *Set Driven Key* window, **click** on *left_ball_pivot* to **select** it.

xxiii. In the channel box, change *RotateX* to "20".

xxiv. In the *Set Driven Key* window, **click** "**Key**". (This sets the key for the fourth pose of the foot roll – the ball leaving the ground with the tip of the toe on the ground.)

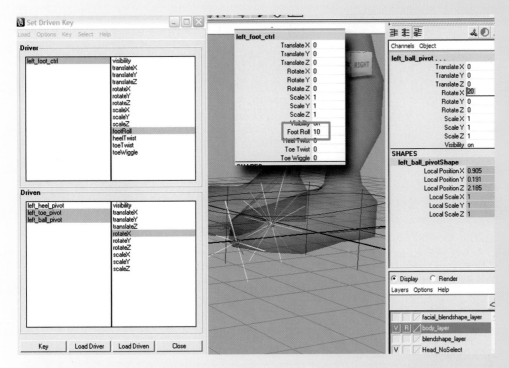

Setting the fourth key so that when the footRoll is set to "10", the ball lifts off of the ground with the heel in the air.

c. Test the foot roll to make sure that it works properly.

 i. In the *Driver* section of the *Set Driven Key* window, **click** on *left_foot_ctrl* to **select** it.

 ii. In the channel box, **click** on the words *Foot Roll*.

 iii. Place your cursor in the PERSPECTIVE window, **click** and hold your **MMB**, and drag left to right to see the foot roll.

d. Repeat for the right leg.

! Remember, if you make a mistake you can start all over again by breaking the connections in the channel box. In the OUTLINER, **select** the *left_heel_pivot* locator, hold down the **(ctrl)** key and **click** the *left_toe_pivot* locator and the *left_ball_pivot* locator, then **click** on the word RotateX in the channel box, RMB and choose "break connections" which will delete the keyframes and you can start again.

11. Make the remaining attributes function using the *Connection Editor*. Do the following:

 a. Go to [**Window > General Editors > Connection Editor**].

 b. In the OUTLINER, **select** the *left_foot_ctrl* and **click** "Reload Left" Scroll down to the bottom of the list and choose "heelTwist".

 c. In the OUTLINER, **select** the *left_heel_pivot* and **click** "Reload Right" Scroll down to Rotate and **click** on the (**+**) to open the values. Choose "RotateY" to make the connection.

Using the connection editor to create a direct relationship between the left_foot_ctrl.heelTwist attribute and the left_heel_Pivot.rotateY attribute.

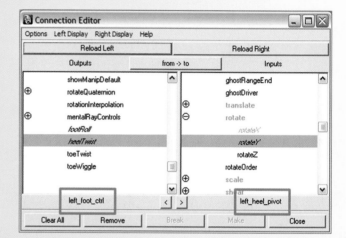

 d. **Click** "Clear All".

 e. In the OUTLINER, **select** the *left_foot_ctrl* and **click** "Reload Left" Scroll down to the bottom of the list and choose "toeTwist".

 f. In the OUTLINER, **select** the *left_toe_pivot* and **click** "Reload Right" Scroll down to Rotate and **click** on the (**+**) to open the values. Choose "RotateY" to make the connection.

Using the connection editor to create a direct relationship between the left_foot_ctrl.toePivot attribute and the left_toe_Pivot.rotateY attribute.

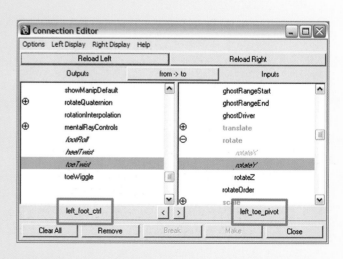

g. **Click** "Clear All".

h. In the OUTLINER, **select** the *left_foot_ctrl* and **click** "Reload Left" Scroll down to the bottom of the list and choose "toeWiggle".

i. In the OUTLINER, **select** the *left_toe_wiggle* and **click** "Reload Right" Scroll down to Rotate and **click** on the **(+)** to open the values. Choose "RotateX" to make the connection.

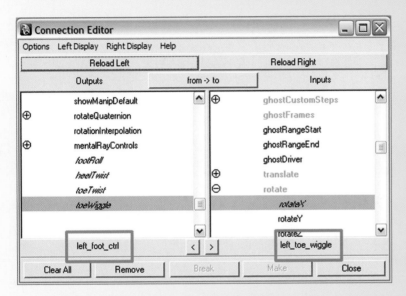

Using the connection editor to create a direct relationship between the left_foot_ctrl.toeWiggle attribute and the left_toe_wiggle.rotateX attribute.

j. Test the attributes to make sure that they work properly.

 i. In the OUTLINER section **click** on *left_foot_ctrl* to **select** it.

 ii. In the channel box, **click** on the words *heelTwist*.

 iii Place your cursor in the PERSPECTIVE window, **click** and hold your MMB, and drag left to right to see the foot roll, repeat the test for *toeTwist* and *toeWiggle*.

k. Repeat the connections for the right leg.

12. Integrate the legs into the existing spine controls by doing the following:

a. In the OUTLINER, **select** the *left_hip*, hold down the **(ctrl)** key, **click** the *right_hip*, the *pelvis*, and press **(p)** to parent.

b. In the OUTLINER, **select** the *pelvis*, hold down the **(shift)** key, and in the PERSPECTIVE window **click** the *hips_ctrl* and press **(p)** to parent.

The new OUTLINER hierarchy after integrating the legs into the existing spine controls.

13. Save your scene file. Name your scene *06_asgn06.ma*.

Assignment 6.7: Creating a Control System for the Eyes and Face

1. Open Maya and set your project.

 a. From your computer's desktop, go to [Start > Programs] and **select** Maya.

 b. Once Maya is open go to [File > Project > Set...] and browse to your project folder then **click "OK"**.

2. Open your last saved file: Go to [File > Open] and **select** *06_asgn06.ma*.

3. Turn X-ray Joints mode off by going to [Shading > X-ray Joints].

4. Make sure that your geometry layer is set to **R** for reference so that you are unable to **select** the geometry by mistake when working.

5. To make selection easier open your OUTLINER by going to [Windows > Outliner].

6. The eyes become part of the skeletal structure so that they move along with the skeleton, but do not deform. In the OUTLINER, **select** the *right_eye_geo* and *left_eye_geo*, then group them together by pressing (**ctrl+g**). Double-click on the group in the OUTLINER and rename the group *eye_geo_group*.

7. In the PERSPECTIVE view, with the *eye_geo_group* selected, shift **select** the *headTip* joint and press (**p**) to parent the *eye_geo_group* to the top joint in the head.

Parenting the Eye groups to the *headTip* joint.

8. Create a control system for the eyes by doing the following:

 a. Go to [**Create > NURBS Primitives > Circle**].

 b. In the channel box, rename *nurbsCircle1* to *eye_ctrl*.

 c. With the *eye_ctrl* selected set the following in the channel box: RotateX: type "90".

 d. In the FRONT orthographic with the *eye_ctrl* selected, **select** the move tool by pressing (**w**) and position the *eye_ctrl* in front of your character's face.

 e. In the PERSPECTIVE view, with the move tool, **click** on the Z axis (**blue arrow**) and move the controller in front of your character's face, about half an arm's length.

 f. With the *eye_ctrl* selected, **select** the scale tool by pressing (**r**) and scale if necessary.

Creating and positioning the *eye_ctrl*.

g. Duplicate the *eye_ctrl* by going to [**Edit > Duplicate**] or press (**ctrl+d**).

h. In the channel box, rename *eye_ctrl1* to *left_eye_ctrl*.

i. With the *left_eye_ctrl* selected, **select** the scale tool by pressing (**r**) and scale it smaller.

j. In the FRONT orthographic view, with the *left_eye_ctrl* selected, **select** the move tool by pressing (**w**) and position the *left_eye_ctrl* in front of the *left_eye*.

k. Duplicate the *left_eye_ctrl* by going to [**Edit > Duplicate**] or press (**ctrl+d**).

l. In the OUTLINER, **double-click** on *left_eye_ctrl1* and rename it *right_eye_ctrl*.

m. In PERSPECTIVE view, **select** the move tool by pressing (**w**) and **click** on the X axis (**red arrow**), and position the *right_eye_ctrl* in front of the *right_eye*.

n. With the *right_eye_ctrl* selected, hold down the (**shift**) key and **select** *left_eye_ctrl* and *eye_ctrl* then go to [**Modify > Freeze Transformations**]. (To return both translate and rotate values to 0 and the scale values to 1.)

o. The rotation order does not need to be changed on these controllers, because rotations are not necessary for control.

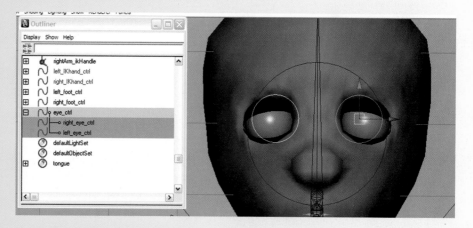

Creating and positioning the *left_eye_ctrl* and the *right_eye_ctrl*.

p. In the OUTLINER, **click** on the *left_eye_ctrl* with the MMB and drag it onto the *eye_ctrl*. (This makes the *left_eye_ctrl* child to the *eye_ctrl*.)

q. In the OUTLINER, **click** on the *right_eye_ctrl* with the MMB and drag it onto the *eye_ctrl*. (This makes the *right_eye_ctrl* child to the *eye_ctrl*.)

r. In the OUTLINER, **click** on the *eye_ctrl* with the MMB and drag it onto the *upperBody_ctrl*. (This makes the *eye_ctrl* child to the *upperBody_ctrl*.)

s. In the PERSPECTIVE window, **select** the *eye_ctrl*, hold down the (**shift**) key, **click** the *upperBody_ctrl* and press (**p**) to parent. (Parenting the *eye_ctrl* to the *upperBody_ctrl* provides the ability to fix the character's gaze in space. As another option, you could parent the *eye_ctrl* to the *face_ctrl* which is created next.)

9. Make the controllers function using *Constraints* by doing the following:

 a. In the PERSPECTIVE window, **click** on the *left_eye_ctrl* (the leader), hold down the **(ctrl)** key, and **click** on the left *eyeball_geo* (the follower), then go to [Constrain > Aim – option box].

 b. Place a check mark in the box next to *Maintain Offset*.

 c. Then **click "add"**.

 d. Repeat this for the right eye.

 e. You can test the controls out by selecting them and moving them around in the PERSPECTIVE window.

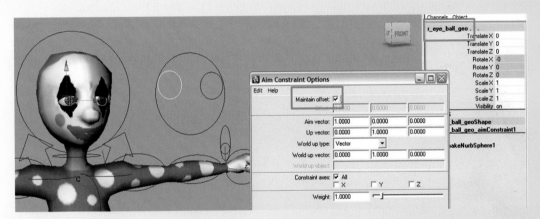

Creating an aim constraint between the *left_eye_ctrl* (leader) and the left eyeball geometry (follower). Make sure the geometry is selected second to add the constraint correctly.

10. Create a control system for the facial expression by doing the following:

 a. Go to [**Create > NURBS Primitives > Circle**].

 b. In the channel box, rename *nurbsCircle1* to *face_ctrl*.

 c. With the *face_ctrl* selected set the following in the channel box: **RotateX:** type "90".

 d. In the PERSPECTIVE view panel, with the *face_ctrl* selected, **select** the move tool by pressing **(w)** and position the *face_ctrl* above your character's head.

 e. With the *face_ctrl* selected, **select** the scale tool by pressing **(r)** and scale if necessary.

 f. The rotation order does not need to be changed on this controller, because rotations are not necessary for control.

 g. In the PERSPECTIVE view, **click** on the *face_ctrl*, hold down the **(shift)** key, click on the *head_ctrl*, and then press **(p)** to parent. (This makes the *face_ctrl* child to the *head_ctrl*.)

 h. With the *face_ctrl* selected go to [**Modify > Freeze Transformations**]. (To return both translate and rotate values to 0 and the scale values to 1.)

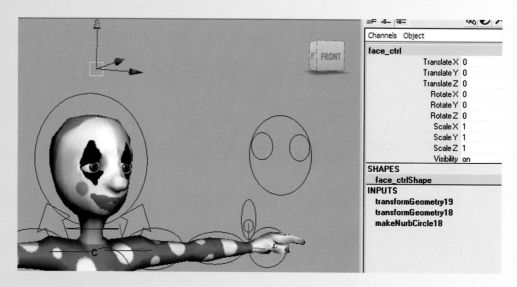

Creating and positioning the *left_eye_ctrl* and the *right_eye_ctrl*.

11. Add attributes to the face control to control the blend shapes by doing the following:

 a. **Select** the *face_ctrl* and go to **[Modify > Add Attribute]** and **enter** the following:

 i. Attribute name: type "leftEyeBlink".

 ii. Under *Numeric Attribute Properties*

 1. Minimum: type "−10".

 2. Maximum: type "10".

 3. **Click** "**Add**".

 iii. Attribute name: type "rightEyeBlink".

 1. Minimum: type "−10".

 2. Maximum: type "10".

 3. **Click** "**Add**".

 iv. Attribute name: type "leftEyebrowRaise"

 1. Minimum: type "−10".

 2. Maximum: type "10".

 3. **Click** "**Add**".

 v. Attribute name: type "rightEyebrowRaise"

 1. Minimum: type "−10".

 2. Maximum: type "10".

 3. **Click** "**Add**".

 vi Attribute name: type "leftEyebrowFurrow"

 1. Minimum: type "−10".

 2. Maximum: type "10".

 3. **Click** "**Add**".

 vii. Attribute name: type "rightEyebrowFurrow"

 1. Minimum: type "−10".

 2. Maximum: type "10".

 3. **Click** "Add".

 viii. Attribute name: type "nose"

 1. Minimum: type "−10".

 2. Maximum: type "10".

 3. **Click** "Add".

 ix. Attribute name: type "smileFrown"

 1. Minimum: type "−10".

 2. Maximum: type "10".

 3. **Click** "Add".

 x. Attribute name: type "puckerWide"

 1. Minimum: type "−10".

 2. Maximum: type "10".

 3. **Click** "Add".

 xi. Attribute name: type "mouthOpen"

 1. Minimum: type "0".

 2. Maximum: type "10".

 3. **Click** "Add".

Adding custom attributes to the *face_ctrl* using [Modify > Add Attribute].

12. Before making the controls work, you must import your referenced model (at this point your model MUST be completed before importing). If you have not done so already, do the following:

 a. Go to [File > Reference Editor].

 b. **Click** on the file in the bottom half of the reference editor.

 c. Go to [File > Import Objects from Reference].

13. Delete history on geometry that will be skinned. This should already be done, but it is a good idea to make sure that history is deleted on all skinable geometry. Go to [Edit > Delete by Type > Non Deformer History]. DO NOT DELETE HISTORY ON EYELIDS, as this will remove the makeNurbsSphere input, and the eye blinks will no longer work.

To verify that the INPUTS still exist on the eyelids, click on each eyelid and check the channel box.

14. Make sure blend shapes are applied by clicking on the base shape and checking the INPUT section of the channel box. If the blend shape input is not listed, then do the following:

 a. **Select** your target shapes then shift **select** your base shape.

 b. **Select** [Create Deformers > Blend Shapes].

Verifying that the blend shape input still exist on the geometry base shape by checking the INPUTS in the channel box.

15. Make the *leftEyeBlink* attribute function using *Set Driven Key* by doing the following:

 a. In the PERSPECTIVE window, **select** the left *eyeball_geo*. In the channel box, under the INPUTS section, **click** on *makeNurbSphere*, then go to [**Animate > Set Driven Key > Set...**].

 b. **Select** the *face_ctrl* and **click** "Load Driver" in the *Set Driven Key* window.

 i. In the *Driver* section of the *Set Driven Key* window, choose "leftEyeBlink" in the right column.

 ii. In the *Driven* section of the *Set Driven Key* window, **click** on the *makeNurbsSphere* to **select** it.

> If your eyelid does not have the input for *makeNurbSphere1* you will need to recreate the eyes, or find an earlier version of your saved files and import those into this file.

 iii. In the *Driven* section of the *Set Driven Key* window, in the right column choose "startSweep" then hold down the **(ctrl)** key and **click** on "endSweep".

 iv. In the *Set Driven Key* window, **click** "**Key**". (This sets a default position of the leftEyeBlink value of "0".)

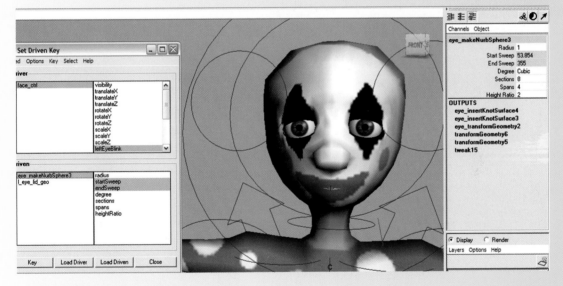

Loading the Set Driven Key window and setting the first key so that when the *leftEyeBlink* attribute is set to "0", the face is in the default (original) position.

 v. In the *Driver* section of the *Set Driven Key* window, **click** on *face_ctrl* to **select** it.

 vi. In the channel box, change *leftEyeBlink* to "10".

 vii. In the *Driven* section of the *Set Driven Key* window, **click** on *makeNurbsSphere* to **select** it.

 viii. Change the start and end sweep to a closed position. In the channel box, change startSweep to about "0", change endSweep to about "359.8".

 ix. In the *Set Driven Key* window, **click** "**Key**".

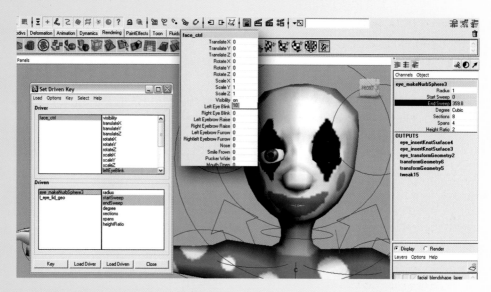

Setting the second key so that when the *leftEyeBlink* is set to "10", the left eye is blinking.

 x. In the *Driver* section of the *Set Driven Key* window, **click** on *face_ctrl* to **select** it.

 xi. In the channel box, change *leftEyeBlink* to "−10".

 xii. In the *Driven* section of the *Set Driven Key* window, **click** on *makeNurbsSphere* to **select** it.

 xiii. Change the start and end sweep to a wide eyed position. In the channel box, change startSweep to about "70", change endSweep to about "315" (these values could be more or less for your character).

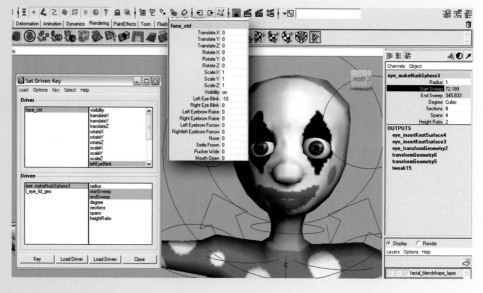

Setting the third key so that when the *leftEyeBlink* is set to "−10", the left eye is open wide.

xiv. In the *Set Driven Key* window, **click "Key"**.

c. Test the *leftEyeBlink* to make sure that it works properly.

i. In the *Driver* section of the *Set Driven Key* window, **click** on *face_ctrl* to **select** it.

ii. In the channel box, **click** on the words *Left Eye Blink*. Place your cursor in the PERSPECTIVE window, **click** and hold your **MMB**, and drag left to right to see the eye blink.

d. Repeat for the *rightEyeBlink*.

16. Make the *leftEyebrowRaise* attribute function using *Set Driven Key* by doing the following:

a. In the *Driver* section of the *Set Driven Key* window, choose "leftEyebrowRaise" in the right column.

b. Go to [**Window > Animation Editors > Blend Shape**] **click** on the "**select**" button in the blend shape window. Then **click** on "Load Driven" in the *Set Driven Key* window.

i. In the *Driven* section of the *Set Driven Key* window, in the right column choose "left_eyebrow_raise" then hold down the (**ctrl**) key and **click** on "left_squint".

ii. In the *Set Driven Key* window, **click** "Key". (This sets a default position of the *leftEyebrowRaise* value of "0".)

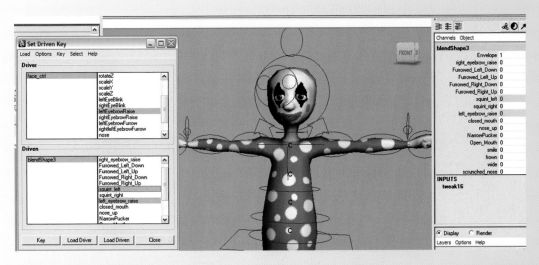

Loading the Set Driven Key window and setting the first key so that when the *leftEyebrowRaise* attribute is set to "0", the face is in the default (original) position.

iii. In the *Driver* section of the *Set Driven Key* window, **click** on *face_ctrl* to **select** it.

iv. In the channel box, change *leftEyebrowRaise* to "10".

v. In the *Driven* section of the *Set Driven Key* window, **click** on *blendShape1* to **select** it.

 vi. In the channel box, change *left_eyebrow_raise* to "1".

 vii. In the *Set Driven Key* window, **click** "Key".

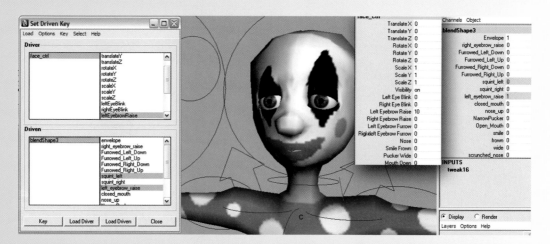

Setting the second key so that when the *leftEyebrowRaise* is set to "1", the blend shapes cause the left eyebrow to raise.

 viii. In the *Driver* section of the *Set Driven Key* window, **click** on *face_ctrl* to **select** it.

 ix. In the channel box, change *leftEyebrowRaise* to " − 10".

 x. In the *Driven* section of the *Set Driven Key* window, **click** on *blendShape1* to **select** it.

 xi. In the channel box, change *left_ squint* to "1".

 xii. In the *Set Driven Key* window, **click** "Key".

 xiii. Repeat these steps for the *rightEyebrowRaise*.

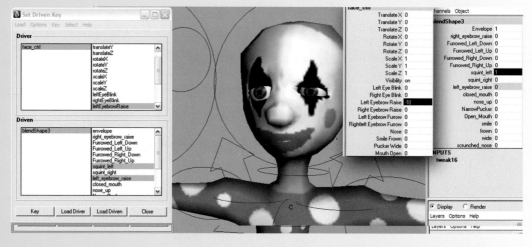

Setting the third key so that when the *leftEyebrowRaise* is set to " −1", the blend shapes cause the eyes to squint.

17. Make the remaining attributes function using *Set Driven Key* the same way using the following as Driver and Driven:

 a. Driver: *face_ctrl* : "leftEyebrowFurrow".

 b. Driven: *blendShape1*: "left_furrow_up" and "left_furrow_down".

 c. Driver: *face_ctrl*: "rightEyebrowFurrow".

 d. Driven: *blendShape1*: "right_furrow_up" and "right_furrow_down".

 e. Driver: *face_ctrl*: "nose".

 f. Driven: *blendShape1*: "scrunched_nose" and "nose_up (optional)".

 g. Driver: *face_ctrl*: "smileFrown".

 h. Driven: *blendShape1*: "smile" and "sad_frown".

 i. Driver: *face_ctrl*: "puckerWide".

 j. Driven: *blendShape1*: "narrow_pucker" and "wide".

 k. Driver: *face_ctrl*: "mouthOpen".

 l. Driven: *blendShape1*: "open".

18. Save your scene file. Name your scene *06_asgn07.ma*.

Assignment 6.8: Creating a Control System for the Tails, Ears, and Other Things That Move (Neckties)

Well congratulations, you have successfully learned many of the tools and techniques used to create a control rig for a 3D character. Depending on your design, however, you may still have a few body parts that need to be addressed. So here's a chance to apply what you've learned.

If your character has ears, it is usually a good idea to add some type of joint system to control them. Ears can be a very expressive part of a character's body and really helped an animator show great emotion from a character. Usually, three or four joints may be enough to create controls for short ears, but if the character has lengthy ones you may want to include a few more. Remember to check the local rotation axis and reorient the joints if necessary. You can use Set Driven Key or an IK chain with a controller to control the ear joints. Just make sure, if you're using IK, to parent the ear controller to the existing head control. This way the ears won't stick behind the character as he moves around.

Tails, antenna, and neckties can be easily controlled using the same system that we created for the spine. Usually the Spline IK creates a very fluid movement for long joint chains. Again, make sure the controllers for these body parts are parented to the existing control system. Tail controllers should be parented to the upper body control, antenna would most appropriately be parented to the head control, and a necktie of course would probably work best on the net control.

Whatever you are rigging, applying the tools that you've learned in this chapter can provide you with much of the control that will be needed when animating. This chapter has also provided you with a great foundation for learning more advanced techniques.

Wrapping Up the Setup

7

- ➢ **Former Student Spotlight: Rob Miller**
- ➢ **Workflow**
- ➢ **Introduction**
- ➢ **Cleaning up the scene file for animation**
- ➢ **Preparing the scene file for skinning**
- ➢ **Summary**
- ➢ **Assignments**

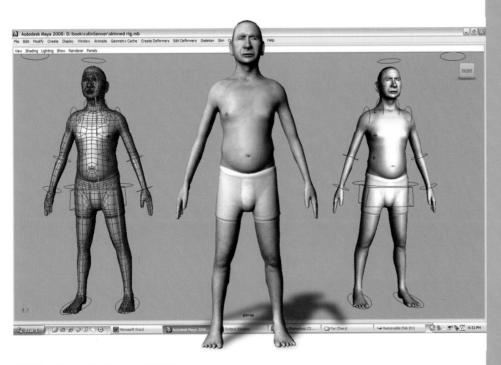

Old Man by Colin Senner (2006).

Former Student Spotlight: Rob Miller

Those interested in one day aspiring to join the ranks in the CG industry have the perfect opportunity to break into it by creating a "customized business card". No, I'm not talking about the small piece of thick paper used to pick teeth … a short film! From experience, creating a short film opened so many doors for me and acted as a personalized business card. It showed employers what I was capable of producing and that I was able to follow through to the end with my own personal objectives and goals.

If you end up catching the short film bug as I've done, be sure you keep these very simple pointers in mind. First and foremost, PLAN! In school I created a short called "The Pick Up" that was originally supposed to be 30 seconds long. Needless to say I started animating with a rough storyline idea in my head, and what I thought would have been 30 seconds ended up being almost four minutes long. The problem was there were no storyboards, no animatics, and no thumbnails. I was so excited and more concerned with getting started on the animation that I suppose I hoped it would all work out in the end. Needless to say, it caused a lot of pain later on down the road. A former teacher once told me "If you fail to plan, you plan to fail," and these words are so true. I cannot emphasize enough how important planning is. You owe it to yourself and you'll have a much happier experience.

After planning out your next project, take a look at what you have. It's easy to get excited about your next endeavors, thus wanting to make an epic, but if you are first starting out, keep it short and simple. The only thing I did right in creating "The Pick Up" was the simplicity of the characters and the 3D set. I intentionally thought to myself that I wanted to sell my skill set as an animator and storyteller, so I made simple characters, created a simple set, and then applied a simple story. Don't strive for anything epic or expect to create a masterpiece on your first go round. Remember you have to start your learning curve from the beginning, so start with simplicity first. It's far better to have a very strong 30 seconds short film then a 10 minutes mediocre epic with 200 plus shots.

Finally, the biggest lesson I learned that helped considerably in getting to where I am today came from surrounding myself with people and teachers who would give brutal critiques. If it's available, find those with better abilities than you and ask for critiques on your work. Don't be shy and don't wait until you are finished with your project. The more you lend your ear to a great critique, the faster you will get better and better. The friends you surround yourself with will become invaluable to you as you continue through your education and break into the industry. Thankfully the Internet is a wonderful resource with its wide array of forums should you not attend a formal school.

So to wrap up: plan, keep it simple, and lend an ear for critiques as you progress. Hope to see you working alongside me one day. Best of luck!

Rob T. Miller graduated from the Savannah College of Art and Design and was awarded with the Outstanding Academic Achievement Award in Animation, the highest honor from an academic department. His short film "The Pick Up" was screened in many film festivals around the world most notably at FMX in Stuttgart Germany in Peter Plantec and Shelly Paige's panel presentation of "Understanding Exceptional Short Animation". His professional works have included high-end television commercials and various video game

cinematics across multiple titles. Currently he resides in Los Angeles, California as a cinematic animator in the video game industry. His work can be seen at:

www.robtmiller.com

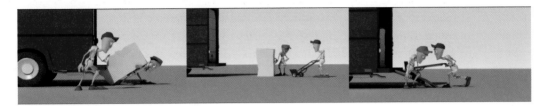

The Pickup by Rob T. Miller (2004).

Workflow

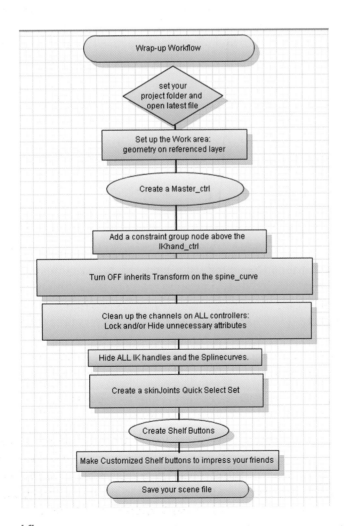

Wrap-up workflow.

Introduction

Before this control rig can be considered complete, there must be some time spent in cleaning up the scene file. Making sure that everything is labeled properly is an ideal place to start, but it is also important to group or organize all of the elements into one node, so that bringing the character into an environment ready for animation is a neat and tidy process. It is rather frustrating for a production team to have a messy scene file.

Cleaning up the scene file for animation

There are times that you will need to resize, move or rotate your character into place before you begin animating. Creating a master control can make this simple, as well as organize your objects in the scene file.

Now that you are finishing up the character rig, go back over the controls and make sure they are optimized for animation. Hide any channels that the animator should not keyframe. In most cases, this includes the scale and visibility channels. For some, it will include the rotations or translations. It is also a good idea to lock those channels also, so that the animator cannot alter the locked and hidden channels. Any channel that has color should be hidden so that they are not keyframed (colored channels are controlled by constraints, set driven keys, expressions, etc.).

The process of hiding a channel is quite simple. Simply go to the channel box, click on the attribute name that you would wish to hide, hold down the right mouse button on top of those words, and choose either *lock and hide selected* or *hide selected*. If a mistake is made while hiding attributes, it is a bit more difficult to bring them back to the channel box. To make an attribute visible again, you must go to **[Window > General Editors > Channel Control]** and do the following:

- Click on the **KEYABLE** tab.
- **Select** the attributes in the middle column that you want to place into the keyable list and click on the MOVE button on the bottom right. This moves them into the Keyable list and they should also appear in the channel box.

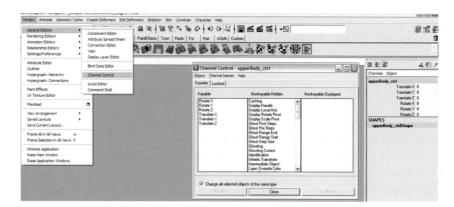

The Channel Control window.

- Now click on the **LOCKED** tab.

- **Select** the attributes on the left column that you want to move to the non-locked list and click the MOVE button on the bottom left. This moves them to the NON-LOCKED list.

- Repeat this for every controller.

IK handles and IK spline curves should also be hidden so that the animator doesn't accidentally keyframe them during the animation process. This is also an easy process. Simply select the IK handles and press **(ctrl + h)** on the keyboard to hide them.

Preparing the scene file for skinning

The last part of the actual character setup is adding the skin deformer so that when the joints move and rotate, the geometry moves and deforms with it. Since there are multiple joint chains for the spine and the arms, it is unnecessary to add all of the joints to the skin deformer. In fact, this would actually create more problems because the multiple joints would share the deformation and stretch the geometry between them, causing undesirable results. To avoid this and expedite the skinning process, which is covered in Chapter 8, we will create a set that contains only the joints needed to deform the geometry.

Wombat by Brett Rapp (2006).

It is also helpful to add some control to speed up the process of animating. There are several techniques that help the keyframing process. The two most common are the use of character sets and MEL buttons to select controllers. While characters sets seem to be a popular tool, I personally do not like the way they work. The character set is simply a defined set of attributes so that when the keyframe is placed on one controller, all of the other attributes that are part of the set are also keyframed. To

create a character set, you simply select all of the controllers and go to the menu item [**Character > Create Character Set**].

While this approach sounds wonderful, I have found that it does cause major confusion with beginning animators. Because Maya is setting keyframes on many attributes, the amount of keyframed data can easily become overwhelming. So my advice to a beginning animator is to make sure you are completely aware of all keyframes being set and not let the computer do the work for you.

This brings me to my preferred method: creating MEL Script buttons on a shelf that allows for ease in the selection of all of the controllers or a specified area of controllers. A button that allows you to select all of the controllers gives you the ability to key the entire character on your key poses. Additional buttons that specify all of the controls in an arm, the leg, or the spine provide the animator a method of keying specific areas quickly.

Summary

7.1 After all the controls have been created, it is important to take time and organize a scene file so that it can be used efficiently during production.

7.2 Make sure that everything is labeled properly in the scene file.

7.3 Create a master control that provides the ability to move, rotate, and scale the character prior to animation.

7.4 Go through every control and optimize them for animation by hiding and locking (if necessary) any attributes that will not be animated.

7.5 You can also go through the scene file and hide any objects that are not necessary, such as IK handles, so that they are not keyframed accidentally during the animation process.

7.6 Creating selection buttons for the controllers is one way to speed up the animation workflow and can be easily done and customized. This provides the animator a quick way of selecting groups of controllers that need to be keyframed.

7.7 Character sets can be used for the same purpose, but can cause more work with the amount of keyframe data that is created.

Assignments

Assignment 7.1: Cleaning Up the Scene File for Animation

Set up your work environment by doing the following:

1. Open Maya and set your project.

 ● From your computer's desktop, go to [START > PROGRAMS] and **select** Maya.

 ● Once Maya is open go to [**File > Project > Set ...**] and browse to your project folder then **click OK**.

2. Open your last saved file: Go to [**File > Open**] and **select** *06_asgn07.ma*

3. Continue working in X-ray Joints Mode.

4. Make sure that your geometry is placed on a layer and that the layer is set to **R** for reference so that you are unable to select the geometry by mistake when working.

5. To make selection easier open your outline by going to [**Window > Outliner**].

6. Create a master control for the rig by doing the following:

 - First create the controller by doing the following:

 i. Go to [**Create > NURBS primitives > Circle**].

 ii. In the channel box, rename the circle *Master_ctrl*. (You can replace the word *Master* with your character's name. For example, my character's name is Bobo, so I would rename the circle *Bobo_ctrl*).

 iii. In perspective view, **select** the move tool by pressing (**w**) and position the *Master_ctrl* into place around the feet of the character.

 iv. Use the scale tool by pressing (**r**) and resize *Master_ctrl*. (This control should be scaled large enough that it is OUTSIDE of the character's feet to make it easy to select.)

 v. With the *Master_ctrl* selected, go to [**Modify > Freeze Transformations**] (to return both translate and rotate values to 0 and the scale values to 1).

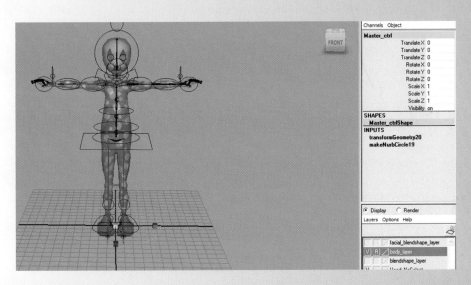

Creating the Master_ctrl.

7. Parent all rig controls and geometry to the *Master_ctrl* by doing the following:

 - In the outliner, **select** the *right_IKHand_ctrl*, hold down the (ctrl) key and **click** on the *left_IKHand_ctrl*, the *rightArm_ikHandle*, the *leftArm_ikHandle*, the *spine_curve*, the *spine_ikHandle*, the *upperBody_ctrl*, the *IK_Spine1*, *left_foot_ctrl*, *right_foot_ctrl*, all of your geometry, and the *master_ctrl*.

 - Press the (**p**) key to parent. (This makes the *master_ctrl* parent to all of the other selections.)

The OUTLINER hierarchy after parenting everything to the Master_ctrl.

8. Add constraint groups to the IK arm controls to assist in object interaction when animating by doing the following:

- In the perspective window, **select** the *right_IKhand_ctrl*, and press (**ctrl + g**) to group it.

- In the channel box, rename group1 *right_IKhand_constraint_grp*

- In the perspective window, **select** the *left_IKhand_ctrl*, and press (**ctrl + g**) to group it.

- In the channel box, rename group1 *left_IKhand_constraint_grp*

The OUTLINER hierarchy after creating the constraint groups for the IKhand controls.

9. If the *Master_ctrl* is moved at this point, the spine explodes out of the rig because the spine curve has two inputs of control: the cluster deformers (controlling the CVs) and the *Master_ctrl* (acting as a parent node). This leads to double transformations in the rig (moving twice as far as everything else).

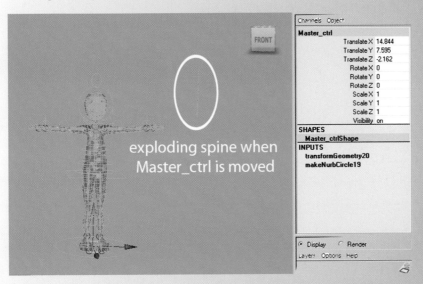

The spine moves out of the skeletal structure because it is being controlled by both the skin deformer and the parent controller.

To solve this problem, do the following:

- In the outliner, hold down the shift key and **click** on the **plus sign (+)** next to the *Master_ctrl* to open the hierarchy and display the children.

- Find the *spine_curve* and **click** on it to **select** it.

- Press (**ctrl + a**) to open the attribute editor.

Unchecking the Inherits Transform on the spine curve in the Attribute Editor.

 i. **Select** the *spine_curve* tab.

 ii. Under *Transform Attributes* set the following:

 1. Remove the check next to *inherits transform*. (This makes the *spine_curve* free from the parent *Master_ctrl* transformations.)

10. Clean up each controller in the table below by doing the following:

- In the channel box, **click** on the words of the channel(s) that are not used during animation for that controller.

- If the channel is white, hold down the **RMB** (right mouse button) and **choose** *Lock and Hide selected*.

- If the channel is orange, blue, yellow, or purple, hold down the **RMB** (right mouse button) and **choose** *Hide selected*.

CONTROL NAME	LOCK AND/OR HIDE (select in channel box, rmb)
Master_ctrl	**visibility**
left_foot_ctrl, right_foot_ctrl *upperBody_ctrl** *upper_spine_ctrl, lower_spine_ctrl** *spine_shoulder_ctrl* *hips_ctrl* *left_IKhand_ctrl, right_IKhand_ctrl** *eye_ctrl*	**ScaleX, ScaleY, ScaleZ, and visibility**
*head_ctrl** *neck_ctrl** *FK_left_wrist_ctrl, FK_right_wrist_ctrl** *FK_left_elbow_ctrl, FK_right_elbow_ctrl** *FK_right_shoulder_ctrl, FK_left_shoulder_ctrl** *left_FKarm_ctrl, right_FKarm_ctrl**	**TranslateX, TranslateY, TranslateZ, ScaleX, ScaleY ScaleZ, and visibility**
left_eye_ctrl, right_eye_ctrl *left_IKelbow_ctrl , right_IKelbow_ctrl** *left_clavicle_ctrl, right_clavicle_ctrl* *left_knee_ctrl, right_knee_ctrl*	**RotateX, RotateY, RotateZ, ScaleX, ScaleY ScaleZ, and visibility**
right_finger_ctrl *left_finger_ctrl* *right_FKIK_Switch* *left_FKIK_Switch* *face_ctrl*	**TranslateX, TranslateY, TranslateZ, Rotated, RotateY, RotateZ, ScaleX, ScaleY ScaleZ, and visibility**

*** remember to ONLY hide anything with color on these controllers.**
Do NOT lock anything with color as it may prevent the control from working properly.

11. Hide IK so that during animation, they are not accidentally selected and keyframed.

- Select the spine_ikHandle, spine_curve, left_heelPivot, right_heelPivot, leftArm_ikHandle, rightArm_ikHandle, leftWrist_ikHandle, rightWrist_ikHandle, leftClavicle_ikHandle, rightClavicle_ikHandle, and press (ctrl + h) to hide them.

12. Save your file as *07_asgn01.ma*.

Assignment 7.2: Preparing the Scene File for Skinning

Set up your work environment by doing the following:

1. Open your last saved file: Go to [File > Open] and **select** *07_asgn01.ma*

2. Continue working in X-ray Mode.

3. Make sure that your geometry is placed on a layer and that the layer is set to R for reference so that you are unable to **select** the geometry by mistake when working.

4. To make selection easier open your outline by going to [Window > Outliner].

5. Prepare the character for skinning.

 a. Create a set of skinnable joints by doing the following:

 i. Go to [Edit > **Select all by Type** > **Joints**].

 ii. Hold the cursor over the outliner and press (f) to frame the selected joints.

 iii. In the outliner, deselect the following joints from the selection by holding down the **(ctrl)** key and clicking on each of the following joints:

 The FK spine:

 FK_spine1, lower_spine_ctrl, upper_spine_ctrl, FK_spine6.

 The left IK arm:

 IK_left_shoulder, IK_left_elbow, IK_left_wrist, IK_left_palm.

 The left FK arm:

 FK_left_shoulder_ctrl, FK_left_elbow_ctrl, FK_left_wrist_ctrl, and FK_left_palm.

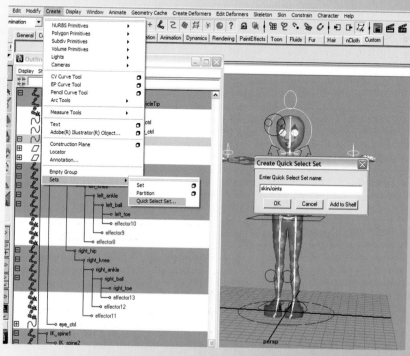

Creating a Quick Select Set for the skinnable joints.

The right IK arm:

IK_right_shoulder, IK_right_elbow, IK_right_wrist, IK_right_palm.

The right FK arm:

FK_right_shoulder_ctrl, FK_right_elbow_ctrl, FK_right_wrist_ctrl, and FK_right_palm.

 iv. Go to [**Create > Sets > Quick Select Sets**].

 – Enter Quick Select Set name: **skinJoints**.

 – **Click "OK"**.

6. Turn IK off in the arms before binding. This is important since IK rotates the joints immediately. Because the arm position can be altered by the IK solver, it is best to key FK position in the arms for skinning. In the perspective window, **click** on the *left_FKIK_switch*, hold down the (**shift**) key and **click** the *right_FKIK_switch*. In the channel box, set the FKIK attribute to "0" to turn IK off.

Turning IK off in the arms.

7. Save your file as *07_asgn02.ma*.

Assignment 7.3: Creating Additional Tools for Animation (Optional)

Set up your work environment by doing the following:

1. Open your last saved file: Go to [**File > Open**] and **select** *07_asgn02.ma*.

2. Turn X-ray mode off if it isn't already.

3. Make sure that your geometry is placed on a layer and that the layer is set to "R" for reference so that you are unable to **select** the geometry by mistake when working. (It should be by now!)

4. To make selection easier open your outline by going to [**Window > Outliner**].

5. Creating selection MEL buttons by doing the following:

 a. With nothing selected (**click** in an empty area of the perspective window to be sure) go to [**Window > General Editors> Script Editors**].

 b. In the Script Editor, go to [**Edit > Clear History**].

The Script Editor.

c. In the perspective window, go to [Show > None].

d. In the perspective window, go to [Show > NURBS Curves].

e. In the perspective window, LMB **click** + drag around all curves to **select** them.

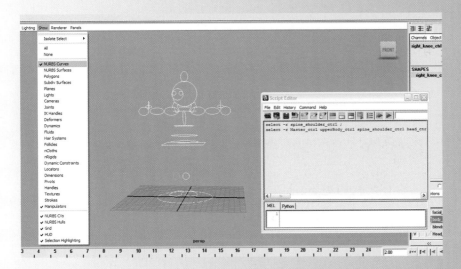

Selecting all of the curves in the perspective window.

f. In the shelf area, **click** on the CUSTOM tab.

g. In the Script Editor, LMB **click** + drag the entire row of MEL that appears to highlight the selection (this is the command to **select** all of the NURBS curves).

h. In the Script Editor, **MMB click** + drag the entire row of MEL onto the CUSTOM shelf.

a. Save script to shelf as type: **choose MEL.**

i. Add a name to the shelf button by going to [**Window > Settings/Preferences > Shelf Editor**] and enter the following:

Icon Name : type 'all'.

Creating a customized selection button.

These steps can be repeated for different sections of the body controls. For example, the hand, elbow, and shoulder FK. Controls can be made into a shelf button for each arm. The spine, neck, and head controls should be a button also, as well as each IK arm and elbow, in addition to the IK foot and knee.

6. Save your file as *07_asgn03.ma*

As an added challenge (which will impress all of your friends) you can create your own shelf icons in a graphics software package. The images must be pixel dimensions of 32 X 32 pixels and must be saved as a bitmap image. These are placed in the icons folder of your Maya preferences. In the Shelf Editor, **click** on **Change Image** to browse to the icons folder in your preferences.

Creating customizable shelf icons.

Using the shelf editor to change the icon image.

If you are not sure where these are stored on the computer, go to [**Window >
Settings/Preferences > Preferences**] **click** the save button. Then go to [**Window
> General Editors > Script Editor**]. The Script Editor will give you the path to the
directory where your preference folder is located.

Skinning Your Character

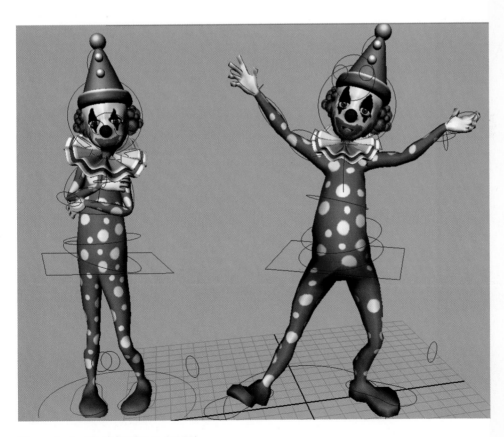

Character by Cheryl Cabrera (2007).

Former Student Spotlight: Tonya Payne

Skinning can be a really frustrating process if you are new to character modeling and setup. It's also a very important step in the process of setting up your character for animation. It will ultimately determine how your character deforms.

Having enough joints and having those joints in the right place is part of whether or not your character is going to deform in a desirable way. However, there are other things to take into consideration as well that will determine whether or not your character will deform properly. Perhaps more important than bone placement is the model itself. This is where bad edge looping will make you want to pull your hair out. This really comes into play around areas that bend, especially the shoulders. The shoulders are really the number one place where bad deformations occur. You can avoid having to do extensive weight paintings around the shoulders if, when you are modeling your character, you make the edge looping follow the musculature. In much the same way as you concentrate on looping the edges around the mouth and the eyes to follow the musculature, you should do the same with the shoulders. Unfortunately, many modelers do not do this. By having edge looping follow the musculature of the character, you will have fewer weights to tweak.

Also, you want to keep the number of edges down to a minimum. You want just enough so that the model can deform, but not so many that you are painting weights on thousands of vertices. More edge loops should be allowed where the character is going to be bending at, such as the elbows, the shoulders, and the knees. You can always apply a smooth skin after you paint weights on a lower poly version of your model.

Another thing to take into consideration when skinning is the interpenetration of clothing and other geometry that is close together. A great way to solve this problem is to make sure that the vertices are weighted identically using the weight table. On a bat character that I rigged, the wings had double-sided geometry that was very close together and we had problems with the vertices on the back of the wing going through to the front of the wing and vice versa. We solved the problem by making sure vertex pairs had matching weights on each joint they were weighted to. Skinning and painting weights can be a tedious and painstaking process if you are sloppy about the way you've modeled your character, but if you are careful and plan ahead, you will save yourself a lot of time and extra work.

Mr. Hyde – **Bat rig by Tonya Payne (2006) for the short film *Bait* by Luke Nalker.**

Tonya Payne graduated from the Savannah College of Art and Design with a BFA in Animation. She currently works for BreakAway Games in Corpus Christi, Texas as a Character Setup Artist and Animator.

Workflow

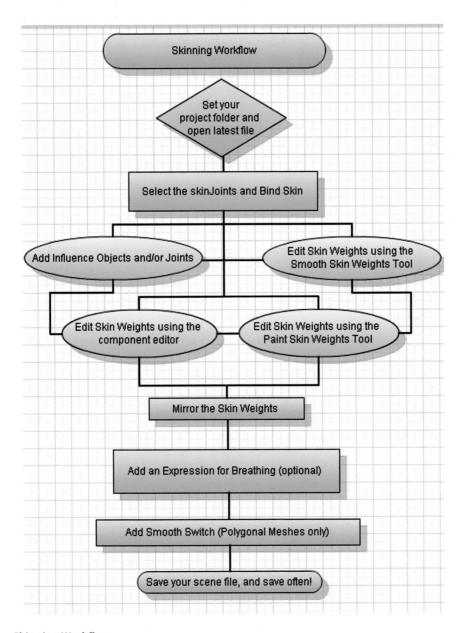

Skinning Workflow.

FuMan **by Chris Beaver (2007).**

The final step in character creation is the process of skinning. Skinning is another type of deformer, which means it is a tool that changes the shape of the geometry. This deformer takes points from the geometry and assigns them to one or more joints in the skeleton so that when the joints rotate, the geometry bends and moves with them.

Skinning can become a tedious and arduous task. Many times, problems that arise during the skinning process are caused by problematic or inadequate geometry, or inaccurate joint placement. This is why it is so important to test bind after joint placement. If problems exist in the geometry or joint placement, it is good to see it at that point during the workflow and much easier to make changes.

With the release of Maya 2008, new tools are now available to help make the skinning process less painful and more productive. Knowing what tools to use and in which order to use them also speeds up and refines the skinning process.

There are two types of skin deformers: rigid bind and smooth bind. This chapter will focus on the smooth bind process. Rigid bind is generally used when creating characters for game engines, as most game engines at this point in time do not support the smooth bind process. Rigid bind simply assigns one joint influence to each point on the character's geometry. Because of this, when a joint bends the geometry has a tendency to crack in areas or look rigid. Smooth bind, however, will assign multiple joints to each point, allowing the ability to spread the influence over several joints, giving a more natural look and smoother deformations.

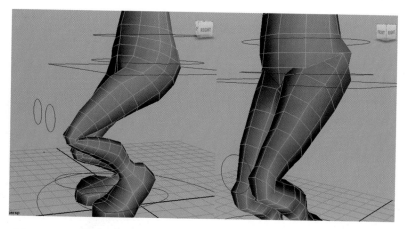

Smooth bind (left) compared to rigid bind (right).

Skinning Tools in Maya

There are several tools available that can speed up the process and make it easier. Knowing these tools can make the difference from having a great result or pulling your hair out in the process. Again, we'll take a look at those that we'll be using during the assignments.

Creating the skin deformer [Skin > Bind Skin > Smooth Bind – option box …]

For best results, the smooth bind options will need to be adjusted before the smooth bind has been applied. I have found that some of these options work fine in the default setting for testing the skin binding. However, for the final bind, it is best to adjust some of the options in this window. The following settings are the changes that I suggest:

Bind to: **Selected Joints** (This will only bind the geometry to the joints you select, which is important when you have multiple joint chains in each area, like the arms and spine.

Bind method: **Closest in hierarchy** (This will bind to the joints connected to each other so that points are shared by nearby joints).

Max influences: "**3**" (This means that no more than three joints will share the influence over a single point. I find that more than three usually creates too many problems).

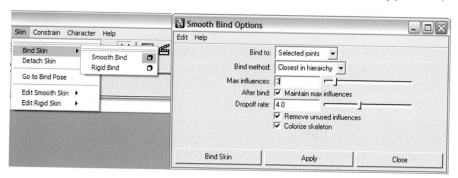

The Smooth Bind option box with suggested settings.

> ! Make sure that the only history on your geometry is your blend shape input. Geometry history can cause all types of problems during the skinning process **[Edit < Delete by Type > Non-deformer History]**.

Adjusting the Skin Weights

Character **by Tim Robertson (2005).**

The Component Editor [Window > General Editors > Component Editor]

Once the skin deformer has been applied, there will probably be joints that pull on areas of geometry where those joints clearly should have no influence. For example, the left foot will probably pull on the right foot. The shoulders will probably pull on the face and hair. This is actually a pretty simple problem to fix when using the component editor. Simply select the CVs or vertices in question, and open the component editor. Choose the Smooth Skin tab. Here you will see a list of the selected points in the left hand side of the window, and across the top you will see all of the joints that affect those points. The values total "1" for full influence. Left mouse button **(LMB) click** and shift + select all of the values for the joints in question. This highlights the values in the columns for the joints where you can type "0" to remove the influence. On occasion, the column may not disappear because the value may be "1" indicating that joint has full influence on a point. If this happens, simply type "1" on a joint that should influence the point. (For example, if the left toe joint is affecting a point in the right foot toe area, type "1" on the right toe joint column for that point.)

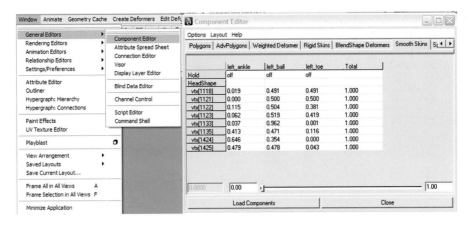

The Component Editor showing several vertices and which joints affect them.

(New in Maya 2008) – Smoothing the Skin [Skin > Edit Smooth Skin > Smooth Skin Weights]

Once the skin deformer is applied, there will probably be areas that push in or pull out of the geometry when the joints are rotated. The most common areas where this occurs are under the arm in the armpit region, around the waist in the pelvic area, and at the top of the thigh. To fix this problem, select the vertices in question and go to **[Skin > Edit Smooth Skin > Smooth Skin Weights]**. This new feature does a pretty good job of fixing those faulty areas. Any remaining issues can be adjusted with the *Paint Skin Weights Tool*.

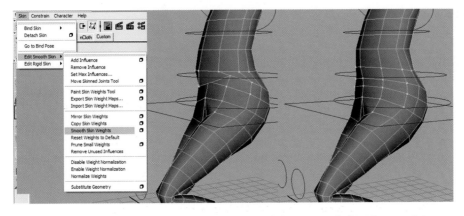

After smooth binding, you may have undesirable deformation (left). After applying the smooth skin weights, the results are much better (right).

Adding Influences [Skin > Edit Smooth Skin > Add Influence]

Once the skin deformer has been applied, there may be areas that pinch when rotating the joint (such as the elbows and knees). First make sure that there is adequate geometry in the area. If lack of geometry is not a problem, additional joints may be added as influences to help keep the shape from pinching when the joint bends the geometry. Influence objects can also be used to create muscle bulges and breathing motion.

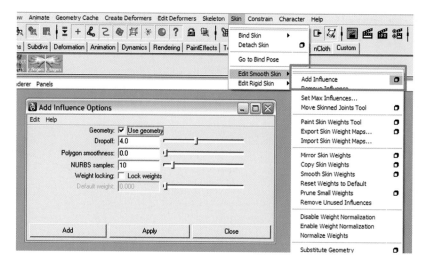

The Add Influence Options.

Paint Weights – [Skin > Edit Smooth Skin > Paint Skin Weights Tool]

Additional skin deformation problems can be addressed interactively with this tool. The approach to use is the idea of adding influence to joints (that should be affecting a particular area) as opposed to removing influence from joints that affect the area incorrectly.

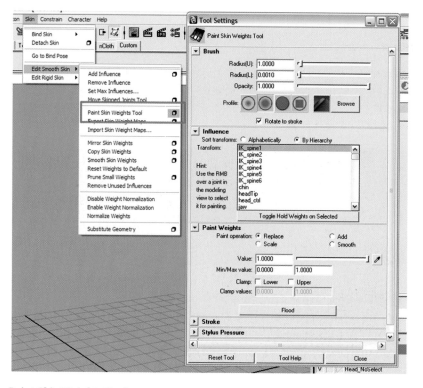

The Paint Skin Weights Tool.

Mirror Weights – [Skin > Edit Smooth Skin > Mirror Skin Weights – option box]
For solid pieces of geometry (like the torso, or a seamless character), you only need to paint weights on one side (left OR right, but be consistent). This tool can be used to mirror the skin weights to the other side. For this tool to work properly, the character must be completely centered at the origin on the X-axis, and the geometry must be identical on both halves.

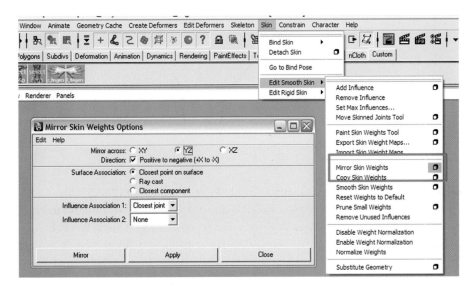

The Mirror Skin Weights Options.

One Final Challenge

Now that you have a foundation in the rigging process, challenge yourself with characters that are not bipeds. All of the tools and techniques that you have learned can be applied to other types of characters and creatures. Remember, start in the beginning and do your research.

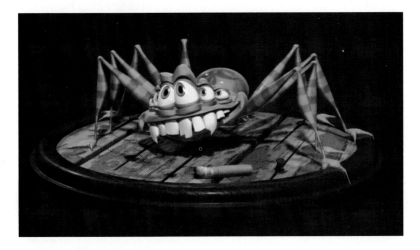

Mr. Bojangles by Luke Nalker (2006).

Summary

8.1 Skinning is a deformer that controls geometry points with joints.

8.2 There are two types of skin deformers: rigid bind and smooth bind.

8.3 Rigid bind assigns each point to only one joint in the skeleton.

8.4 Smooth bind assigns each point to one or more joints in the skeleton. Smooth bind allows a single point to be shared across multiple joints. Because of this, smooth bind provides smoother deformations.

8.5 The component editor provides a quick and easy way to edit individual points on the smooth skin.

8.6 The total amount of influence that point can have must equal one. This can be spread out on several joints or found on a single joint.

8.7 The smooth skin weights tool provides a quick easy way to spread the weights of selected points to joints nearby.

8.8 Influence objects can be added to a smooth skin and used to help obtain the results of a particular shape during the deformation process when joints are rotating. They can also be used to mimic muscle contractions and breathing.

8.9 The paint skin weights tool is an interactive approach to adjusting how the joints influence the points in the geometry.

8.10 Correcting the skin weights on the geometry is a tedious and time-consuming process. The mirror skin weights command provides the ability to reflect the corrections from one side of a character to the other. Because of this, the time correcting skin weights can be reduced in half.

8.11 It is important to remember to save often during the scanning process. It is a good idea to save versions of your files and save often.

Assignments: Skinning a Character

Because of this process can be a long and tedious one, it is a good idea to save your work often. In case there is a problem, you can simply reopen the latest file. Many times the undo command does not work during the skinning process.

Assignment 8.1: Skin the Character

Set up your work environment by doing the following:

1. **Open** Maya and **set** your project.

 ● From your computer's desktop, go to [**Start** > **Programs**] and **select** Maya.

 ● Once Maya is open go to [**File** > **Project** > **Set** ...] and browse to your project folder then **click OK**.

2. **Open** your last saved file: Go to [**File** > **Open**] and select *07_asgn01.ma*.

3. Turn off X-ray Mode. In the view panel, go to [**Shading** > **X-ray**].

4. Import your objects from the reference file if you didn't do this in Chapter 6.

 ● **Open** the reference editor by going to [**File** > **Reference Editor**]

 ● **Click** on the filename to highlight it, then in the reference editor window, go to [**File** > **Import Objects From Reference**]. This will PERMANENTLY import the reference file into your scene.

5. If you didn't do this in Chapter 6, make sure that history has been deleted from the geometry, except for the blend shape deformer. To do this, go to [**Edit** > **Delete by Type** > **Non-deformer History**]. DO NOT DELETE HISTORY FROM THE EYELIDS if you have created them using the NURBS sphere method as discussed in Chapter 2.

6. If you didn't do this in Chapter 7, take time now to go through the outliner and hypergraph and rename your geometry nodes as appropriate.

7. Make sure that your geometry layer is **set** to *normal* by **clicking** on the **R** until the box is empty so that you are able to add the geometry to the selection.

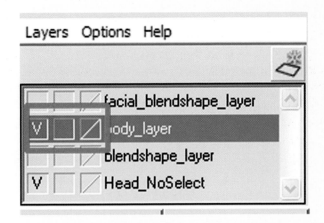

Setting the geometry layer to *NORMAL*.

8. To make selection easier, **open** your outliner by going to [**Windows** > **Outliner**]

9. **Select** the skinnable joints (open the + next to skinJoints in the outliner and **drag** select all joints).

10. Hold down the **shift key** and **click** on the character geometry piece(s).

11. Go to: [**Skin** > **Bind Skin** > **Smooth Bind – option box**] and reset the settings. Then **change** the following:

 ● Bind to: Selected Joints.

 ● Bind method: Closest in hierarchy.

 ● Max influences: "3".

 ● **Click** apply.

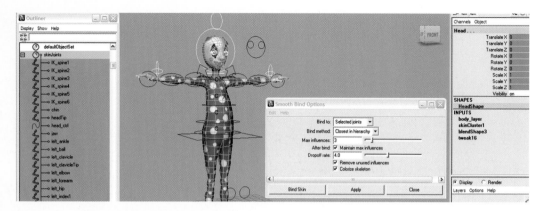

Skinning your character.

12. If the *Master_ctrl* is moved at this point, the body geometry explodes out of the rig because it has two inputs of control: the skin deformer and the *Master_ctrl* (acting as a parent node). This leads to double transformations in the geometry (moving twice as far as everything else).

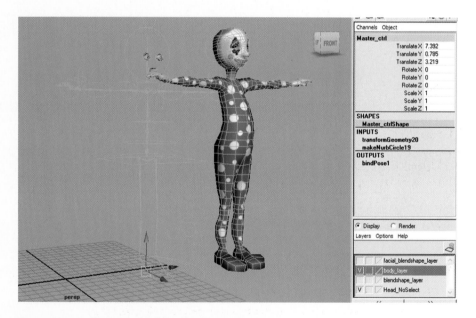

Geometry moving with double transformations.

To solve this problem, do the following:

● In the PERSPECTIVE window, select the geometry that is moving away from the control rig. (If your geometry was already in a group, like mine is, make sure to find the group in the outliner and select that instead.)

● Press **(ctrl + a)** to open the attribute editor.

 i. **Select** the first tab.

ii. Under *Transform Attributes* set the following:

1. Remove the check next to *inherits transform*. (This makes the *geometry* free from the parent *Master_ctrl* transformations.)

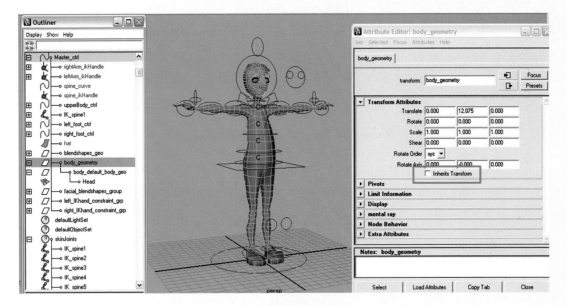

Turning OFF inherits transform on the geometry or the geometry group.

13. **Save** your file as *08_asgn01.ma*.

> ❗ If your character has multiple pieces of geometry, it is possible to skin each piece separately instead of all at one time. This usually provides for cleaner binds and less problems to fix. To skin individual pieces, select only the joints in the area of the piece of geometry plus one additional joint beyond, then select the piece of geometry, and then apply the Smooth Bind procedure. (For the head, I would select the neck, skull, chin, jaw, AND the top IK spine joint.)

Assignment 8.2: Fix the Skin Weights Using the Component Editor

1. **Continue** working on scene *08_asgn01.ma*.

2. **Test** the movement of your character by selecting controllers and translating or rotating them around.

3. **Determine** if joints are affecting the wrong area of geometry (e.g. the left foot moves the right foot geometry).

> ❗ The main areas for shared weights are usually in the legs and feet, the head and shoulder, or the fingers. Basically, anywhere when you have parallel areas of geometry and joints.

In this example, the toe geometry is being affected by both the left and the right toe joints, so there is a pulling of the geometry when the feet move.

4. In the view panels, **go to [Show > None]**, then go to [Show > NURBS curves], [Show > NURBS surfaces], and [Show > Polygons] (this way you don't accidentally select joints or IK handles while making corrections).

5. **Select** the vertices or CVs that are being affected incorrectly **RMB** (right mouse button, to display them, and then **drag** your mouse around to **select** them).

In this example, the right toe geometry vertices are selected. Work only on one area at a time to avoid confusion.

6. Go to [Window > General Editors > Component Editor] and **click** on the **Smooth Skin** tab.

7. In the top list, find the joints that are affecting these points and should not be. **Click** on the box in the very top row, **scroll** down to the bottom of the list, **hold** down the **shift key** and **click** on the bottom row, then **type "0"** to remove the influence (e.g. the left toe joint should not be affecting the right foot geometry).

8. **Repeat** this for other affected areas.

9. **Return** the controllers back to their default position by typing "0" in the channel box for the translations.

10. **Save** your file as *08_asgn02.ma*.

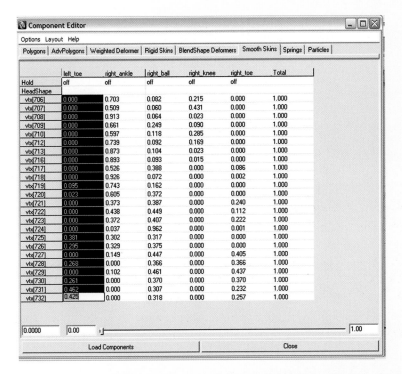

	left_toe	right_ankle	right_ball	right_knee	right_toe	Total
Hold	off	off	off	off	off	
HeadShape						
vtx[706]	0.000	0.703	0.082	0.215	0.000	1.000
vtx[707]	0.000	0.509	0.060	0.431	0.000	1.000
vtx[708]	0.000	0.913	0.064	0.023	0.000	1.000
vtx[709]	0.000	0.661	0.249	0.090	0.000	1.000
vtx[710]	0.000	0.597	0.118	0.285	0.000	1.000
vtx[712]	0.000	0.739	0.092	0.169	0.000	1.000
vtx[713]	0.000	0.873	0.104	0.023	0.000	1.000
vtx[716]	0.000	0.893	0.093	0.015	0.000	1.000
vtx[717]	0.000	0.526	0.388	0.000	0.086	1.000
vtx[718]	0.000	0.926	0.072	0.000	0.002	1.000
vtx[719]	0.095	0.743	0.162	0.000	0.000	1.000
vtx[720]	0.023	0.605	0.372	0.000	0.000	1.000
vtx[721]	0.000	0.373	0.387	0.000	0.240	1.000
vtx[722]	0.000	0.438	0.449	0.000	0.112	1.000
vtx[723]	0.000	0.372	0.407	0.000	0.222	1.000
vtx[724]	0.000	0.037	0.962	0.000	0.001	1.000
vtx[725]	0.381	0.302	0.317	0.000	0.000	1.000
vtx[726]	0.295	0.329	0.375	0.000	0.000	1.000
vtx[727]	0.000	0.149	0.447	0.000	0.405	1.000
vtx[728]	0.268	0.000	0.366	0.000	0.366	1.000
vtx[729]	0.000	0.102	0.461	0.000	0.437	1.000
vtx[730]	0.261	0.000	0.370	0.000	0.370	1.000
vtx[731]	0.462	0.000	0.307	0.000	0.232	1.000
vtx[732]	0.425	0.000	0.318	0.000	0.257	1.000

Highlighting the column of influence on the joint that should NOT be affecting the area.

Assignment 8.3: Fix the Skin Weights Using the Smooth Skin Weights Tool
[*Skin > Edit Smooth Skin > Smooth Skin Weights*] *(New in Maya 2008)*

1. **Continue** working on scene *08_asgn02.ma*.

2. **Test** the movement of your character by **selecting** controllers and **translating** or **rotating** them around.

3. **Determine** if joints are affecting the geometry too much (e.g. the arm rotation causes the underarm area to indent too far, or the leg translation causes the pelvis area to collapse).

In this example, the movement of the foot control is collapsing the pelvis region.

> ❗ The main areas for collapsing weights are usually in the pelvic region, the buttock area, and the underarm area.

4. In the view panels, make sure only NURBS curves, NURBS surfaces, and polygons are seen. If not, go to [**Show > None**], then go to [**Show > NURBS curves**], [**Show > NURBS surfaces**], and [**Show > Polygons**] (this way you don't accidentally select joints or IK handles).

5. **Select** the vertices or CVs that are being affected incorrectly (**RMB** to display them, and then **drag** your mouse around to select them).

Selecting the points in the problem area.

6. Go to [**Skin > Edit Smooth Skin > Smooth Skin Weights**].

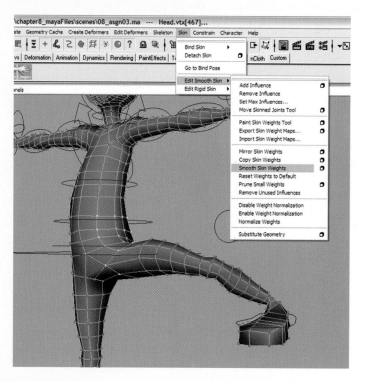

The results look MUCH better!

7. **Repeat** this for other affected areas.

8. **Save** your file as *08_asgn03.ma*.

Assignment 8.4: Adding Influence objects

You can use influence objects (additional joints or geometry) to help the knees, heel, and elbows hold their shape when bending. You can also add an influence object in the character's chest cavity and create a control for breathing. Influence objects can also be used to create simulated muscle flexing, such as in the bicep.

If your character's knees and/or elbows are pinching when they bend (and you have ruled out that it is a geometry issue, like the flexi straw and regular straw comparison in Chapter 5) extra joints can be placed in those areas and added as influence objects to help hold the shape.

1. **Continue** working on scene *08_asgn03.ma*.

2. **Test** the movement of your character by **selecting** controllers and **translating** or rotating **them around**.

3. **Determine** if the geometry is pinching in the elbows and/or knees.

4. In the view panels, **turn** X-ray ON.

5. For the knees: In the side view panel, use the joint tool [**Skeleton > Joint Tool**] and **click** a single joint behind the knee at the top of the calf and in the outliner, **rename** this joint *left_knee_influence*.

6. In the front view panel, use the move tool by pressing **(w)** on your keyboard and position the *left_knee_influence* and **align** it with the left leg.

7. Go to [**Skeleton > Mirror Joint**].

Creating and positioning the knee influence joints.

8. **Select** the *left_knee_influence*, shift select the left_knee, and press (**p**) on your keyboard to parent. **Repeat** for the right side.

9. For the elbows: In the top view panel, use the joint tool [**Skeleton > Joint Tool**] and **click** a single joint in front of the elbow at the bottom of the bicep and in the outliner. **Rename** this joint *left_elbow_influence*.

10. In the front view panel, use the move tool by pressing (**w**) on your keyboard and position the *left_elbow_influence* to align it with the left arm.

11. Go to [**Skeleton > Mirror Joint**]

Creating and positioning the elbow influence joints.

12. **Select** the *left_elbow_influence*, **shift select** the left_shoulder, and press (**p**) on your keyboard to parent. Repeat for the right side. You should also add influence joints for the heels and parent them to the ankle joints.

13. To add each new joint influence, **do** the following:

 a. **Select** the geometry (if there are multiple pieces, **select** only the geometry in the area of one influence joint), **select** one influence joint, and then **go to** [**Skin > Edit Smooth Skin > Add Influence – option box**].

 b. **Uncheck** the use geometry option.

 c. **Click** Apply.

 d. **Repeat** for each new joint influence.

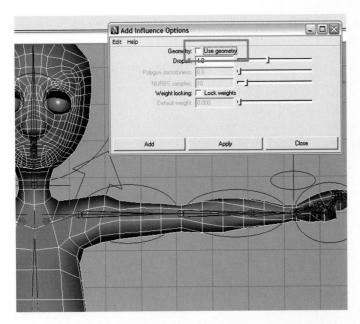

Adding a new joint as an influence. This must be repeated one at a time.

14. For the breathing influence, go to [**Create** > **NURBS primitives** > **Sphere**] and rename the sphere *breathing_influence*.

15. Using the move tool by pressing (**w**) on the keyboard, reposition the sphere into the chest cavity of your character. Using the **scale** tool by pressing (**r**) on the keyboard, **resize** the sphere so that it fills the chest cavity of your character, but does not extend outside of the character's geometry. You can also go into component mode (F8) to reshape the sphere.

16. To add the breathing influence, do the following:

 e. **Select** the geometry (if there are multiple pieces, **select** only the torso geometry), **select** the *breathing_influence* sphere, and then go to [**Skin** > **Edit Smooth Skin** > **Add Influence – option box**].

 f. **Check** the use geometry option.

 g. **Click** Apply.

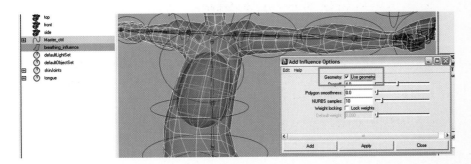

Adding a piece of geometry as an Influence Object.

17. In the outliner, **select** the *breathing_influence* and the *breathing_influence_base* that is created. Press **(ctrl + g)** to group them and rename the group *breathing_influence_group*.

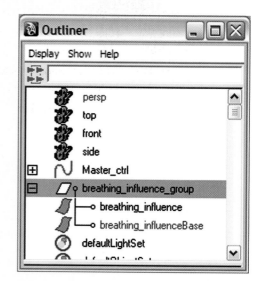

Grouping the influence object and base.

18. With the group still **selected, press (shift)** and **click** on the nearest IK spine joint (mine was *IK_spine5*). Then press **(p)** to parent the group to the joint.

19. **Create** a control for the breathing influence by doing the following:

 h. **Select** the *upperBody_ctrl* and go to [**Modify > Add Attribute**] and enter the following:

 i. Attribute name: type "Breathe".

 ii. Under *Numeric Attribute Properties*

 1. Minimum: type "–1".

 2. Maximum: type "1".

 iii. **Click** "OK".

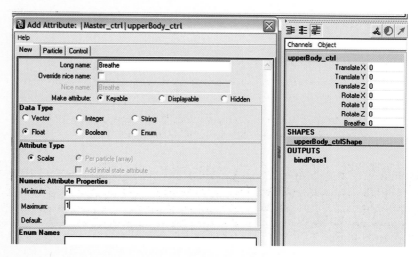

Adding the attribute "Breathe" to the *upperBody_ctrl*.

i. **Select** the *breathing_influence* and go to [**Animate > Set Driven Key > Set ...**] (this places *breathing_influence* as the driven in the *Set Driven Key* window).

 i. **Select** the *upperBody_ctrl* and **click** "Load Driver" in the *Set Driven Key* window.

 ii. In the *Driver* section of the *Set Driven Key* window, **choose** "Breathe" in the right column.

 iii. In the *Driven* section of the *Set Driven Key* window, **choose** "ScaleX" in the right column, hold down the **(shift) key** and also **click** on "ScaleY" and "ScaleZ".

 iv. In the *Set Driven Key* window, **click** "Key" to set a default pose at "0".

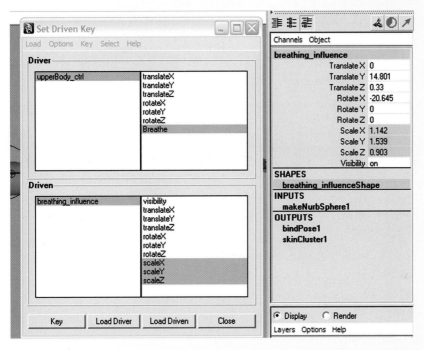

Loading the Set Driven Key window and setting the first key so that when Breathe is set to "0", the breathing influence is in the default (original) position.

 v. In the channel box, **change** *Breathe* to "1".

 vi. In the *Driven* section of the *Set Driven Key* window, **click** on *breathing_influence* to **select** it.

 vii. With the scale tool – **(r)** on the keyboard, **scale** the *breathing_influence* until the chest looks inflated with air, as when inhaling.

> Do not worry if the inhaling does not look correct. You can fix this using [**Skin > Edit Smooth Skin > Smooth Skin Weights**] or the [**Skin > Edit Smooth Skin > Paint Skin Weights Tool – option box**] All influences will appear in the *Influence* section of the paint weights options. The weights will be painted in the next assignment.

 viii. In the *Set Driven Key* window, **click** "Key".

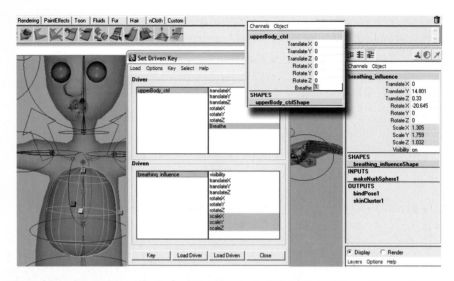

Setting the second key so that when Breathe set to "1", the breathing influence is scaled for inhaling.

 ix. In the *Driver* section of the *Set Driven Key* window, **click** on *upperBody_ctrl* to **select** it.

 x. In the channel box, **change** *Breathe* to "–1".

 xi. In the *Driven* section of the *Set Driven Key* window, **click** on *breathing_influence* to **select** it.

 xii. With the scale tool – **(r)** on the keyboard – **scale** the *breathing_influence* until the chest looks slightly deflated as when exhaling.

 xiii. In the *Set Driven Key* window, **click** "Key".

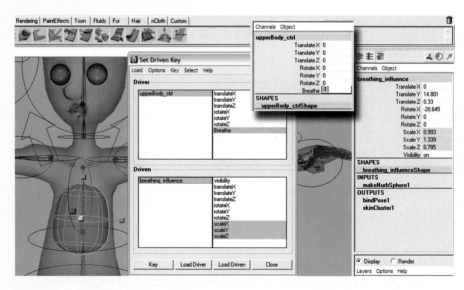

Setting the second key so that when Breathe set to "-1", the breathing influence is scaled for exhaling.

j. Hide the *breathing_influence* by selecting it in the Perspective window or the outliner and pressing (**shift + h**).

k. Test the *Breathe* attribute by **selecting** the *upperBody_ctrl*. In the channel box, **click** on the word *Breathe*. In the Perspective window, **MMB** (middle mouse button) **click** and **drag** the mouse left to right to test the breathing motion.

20. Save your file as *08_asgn04.ma*.

Optional assignment 8.7 creates an expression to give automated breathing animation to your character using this *Breathe* attribute.

Assignment 8.5: Fix the Skin Weights Using the Paint Skin Weights Tool (optional)
[Skin > Edit Smooth Skin > Paint Skin Weights Tool – option box]

I say this assignment is optional, because you will probably be able to solve all of your weight issues with the tools that we have already used. If you are working in an earlier version of Maya (before Maya 2008), you won't have access to the Smooth Skin Weights tool, and you will need to paint all of your weights as shown in this assignment.

1. **Continue** working on scene *08_asgn04.ma*.

2. **Test** the movement of your character by **selecting** controllers and translating or rotating them around.

3. Identify the problem areas that could not be corrected using the component editor or the smooth skin weights tool.

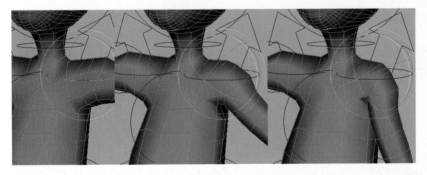

In this example, the movement of the arm shows that the shoulder geometry is not moving with it, causing it to crack slightly.

4. In the view panels, **turn** X-ray OFF.

5. In the view panels, go to [**Show > None**], then go to [**Show > NURBS curves**], [**Show > NURBS surfaces**], and [**Show > Polygons**] (this way you don't accidentally **select** joints or IK handles).

> A great tip is to **select** all of your controllers and set a key frame (Keys can be set by pressing **(s)** on the keyboard) on all of the controllers on frame one. Move the timeline to frame 10 and rotate or move the controllers to place the character into a pose where the problem areas can be seen. Key the controllers again on frame 10, then move to frame 20 and pose the character again where you can see different problems, and key this pose. MAKE SURE TO DELETE THE KEY FRAMES WHEN YOU ARE FINISHED. To do this, **select** all of the controllers and in the channel box, **click** on the top attribute name and shift **click** on the bottom attribute name. Then RMB and choose break connections.

6. **Select** the vertices or CVs that are being affected incorrectly (**RMB** to display them, and then **drag** your mouse around to **select** them).

Selecting the points in the problem area.

7. Go to [Skin > Edit Smooth Skin > Paint Skin Weights Tool – option box].

8. Under Display section, **UNCHECK** multi color feedback to see the weights in black and white.

9. In the *Influences* section of the *Paint Skin Weights Tool* – option box, **select** the joint or influence that SHOULD be affecting the area more (e.g. in this case, the *left_shoulder* joint).

10. In the Paint Weights section, **use** the ADD paint operation and change the value to about 0.1.

11. You can adjust the size of the brush. Simply hold down the **(b)** key, place your brush over your model, and **LMB** click and drag left to right to change the brush size smaller and larger.

12. **Begin** painting (single clicks on top of the cross areas of your geometry lines) or **click** and **drag** on the geometry.

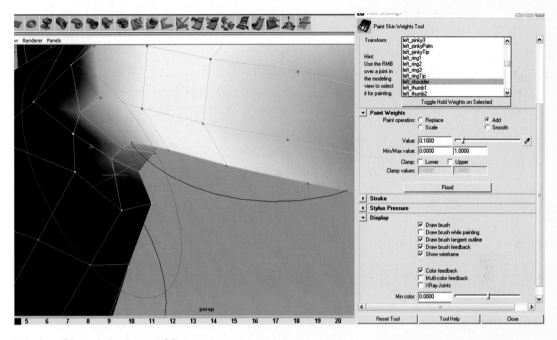

Painting skin weights in a problem area.

13. You may need to **check** the surrounding joints and **add** a little influence there (e.g. the spine joint above and below the one you originally chose to paint, if working on the spine).

14. **Scrub** your timeline (to scrub the timeline, **click** on the indicator in the time line and **drag** your mouse left to right) to see how it looks (if keys were set on the controls). If keys have not been set, test the deformation of your character by **selecting** controllers and **translating** or **rotating** them around.

15. You may need to change the Paint Weights section to SMOOTH and paint the joint that should NOT be affecting that area (in this example, the shoulder joint), then also smooth the other joints in the area.

16. **Repeat** this for other affected areas.

17. REMEMBER, you only need to paint the left side or the right side as we can mirror the weights to the other side in the next assignment.

18. **Save** your file as *08_asgn05.ma*.

MAKE SURE TO DELETE THE KEY FRAMES on the controllers if you created them. To do this, **select** all of the controllers and in the channel box, **click** on the top attribute name and shift **click** on the bottom attribute name. Then RMB and choose break connections.

Assignment 8.6: Mirror the Skin Weights [Skin > Edit Smooth Skin > Mirror Weights – option box]

1. **Continue** working on scene *08_asgn06.ma*.

2. **Select** the geometry that needs to have the skin weights mirrored. Go to [**Skin > Edit Smooth Skin > Mirror Weights – option box**] and set the following:

 a. **Mirror** across the YZ axis (on the X axis).

 b. **Uncheck** positive to negative only IF you painted on the character's right side and need to mirror to the left (your left to right – character's right to left).

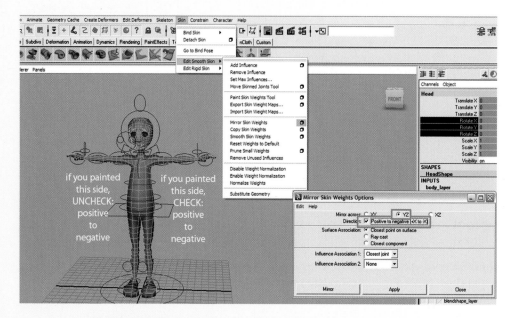

Mirroring the Skin Weights from positive X to negative X.

3. **Save** your file as *08_asgn06.ma*.

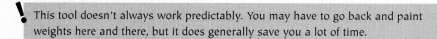

This tool doesn't always work predictably. You may have to go back and paint weights here and there, but it does generally save you a lot of time.

Assignment 8.7: Create a Breathing Expression (Optional)

1. **Continue** working on scene *08_asgn06.ma*.

2. **Create** an expression that will automatically animate the *Breathe* attribute by doing the following:

 a. **Select** the *upperBody_ctrl* and go to [**Modify > Add Attribute**] and **enter** the following:

 i. Attribute name: type 'BreathSpeed'

 ii. **Click** 'OK'

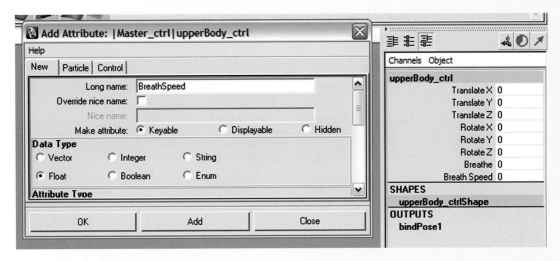

Adding the attribute 'BreathSpeed' to the *upperBody_ctrl*.

 b. **Create** the expression. Go to [**Window > Animation Editors > Expression Editor**] and **type** the following in the *Expression* section:

```
upperBody_ctrl.Breathe = sin(time * upperBody_ctrl.
BreathSpeed).
```

 i. **Click** 'create'

> This expression makes Breathe equal to the value of BreathSpeed (the number set in the channel box) times the current time line value and multiplies it with a sine wave. The sine wave causes the value of Breathe to fluctuate between −1 and 1 (where −1 and 1 are also the min/max of the Breathe attribute).

3. **Test** the expression:

 a. **Select** the *upperBody_ctrl*.

 b. In the channel box, **change** *BreathSpeed* to '5'.

 c. In the timeline, **press** the play (>) button to see the breathing occur.

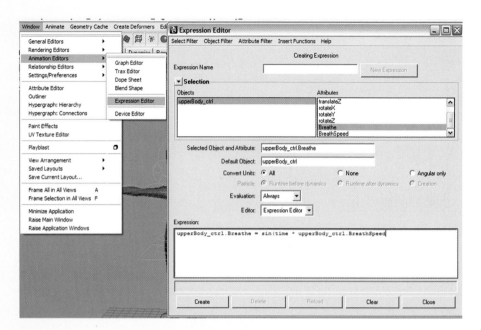

Creating the expression for breathing.

> The BreathSpeed Attribute can be set to '0' for no motion, or any other number to vary the speed. The breathing motion will automatically occur when animating.

4. Click on the attribute word *Breathe* in the channel box. Since the channel is purple, hold down the **RMB** (right mouse button) and **choose** *Hide selected*.

5. Save your file as *08_asgn07.ma*.

Assignment 8.8: Create a Smooth Switch for Polygonal Characters (Optional)

This should be done AFTER skinnings!

1. **Continue** working on scene *08_asgn07.ma* (or *08_asgn06.ma*).

2. **Select** the polygonal geometry and go to [Mesh > Smooth]. (If any geometry is parented to other geometry, this will not work. You must first un-parent by **selecting** the children and pressing (shift + p) on the keyboard, smooth, then re-parent.)

3. **Select** the *Master_ctrl* and go to [Modify > Add Attribute] and enter the following:

 a. Attribute name: **type** 'SmoothSwitch'

 b. Under *Numeric Attribute Properties*

 i. Minimum: type '0'

 ii. Maximum: type '2'

 c. **Click** 'OK'

Adding the attribute 'SmoothSwitch' to the *Master_ctrl*.

a. **Select** each piece of polygonal geometry (or the one combined piece, if you took the time to combine it in Chapter 2), in the *Inputs* section of the channel box, **click** on *polySmoothFace1*, and then go to [ANIMATE > SET DRIVEN KEY > SET ...] (This places the geometry as the driven in the *Set Driven Key* window.)

 i. **Select** the *Master_ctrl* and **click** 'Load Driver' in the *Set Driven Key* window.

 ii. In the *Driver* section of the *Set Driven Key* window, **choose** *SmoothSwitch* in the right column.

 iii. In the *Driven* section of the *Set Driven Key* window, **click** on *polySmoothFace1* to **select** it.

 iv. In the *Driven* section of the *Set Driven Key* window, **choose** 'divisions' in the right column.

 v. In the channel box, **change** *divisions* to '0'

 vi. In the *Set Driven Key* window, **click** 'Key', setting a default key.

 vii. In the *Driver* section of the *Set Driven Key* window, **click** on *SmoothSwitch* to **select** it.

 viii. In the channel box, **change** *SmoothSwitch* to '2'.

 ix. In the *Driven* section of the *Set Driven Key* window, **click** on *polySmoothFace1* to **select** it.

 x. In the channel box, **change** *divisions* to '2'.

 xi. In the *Set Driven Key* window, **click** 'Key'.

 xii. Return the character back to the non-smoothed version. In the *Driver* section of the *Set Driven Key* window, **click** on *SmoothSwitch* to **select** it.

 xiii. In the channel box, **change** *SmoothSwitch* to '0'.

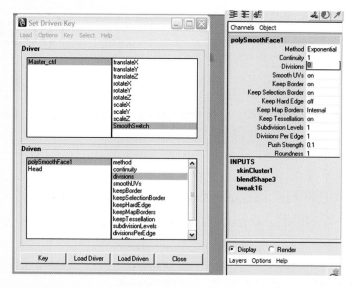

Loading the Set Driven Key window and setting the first key so that when the SmoothSwitch_is set to '0', the Polygonal Mesh will not be smoothed.

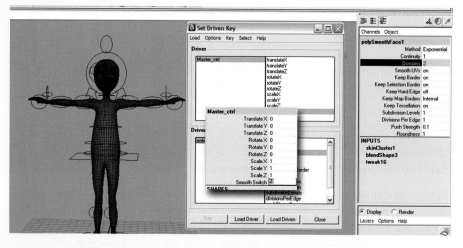

Setting the second key so that when the SmoothSwitch_is set to '2', the Polygonal Mesh will be smoothed.

! This provides an easy way of switching the display of the low res polygonal mesh at SmoothSwitch = 0, and the higher res for rendering at SmoothSwitch = 2.

4. Return your geometry layer back to *reference* by **setting** the layer to **R** so that you are unable to select the geometry by mistake when animating.

5. Save your file as *08_asgn08.ma*.

Glossary

Attribute – An aspect of a node. For example, rotation values, translation values, and scale values are all attributes of a node.

Bake – A term used to describe the process of making a change permanent, such as deleting history bakes changes to the geometry.

Biped – Characters that walk around like a human, stand upright, and walk on two feet.

Blendshape – A deformer that changes the shape of one piece of geometry to look like the shape of another.

Character analysis – The answers to questions that round out a character and define their appearance, background, and emotional makeup.

Character sheet – A series of drawings of your character from different views, such as front, side (profile), top, back, and ¾.

Child – Something in the Maya scene that is controlled by a parent object. It is important to note that a child can also be a parent of another child object. A child can only have one parent.

Construction history – A list of everything you do to an object. This list can be seen in the INPUTS section of the channel box and can be edited.

Deformer – A tool that changes the shape of an object.

Dolly – The camera physically moves in and out, closer or farther from your subject. This is not a zoom. Many students confuse a dolly move with a camera lens zoom. A zoom is a change in the focal length of the lens of a camera, for example, 35 mm to 50 mm.

Double transformations – A double transformation is when an object moves, rotates, or scales twice as much as you think it should. This is caused by getting the same transform information twice. This can occur to an object when it is parented to something else and skinned (the information then comes from the parent AND from the joints).

Euler rotation – A system of calculating the rotation of joints according to the degree set along the X, Y, and Z axis but evaluates the rotation based on the chosen rotation order. This is the default rotation calculation that Maya uses to figure joint rotations during the animation process.

File texture – A raster image created from photographs or painted in a 2D or 3D software package that is connected to a shader's color attribute.

Forward kinematics – A method where a hierarchy of joints (or objects) is rotated one at a time to create a pose. A key is then set on the rotation channels for each joint (or object). The position of a joint in the hierarchy is calculated based on the positions of each and every joint above (from the top of the hierarchy down, in a forward direction).

Gimbal – Only a single X, Y, or Z rotation axis value in the channel box will change when clicking on the specified color ring.

Gimbal lock – A problem that arises during gimbal rotation where 2 axes align, causing the inability to rotate in a particular direction.

Hierarchy – The structure of parents and children in the Maya scene file, and looks very similar to a family tree.

Hotbox – A quick method for accessing menu items and tools wherever your cursor is located.

Hotkeys – Maya's keyboard shortcuts to access different tools and commands.

Hypergraph – Shows everything in the scene in node format, and how each node is connected to others in the scene that contains information and actions for that information. The data is provided, held, or received with attributes. A node appears as a rectangle or box in the hypergraph. Nodes can be joined to each other by connecting one attribute to another, resulting in a node network.

.iff – Maya's image file format where an image is saved with no data loss.

Inverse kinematics – A mathematical system that calculates the rotations of a joint chain from the identified start joint all the way to the established end joint of the chain. An IK handle is created at the end of the chain that allows the animator to position the location of the end of a limb. Because of this, IK is a more intuitive way of positioning a character, much like a digital puppet. Once the handle is positioned, the calculations then occur to position the rest of the chain based on the location of the end joint, all the way back up to the start joint (from the bottom of the hierarchy up, or in an inverse direction).

Isoparm – A shortened form of *isoparametric curve which* is a line that runs across a surface on the U or V.

Keyframe – A defined position of an object or objects on a particular frame.

LMB – Left mouse button.

Local rotation axis – A separate coordinate system for joints where the axis of a joint is determined by the position of its child.

Local space – A coordinate system where an object uses the origin and axes of its parent for its position in space.

Marking Menu – A quick method for accessing a subset of menu choices of the most commonly used tools for a particular object.

MEL – Stands for Maya Embedded Language. This is the scripting language that Maya uses to do everything and anything. The true power of the Maya software is its ability to be customizable using MEL by an end user.

MMB – Middle mouse button.

Normal – A line that is perpendicular to the face of an object. Faces are only rendered correctly when the normal points outwards.

Ngon – A term used in computer graphics to refer to Polygons made of more than four sides.

Node – An element in the scene.

Nonmanifold geometry – Geometry that creates deformation and rendering issues because of faces whose normals face inconsistent directions; faces, vertices, or edges that lie directly upon each other.

NURBS – Stands for Non-Uniform Rational B-Spline and are curves and surfaces represented by mathematical algorithms, originally created by engineers to make an exact representation of the organic surfaces of ships.

Object space – A coordinate system where an object uses the origin and axes of itself for its position in space.

Origin – The point on the X, Y, Z coordinate system where the X, Y, and Z values are 0.

Parent – Something in the Maya scene (a joint, a piece of geometry, etc.) that controls the position, rotation, or scaling of something else – which is considered a child of that parent (such as another joint, or geometry). It is important to note that a parent can also be a child of another parent object. A parent can have multiple children.

Path – The place where the computer looks to find the file, or other files that are mapped within the file itself, such as a file texture. An absolute path (outside the project folder) to an image file looks like this: G:\jody\sourceimages\jody_front_1095_1647.tif, while a relative path (inside the project folder) to the same image file looks like this: \sourceimages\jody_front_1095_1647.tif.

Pivot – The point around which an object rotates.

Preferred angle – An angle created when a joint is rotated. Setting a preferred angle signals Maya by indicating the direction that the joint should rotate when an IK solver runs through it.

Polygons – A straight, three or more sided shape, called a face. Connected faces are called polygonal objects or meshes.

Quaternion rotation – A system of calculating the rotation of joints according to the position of the joint on the X, Y, and Z axis based on XYZ curves plus a fourth curve (W).

Rig – The skeletal structure and a system of controls for that structure.

Raster image – An image made of squares of color, or pixels, saved with file extensions such as a .jpg .tiff, or .tga.

Real numbers – Numbers that have an infinite decimal representation such as 5.3592847529…

RMB – Right mouse button.

Selection masks – Determine what type of objects or components you can select. Maya has a specific order of selecting things. Sometimes, it is difficult to select one thing over another. For example, this can be particularly helpful when working with skeletal joints,

because Maya selects geometry before joints, as joints are usually placed inside of geometry. By turning off surface objects, you are no longer able to select geometry, making it easier to select the joints.

Scene file – The file created as you work in Maya.

Scrub – Clicking on the indicator in the time line and dragging the mouse left to right to see action.

Shader – Also known as a material, defines the way the surface of an object appears once it is rendered, for example, shiny, glossy, matte, transparent, rough, smooth, etc.

Skinning – The skin deformer uses joints to move geometry points. The term *skinning* usually refers to the process of setting up the skin deformer.

Skin weights – The amount of influence that a point on the geometry is given to a joint, or several joints. This amount must total "1" and with the *smooth bind*, can be spread over several joints.

Specular highlights – A concentrated area of reflected light from a surface caused by bright lights or sunlight on a highly reflected surface, such as metal or glass.

Subdivision surfaces – Unique to Maya, these surfaces are a blend of NURBS and polygon characteristics.

Tangent – A line that touches a curve at a single point without crossing.

.tif – A 32 bit raster image file format (so that it could store CMYK color data), traditionally used for print media, that allows for lossless data compression – the ability to have smaller file sizes but be able to reconstruct the data back to the exact original image.

.tga – A 32 bit raster image file format (so that it could store RGBA color data), traditionally used for video media, that allows the storage of an Alpha channel – the ability to have transparency data for each pixel of the image.

Track – The camera physically moves horizontally and vertically.

Tumble – The camera rotates the view around a focal point. To create a focal point, select an object and then press (**f**) to frame the object.

Topology – The parts that make up an object and their relationship to each other. For example, a polygonal piece of geometry is made up of faces, edges, and vertex points. Each edge should be shared by only two faces.

UVs – A 2D coordinate system that corresponds to positions on polygonal geometry which makes the placement of image texture maps possible on a 3D surface.

Visual death – A term used to describe a lifeless area in art, such as a section of an artwork that has nothing going on in it, making it boring.

Index

Folders and Files on the DVD

AndyRig: A character rig (much more advanced than what is covered by this book) ready for animation plus the auto-rigging tools and movie files. Created by a former graduate student at the Savannah College of Art and Design, *John Doublestein.

ExampleCharacterSheets: Example student character drawings to illustrate Chapter 1.

StudentShorts: Student Short Films created from the characters made in class.

RiggingChecklist.pdf: A 26 page Rigging Checklist that is the shortened step-by-step instructions for Chapters 5–8: creating and skinning the rig.

MayaFiles: All of the working Maya files for Chapters 1–8, including controllers for the rig (ready to import into your own Maya scene file) and the optional assignments. These files are for MAYA 2008. If you would like an earlier version, please contact me at info@mayacharacterrigging.com

The Andy Rig by John Doublestein.

If you love what you have done so far, make sure to post your comments on your favorite online bookstore today!

Ready for more? Check out the Animator Friendly Rigging DVDs available on Autodesk's website by Jason Schleifer.

Also – don't forget to check out the website: www.mayacharacterrigging.com